Bourdieu and Data Analysis

Bourdieu and Data Analysis

Methodological Principles and Practice

Edited by Michael Grenfell
and Frédéric Lebaron

PETER LANG

Oxford · Bern · Berlin · Bruxelles · Frankfurt am Main · New York · Wien

Bibliographic information published by Die Deutsche Nationalbibliothek
Die Deutsche Nationalbibliothek lists this publication in the Deutsche Nationalbibliografie;
detailed bibliographic data is available on the Internet at http://dnb.d-nb.de.

A catalogue record for this book is available from the British Library.

Library of Congress Control Number: 2013954292

ISBN 978-3-0343-0878-6

Peter Lang AG, International Academic Publishers, Bern 2014
Hochfeldstrasse 32, CH-3012 Bern, Switzerland
info@peterlang.com, www.peterlang.com, www.peterlang.net

This publication has been peer reviewed.

Printed in Germany

Contents

Acknowledgements

The contributors to this volume first came together as part of the International Classification Conference that was held in St Andrews, Scotland in the summer of 2011.

I would like to thank Prof. Fionn Murtagh of the British Classification Society who welcomed the Bourdieu strand into the conference, and indeed was so helpful in the planning stages for both the workshop and papers presentation.

I would also acknowledge with thanks the support of Dr David Wishard, President of the BCS.

In Paris, Brigitte Le Roux (Université Paris Descartes and CEVIPOF/CNRS, Sciences-Po) was tremendously helpful in putting together the programme of speakers, and indeed contributing at the conference.

We could not have done either without the active support of Philippe Bonnet (Laboratoire de Psychologie et Neuropsychologie Cognitives, CNRS, Université Paris Descartes) both at the planning stages and, especially, in conducting the MCA workshop at the conference.

My fellow editor, Frédéric Lebaron (CURAPP/CNRS, Université de Picardie – Jules Verne), was also a constant support in bringing together the conference and the book that arose from it.

I would like to thank Christabel Scaife, commissioning editor at Peter Lang, for the positive manner she engaged with the project from the outset and for the numerous ways she has, with patience, helped and supported at various stages of the way towards the book's production.

Finally, we could not have done without the commitment and conscientiousness of our copyeditor, Fiona Loxley, who, besides working so hard to achieve such an excellent text, also made numerous changes to make this a better book. Big thanks!

Many of us who have been working with the ideas and work of Pierre Bourdieu for some time believe the next significant advances in

Bourdieusian applications must come through methodological advancement and integration. I need to offer my thanks and gratitude to all of the contributors to this volume for the part they have played in developing methodological uses of Bourdieu.

— MICHAEL GRENFELL, October 2013

MICHAEL GRENFELL AND FRÉDÉRIC LEBARON

Introduction

Interest in the work of the French social theorist, Pierre Bourdieu, has continued to grow since his untimely death in 2002. At this time, Bourdieu had risen from being a relatively obscure French sociologist in the 1960s to an intellectual star of international repute. He had long since been acknowledged in the principal fields of his research – Algeria, Education and Culture. However, since his death, as well as continued extensions and applications of his work in these areas, it is now not uncommon to discover major discussions of his ideas in such diverse disciplines as theology, geography, media and journalism, the arts, language, economics, politics, history, and philosophy. Of course, some of these fields were indeed discussed by Bourdieu himself, sometimes as preliminary remarks, sometimes more extensively. However, many remained undeveloped by him. Subsequent researchers have then been able to develop his initial ideas more comprehensibly. In other areas, bringing a Bourdieusian lens to traditional preoccupations has required a whole new conceptualization from a perspective derived from his theory of practice. Here, we are able to observe the potential of Bourdieu's approach to elucidate a wide range of themes and topics within the social sciences. Much of the work presented in this book is of this type.

Bourdieu was probably the most 'empirical' of the celebrated intellectuals of the late twentieth century. Work across his career is often exemplified with copious analyses collected in field contexts and analysed from various directions. However, Bourdieu was, of course, first a philosopher, since he was trained in that subject discipline, and even taught it at the early stages of his career. The brutal experience of living and working in Algeria at the time of the war of independence there in the 1950s then contributed to his re-orientation to anthropology and then sociology, which he further

developed in studies of education, culture and the local environs of his home community in the Bearn, France. This work shows Bourdieu's early commitment to 'make sense' of real, living, practical contexts. He seems to have adopted sociology as the best means to uncover the generating processes of social situations and to 'restore to men the meaning of their actions'. But, unsurprisingly given his background, his was a very particular form of sociology; one heavily accented by philosophical considerations. Key themes implied epistemological and ontological questions, which he answered by proposing a new view of the social world. Bourdieu himself termed this viewpoint 'structural constructivism' or 'constructive structuralism' and, in so doing, highlighted its two-way *structured-structuring* nature. By 'structure' Bourdieu intended the ordering, relational, principled processes – both material and phenomenological – that generated social activities.

He presented this perspective through a series of epistemological 'breaks' – from empirical sense experience, from subjective knowledge and objective knowledge, and through the analysis and elucidation of voluminous amounts of data gathered in field studies. This engagement necessitated the development of a particular form of language – articulated through Bourdieu's *key concepts*. These concepts were intended as instruments or techniques used to frame data analysis. Terms such as *habitus, field, capital* have now become synonymous with work approaching the study of any aspect of the social world through a Bourdieusian viewpoint. As well as enhancing many discussions in a range of associated fields en passant, these concepts have themselves given rise to in-depth and detailed debate, and many books have appeared which explore and express the nature of this way of seeing the world, along with its methodological implications. The majority of these works are discursive rather than analytic, however, theoretical rather than practical. The current publication differs on both counts.

What follows in the next three parts of the book is concerned almost entirely with methodological and practical exemplification and application. We take Bourdieu's philosophy, theory of practice and consequent concepts as axiomatic and concern ourselves with how to carry out research from such a perspective. We begin with laying some methodological foundations

in PART I. Here, we consider the whole relationship between theory and practice, and indeed the role that Bourdieu's key theoretical concepts have in mediating the two. We explore what this approach means in terms of the various stages of research practice; for example, the whole *construction of the research object* in the first place, and the key components of a *field analysis*. Bourdieu often approached his research by conceptualizing social space in terms of 'fields', which were then analysed as structural relations – inside of fields, between fields, and of those who occupied positions in them. For Bourdieu, reflexivity was also a chief feature of his work, and he argued that the scientific worth of any research might best be evaluated to the extent that the researcher was able to develop this dimension of their work. Reflexivity, or *participant objectivation*, is, therefore, also discussed in PART I.

PART II then deals with qualitative research. Here, we see a range of researchers pursuing studies through the deployment of traditional modes of qualitative data collection and analysis: interviews, questionnaires, observation, focus groups, diaries, and documentary analysis. Topics include school inclusion, language education, the artistic avant-garde, and higher education. These chapters are introduced through a brief consideration of their content and the style of research this approach gives rise to. We take up similar points in the conclusion to PART II in order to emphasize the relationship between the researcher and the researched, and the consequence this has for outcomes.

Qualitative research was, of course, a feature of Bourdieu's own work throughout his career, and all of the techniques used in PART II were, to a greater or lesser extent, employed by Bourdieu himself. However, and again from his earliest work, we see how he extended his analyses through the use of quantitative methods; most noticeably in a range of statistical analyses in the 1950s and 60s. Increasingly, though, he adopted a form of 'quantitative' method that allowed him to graphically demonstrate the form of structural relations evident in any given data sample. Termed Geometric Data Analysis, or Multiple Correspondence Analysis, these procedures allow the researcher to correlate 'clouds' of individuals in terms of a range of connecting relational features. The chapters in PART III almost exclusively adopt this approach, and our aim is to show, again, how such

techniques can enhance our understanding of a range of social contexts and synergize with the epistemological perspective offered by Bourdieu. Topics covered here include the education and economics fields, language, politics, and even video games.

We are not presenting any of the chapters as 'ideal' in terms of approach or method, and there are questions raised by each of them. Neither are we implying that quantitative is better than qualitative, or vice versa. However, as noted above, discussion of Bourdieu has hitherto been preoccupied with theoretical issues. These chapters show those theories in practice. The researchers here represented form part of a group who are increasingly looking to use Bourdieu in practice; indeed, we might say that the future worth of this approach depends on such applications. For our purposes, and to focus the narrative, we have selected investigations, which tend to adopt either a qualitative or quantitative approach. However, we must stress that Bourdieu's best studies were perhaps achieved when he adopted both, and we would finally urge any would be researcher to act in a similar way.

As we have observed, Bourdieu's sociology had the ambition to see the world in a new way. However, we need the instruments to aid us to this end. The theoretical tools to conceptualize research in this way are now well elucidated. This book aims to provide methodological exemplification more on the practical front. Our final conclusion will take up this theme again in considering the salient methodological principles for a Bourdieusian social science and the kind of knowledge it gives rise to.

PART I

Bourdieu and Data Analysis

MICHAEL GRENFELL

Bourdieu and Data Analysis

> Those who classify themselves or others, by appropriating or classify-
> ing practices or properties that are classified and classifying, cannot be
> unaware that, through distinctive objects or practices in which their
> powers are expressed and which, being appropriated by and appropriate
> to classes, classify those who appropriate them, they classify themselves
> in the eyes of other classifying (but also classifiable) subjects, endowed
> with classificatory schemes analogous to those which enable them more
> or less adequately to anticipate their own classification.
>
> — BOURDIEU 1984a: 484

Introduction

This chapter offers a conceptual introduction to Bourdieu and data analy-
sis. It sets out key stages in approaching any research topic from a perspec-
tive developed from his theory of practice. Behind this perspective lay
Bourdieu's vision to build a 'new social gaze' on the social world, what he
referred to as a *metanoia*. Key components in this approach are how we
construct the research object and the place that *participant objectivation* plays
in research. The chapter considers these as elements in a three-stage meth-
odology, which also includes at its core *Field Analysis*, itself explicated in
terms of three levels – of a field with respect to the field of power, the struc-
ture of the field itself, and the habitus of those occupying positions within
that field. These stages and levels are discussed later in the chapter. First,
however, we consider Bourdieu's conceptual thinking tools; not so much
in terms of their full range and meaning, which is already accomplished

elsewhere (Grenfell 2012), but by focusing on the relationship between data and the language used to explain and interpret it. Any question of data analysis within a Bourdieusian frame will inevitably raise issues of the quantitative versus the qualitative; a dichotomy which is also often erroneously referred to in terms of the tensions between subjectivity and objectivity. Both these pairs are similarly associated with different data sources and analysis thereof; for example, the quantitative is implicated with statistical analysis and the qualitative with ethnographic and more naturalistic approaches. It is probably worth emphasizing that Bourdieu employed both approaches extensively throughout his empirical studies. His earliest field work in the Bearn and Algeria was both statistical and ethnographic; indeed, the combination of the two is precisely what makes these studies so powerful (see Bourdieu 1958, 1961, 1962a, 1962b, 1963, 1964). Of course, Bourdieu was a philosopher first, and then a would-be anthropologist. No surprise, therefore, to read him warning against the way statistics can be used to 'crush one's rivals'.

Nevertheless, as noted, he himself used statistics extensively in these early works, and extended their applications to Multiple Correspondence Analysis/Geometric Data Analysis (MCA/GDA) in later works from the 1970s onwards. Parts II and III of this book deal respectively with what is termed the 'qualitative' and the 'quantitative', and offer a number of studies using a variety of statistical and non-statistical techniques. The main point behind these separate studies is that both imply the same issues in terms of data collection and analysis, of theory and practice, of explanation and interpretation, of research construction and conduct, and this is a theme the various contributors to this book develop across its content. Approaching the analysis of data through MCA and GDA requires as much sensitivity, care, and understanding as any ethnographic study, and vice versa. Issues particular to each will be raised in the individual parts. Here, we consider the epistemological and methodological principles underlying the various techniques employed.

Structural Relations

The first part of the discussion addresses the centrality of 'structure' to Bourdieu's theory of practice and research methodology. We consider this from its most fundamental form, as the relationship between an individual and the social world and the implications this may have for constituent activity within it, including that of conducting research.

We can say that the basis of Bourdieu's science is the simple fact of a *coincidence* between an individual's connection with both the material and the social world. Everything lies in this connection: here are the structures of primary sense, feeling and thought – the inten*s*ional (sic.) links that are established between human beings and the phenomena – both material and ideational – with which they come in contact. This is a basic phenomenological precept; and the 's' here is intended to draw attention to this *s*tructural relationship. Everything we know about the world is both established and developed as a consequence of individual acts of perception, which are by their very nature structural because they are relational. However, such structures have defining principles, which are both pre-constructed and evolving according to the logic of differentiation found within the social universe. In other words, such principles do not exist in some value-free, Platonic realm; rather, they are the product and process of what already-has-been – values which serve the status quo and/or emerging social forms. This phenomenological structural relation is, therefore, also a product of environmentally structural conditions, which offer objective regularities to guide thought and action – ways of doing things. This understanding is also central to research activity.

As noted above, at the base of Bourdieu's science is an attempt to transcend the opposition between subjectivity and objectivity. Methodologically, this dichotomy is also played out in terms of two approaches: one substantialist, the other relational. The substantialist approach treats things as pre-existing entities, with essential properties – as realist objects; whilst the relationalist approach understands things in terms of their relational context – how they acquire sense in terms of their position with respect to

other phenomena which share their context (see Bourdieu 1998b: 3–6). So, when Bourdieu uses a term such as *Disposition*, he is intending them not as actual, hidden entities but only existing in as much as they are part and parcel of social and psychological structures in their mutually constituting existence: they are 'energy matrices' in that they are constituted in the process of socialization of individuals and lay in the structural generative schemes of thought and action, which are activated in particular social conditions – fields: the real is relational: what exists in the social world are relations – not interactions between agents or intersubjective ties between individuals, but objective relations which exist 'independently of individual consciousness and will'.

The objective and subjective bases to Bourdieu's theory of practice can also be illustrated by his understanding of culture. Bourdieu writes that there are two traditions in the study of culture: the *structural* tradition and the *functionalist* one (1968a). The structuralist tradition sees culture as an instrument of communication and knowledge, based on a shared consensus of the world (for example, the anthropology of Lévi-Strauss). The functionalist tradition, on the other hand, is formed around human knowledge as the product of a social infrastructure. The sociology of both Durkheim and Marx would form part of this second tradition, as both are concerned with ideational forms emergent in the structures of society – material, economic, organizational – one being positivist and the other critical-radical. Bourdieu criticizes both traditions. The first tradition is too static for Bourdieu: *structured structures* taken as synchronic forms, and often based on primitive societies. Whilst the second tradition reifies ideology – as a *structuring structure* – in imposing the ideology of the dominant class, in the Critical tradition, or maintaining social control in the Positivist one. Bourdieu attempts to reconcile these two traditions by taking what has been learnt from the analysis of structures as symbolic systems in order to uncover the dynamic of principles, or logic of practice, which gives them their structuring power (see Bourdieu 1971a). In short, a theory of structure as both *structured* (*opus operatum*, and thus open to objectification) and *structuring* (*modus operandi*, and thus generative of thought and action).

In the *Outline to a Theory of Practice* (1977/72b), Bourdieu sets out this approach in terms of a series of 'breaks': from empirical knowledge; from phenomenological knowledge; from structural knowledge; and from scholastic (theoretical) knowledge itself (pp. 1–2). These breaks are not to be seen as a series of exclusions, however; rather each theoretical position is retained and integrated into an overarching theory *of* practice. In effect, we need to understand these breaks as implying the addition of a fourth type of theory – *structural knowledge*. The key to the integration of the theoretical breaks is indeed the addition of *structural knowledge* in relationship to the phenomenological, scientific and practical in order to indicate their essential structural nature. Indeed, we might say of such structural knowledge that it arises from practical action – that is the empirical cognitive acts of individuals in pursuit of their aims. Such an engagement involves a social context and individual agency – in Bourdieusian terms, field and habitus. However, it is important to understand it as an essential *constructivist* aspect of human praxis – and from birth. Several epistemological principles follow from this account:

- That the primary cognitive act (i.e. that of a newborn child) takes place in a social environment and is essentially structural as it sets up intentional (what phenomenologists refer to as inten*s*ional) relations between the social agent and the environment;
- That environment includes both material and ideational structures;
- That the primary cognitive act therefore needs to be understood in terms of a search for social-psychic equilibrium, or control over Self, Objects and Others;
- That such an act – and subsequent acts – do not establish themselves in a value neutral vacuum, but in an environment saturated with values and ways of seeing the world;
- That such values and such ways constitute a pre-set orthodoxy into which agents are inducted;
- That such values and orthodoxies are dynamic and constantly evolving. However, their underlying logic of practice remains the same: they represent a certain way of seeing the world on the part of particular social factions of society;

- That way of seeing the world conditions and shapes the primary cognitive act in a dynamic relationship with individuals involved. In this way, individuals can be particular, all whilst sharing commonalities with those immediately in their social environment;
- Both the particulars and the commonalities develop 'dispositions' to think and act in certain ways. The extent to which such dispositions are 'fired' depends on patterns of resonance and dissonance set up in the range of contexts in which individuals find themselves;
- The characteristics of orthodoxies, dispositions, and their underlying values are defined by the position particular social groupings hold in relation to other social groupings in the social space as a whole;
- That position is also structural and relational;
- Orthodoxies, values and dispositions express certain interests – those interests of the most dominant social groupings;
- In this way, there is a dialectical relationship between actual structures of social organization and the structures of symbolic systems that arise from them;
- Nothing is pre-determined; everything is pre-disposed.

And, we need to *think in these terms* both for the object of research, the activity of research, and those carrying it out. In other words, researchers, just as much as those whom they research, are subject to the same theory *of* practice. This understanding needs to be a constituent part of the process. The next section explores further the relationship between the language of research – the concepts used in analysis – and the social 'reality' it purports to represent. The relationship between the two is particular in the case of Bourdieu: what do these concepts mean? Where do they come from? How 'real' are they?

Language and Concepts

We need to remember that Bourdieu's early work was developed in opposition of two salient intellectual traditions, both of which were highly influential during his formative years (the 1950s): existentialism and structuralism. Existential is best represented by the work of the French philosopher Jean-Paul Sartre, with its philosophy of personal liberation through the subjective choices we make in defining our lives. Structuralism may be represented by the work on the anthropologist Claude Lévi-Strauss and its study of the objective 'rules' which can be found across cultures and which govern human behaviour – taboos, myths, etc. Bourdieu referred to the divide between objectivism and subjectivism in the social sciences as 'the most fundamental, and the most ruinous' (1990a/80: 25). Bourdieu's entire 'theory of practice' can be seen as an attempt to bridge this divide. He defined his approach as a 'science of the dialectical relations between objective structures... and the subjective dispositions within which these structures are actualized and which tend to reproduce them' (1977b/72: 3). The key concepts to represent these structures are articulated through the terms *field* and *habitus*, the relationship between which he described as one of 'ontological complicity' (1982a: 47).

Field is the 'objective' elements of the social environment, and is defined as:

> ... a network, or a configuration, of objective relations between positions. These positions are objectively defined, in their existence and in the determinations they impose upon their occupants, agents or institutions, by their present and potential situation (situs) in the structure of the distribution of species of power (or capital) whose possession commands access to the specific profits that are at stake in the field, as well as by their objective relation to other positions (domination, subordination, homology, etc.). (Bourdieu and Wacquant 1992: 97)

Habitus, on the other hand, is an expression of *subjectivity*:

> Systems of durable, transposable dispositions, structured structures predisposed to function as structuring structures, that is, as principles which generate and organize

practices and representations that can only be objectively adapted to their outcomes without presupposing a conscious aiming at ends or an express mastery of the operations necessary in order to attain them. Objectively 'regulated' and 'regular' without being in any way the product of obedience to rules, they can be collectively orchestrated without being the product of the organizing action of a conductor. (Bourdieu 1990a/80: 53)

In line with the discussion above, *habitus* and *field* are homologous in terms of structures that are both structured and structuring. In other words, *social spaces* must be understood as differentiated, and thus structural in essence. Similarly, individual cognition arises from, generates and is generated, by mental structures, which are also essentially structured because of their systems of differentiation. In a seminal paper in 1966 – *Intellectual Field and Creative Project* (1971c/66) – Bourdieu builds on the discovery of the historian Panofsky that there was a link between Gothic art, for example in the design of cathedral architecture, and the mental habits of those involved. In other words, each was symptomatic of the other. Bourdieu used this principle to argue that there was a *structural homology* between subjective thought and objective surroundings, the latter, for Panofsky, most noticeable in forms of social organization rather than cathedrals. Such homologies exist because they are both generated by and generate the *logic of practice* of the *field*, itself defined in terms of its substantive raison d'être. This reinforces the point: social and mental 'structures' are co-terminus, are both 'structured' and 'structuring' – concrete and dynamic – stable but in flux.

This discussion still raises questions concerning what conceptual terms we use to describe such structures? We know something of the epistemology, which underpins them but on what practice are they based? What is their value? Briefly, what is the relationship between the real world and the symbolic world?

The Symbolic and the Actual

As emphasized, Bourdieu's approach to investigating the social world is essentially empirical, in which he saw its relational and dynamic nature. Here, at a particular time and place, its changing structures and institutions

are analysed (an external objective reading) at the same time as the nature and extent of individuals' participation in it (an internal subjective reading). These two distinct social logics are inter-penetrating and mutually generating, giving rise to 'structured' and 'structuring structures' (see above). Bourdieu consequently distinguishes between a theorist's viewpoint and a researcher's viewpoint: A theorist is interested in developing hypotheses to account for the particularities and functioning of an object of study, whereas a researcher collects empirical data and analyses it in order to obtain a picture of how the 'real world' is constituted. Either of these viewpoints gives only a partial view if used alone. Bourdieu's approach seeks to do both, and more. Here, the study of a social object can be described most simply as an on-going and reflexive interplay between the two positions – empirical investigation and theoretical explanation. In place of continued separation between the two positions, mitigated only by intensified interactions, Bourdieu advocates the fusion of theoretical construction and practical research operations – a theory *of* practice – which is at one and the same time a practice of theory. Bourdieu, however, goes still further, arguing against simply adopting a scholastic view (from a distance). He sees the necessity for a return to practice and to the social world. Here, modes of thinking are necessary to understanding an object of study in relation to its *field* context and to the interests and positioning of the researchers themselves.

The world is infinitely complex. Any researcher struggles with representing that complexity. Faced with the multidimensionality, there seems to be a choice between two primary ways of tackling it. As noted above, the 'theoretical' approach held to be most robust and 'scientific' seeks to extract, simplify, and hypothesize on the basis of findings, which can then be tested against further data analyses. However, a Bourdieusian approach to research takes a different course; one which begins with the totality, accepts the complexity and seeks organizing structures within it and their underlying generated principles. The logic of such principles is always to differentiate, but they do express themselves in different terms. In this way, the principles can be functionally operative at the same time as being *misrecognized*: if they were not, they would not be as effective. The whole of Bourdieu's conceptual universe – his theory of practice and

the terms in which it is expressed – *Habitus, Field, Capital, Disposition, Interest, Doxa*, etc. – is predicated on this epistemological stance. However, it is a stance with conceptual and practical implications. Let us take 'social class' as an example.

Bourdieu in the Field – The Study of Social Grouping

In another publication (Grenfell 2004) I evoked the image of Bourdieu the photographer as a way of understanding his own 'gaze' on the social world. I argue that, for Bourdieu, very often, a single image is the source of his investigations. Two such images are particularly striking. The first is from Algeria where Bourdieu first went in 1955 in order to complete his military service. It was a turbulent time of 'troubles' and Algeria was engaged in a cruel war of independence with the occupying French colonialists. Besides the profound changes in the structure of the population, which had been brought about by France since it first occupied Algeria in 1830, new displacements had taken place as a result of war and the fight for independence. Here, Bourdieu saw a society in turmoil: the old traditional way of life was being displaced by modern urban living; the peasant economy was submerged in new capitalist systems; the agricultural peasant was confronted by a growing industrial workforce. Amongst all these changes, and the images to which they gave rise (see Bourdieu 2003a), one seems to have struck Bourdieu as particularly telling. It is the photo of the modern salesman, one who literally carried his shop on his bike (ibid.: 165). The second image comes from Bourdieu's home region in the Béarn. Here, a simple village ball with the village gathered for its Christmas dance; and around the dance floor, the middle-aged bachelors who watch but do not dance – the 'unmarried' and the 'unmarriable' (see Bourdieu 2002a). In both cases, I argue, there is the gaze of Bourdieu – both as photographer and sociologist – and the implied questions: Who are these people? What made them? What are their motives? What will become of them? (see Grenfell 2004: 34 and 119; Grenfell 2006). It is in addressing these questions, and unpacking the multidimensional factors at play, that Bourdieu constructed his sociology. The 'bal des célibataires' was to occupy him for

the next thirty years with substantial reworkings of the data in papers at ten year intervals (See Bourdieu 1962c, 1972a, and 1989b). Algeria was also to furnish him with a lot of empirical data material to draw on, not only for his early works on the ethnography of this country, but also formed the basis of his major methodological statements: *Esquisse sur une théorie de la pratique* (1972) and *Le sens pratique* (1980). In a sense these topics never left him, and he returned again and again to these early field work experiences. These two topics, perhaps more than any others, support Bourdieu's claim to have only published the 'work of his youth'!

The substantive points to make here are as follows. Firstly, Bourdieu often begins with a practical context – an image, sometimes a social entity – and uses this to conduct his enquiries. In his early studies, data was collected first, and only then was theory developed after immersion in its analysis. This was a necessary first stage if he was to 'rupture with the pre-constructed'. He says so: in interviews I conducted with him (Bourdieu and Grenfell 1995a), he describes the main motive for studying and publishing analyses on Algeria as the desire to elucidate a topic that was poorly understood by the majority of French men and women. Similarly, his work on education came partly from a wish to understand what it was to be 'a student' (itself part of a self-objectification of academic life). It is important to stress that there is a particular phenomenon, or research question, at the point of initiation in Bourdieu's work – not a theoretical motive. He says so quite explicitly on several occasions, and in the Foreword to *Reproduction* (1977a/70: xviii) goes out of his way to insist that, although the book is divided into two parts – the first theoretical, and the second empirical – really their provenance should be understood as being the other way around, from practice to theory; in other words, to come up with a set of propositions for the research which were 'logically required as a ground for its findings'.

As stated above, Bourdieu is looking to break with the 'pre-given' or 'pre-constructed'. For example, in his very first publication on Algeria (1958), he begins by arguing that 'Algeria' itself is a social construct, which first needs to be understood in terms of its actuality rather than any historical accumulation of meaning. What follows amounts to a social topography of the morphology of Algerian society. Similarly, with respect to education,

he addresses the 'common sense' view of democratic schooling, so centrally cherished and upheld by successive political establishments within the French Republic after its foundation by the Jacobins (see Bourdieu 2008a/ 2002). This preoccupation with the 'social construction' of social 'facts' preoccupied him for the rest of his career. For example, even in 1990, in response to a letter from sixth-form students requesting support for the '*lycée* movement' he begins with asserting that he refuses to speak of '*lycée* students' in general as this is an 'abuse of language' (ibid: 181). They are not a homogenous entity but a diverse collectivity. The point is more than semantics, rather one of philosophy and methodology. Bourdieu describes his own 'epiphanic moment' when he saw that, in order to proceed in the social sciences, it was necessary to look at the total structure of the social space, not a 'representative' sample (see Bourdieu and Grenfell 1995). But this moment only came as part of his empirical experiences in Algeria and the Béarn, viewed in the light of his own philosophical background and readings of the founding fathers of sociology.

As noted above, Bourdieu's own empirical and academic experience was mounted against a background of intense intellectual debate in the immediate post-war period. Much of this debate was conducted in the (pre-constructed) terms of the day; of which those of race and social class were amongst the most dominant. Bourdieu too adopts a conventional rubric – working class, middle class, upper class – as a working model to group findings emerging from his analysis of data collected on education and culture (for example, in *Reproduction* (op. cit.) and *The Love of Art*, 1990c/66); just as, in the same way, he had (in 1963) attempted a description of the social structure of Algerian society in classic Marxist terms: sub-proletariat, proletariat, semi-proletariat, traditional bourgeoisie, new bourgeoisie (p. 383). However, behind all of these accounts lay super-ordinate concerns to account for social systems as a multidimensional space that required both statistical and ethnographic analyses. Change, its medium and process, was central to this concern, as was the desire to show up the mechanisms of social reproduction (education, culture, religion, etc.) in contributing to the evolution of French society. It is out of these practical concerns, rather than theoretical opposition to dominant paradigms, that Bourdieu began to develop the conceptual tools of analysis. These did not

emerge deductively, but as a way of accounting for what was seen in the empirical data collected and analysed:

> ... the concept of *habitus* which was developed as part of an attempt to account for the practices of men and women who found themselves thrown into a strange and foreign cosmos imposed by colonialism, with cultural equipment and dispositions – particularly economic dispositions – acquired in a pre-capitalist world; the concept of *cultural capital* which, being elaborated and deployed at more or less the same time as Gary Becker was putting into circulation the vague and flabby notion of 'human capital' (a notion heavily laden with sociologically unacceptable assumptions), was intended to account for otherwise inexplicable differences in academic performance with children of unequal cultural patrimonies and, more generally, in all kinds of cultural or economic practices; the concept of *social capital* which I had developed, from my earliest ethnographical work in Kabylia or Béarn, to account for residual differences, linked, broadly speaking, to the resources which can be brought together *per procurationem* through the networks of 'relations' of various sizes and differing density...; the concept of *symbolic capital*, which I had to construct to explain the logic of the economy of honour and 'good faith' and which I have been able to clarify and refine in, by and for the analysis of the economy of symbolic goods, particularly of works of art; and lastly, and most importantly, the concept of *field*, which has met with some success... The introduction of these notions is merely one aspect of a more general shift of language (marked, for example, by the substitution of the lexicon of dispositions for the language of decision making, or of the term 'reasonable' for 'rational'), which is essential to express a view of action radically different from that which – most often implicitly – underlies neoclassical theory. (Bourdieu 2005/00: 2)

Bourdieu's interest in a term like 'social class' was, therefore, secondary. The photos of the Algerian street sellers show individuals who have no class, as such. The important questions about them are more ethnographic: who are they? Why are they there? The photos of the Béarnais peasants show individuals who are all of the same class – they are peasants. However, here, there are important questions about how differentiation occurs and why. What are the structures that operate to exclude a certain group from matrimony. The methodological point is that it is in response to questions like these that Bourdieu developed concepts such as *field*, *habitus* and *capital*. It was not an attempt to provide a theory of 'social class', more an explanation of individual trajectory and change in society.

Bourdieu and Social Class – 'Classifying' Society

Bourdieu's view of 'social class' is, at one and the same time practical, philosophical and methodological – and, in fact, ultimately political. It unfolded in the course of his intellectual development. Above I argued that for Bourdieu, the primary human act is one of cognition; that is an individual engaging in their social (material and ideational) environment. The response of social agents is both empirical and naïve at source, but increasingly conditioned by the pre-given, what has been experienced before. That internalization, for Bourdieu, is both mental and corporeal (*hexis*) – embedded in the being of social agents. Bourdieu is seeking to 'break' with that empirical state in disclosing the meaning of social action. However, to sum up the above, that break is mounted in terms of further 'breaks' from different forms of knowledge derived from the philosophical field; namely, subjectivist and objectivist knowledge (see Grenfell and James 1998: Chapter 2; and Grenfell 2004: 174.ff for further discussion). As noted above, Bourdieu sees this dichotomy to be 'fundamental' and 'ruinous' (1990a/80: 25.ff). On the one side, is the 'objective mode' with its representations of reality as things to be thrown into sharp relief. On the other, is the 'subjective mode', where agents manipulate their self-image in presenting themselves to a world that is experienced as a series of spontaneous events. As we have seen, Bourdieu places Marx and Durkheim on the objective side, and Schütz and phenomenology on the subjective side. This issue is central to Bourdieu's thinking since, in effect, it represents a struggle over our very perceptions of the social world. A struggle in which the 'truth is at stake'. This leads to a fundamental question: 'Are classes a scientific construct or do they exist?' If we were to regard them through the substantialist mode of knowledge referred to earlier, they are seen as 'ready-made' generators of social practice. The action of social agents is therefore, reduced, to being a product of their membership of certain social groups identified by the researchers. Whilst the relational mode sees classes in terms of invisible relationships, which are actualized at any given moment. The power of social classes is indeed that they are 'misrecognized' as such: what is seen in terms of social class does not exist; while what is not seen does. No-one knows really when and where one class

ends and another begins and, in reality, any one individual may exist in a number of 'classes' throughout their life without ever belonging to any of them. For Bourdieu, 'the real' is hence relational because reality is nothing other than structure, a set of relationships, 'obscured by the realities of ordinary sense-experience' (Bourdieu 1987: 3). This relational reading of Bourdieu's work is fundamental to grasping what he is in fact offering in his 'class-based' analyses:

> It is because the analyses reported in *Distinction* are read in a realist and substantialist way (as opposed to a relational one) – thus assigning directly this or that property or practice to a 'class', playing soccer or drinking *pastis* to workers, playing golf or drinking champagne to the traditional *grande bourgeoisie* – that I am taken to task for overlooking the specific logic and autonomy of the symbolic order, thereby reduced to a mere *reflection* of the social order. (In other words, once again, the charge of reductionalism thrown at me is based on a reductionist reading of my analyses). (Bourdieu 1994a/80: 113)

So, what is Bourdieu doing that is different? Instead of attributing particular practices to particular classes, Bourdieu's intent is to construct a model of the social space (see Part II, chapter by Hardy), which accounts for *a set of practices* found there. These practices differentiate themselves according to observed differences based on the principles defining position in the social space. What is at issue here is not so much the similarities that classes share, but their differences; we need to 'construct social space in order to allow for the prediction of the largest possible number of differences' (1994a/87: 3). What he offers is therefore less a sociology of 'social class' than a 'sociology of distinction' – its defining logic of practice, and social classification. Here, acknowledgement that 'distinction' is a basic human instinct is not enough. Bourdieu therefore takes exception with Veblen's view of 'conspicuous consumption': it is not enough to be conspicuous, but to be noticed in terms of a *specific sign of signification*. Classes only exist, therefore, to the extent to which they are acknowledged as such in practical contexts governed by the particular principles of their position in the social space. The purpose of sociology is to indicate the processes and consequences of that acknowledgement. Anything else is to confuse the 'things of logic with the logic of things' (ibid.: 117). Naming a class,

without this view, is tantamount to an insult as it acts as a form of 'symbolic violence' in imposing a certain (absolute) perspectivism.

The issue of 'social classes' and how they are defined, therefore, goes to the heart of Bourdieu philosophy and method. *Social classes therefore do not exist.* What exists is 'social space' and virtual classes defined in terms of particular activities within it.

He is struggling not to substantiate 'classes' in a field in which its *modus operandi* include a struggle for philosophical and methodological saliency. 'To name' something is tantamount to an act of magic since, if accepted, it allows for one view to take precedence over another, itself a form of 'symbolic violence'. Classificatory strategies mark an ambition to accept or modify a certain world view: Capitalist? Marxist? Bourdieusian? Therefore, we should beware of researchers who pass over the relational aspect of 'classes on paper', and be aware further of their virtual aspect. Yet, this is exactly what does happen, Bourdieu argues, in fields where certain agents (with their own objective interests) assign members to certain categories. These agents may exist in the political, media or academic fields. However, in each case, there is an issue of 'legitimacy' in the naming of others. This argument moves Bourdieu to a view of taking the actual process of 'classes' and 'classification' as an object of study: 'one cannot establish a science of classifications without establishing a science of the struggle over classifications and without taking into account the positions occupied in this struggle for the power of knowledge' (1991a/82: 241). The point here is that Bourdieu is arguing that certain agents, or groups, have power over others in their assigning of class definitions. The power to do this is almost a 'sacred' act as it separates social groups – the elite and the masses – good and evil, distinguished and vulgar, and is therefore inherently political: 'Analysis of the struggle of classifications brings to light the political ambition which haunts the gnoseological ambition to produce the correct classification' (ibid: 243). This is understandable for the dominant, with an interest in preserving the status quo and the social space as it is commonly conceived. It is not acceptable for a 'science' aimed at discovering the reality of class. Ultimately, therefore, this discussion moves us towards methodological issues of practice – to avoid reifying class and to objectify the very ambition to objectify classes itself. And, of course, the

same argument follows for any other social construction of analysis, be it topic, concept or phenomenon. In the next section, I address different stages and levels in data analysis; this as a way of setting out a range of issues against which we might set the empirical chapters to follow.

A Three-Stage Methodology

1) The Construction of the Research Object

At one point, Bourdieu refers to the 'construction of the research object' as 'summum of the art' of social science research (1989c: 51). As researchers, our choice of research topic is shaped by our own academic backgrounds and trajectories. To this extent, our research activity is a symbolic homology of the academic infrastructure with its various structural positions and groupings. Key concepts in the social sciences are subject to intense argument about the terms of their representation – for example, the 'elderly', 'young', 'immigrants', poverty', 'classroom', etc. Bourdieu warns the would-be researcher to 'beware of words': beware of them because words present themselves as if they are value-neutral, whilst in effect they are socio-historical constructions, taken-for-granted as expressions of 'common sense', but with specialist assumptions about their meanings and imbued with logically practical implications of such meanings. In practice, words are susceptible to a kind of 'double historicization': firstly, a word is used to represent a certain phenomenon at a particular point in time – one which is often constructed and presented in a way which renders as transparent the social and historical aspects of its construction; secondly, that dehistoricized form is then subject to further historicization, as the original form is taken as the basis of fact from which further work and elaboration is operationalized. In this way, the most innocent word can carry within it a whole set of un-objectified assumptions, interests, and meanings which confuse the reality of representation with the representation of reality. To

confuse 'substantialist' and 'relational' thinking: in effect, it is so easy to (miss)take constructs as things in themselves rather than as sets of relations. To do one rather than the other – without knowing about it, still less acknowledging it – is to accept a whole epistemological matrix which has direct consequences for the way that an object of research is thought about, with the implications this error entails for the methodologies employed to collect and analyse data, and for the conclusions drawn as a consequence. Bourdieu offers the example of the word 'profession', making the point that as soon as it is taken as an *instrument*, rather than an *object* of analysis, a whole set of consequences follows. Moreover, such assumptions are not merely an innocent oversight, since one modus operandi necessary sets itself against another in a *field* competing for the limited *symbolic capital* that can be accrued from occupying a dominant position within it. This is no less true of the scientific field, all of which raises questions about the value, power and integrity of a word itself for representing both a product and process. Different factions of the academic field compete as an element in their struggles for dominant field positions. Many simply do not recognize the contested nature of 'concepts'. To this extent, the 'construction of the research object' is often the most difficult methodological stage to undertake: firstly, because, its terms – the names of the game – are the product of history, and therefore have developed a certain 'taken-for-granted' orthodoxy; secondly, because a whole set of specific interests are often co-terminus with seeing the world in this way. Bourdieu argues that to break from these risks 'relegating to the past' a whole set of thinking, hierarchically established by the history and consequent structure of the science field itself (Bourdieu 1996a/92: 160), jobs might literally be lost, careers ruined, etc.! What Bourdieu argues for is a combination of 'immense theoretical ambition' and 'extreme empirical modesty'; the constitution of 'socially insignificant objects' into 'scientific objects'; and the translation of 'very abstract problems' into 'concrete scientific operations' (1989c: 51).

> The construction of the research object – at least in my personal research experience – is not something that is effected once and for all, with one stroke, through a sort of inaugural theoretical act... it is a protracted and exacting task that is accomplished little by little through a whole series of rectifications and amendments... that is, by a

set of practical principles that orients choices at once minute and decisive... one of the main difficulties of relational analysis is that, most of the time, social spaces can be grasped only in the form of distributions of properties among individuals or concrete institutions since the data available are attached to individuals or institutions...

And this is as true if using ethnographic techniques as geometric data analysis. In either case, data is analysed against Bourdieu's conceptual framework: habitus, field, etc. Indeed, the whole constitutes data analysis as set within social space. Often times, such space needs to be understood as a 'field', which itself is analysed in terms of various 'levels'.

2) Three-Level Field Analysis

When asked explicitly by Loïc Wacquant (1992a: 104–7) to sum up this methodological approach, Bourdieu described it in terms of *three distinct levels*:

1. Analyse the position of the field *vis-à-vis* the field of power;
2. Map out the objective structure of relations between the positions occupied by agents who compete for the legitimate forms of specific authority of which the field is a site;
3. Analyse the habitus of agents; the systems of dispositions they have acquired by internalizing a deterministic type of social and economic condition.

It is possible to see how these three levels represent the various strata of interaction between *habitus* and *field*.

In *level one*, it is necessary to look at a *field* in relationship to other fields; in particular the recognized field of power. Ultimately, this is political power and government; although there are a number of mediating institutions and fields: royalty, international business, etc.

In *level two*, the structural topography of the field itself is considered: all those within it and the positions they hold. This positioning is expressed in terms of *capital* and its configurations. *Capital* can be expressed in terms

of three forms: economic, social and cultural. *Economic* refers to money wealth; *Social* to useful or prestigious network relations; and *Cultural* to symbolically powerful cultural attributes derived from education, family background and possessions. They are all *capital* because they act to 'buy' positioning within the field. *Capital* therefore has value derived from the field as the recognized, acknowledged and attributed currency of exchange for the field so that it is able to organize itself and position those within it according to its defining principles. The generating principles of a field have a logic of practice, a common currency expressed through the medium of its *capital*. It defines what is and is not thinkable and what is do-able within the field by systems of recognizing, or not, which give differential value according to principles of scarcity and rarity. In other words, that which is most valued is most rare and thus sought after and therefore valuable; that which is most common is of least value.

In *level three*, the actual individual agent within the field is analysed; their background, trajectory and positioning. This level is expressed in terms of individual features of the characteristics of individuals, but only in so far as they relate to the field, past and present. In other words, we are interested in how particular attributes, which are social in as much as they only have value in terms of the field as a whole. We are not concerned with individual idiosyncrasies. *Habitus* then directs and positions individuals in the field in terms of the capital configuration they possess and how this resonates, or not, with the ruling principles of logic of the field. We can then compare individuals, groups and the way structures intersect and resonate in the homologies set up in the course of the operations of this field with other fields. For educational research, this implies greater attention being given to such aspects as biography, trajectory (life and professional) and site practice with respect to the logic of practice of fields in which they occur. The structure of fields, their defining logic, derivation, and the way such logics are actualized in practice are important; especially those of official discourses, etc. Finally, it is the links between individuals (*habitus*), field structures, and the positionings both within and between fields which form a conceptual framework for educational research (see Grenfell 1996 for an application of this 3-level analysis to the area of teacher education; and Grenfell and Hardy 2007 to the study of art and educational aesthetics).

Of course, there is a question about whether the researcher begins with level 1, 2 or level 3. In a sense, data collection possibly presupposes an initial gathering of personal – habitus – accounts (level 3) as a way of building up an ethnography of field participants. However, it must be stressed that biographical data are not enough on their own. They also need to be analysed with respect to field positions, structures, and their underlying logic of practice. And, most importantly, the *relationship* between field and habitus – not just the one and/or the other. Finally, that field analysis, and its interactions with individual habitus, needs to be connected with a further analysis of the relations between the field and its position in the overall structures of fields of power. All three levels are then needed.

In order to construct such a field analysis, the issue of the traditional dichotomy between qualitative and quantitative approaches becomes less significant. Indeed, the researcher needs to obtain the best data analyses to undertake the construction of a relational analysis; both within and between fields. This may be Multiple Correspondence Analysis; documentary analysis; biographical studies; ethnographic case studies, etc.

DATA COLLECTION AND ANALYSIS:
ETHNOGRAPHY OR MULTIPLE CORRESPONDENCE ANALYSIS?

As noted, Bourdieu uses both ethnographic and statistical techniques (in particular, Multiple Correspondence as part of a suite of Geometric Data Analysis). In *The Weight of the World* (1999a/93), Bourdieu considers guiding principles for ethnographic research, about which we refer to more in Part II of this book – for example, the importance of 'matching' the interviewer and the interviewee in order to avoid the imposition of one view of the world from one to another. I have argued that in classifying data – whether from an ethnographic or MCA perspective – Bourdieu is drawing a distinction between the actual structure of the social system in its multidimensional stratification, and the symbolic products which arise from it: 'In reality, the space of symbolic stances and the space of social positions are two independent, but homologous, spaces' (1994a/87: 113). This approach is described as attempting to reconstruct the space of differences, or differential positions, and only then accounting for these

positions as differential properties of the social space. One method for
this is the use of the square-table of pertinent properties of a set of agents
or institutions. Here, each agent or institution is entered on a line, and a
new column is created each time a property necessary to characterize one
set of them is identified. Bourdieu argues that this obliges the researcher
to question all other agents or institutions on the presence or absence of
this property. This may be done initially at an inductive stage of locating.
Then, redundancies picked out and columns devoted to structurally or
functionally equivalents are eliminated so as to retain all traits – and only
these – that are capable for discriminating between the different agents or
institutions – thereby analytically relevant. This makes the researcher think
relationally – both in terms of social units under consideration and their
properties which can be characterized in terms of presence and absence –
yes/no – or gradients (0, 1, 2, 3, 4, 5).

Such properties are eventually defined in terms of *capital*: in other
words, what is symbolically valued in a field. Regions are then 'cut up' to
see the operation and placing of a range of social groupings. These group-
ings may be of any kind – race, gender – although, at least in his work in
education and culture, occupation was a major classifier: but names and
clusters of occupations defined in terms of criteria and affinities, and the
way they were distributed across the range of occupational categories.
Bourdieu further argues that, in his empirical studies, the major 'primary'
principles of differentiation could be attributed to both the *volume* and
the particular *configuration* of (cultural, social and economic) *capital*. In
other words, individuals and groups define themselves by how much capital
they hold and the balance of capital types within that holding. A further
point is the social trajectories of individuals and groups. This is a way of
relating classes and categories 'on paper' with what exists in reality. To
the extent to which various individuals hold similar capital volumes and
capital configurations (i.e., share material conditions) in conjunction with
others, they will constitute a homogeneous, and thus identifiable, group.
In other words, they share a similar position in the overall structure of the
social space, and thus also share similar *habitus* and consequent disposi-
tional characteristics. And, of course, it follows that we need at all times
to think in terms of the conceptual language we are employing in forming

classes and categories for the analysis of data. Both need to be understood in terms of the underlying structural relations which generate them and the generative principles on which they are based. MCA is particularly helpful in this regard:

> ... concepts have no definition other that systemic ones, and are *put to work empiri-* ✎
> *cally in systematic fashion.* Such notions as habitus, field, and capital can be defined, |
> but only within the theoretical system they constitute, not in isolation... Science ✎
> admits on systems of laws... And what is true of concepts is true of relations, which
> acquire their meaning only within a system of relations... If I make extensive use of
> correspondence analysis, in preference to multivariate regression, for instance, it
> is because correspondence analysis is a relational technique of data analysis whose
> philosophy corresponds exactly to what, in my view, the reality of the social world is.
> It is a technique which 'thinks' in terms of relation, as I try to do precisely in terms
> of field. (Bourdieu 1992a: 96)

However, the same is as true for qualitative and ethnographic techniques.

What this three-level analysis of field amounts to in effect is a methodological application of a 'theory of situatedness' or 'existential analytics'. Bourdieu did, however, anticipate criticism:

> The questioning of objectivism is liable to be understood at first as a rehabilitation
> of subjectivism and to be merged with the critique that naïve humanism levels at
> scientific objectification in the name of 'lived experience' and the rights of 'subjec-
> tivity'. (Bourdieu 1977b/72: 4)

However, he argued that such an approach was absolutely essential if we are to free ourselves of the mistakes of the past and 'to escape from the ritual either/or choice between objectivism and subjectivism' (ibid.). Bourdieu's way of doing this was, therefore, expressed in terms of this playing back and forth between *habitus* and *field*.

For Bourdieu, any theoretical view of the world, by the specialist or non-specialist, involved a symbolic assertion of truth in the struggle for *legitimation*; that is, for recognition of authenticity. This is why any theory of knowledge for Bourdieu had to be both ontological *and* political, since it represented a particular world-view or, *raison d'être*, together with the latent *interests* presented there. What Bourdieu's theory of practice is attempting

to do is to look at the logic of these 'points of view' in terms of the episte-
mological complementarity of objective structures and cognitive structures
– but to do so in a way, which applies the same epistemological approach
to the researcher/philosopher as to the researched/ theory of knowledge.
It is one thing to make sense of practical action and knowledge in this
way, it is another to make sense *of this* making of sense. This point takes
us to our third stage in a Bourdieusian approach to research methods and
data analysis.

3) Participant Objectivation

In a sense, the main conviction behind a Bourdieusian approach is not
simply that in our normal operative state the world is not so much more
complicated than we think, but that it is more complicated than we *can*
think. The thinking tools that Bourdieu's method provides are intended
as a way of opening up that complexity in order to provide new insights.
However, it would be a mistake to consider the deployment of terms like
habitus, field and capital as an end in itself, or that simply expressing data
analysis with these words is a sufficient route to understanding and expla-
nation. At its extreme, such an approach can result in little more than a
metaphorizing of data with Bourdieusian language. The three-level approach
to data analysis outlined above is intended to be a key to avoiding such a
reification of conceptual terms. However, there is a third vital ingredient
for Bourdieu: Reflexivity. We find it everywhere in his writing.

The whole focus on the construction of the research object is that it is
partly an attempt to break with the 'pre-given' of the world, especially the
academic one, and to re-think language and language pedagogy in a new
way. As part of this process, reflexivity is more than a pragmatic option;
it is rather an epistemological necessity. What Bourdieu is proposing is
to break from 'scholastic knowledge' itself! In other words, the scholastic
world of theory about language teaching and learning needs to be seen as
being just as prone as the empirical world of language classrooms to acting
on the basis of presuppositions created historically; so much so that there
is indeed the danger of research knowledge becoming a kind of 'scholastic

fallacy', where what is offered in the name of scientific knowledge is, in actuality, simply the reproduction of a certain scholastic relation to the world, and one indeed imbibed with its own interests. Bourdieu writes of three presuppositions, which are key dangers in this potential 'misrepresentation' (see Bourdieu 2000a/ 97: 10). Firstly, there is the presupposition associated with a particular position in the social space; in other words, the particular habitus (including gender) as constituted by a particular life trajectory, and thus the cognitive structures which orientate thought and practice. Secondly, there is the orthodoxy of the particular site of the field of language pedagogy itself – its *doxa* – with its imperative to think (only!) in these terms, as they are the only ones acknowledged as legitimate in the field. Thirdly, there is the whole relation to the social world implied by scholastic *skholè* itself; in other words, to see the former as substantive, given, and an object of contemplation rather than relationally – praxeologically – and existentially dynamic. Finally, therefore, in order to break from scholastic reason itself, it is, for Bourdieu, not sufficient simply to be aware through some form of return of thought to thought itself. Such actions are for him a part of the same scholastic fantasy that believes that thought can transcend thought and, in so doing, escape from all the socio-culturally constructed presuppositions listed above. Because these presuppositions are unconscious, implied and occluded in the very nature of thought itself, it is necessary to find another means to escape from them than the type of reflexivity commonly accepted by social scientists (for example, Alvin Gouldner). For Bourdieu, the necessary alternative is through a process of 'participant objectivation', or the 'objectification of the objectifying subject':

> I mean by that the one that dispossesses the knowing subject of the privilege it normally grants itself and that deploys all available instruments of objectification... in order to bring to light the presuppositions it owes to its inclusion in the object of knowledge. (Bourdieu 2000a/97: 10)

Social scientists are called on to apply the same methods of analysis to themselves as to their object of research. What this means, in effect, is to see their own research field in terms of habitus, field and capital, and to objectify their own position within it. Bourdieu attempted such a procedure

in books such as *Homo Academicus* (1988a/84) and *Sketch for a Self-analysis* (2007/2004). However, one point is crucially clear: Although this undertaking can be attempted on an individual basis, and is partly necessitated by a personal epistemological imperative, what is even more important is that participants in a particular academic field, here language education, commit themselves to a similar process of reflexivity as a way of showing up the limits of its science. Bourdieu is perfectly aware that such an activity runs counter to the conventional underlying logic of practice of the scientific field, with its interest in asserting its own worldview in competing for a dominant position in the academic field overall. As a result of the latter, there is often a reluctance on the part of academics to recognize and acknowledge the limits of thinking that a truly reflexive process would reveal. For Bourdieu, it is the particular mission of sociology – or at least his version of sociology – to insist on this reflexive stance. Indeed, anything else is a kind of ultimate act of scholastic bad faith.

Conclusion

This introductory chapter to Bourdieu and data collection has sought to offer a conceptual framework for working with his perspective in empirical contexts, and where data is collected and analysed. The focus has not been theoretical per se. Nevertheless, to engage in research is to form relationships which are both structural and value laden; so, it has been necessary to consider how such dimensions are shared both by the object of research and by those who seek to study it. The levels of those structures and relations have also been alluded to. There has been little discussion of the actuality of Bourdieu's key concepts – habitus, field, capital, etc. However, the chapter has presented the principal components of his theory of practice and the language used to represent it. The relationship between the symbolic and the real has been explored, together with the way language is used to represents social phenomena. It is in such language that categories of

analysis are formed and classificatory schemes developed. The chapter has also offered a Bourdieusian approach to research methodology in terms of three concurrent stages: construction of the research object, field analysis and participant objectivation. Field analysis was also broken down into three 'levels', the relationship of the field to the field of power, the structure of the field itself, and the habitus of those occupying positions within the field. It is in the light of these stages and levels that the empirical projects included in this book are presented. Some preliminary comments have also been made with respect to the role ethnographic data and geometric analysis may play in such a framework. The discussion has raised many questions – of theory and practice – but these can only really be addressed after empirical illustration to which the book now turns in Parts II and III.

+ Three types of
capital:
• economic
• cultural
• social

PART II

Qualitative

MICHAEL GRENFELL

Introduction to Part II

Part II deals with research carried out from a Bourdieusian perspective where an essentially qualitative approach has been adopted. We take a broad definition of the term 'qualitative' to include any project where data are collected but explicit statistical and geometric systems are not used to analyse them. Such an approach can itself be re-expressed more specifically, and various other research traditions may be grouped under this rubric: natural, symbolic interactionalist, ethnographic, interpretative, etc. It is not our intention to tease out the differences between these, nor to compare and contrast them in terms of Bourdieu's own approach. Still, it is worth noting that all of these perspectives, including Bourdieu's, are conducted from the basis of a fairly limited range of data sources: either the researcher interviews subjects, or constructs questionnaires, or observes them, or undertakes documentary analyses, or gives the subjects tasks and records their response to them. Of course, the devil is in the detail here and, in each case, it is worth considering how a Bourdieusian approach to each of these forms of data collection may differ from more traditional ways. We will take another look at such considerations later in the book. These issues, along with those outlined in Part I of the book, should be kept in mind whilst reading the contributions to Part II. It is made up of four separate chapters.

The first deals with the topic of inclusion in a Minority Language School. Data from interviews, observation and documents were collected from a range of participants (including both teachers and pupils) and sources. Analysis then proceeded through the construction of various themes by means of 'constant comparison' between individual categories and data. The emergence of issues of power and identity meant that a Bourdieusian lens was particularly useful in interpreting results. Further analysis of these shows how such issues are inextricably linked to patterns

of inclusive practice in the school, and that these can be understood in terms of the habitus of those involved and the field context in which they operate. As always, capital configurations are the medium for this interaction. The whole study shows how differentiation and distinction are still prevalent in a social site where greater homogeneity might be expected.

The second chapter takes us to another level of schooling, that of Higher Education. The specific focus here is the teaching of English to non-native speakers. Whilst the first chapter dealt with an intra-institutional microcosm, this chapter explores the way that the State itself has encouraged universities to 'export' English language education in the name of global aid. Whilst clearly benefitting some, such a policy is shown to be a prime income generator for universities leading to the 'commodification and corporatization' of English. Data here included interviews and documents collected over a three-year period, and the analysis was set within the three-level approach to fields set out in Part I, especially level 2 – the map of relations between the agents in the field. Such a mapping allows us to see the structural relations between stakeholders and, once again, the capital resources used by those occupying differential positions within the field. This study shows the misrecognized nature of the field – its conflicts and tensions – and the way donor countries can represent a dominant, legitimizing force which places recipient countries in a difficult position in terms of acknowledged legitimacy for their own activities.

The third chapter takes us to the art world. The focus here is how we might approach the analysis of social space, exemplified through the case of an internationally renowned artistic avant-garde; that is the St Ives art colony in the UK during the 1940s and 50s. The author considers Bourdieu's own range of graphic devices for re-presenting social space based on the relationship between social and symbolic structures. The issue of change is central to this study. We see how art movements change and why. The author follows the three-stage methodology set out in Part I, including the three levels for field analysis. Descriptions of data collection and analysis show the links between empirical features of habitus and the evolution of the art field. Issues of participant objectivation are also included by extending the discussion to include the use of photography in the context of an art gallery. The chapter ends with some reflections on the approach and further principles we may take into future research activity.

The final chapter in Part II returns us to the Higher Education sector, but this time in terms of the actual teaching and learning of a group of students studying for a vocational degree. In this case, focus groups, interviews and reflective diaries were used to collect data. These data were set beside biographical information and the relevant documents to tease out the relationship between social provenance and outcome. There are, then, clear issues concerning the construction of the research object and the deployment of the three-stage/level methodology outlined in Part I. Clearly the behaviour and outcomes of the students need to be read against the background of university structures and national policy. Once again, this needs to be considered as a field context – a microcosm. Salient forms of cultural capital, themselves attached to social background, prove to be critical in shaping student response. Such provided the 'academic capital' (including linguistic and social) necessary for successful 'navigation' through the course. Whilst some students appeared as veritable 'fish in water', others in effect excluded themselves; a kind of social fatalism or destiny that did not 'allow' them to manage what was required to operate effectively in this field context.

None of the contributors would claim that theirs is necessarily the only, or indeed the best, approach to the research topic. And it has been necessary to cut down on the voluminous banks of qualitative data through lack of space in this fairly short exposition. However, the chapters as a whole, and as a group, do share the same problematic: to actualize Bourdieu's research perspective in practice. Indeed, they demonstrate how principles of practice might indeed be translated into practice; how there are distinct stages of research, each with particular concerns – whether of conceptualization, research question formulation, or data collection and analysis. These, of course, raise a number of further issues, some of which will be addressed in a later conclusion to Part II.

CARLA DIGIORGIO

The Interaction Between Identity, Power and Inclusive Practice in a Minority Language School

Introduction

The movement toward inclusion of students with special needs in the regular classroom has evolved in the education systems of countries around the world. This is a result of government policy, legal battles, and society's changing response to the segregation of groups and the rights of individuals (Kavale and Forness 2000). Inclusion involves not only placement, but as an ideal it promotes the belonging of all students as part of their neighbourhood learning communities, regardless of language, creed, colour, race, or physical, social or mental ability. Research has found that the practice of inclusion has been more difficult to implement than its philosophy (Valentine 2001). The practices at the school level are what ultimately determine the extent of inclusion of students with special needs – be those needs physical, academic, or social (Carrington 1999).

These practices include not only those of teachers in classrooms, but also interactions between staff, parents, and students (Pearson 2000). The experiences and beliefs that all participants in inclusion bring to these interactions influence the success of inclusion at the school level (Carrington 1999). As noted, Bourdieu (1986, 1994a and b, 1991b, 1995b, 1977b/72) theorized that individuals act on their own self-perceptions of their worth, as compared to others in social groups within society. This theory underpins the approach I have taken to my research into better understanding the way that inclusion is implemented.

The research arose from an interest in the 'how' of inclusion. I wanted to study the effect that identity and power of individuals and groups have on

the implementation of inclusion at the school level. In doing so, I wanted to be open to the variety of special needs that students brought to one school, including learning, behavioural and social difficulties, speech and hearing issues, and physical and health challenges. I chose to do an ethnographic case study of one school's experience of inclusion, using the Bourdieusian notions of identity and power to structure my analysis.

The field of education has its own identities, capital and rules for its professional and student members (Bourdieu and Passeron 1977a/70). The home has its own for parents and children. The law also provides principles and precedents for schools and society to follow to become more inclusive of people with differences. The media represent another field which open up the semi-private fields of education and home to one another (Oplatka et al. 2002). Inclusion requires that schools and homes cross borders in order to provide appropriate service for students with special needs (Blue-Banning et al. 2004). Identity and power became the lenses through which I examined the sources and means by which stakeholders at the school level took part in inclusive practices for students with special needs. The overlap between the jurisdictions of fields involved in inclusion, led to the complexity of stakeholders' experiences, and became a means to examine this complexity.

Methodology

The research question of this study was: How do identity and power impact the inclusion of students with special needs in the regular classroom, in this case in a second language school?

In approaching the question of how inclusion is developed at the school level, I chose to do a case study of one school. I felt this was the best way to fully explore all of the aspects of the school as they were being lived (Stake 1994). As an ethnography, this case study differs from others in the literature as it is not intended to be evaluative. I wanted to spend months,

as a participant observer, getting to know the school very well on the inside. As a fellow teacher and parent from the greater community, I wanted to be able to speak with participants and understand their varied perspectives. As the school I studied was from a different school board than my own, however, I was able to compare my observations to my own experience.

Data Collection

Royale Education Centre (all names in the paper are pseudonyms) was four years old and composed of 173 students and fifteen teachers at the time of the study (the 2003–4 school year). It was located in a regional municipality of about 100,000 people within the jurisdiction of the Francophone school board of Nova Scotia. Royale was a K-12 school and had an attached day care and community centre run by a Francophone community group. My initial entry to the school was made through the principal and with the school board's interest and consent. Information letters and consent forms were used to ensure that participants took part on a voluntary basis. Data were collected through interviews, observation, and document analysis. Interviews were conducted with eight students with various challenges ranging from physical (for example, cerebral palsy), to academic (for example, learning disabilities), thirteen parents, eleven teachers, three teaching assistants, and five administrators and special service staff, totalling forty interviewees. In the case of teachers and teaching assistants, interviews were conducted in classrooms. In the case of parents and students, interviews were conducted in homes and school offices. The language of interview – French or English – was selected by the interviewee, and interviews lasted forty five to sixty minutes.

Children were interviewed with a parent in attendance in accordance with school stipulations. Interviews were semi-structured and asked participants both for their views of the school and its purpose, and their reasons for being members. In most cases, observations were carried out over two

visits to the classroom. There were sixty observation days, involving the 173 students, and twenty staff of the school. I also participated in staff meetings, lunch hours, and observed in hallways and outside in the schoolyard. Observations provided insight both into the outward appearance of the school, and members' interactions as creators of this educational community. Sixty-six documents for analysis were collected from the school, school board, the Internet and newspapers. They included pamphlets, website information, government documents, and in the case of newspapers, editorials, information pieces regarding Francophone education and the school board and school in particular. These documents were assembled to provide an understanding of the school's marketing to prospective clients and its relationship to the public. Measures were taken to ensure that data collection accurately reflected participants' experiences. Interviews and observations covered a large span of time, and richly described the participation of members. Participation of a large number of subjects in the study contributed to greater reliability.

Data Analysis

I analysed interviews, observations, and school and provincial board documents on a continual basis throughout the study (following Glaser and Strauss' 'constant comparison' method, 1967). By coding data for themes reflecting how stakeholders experienced and implemented the inclusion policy, I found that the processes of identity, power and inclusive practice arose most significantly. These three processes became the main vehicles through which I was able to understand the complexity of inclusion in this school.

I used the work of Bourdieu to analyse these beliefs and actions as presented by the participants in my study. I aimed to relate the identities of individuals and groups, as based on their particular group membership, and personal experiences, and explore how these identities resulted

in particular power and actions. These processes are thought not to be static but continually evolving (Bourdieu and Passeron 1994a). As a result, identity and power would be expected to be constantly changing according to the participants in the school's inclusive practice, and the evolving mandate of the school.

With the help of Bourdieu's theory, I was able to articulate a process whereby identity and power relationships were able to help explain and connect the beliefs, experiences and practices which study participants had shared with me. The three areas of identity, power and inclusive practice were set up to represent the main foci of the study. The three were inseparable and multidirectional, affecting each other in the process of inclusion over time (Figure 1):

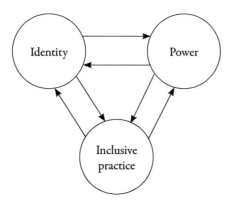

Figure 1 The Relationship between Identity, Power and Inclusive Practice

Theory Elaboration

Vaughan (1992) advocated looking to extant grounded theories in order to supplement one's own grounded theory development, and calls this 'theoretical elaboration'. Pierre Bourdieu's theories were explored as they

pertained not only to culture but to language as well. As communication was the basis for my data, I wanted to find a way to connect the communication I received and observed with the beliefs they represented. How were individual motives tied to those of groups? How did groups jostle to position themselves in the school arena? What were the histories behind this and what were the results for students with special needs? In the end, I wanted to see how all of these processes affected students' inclusion in school.

The effect of inclusion on students with special needs has been a crucial but difficult result to measure in past research. Some studies have attempted to measure student achievement, while others have called for a more personal involvement of students in their own reporting of the effects of inclusion on their lives in schools (Avramidas et al. 2002). As stakeholders who receive the least amount of attention in the inclusion literature, students with special needs needed to be part of the discussion of power and identity for my study. The difficulties surrounding collecting data from students with special needs were evident, but the end result of inclusion was the learning of students, and I wanted to include these students as participants.

Results

Identity

The relationships between all of the players at this school were based in part on their own self-perceptions, as people and as professionals, which were based on their backgrounds, and their perceptions of the roles of others. Issues such as language, education, family, childhood, single-hood, gender, money, status, and age, all intersected with each other. Yet they all pointed to particular, though complex and ever-changing effects on students with special needs. The school, in its inclusivity/exclusivity toward the outside

world, was trying to establish a different way of approaching inclusion of students with special needs which was conducive to its other goals, while being amenable to parents' demands. The outside identity of the school only scratched the surface of what was going on inside.

The identity of the school as a place where language is the key distinguisher, was complicated by issues of special needs, high academic standards, and individual attention as provided by caring teachers in small settings. The media and school documents represented the school as addressing a multitude of parents' demands in this modern competitive educational environment. The principal attempted to balance several seemingly conflicting goals for the school: inclusion versus exclusion; French versus English identity for its members; high academic standards versus student-centred environments; and secondary versus elementary pedagogies. However, the different habitus between and within stakeholder groups of parents and staff, revealed that maintaining these goals of identity for the school was an on going challenge for the leaders of the school. Because the pride and antagonism that separated the school from others are based on different motivations on the part of staff and parents, it was difficult to maintain a singular identity for the entire population of Royale's membership. As a result, it was difficult for students to identify what identity they should have as members of the school, yet also members of society outside the school. Since the identity of staff and some parents was so different, the students, especially those with special needs, felt confused about their reasons for attending the school. Was it for the French? Or the small classes? The individual attention? Or the promise of better services in the future? The issues that concerned parents and staff were very different from those of students.

The economic, cultural/linguistic, and educational habitus of parents and staff were found to correspond to key findings in the literature. Especially as some parents were also staff members, and both populations moved a great deal in and out of the school, there was a great deal of change and overlap in members' identities. Their habitus could be affected by their economic and cultural habitus, which also fed into gender differences. Families with both parents contributing to children's education, were more able than single parents to provide the home support required for the challenging duality of

learning a second language in French and English homes. Staff who were inexperienced and lacked job stability, were less able to apply themselves to the challenges that students with special needs presented. This also applied to those who did not identify with the school's adapted language rules.

In keeping with my reading of Bourdieusian theory, people acting in hierarchical structures such as schools, were always trying to improve their status in the game, in order to better acquire the things they need, be they economic, cultural, social or symbolic capital (Bourdieu and Wacquant 1992a). The next section will relate the individuals and groups to one another, to show how power affected the practice of inclusion in the school.

Power: The Wielding of Capital

Capital consists of the resources one brings to everyday experience (Bourdieu 1998b). There are several forms of capital, which members of the school community wielded in order to get what they needed from their school. Hierarchies of power based on economic capital influenced parents and staff. Parents with less economic capital were found to be limited in their ability to provide for their children's education. The independence and language requirements of the school, as well as the school's limited, yet developing extracurricular activities required that parents provide additional supports outside of school, including sports and cultural activities. The participation of parents in growing social activities put on by the school also required money. However, the advantage of individualized transportation and special services costs looked after by the school made Royale a top choice for parents with French heritage, who also had children with special needs. In this way, the extra costs associated with special needs were looked after by the school and allowed parents who would not be able to access additional services, the opportunity to allow Royale to look after these for them. Many parents with physical, educational, professional, mental, and family difficulties experienced economic difficulties as well. Children felt these effects not only in their basic needs, but also in the way their economic difficulties influenced communication between parents and staff. Parents with limited access to school rightly perceived their image in the school's

eye as being less than favourable. Staff saw parents with less involvement with the school as being less interested in their child's learning, and made less contact with these parents as a result.

The difficulties that staff with insecure job situations faced also affected students' learning. Newer teachers were given more difficult workloads and classes with more students with special needs. As a result, students with special needs were seen by these struggling new teachers as being one more thing they had to deal with. The lack of support for new teachers from the senior staff was followed by avoidance of help seeking. The pressure to seem to be managing well in the eyes of senior staff, kept newer teachers from expressing their concerns. As a result, the inclusion of students with special needs was limited by teachers' inability to respond in a qualified and experienced manner to their needs.

Social and cultural capital separated parents and teachers from each other, this time dependent on their French or English heritage. French parents were much more able to access services at the school simply through their ability to speak the same language as staff, and also by way of the male associations made between administration and fathers. Perhaps as a result of the stability of two-parent families, French families with French fathers tended to have more powerful, positive associations with the school than those with single and/or divorced French parents. Those families with English parents may have economic capital, but were disadvantaged socially and culturally as they could not participate fully in the experience of their child's education. This was felt in particular by English mothers who wanted to volunteer and become more involved in their children's education but could not due to language barriers and the French male leadership which served to further alienate them from the school. As a result, many students with special needs did not enjoy a connection between home and school that supported their learning. Many felt a dual identity as French students during the day yet English children at night. Many did not enjoy this separation from their own culture and wanted to leave the school and go to English school. The pull from the school and parents to remain at the school for the supports and safety it offered, went counter to their own feelings of ambiguity and ambivalence toward the school's place in their personal identity and home culture.

Social and cultural forms of capital were also felt by staff, as they came from a myriad of backgrounds and Francophone communities. The difference between Quebecois, Acadian cultures, and the culture of France was always in the conversations of individuals as they communicated their own identities to each other. The hierarchy of this linguistic culture affected relations with parents as well as other staff members. The results of discussions on the school's institutional cultural capital were apt to change as staff changed often and their mandate reflected the values and identities of staff members. The goals of the school reflected a preference for France's academic curriculum, yet mirrored the political will of Acadians to regain their French pride through artistic endeavours. Yet the only significant experience of French heritage for students was when they were able to define their own identities as being part French, and express these through their own artistic creations. In this way, the definition of French identity by staff was not conducive to allowing students the freedom to define their own developing identities.

The conflict between traditional and modern senses of 'Frenchness' kept the school back from fully developing student voice. This was experienced particularly strikingly by students with special needs, who had limited linguistic resources, and tended not to participate as much in social and cultural activities. The participation of parents with more invested in the school due to their appreciation of Royale's welcome of their children despite their needs, resulted in a positive experience for these students. But the isolation of many students, especially those in the higher grades who did not have access to a large population of peers, and as a result did not have the opportunity to socialize normally, led to many students leaving the school and going to English schools instead. The frustration of students who remained, led to discipline problems and bullying. The principal did not address many of these issues because of his avoidance of pushing students away. However, the school's preference for the next generation of young French students in the elementary grades did not encourage the older students to be proud of their identity. Many of them had special needs, and they knew that that was the real reason for their staying at the school.

Finally, symbolic capital represents all of the forms of capital mentioned above, in that symbols communicate immediate value to the members of

a particular field. Fields intertwined at Royale as the symbols of wealth, intelligence, culture, language, profession and education had significance in not only the home, school, but also in the media. The addition of the field of disability to this picture, caused conflict as inclusion and competition were not synonymous. The physical symbols of the success of the school, while slow in developing due to its youth, presented a formidable message to its competition. Parents wanted the school to show its strength, through parades, sports fields, community cultural events, concerts, graduations, technology access, etc. The school also strove to present as strong a message as possible to the community, including other schools, cultures, potential students and their families. It attempted to apply its symbols to multiple cultural groups (French and English), and multiple academic groups (independent and special needs).

As a result, the symbolic messages were sometimes conflicting and were not perceived simply or necessarily appreciated by potential and current clients. This caused difficulty for the school's staff but also provided additional sources of support. It compromised some of the school's attempts to provide inclusive and exclusive educations for its students. The inclusion of students with special needs in some cases was better than they experienced or may experience in English schools, as perceived by their parents. Some families participated and enjoyed the membership in the school culture that Royale offered despite their special needs. However, it was also less than ideal for many students who had to endure linguistic and cultural handicaps as a result of the school's demands in those areas. The development of facilities and approaches that might encourage students with special needs to develop their strengths, such as artistic and sports approaches, was delayed, and many students suffered seriously from lack of social acceptance, severe discipline, and linguistic challenges.

These power relationships set up inclusive and exclusive situations for parents, teachers and students, based not only on special needs. The overlap of groups with different but meaningful types of capital showed the complexity of inclusion of students with special needs. Having a learning difficulty was not always a negative, depending on the other capital that the student brought to the school. Multiple language and cultural, school and home values interacted to create different outlooks on children's

schooling. The next section will further explore these power relationships as they related to the inclusive experiences of students with special needs and their fellow school participants.

Inclusive Practice

On the whole, the school depended on interrelationships between staff to make inclusion a relative possibility. Although the principal and some staff did not see the benefit of sharing their expertise, some sharing among teachers and teacher assistants took place on their own accord. Students were welcomed and planned for on an ad hoc basis. The resource programme was limited to the lower grades, and teachers in higher grades had to cope with making adaptations on their own. This differentiation between grade levels has been found by other researchers (Priestley and Rabiee 2002).

Often, psycho-educational assessments of students' needs were not done early so teachers had to improvise. Students who followed individual programme plans were very rare, and this was probably due to the school's hesitancy to take on a reputation as a special school, as well as its lack of experience. Its involvement of parents was limited to the product rather than the process of programme planning, again in an effort to present an impressive face to the public. However, in the meantime, teachers faced their responsibilities day by day, and those without access or time with resource personnel faced their role alone. A lack of professional development beyond the school level was daunting, as staff relied on the principal and resource teacher for information (this was also reported in Avramidas et al. 2002).

Many teachers wished for the days when students were able to speak French and their parents supported this at home. Now, parents had greater expectations for staff, and the principal was taking on challenges for staff without providing them with the resources and time they needed to do a good job. The communication between parents and teachers was lessening, depending on parents' ability to speak French. Special needs were becoming another added challenge to the school, and some teachers resented this. Their lack of training and understanding of how to teach children with special needs added to their frustration. This left some students isolated and reliant on teacher assistants.

The larger problems of lack of time and resources, mitigated by power relationships within the school, made inclusion a daily challenge. The pressure on the school to present a positive attitude toward all potential students, meant taking on challenges to its identity, mission, and practice. The way the school coped was to communicate differently with parents and staff. People who fell into both groups – parents and staff – got preferential treatment due to their extra knowledge of the way the site really functioned. Those with the language of the culture, which is French, or the language of the economy, which is English, got their way through these different forms of capital, and the results varied according to habitus. In this site, Bourdieu's levels of capital do not build on each other in an orderly fashion. The principal of the school was the conduit through which these contrasting forces were precariously balanced. The students and staff often paid the price in terms of poorer practice, learning, collaboration and socialization.

Although inclusion was professed in the school's welcome to students with varying language and learning backgrounds, once students were in the school, they were segregated according to language, behaviour, and learning needs. As students got older, they were expected to achieve in order to improve the school's image. As higher grade levels intensified, the expectations of students and teachers, the focus was less on adaptations and more on the narrowing of curriculum to promote academic success. This finding is also prominent in studies in high school inclusion (Carrington and Elkins 2002).

Even in the early grades at this school, I saw that inclusion was not as important as academic success. The loose approach in the kindergarten class, aptly called 'Maternelle' or maternal, quickly gave way to separation of students with problems from those who were independent learners. The justification for this approach seemed harmless: students were divided according to language needs. But the language represented the continuation not only of cultural capital, but symbolic, social, and economic capital as well. Not only were these able children able to speak French; they were able to learn faster, and had more experienced teachers, who received more administrative support. These students received more positive, rather than negative reinforcement from staff, socialized with each other, and felt part of the extended community of French compatriots to whom the school

felt most loyal. This pattern continued through the years, resulting in a widening gap between students with and without capital in the school.

Students with difficulties in school became more problematic as they learned poor social skills from each other, had less experienced teachers, learned less academic material, and were disconnected from their school and community because their parents and school did not communicate with each other. It was very early in the school's life to see this happening in full force. However, if this trend of splitting of student identities continued, English and French parents could become dissatisfied with the school, and it may have to shift its priorities once again. This conscious separation of students according to language has resulted in a possibly unintentional separation due to ability and habitus. The effect is similar to that found in other settings and research, in which students who are less able academically, less cultured in the ways of the school, and less economically resourceful, are left out of choice membership in its society (Gay 2002; McCray and Garcia 2002).

Discussion

This chapter has set out to examine the inclusive practice of a school through the lenses of identity and power as adapted from Bourdieu's social theory. I have endeavoured to understand how practice stems from the individual and group habitus and capital. Bourdieu's theory has been very useful and quite often correct in its prediction of the traditional patterns of staff and parent behaviour with regard to their roles and responsibilities. Nevertheless, several unexpected patterns were observed in this study, leading me to surmise that modern day education systems are perhaps more complex than those that Bourdieu himself studied.

Bourdieu addressed the issues of gender, socioeconomic status, language and culture, but their combination was not fully explored in a modern context. In a changing environment such as inclusion has brought about,

beliefs in the roles of school, home and students themselves have been forced to undergo massive upheaval (Kavale and Forness 2000). The very concepts of the inherent 'exclusivity' of schools with particular purpose have called into question the applicability of 'inclusion' in such environments (Clark et al. 1999). Bourdieu admitted that 'crises' enable individuals to call into question their preconceived notions and undergo change (Bourdieu 1991a/82: 131). Perhaps inclusion represents just such a crisis for its participants, in that it forces them to change their traditional notions of schooling, teachers' roles, and the rights of individuals in society. No longer are a select few able to graduate from high school, and aim for post-secondary study, as in Bourdieu's described post-revolutionary France, or even up to recent times. Now everyone in Canada, at least in theory, has the right to an education (Nova Scotia Dept. of Education and Culture 1996).

Yet inclusion by its nature is not as practical a possibility as it is a hypothetical one. As Clark et al. (1999) identified, the very nature of inclusion of students with special needs requires attention to their individual needs and appropriate accommodations. This distinction actually separates individual students from each other, forcing teachers to plan according to individual rather than common shared experience of groups of students. So too was inclusion a relative term in my study, as inclusion of one group required exclusion of another. In a site where multiple goals were being set, a balance of demands necessitated compromise over the complete fulfillment of any one goal in particular (see also Kugelmass 2001).

In terms of Bourdieu's focus on economic and cultural habitus, for example, the two together in one environment made adversary pairings of power (Bourdieu and Wacquant 1992a). The result was an uneasy tension and there were repercussions for practice and student experience. A school such as Royale, in wishing to take advantage of the economic and cultural capital of various parent groups, conveyed a different image to its public and its participants depending on their point of view. The public persona of the school as one of academic and cultural mandates, seemed to fly in the face of accepting students with special needs. Yet as the school responded to parents' demands for specialized services for their children, the role of the school changed as well (see Brain and Reid 2003). Over time, the dynamic of the school identity did change according to its willingness to

accept diverse students in order to keep its cultural mandate alive. Yet as its reputation as a responsive and attentive school grew, its reputation as an academic establishment decreased (as in Avramidas et al. 2002).

This discussion calls into question the notion of inclusion, and whether it is ever possible in its pure state (Ballard 1995). After all, inclusion of one requires exclusion of another, as I have found in this study, and as research has argued in the past (Clark et al. 1999). The result is the need for schools and society to maintain a delicate balance between inclusion and exclusion in order to sustain the access to education for all students regardless of learning ability (Kugelmass 2001). This points to the need for options, such as this French school, for students, parents and teachers to express and develop their own culture. Whereas cultures in the past may have eliminated each other in competition for survival, today multiple cultures coexist in locales and have the political power to assert themselves (Gilbert et al. 2004). When cultural competition meets economic capital acquisition, however, the result in schools is more competition for clientele, more inclusivity, and less exclusivity, at least on the surface. In allowing students of different linguistic and learning identities to join the school community, Royale increased its economic capital but compromised its cultural capital to its French constituents. The result was a struggle for balance between clientele, stakeholder groups, and home/school roles at the school.

JACQUELINE WIDEN

Mapping an Illegitimate Field: Power Relations in International Education

Introduction

This chapter is concerned with the internationalization of Higher Education (HE). In particular, it is concerned with HE English language education, the increasing commodification and corporatization of English and the struggles within the International English Language Higher Education Projects (IELHEPs). I focus on Australian university-led export of English language education and the seeming necessity for 'global inequality in the commercial market in international education' (Marginson 2004: 23). In my exploration of these concerns I am driven to ask: who benefits from the international spread of English language HE?

Initially, my research, based in South East Asia, East Asia and Australia with students, teachers, university and aid organization staff and government officials, set out to problematize the position of the 'beneficiary'. I began by working within the binary framework between the donor/ provider and the beneficiary. I was concerned with how the particular interests of the beneficiary could be more effectively negotiated and represented. However, as my research progressed a more complex picture of the beneficiary emerged.

I owe much to Bourdieu in my efforts to understand the dynamics of the international language HE field. I used Bourdieu's conceptual framework and his explanatory devices of field, capital and habitus that allowed for a multi-layered investigation into both the field of the IELHEPs and the broader social context, the field of power (Bourdieu 1984a/79, 1991a, 1990a, 1990c, 1998a/94, 1999a). Any analysis of the international field

of education must account for two distinctive elements. One element is cross-border flows of people, ideas, knowledge, technologies and economic resources. This element is relatively visible. The other less tangible and one most relevant to this study is the flow of differences and delineations. These include differences in languages, pedagogies, work practices, inclusion and exclusion (Marginson 2008). Bourdieu provides the tools to investigate the unequal distribution of resources and power.

The field of power, in this instance, was represented by powerful institutions at national and international levels. Institutions such as Australian aid agencies, Australian foreign relations organizations, international aid and finance organizations, Australian universities and universities in the countries other than Australia were located in the field of power. Although Bourdieu's research was carried out previous to the intense and volatile globalization of the late twentieth and early twenty-first centuries and in some eyes is nation-bound (Marginson 2008), it offers much to my study of domination and subjugation in the IELHEP field. Bourdieu's framework allowed me to examine the relationships between the different agents mentioned above, the positions they occupied in the field, the capital (the stakes or resources: linguistic, economic, cultural and social) which they accumulated, and the dispositions they brought to the field. The ways in which the agents carried out their practice of project implementation is what Bourdieu refers to as a 'feel for the game'. The focus of this chapter is on the mapping and analysis of these different positions in the field.

Australian Universities and Internationalization

The field of international HE has provided great wealth to Australian universities, albeit uneven and fraught with tensions. The number of international students studying in Australia has risen exponentially since the 1986 deregulation of the tertiary education sector (AEI 2010). In 2009, the sector was worth $AUS18.6 billion, up approximately 20 per cent from 2008, and it remains the fourth largest export behind coal and iron ore (COAG 2010). Between 2010 and 2011, there were more than 540,000 international student enrolments in Australian institutions and in some,

international students comprised over 30 per cent of the student population (AEI 2010). In 2009 the international education sector supported approximately 125,000 jobs across Australia, with the students themselves making a significant contribution to the Australian workforce (COAG 2010). The 2010 Senate Enquiry into International Students Welfare expected the sector to remain economically significant despite some difficulties at the time (AEI 2010).

International education activity is not, however, a neutral activity and critics characterize HE internationalization policies as being underscored by a narrow economic discourse. It is often a one-way process where the students and money flow into dominant wealthy countries. Emphasizing national interests, the Bradley Federal Government Review of HE (Bradley et al. 2008) proposed that universities increase international student enrolment, which has since become an explicit goal of all Australian universities (*Marginson* 2009:1). Australian HE policy positions international students as central to the survival of the sector and the income derived from these students, is embedded in university budgets. The continued flow of this capital relies on, among other things, the global position of English (Marginson 2011; Phillipson 2009)

University involvement in exporting education, especially in ELT (English Language Teaching) projects, is complex and messy; the many different layers of practice existing alongside each other often collide or live in contradiction. English language education and its critical role in the HE marketplace (in general) is a leading factor in this analysis and discussion of linguistic and cultural capital, and it is vital to bring to the surface the values and accumulations of these capitals in the internationalization process. A concern of this chapter is how the linguistic and cultural capital held by the students and staff of the recipient countries is subordinated (de-legitimated) while that held by the Australian institution and staff, dominate (and are legitimated).

Context – The Research Sites

This research is based on experiences of participants in two projects. Project
1 was an aid-funded English language teacher-training project located in
Laos, a small land-locked country in South East Asia. This project was ten-
dered for and won through a collaboration between an Australian project
management company and University Metrop (UM), a large metropolitan
Australian tertiary institution. The relationship with the host-country
Ministry of Education (MOE) and other relevant government representa-
tives was formed according to the notion of 'bilateral aid projects', the model
current at the time within the Australian government aid programme.
Project 2 was a university fee-for-service project developed by a consor-
tium of Australian universities – the consortium's goal was to provide for
the multi-level professional development of English language teachers in
Japan. The project was developed under the auspice of an Australian gov-
ernment agency (AGA) located in Japan. The government organization
liaised with the Japanese MOE and other key language teaching organiza-
tions. The agreed goal of the consortium of universities was to present a
national image of Australian higher education.

There were similarities and differences between the projects: they were
both purporting to introduce a new English language teaching approach
for use with secondary school students and had a component of English
language development for the teacher participants. However, there were key
differences, some of which include the role of English in the two countries,
the conditions under which the Australian team members participated in
the projects and the time frames of the projects. One significant difference
was the way in which each project was conceived. Project 1 (P1) was funded
by Australia's international aid programme and was jointly managed by a
university and a private project management company. Project 2 (P2) was
more explicitly an entrepreneurial venture developed under the auspice of
an AGA which provided some seeding funding.

Methodology

The research was a qualitative study of work in IELHEPs and the processes included the collection and analysis of interview data, the analysis of relevant documents and participant observation in IELHEPs (see Widin 2010 for a full description of the methodology). Interview data was collected from the twenty five participants over a three-year period in the early to mid 2000s. The interviewees were all centrally involved in IELHEP work, ranging from ministry officials, project planners and implementers, lecturers and course participants. The written evidence, collected from project design documents, project tender documents and project feasibility studies and project reports, provided a valuable source of data and was essential to the process of validation of claims made based on the oral data, particularly where claims appear idiosyncratic or out of line with the accepted or common sense way of doing things.

Another source of data used in this research was anecdotal evidence. This is information gained through casual conversations about the topic with an array of relevant people. This data included a collection of valuable recounts, contemporary comments and opinions, which document first hand experiences of projects either as a project participant or a recipient of the service. This type of information is also referred to as 'insider accounts' (Grenfell and Hardy 2003: 24).

English in its contested position as an international language of communication structures and regulates interactions. The interview data was analysed in the framework of the power relations constructed through the use of English as the language of negotiation. Bourdieu's work on legitimate language and language and power was useful here as was the analytical work on English as an international language by Phillipson (1992, 1994, 1999, 2009) and Pennycook (1994, 1995, 1998) amongst others.

From the interview data I looked for ways in which the interviewees or project documents understood or theorized (and the effects of their understandings) the various positions within the field of IELHEPs: as donors or as beneficiaries; what interests were operating in the field; how

capital in all its forms was distributed around these various positions; and the strategies that the players adopted. Drawing on Huberman and Miles (1998), I looked at the data for themes and patterns and the way that the interviewees identified key relationships in the field. The dominant themes that emerged from the data were those of language, English language teaching, culture, work practices and interest. An overriding issue emerged concerning how the dominant players achieved their dominance and maintained it.

Mapping the Fields

Bourdieu's field analysis maps three distinct, though not hierarchical levels of the IELHEPs:

> Level 1: Analysis of the position of the IELHEP field vis-a-vis the meta-field of power.
> Level 2: The map of relations between the agents in the field (see Figures 1 and 2).
> Level 3: Analysis of the habitus of agents.

This study was framed by the IELHEP's relationship to the field of power. The data showed that the field of IELHEPs holds a dominant position within the field of power. A chief explanation for this is that the existence of the projects depended on the direction and interests of the Australian Government. The interests expressed by the dominant players in the aid world or by other Australian government institutions were not surprising, in spite of government rhetoric that its export of education, particularly aid funded education is for the public good (Sammels 2006).

The three levels of analysis must be considered interdependently. However, it is not possible here to present a cohesive integrated analysis of all three levels (see Widin 2010 for a discussion of the three levels). This chapter focuses on Level Two which investigates the way capital and

consequently, benefits were distributed in the IELHEP field. Related to this analysis are the positions taken up by or assigned to the projects' participants. It is within Level Two that one is able to see the interactions between field and capital and to gain insights into the behaviour of participants in the project world, for instance, the role of different languages in the project, the practices of the stakeholders and the interests and investments they have in the field. In creating these figures, I have drawn on Grenfell and Hardy's (2003) work from the art field.

Level Two: The Map of Relations Between the Agents in the Field

The structural connections between those involved and who compete for specific forms of authority are displayed, for example, the students, the teachers, the teacher trainers, the expatriate 'experts', the 'counterpart' trainers, the ministry of education personnel, the Australian university staff and managers, the project management personnel and the relevant Australian government representatives. Using Bourdieusian analytical tools, I am able to identify the dominant and subordinate positions of participants in the field and identify the positions that the research participants hold. Such relations therefore occur at the personal and institutional level and at the formal and informal levels. The medium for these relations can be understood in terms of economic, cultural and social capital.

Figures 1 and 2 illustrate the respective positions of the interviewees and other project positions in relation to the axes of economic and cultural capital for each project. The lines of communication and involvement are represented by either full or broken lines. The full lines represent a direct relationship in the project field, whereas the broken lines are where the relations are more tenuous or distant. The representation of these relationships is drawn from my notes as research participant and from the discussions with project participants.

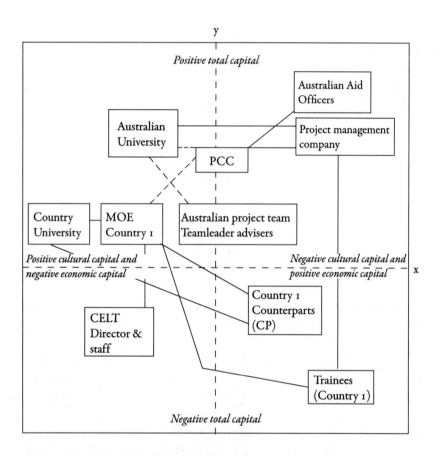

Figure 1 The Map of Relations between the Agents in the Field
– Level Two Analysis of Project 1 (Laos)

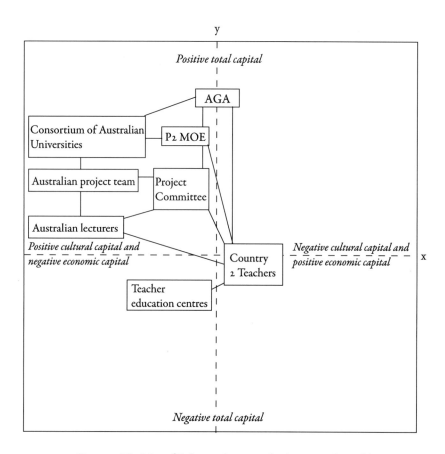

Figure 2 The Map of Relations between the Agents in the Field
– Level Two Analysis of Project 2 (Japan) (p. 75)

Key Stakeholders in Project One – Laos

In Project 1, Laos, the participants (agents in Bourdieusian terms) are: Lao
MOE staff, Lao university staff, Australian university staff, Australian
project team members, Lao project staff, Lao course participants (teachers
and teacher educators), Lao school students, project management company
staff and Australian government aid agency staff.

The Lao (host-country) staffing is complicated. Participants in Project
1, in particular the host country staff, commented on the specific issues
related to the Lao teacher training and programme coordination staff.
Part of the contribution of the host country to the 'bilateral' project was in
the form of trained personnel. Lao participants in the project were mostly
designated as 'counterparts' – non-experts. There was an on going struggle
between the Lao MOE and the Australian project team about which Lao
staff would be attached to the project. The (Australian) project manage-
ment wanted the Lao MOE to arrange for their most skilled and qualified
people to be involved at a management level in the project but at the same
time these staff were to be 'counterparts' of the Australian team. A key
point to note is that if a trained person is assigned a role as a 'counterpart'
that immediately places them in a less powerful position in the project.

The Lao departments may not have appreciated the aid project dic-
tating how their staff were to be deployed. The departments may have
also wanted to protect their staff as many did not want to work with the
project. The project's work practices did not allow them to fulfill other
work obligations and, if they were seconded beyond a certain amount of
time, they might have lost their MOE positions. This reluctance on the
part of Lao lecturers and teachers was not taken seriously by the project
management. Sol, a host-country project participant in P1, expressed her
concern about working with the project: 'One problem that could happen
for me is that if I stay too long with the project I will lose my position at
the university; this is a big problem for me and I don't think the team
leader understands this'.

From the start the Lao staff had a conflict of interests, they had to attend to their substantive MOE work commitments and there was a high expectation by the donors and providers that they would prioritize their work with the projects. An underlying assumption by the Lao staff was that the benefits, the cultural capital offered by the project, were to be distributed fairly and equally. The participants bought into the game. The participants believed that the end result would lead to a more 'profitable' future, a pathway provided by having completed an Australian university English language teaching degree.

Key Stakeholders in Project Two – Japan

In Project 2, Japan, participants were: Japanese MOE staff, Japanese university staff, Australian university staff, Australian project team members, Japanese project team members, Japanese teachers, Japanese school students and Australian government agency staff.

The host-country and Australian participants in Project 2 were difficult to map. Many Australian staff were involved in the larger project meetings but not in the day-to-day running of the project. The Japanese participants were co-opted through the MOE and AGA and were identified as key ELT personnel; however, these participants were not afforded the status of collaborator or expert. Although trained teachers and university lecturers, they were positioned as recipients of the project's product. Similar to the teachers in Laos, they were keen to reposition themselves in the field. This is a key struggle in the IELHEP field; the teachers' strategies to accumulate more cultural capital can be seen as an attempt to change the dynamics of the field, to 'relocate TESOL' (Kumaravadivelu 2006:17). A relocation of the field would necessitate repositioning of participants and a more equal distribution of resources. Yet the teachers were buying into what was offered by the dominant stakeholders, dismissing their own expertise and indigenous knowledge, engaging in the practice of self marginalization.

Discussion

In all respects the IELHEP is an economic exercise. The central activity corporatizes and commodifies English language teaching. Phillipson (2003) paints an insidious picture of the ELT industry when he describes its 'narcotic power' and one where there are 'major commercial interests involved in the global English language industry' (p. 16). The central finding of this research was that the design and implementation of IELHEPs are governed by pecuniary interests and a key struggle was how universities, project management companies and private language education providers positioned themselves in the field. While this chapter focuses on two Australian university projects, agents in the field may be transnational, multinational or national companies and universities. Economic capital is not bounded by national borders and multinational companies share regularities across these borders.

In Bourdieu's terms, a field is a site of struggle. It is clear in the IELHEP that the struggles are around the main forms of capital: linguistic, cultural, social and economic. These forms of largely symbolic capital are realized through language, qualifications, connections and money. Two pervasive sites of struggle are discussed here, economic capital and clashes over the valued resources in the field: (1) forms of capital and exchange rates and (2) struggles over cultural capital in Project 2.

Different stakeholders may feel different levels of ease about their participation in a project, and this is not simply due to whether the participant is from the donor/provider's country or not. Stakeholders from the host-countries may have cultural capital outside of the project from being known as language specialists, ministry officials, teaching professionals or prominent university lecturers or professors but these same qualities that brought cultural capital outside may carry no status within the project. Students may respect the professional qualities or the standing these project stakeholders have in their particular discipline or area of work and these qualities might be essential for bringing in students, but they cannot necessarily be traded for cultural capital inside the project field.

A pivotal struggle in both projects is around who defines the value of the capital one holds. In general the effort to convert one's specific cultural capital through symbolic capital to economic capital may, on the one hand, be a fruitless exercise or, on the other, very rewarding depending on which field and what capital one starts with. An obvious example from this research is the cultural capital host-country teachers hold in their teaching qualification. By their very definition the projects invalidate the host countries' teachers' training in order for the cultural capital held by the Australian providers to be more highly valued (or validated) and to be converted into economic capital through the activities of the projects. Interestingly, the reverse, that is, taking one's economic capital and trying to convert and exchange your way into a field, is much more likely to meet with unmitigated success. For example, the Australian project management company participants (in both projects) do not hold a lot of cultural capital in the form of academic qualifications, but they do hold the economic capital which accumulates the symbolic power in the field. Clearly, economic capital is highly significant in project work and in this research operated somewhat differently in the two projects. The economic capital held by the donors in Project 1, the aid-funded project, delineated the power relations in this project.

Because the IELHEPs are bounded by the rhetoric of 'partnership and collaboration' and the recognition of the host-country contributions, one might assume that the linguistic capital accumulated by the bilingual project participants would place these participants in a powerful position in the field. But as repeatedly revealed in this research, this is not the case. The participants' mother tongue (L1) is invalidated and the dominant language, English, is validated (Skutnabb-Kangas 2000, 1998). The value of one's linguistic capital is far greater if you are a native speaker of English; this then accumulates a greater amount of symbolic capital which converts to economic capital.

Struggle over Resources in the Field:
Forms of Capital and Exchange Rates

The amount of capital one has (regardless of type, that is, the vertical axis of
a field) (see Figures 1 and 2) converts to a relative amount of power, which
can then be converted into economic capital. The transferability of capital
and the 'exchange rates' between different kinds of capital are a focus of
struggle in themselves. Capital is never absolute, the value of capital varies
according to the particular situation or the ways of seeing it. For example,
in Project 1 the course participants, from the project management's per-
spective, may be viewed as holding negative economic capital (in terms
of money) and low or negative cultural capital (i.e. low English language
and perceived low teaching skills). However, from another view, the course
participants hold the 'potential' (this converts capital), for positive eco-
nomic capital as the project companies and universities were funded for
the purpose of their ELT training.

As one would expect in this area of work, the accumulation of eco-
nomic capital is a particularly powerful stake and many of the struggles in
the project field are over the accumulation of this form of capital. References
to this struggle included the issue about disparate financial situations of the
host teachers and the expatriate advisers. Many of the participants from
this project made the point that there was difficulty in meeting some of the
project goals because the host-country participants, teachers and teacher
trainers needed to work outside of their primary job in order to survive
and could not devote the time that is perhaps needed to the project activ-
ities (this is a reason why the project might misbehave). These comments
resonate with Bolitho and Medgyes' (2000) description of the different
economic realities of host-country teachers in a British Council project
in Hungary:

> Many of these experts have been employed under British Council terms and con-
> ditions, which seem to us to be fairly generous, and have been able to give their
> full attention to their institutional or project related obligations. In the meantime,
> teachers in my own institution and, I guess, throughout the region, are so poorly

paid that they have to hold down two or even three jobs simply in order to earn a living. As a consequence, they regard their main job as a part-time occupation too. As soon as they've done their classes, they're off. You can't build an institution on the dedication of its employees alone. Certainly not in the long run. You've got to pay them according to the level of their commitment. But this is wishful thinking in Hungarian universities for the time being. (Bolitho and Medgyes 2000: 381)

Strategies to gain economic capital underpin the IELHEP field; this is often more overt in aid-funded projects. Projects such as the British council one described above, the Lao IELHEP abound with stories of how struggles for economic capital delineate the field. Aid-funded IELHEPS are most often located in poor countries, and the project is a source of income to host-country and expatriate participants; however, from the start, economic capital is unevenly distributed. The story Peter Medgyes recounts in the extract above speaks of a disturbing regularity in the IELHEP field; the example of disparity in income is an explicit process of marginalization (Kumaravadivelu 2006).

Fee-based project fields attract investors; in this case study, it was Australian universities. In other parts of the world, universities may originate from the USA, the UK, New Zealand or Germany (to name a few); the motivation is to offer courses to international students at a vast cost. Host-country students may come from relatively wealthy or poor backgrounds; those from poor backgrounds have often left a huge debt in their home country (Marginson 2011). Struggles over economic capital take the forms of competition between universities and students: students demand for quality, support, assistance and career aspirations and are pitted against the institutional regulations and regularities. Another is the struggle within the university, among faculties and staff, to accumulate the economic profit.

Struggles over Cultural Capital in Project 2

Agents in the IELHEP struggle to accumulate cultural capital that demonstrates their accomplishment, and this is able to be transferred to other parts of the field or other fields. The Japanese MOE was driving change in the EL curriculum, particularly in the areas of method and content; the AGA was providing a product. These key agents at times clashed with each other and their struggles with the universities, teachers and students delineated the field.

In Project 2 the project products were designed for Japanese secondary EL teachers, with a focus on methodology, improving the skills of the teacher. My discussions with interviewees revealed a complexity that is not really addressed by the project design documents, project proposals or implementation documents. From the interview accounts, the MOE in Project 2 desired that teachers introduce more oral language into the classroom to improve the students' speaking skills. To do this the MOE wanted teachers to use more 'communicative language teaching' (CLT) methods. However, the compulsory university entrance exams tested mainly reading and writing; a limited listening component was included by some private universities.

A general response from the interviews with Project 2 Japanese teachers of English, was that the teachers' skills in EL teaching were sufficient; they are well trained to do what they have to do. Most teachers felt that they were more than competent in preparing students for their future needs, which, for the majority of students, was to pass the university entrance exam (mainly written). The skill that needed to be addressed by the project was that of English language proficiency. This presented an inherent difficulty for the project. One of the components was focused on English language development but most teachers would probably seek language proficiency courses in-country. These were probably less expensive and more accessible (among other benefits). The interviewees repeatedly stated that many of the courses offered by foreign universities did not take their teaching context

into account, specifically the issue of why many of their country's students were studying English. As in Project 1, the teachers' skills were invalidated.

Yet the Australian focus was on selling their product – a product that focuses on CLT with an oral component, despite contrary needs outlined above. As Murray, Director of the AGA, said, 'we have this product – this is what we will promote – we will do this in spite of what the teachers say they need'. The Australian universities had undertaken minimal investigation of the needs of teachers and we can see by the comments of the auspicing body (AGA) that it really had no role in pushing these universities to find out more for as far as the auspicing body was concerned the project had met its goal, Australia had been successfully marketed as a provider of HE.

In terms of who will benefit from the Australian university project, the MOE perceived that the increase in English language teaching skills would ultimately assist in the development of this country's internationalization process. The MOE officials presented a demographic scenario similar to other industrialized countries: in general the population is aging, fewer students are entering schools, there are fewer younger teachers and for those aging teachers there is little motivation to change the content and method of teaching English. In the near future, teachers will need to upgrade qualifications to meet the MOE requirements. The MOE was encouraged by the Australian donor to believe that the Australian universities' project would provide appropriate training.

Murray from Project 2, clearly identified the Australian Government as beneficiary. He surmised that the success of the project was determined by how much it was able to raise the perceived quality of higher education in Australia and generate economic capital for Australia:

> As I was explaining to you earlier, the AGA's objective in this particular activity is not to improve the standard of English Language teachers in this country. Our objective is to demonstrate the excellence of the Australian Higher Education sector and we believe that the mechanism best suited to do that is the mechanism of high demand in this country and relatively high quality supply in Australia. [And] when you do those sums, you either come down to medicine, particularly some of the specialties of medicine, or English language.

The AGA wished to construct the Australian higher education sector as a source of cultural capital for Japanese students. It wanted to attract more Japanese students to the higher education market and could only do this if the quality of the institutions is seen to be equal to those in the USA and in the UK. The Japanese MOE was similarly in the game to gain cultural capital that would continue to 'internationalize' the education programmes within the school sector. This struggle over ELT qualifications as the valuable stake deepens the divisions of domination and subjugation within the international language education field.

Conclusion: Bourdieu and the Story of the IELHEP Field

The IELHEP field is revealed as a terrain of conflicting and contested practices: the practices within Australian universities, aid and development projects, investment projects and the teaching and learning of English as a foreign language are sites of on going struggle. Related literature speaks of the failure of projects. The dominant players, the donors and Australian universities hold the validated, most valued capital in the field. Symbolic violence underlies the projects' delivery of ELT and EL teacher education; host-country teachers and ministry officials' skills, knowledge and interests are invalidated and stigmatized.

Bourdieu's conceptualizations of power, struggles and analysis of the multiple ways that the dominant players maintain their position were key to understanding how this particular 'game' of English language teacher education is played. My personal experience of work in this area showed that this 'complicated and messy' (Crehan and Von Oppen 1988) field is shaped by layers of opaque tributes to particular government and donor policies and slight attention to the goals and activities of the projects. And while current literature and reports about IELHEP work, give some critical insight into the machinations of the field, the available analysis does not delve deeply enough into the invisiblized power struggles. Bourdieu's

thinking tools are highly appropriate for a number of reasons: the relational tools of field, capital and habitus resonate with my own sense of the ways in which power, resources and the agents' position in society act in relation to each other; his research areas include universities, language and the ways in which individuals or organizations occupy different positions of power within and across institutions which allowed me to draw parallels with dimensions of the IELHEP field.

An additional point of interest is that there is homology between aid-funded and fee-based projects. The donor's and/or provider's ways of working in projects and their approach to teaching are glorified. It is positioned as superior to the existing systems in the recipient countries; these dominant practices are not only superior but significantly different from the stigmatized practices in the host countries. There is also an underlying assumption that there will be resistance to this new approach or methodology. These types of assumptions underpin the way in which the Australian universities are able to rationalize their approaches and take up the 'legitimate' position in the field.

A critical question for the IELHEP, is how can the recipient countries claim their practices as legitimate and then in subsequent negotiations work towards genuine collaboration. A related question is how can a change in Australian academic discourse effect a change in the relations in the field: in developing new educational practices in internationalization, the contextualization of the educational innovations is consistently thwarted by the individualization and atomization of academic work (Stirrat 2000; Marginson 2011).

CHERYL HARDY

Re-presenting the Social World:
Bourdieu and Graphic Illustrations of Field

Introduction

This chapter discusses the methods and procedures that may be gone through in order to undertake a practical analysis of a field context within a social space. It offers a particular empirical analysis of an artistic field to illustrate how the different models and methods can be applied. I broadly follow the type of methodology set out in Part I of this book; thus, with a consideration of the way the research object is constructed, levels of focus for mapping and studying fields and issues around participant objectivation. My approach is 'qualitative', in that I am working descriptively, without large scale statistics and with descriptive data collected on my chosen topic. That topic is the artistic field of St Ives, Cornwall, UK. Much has been written about this artistic movement (for example, Bird 2009) which, at one time in the 1940s, might be considered to be the 'epi-centre of the art world'. It is a useful example since it is relatively small, bounded, and includes a series of generational shifts (simply recognizable). The data I am working with is initially biographical. However, information about a number of institutional, contextual, and social details is also needed if the field is to be studied in terms of its relations, and thus the field structures, and symbolic values (capital) that constitute this field. It is these details which are analysed for correspondences and inter-relationships and from which I draw conclusions. My aim in choosing the St Ives artistic field is to show how methodological principles can be adapted to practical field case studies. First, though, I shall offer some extended discussion of the actual range of graphic forms that Bourdieu employs in presenting his own field analyses, since it is these models which have provided models for my own analyses.

Graphic and Visual Forms

Graphic Representation of Key Oppositions of Fields/Social Space

Writing in *Distinction* about the 'homology' between spaces, Bourdieu
indicates that the key oppositions that give rise to the structure of any
particular social space are between capital configuration and overall capital
value. He claims that these oppositions 'can be applied, by simple transfer,
to the most dissimilar areas of practice' (Bourdieu 1984a/79: 171). In other
words, objective oppositions exist which are derived from socio-economic
conditions that, in their turn, generate homologous structures in distinct
areas of practice, such as 'choices of food', 'marriage partner' or 'museum
visiting', because the structures in each distinct practice are derived from
the same dialectic tensions between capital value and capital configuration.
In *Distinction*, where the research object is French cultural consumption,
the main oppositions are between the practices of the dominant factions
of society – rich in both economic and cultural capitals – who seek dis-
tinction from the rarity of their cultural practices, and those who are poor
and whose practices are identified as 'vulgar because they are both easy and
common' (ibid.). This social space is mapped onto diagrams with vertical
axes representing the volume of capital possessed, and horizontal axes
representing capital configuration – the balance between economic (CE)
and cultural capitals (CC).

In *Distinction*, complex diagrams are shown (for example, pp. 122–3,
259, 340 or 455). Two different constructions of the social space are super-
imposed on the same diagram: firstly, that of *social conditions* represented
by capital configuration and capital volume; secondly, the space of *practices
and properties* (in *Distinction*, those of life styles). Bourdieu argues that
these diagrams, although complicated, offer a strong intuitive picture of
which structures exist but also how these vary over time (pp. 122–3 for
example). A third construction of the same social space – the theoreti-
cal model of habitus which is implicitly built by the researcher's choices
of coding and capital equivalences – could overlay the same diagrams to
present an additional perspective of the social space. However, this would
risk rendering the diagram unreadable!

The key oppositions in diagrams of this type – between capital *volume* and capital *configuration* – mean that any vertical change of position represents an increasing or decreasing volume of capital without any change in capital configuration – that is, position taking which moves an agent towards a more dominant or more dominated position in the same field. In contrast, a horizontal shift across the diagram moves an agent from one field to another. As Bourdieu writes:

> Transverse movement entail a shift from one field to another field and the reconversion of one type of capital into another or one sub-type into another sub-type (e.g. from landowning to industrial capital or from literature to economics) and therefore a transformation of asset structure which protects overall volume of capital and maintains position in the vertical dimension. (Bourdieu 1984a/79: 126)

Examples of these vertical and horizontal position changes and the corresponding changes in capital configuration or volume can be traced in diagrams presented in *Distinction* – for example, *The Space of Social Positions* on pages 122–3, or *The Variants of Dominant Taste* on page 259. Similar diagrams based on Multiple Correspondence Analyses (MCA) of empirical data can be found in *Homo Academicus or The State Nobility*. Applications of MCA can also be found and discussed in Part III of this book.

Research methods from *Distinction* have been replicated recently by Bennett et al. (2009) to map the social space and lifestyles of UK field participants. Other researchers have also used MCA methods and visual representations of key oppositions in social spaces, for example, to map social space in Canada (Veenstra 2009) and to map the field of power in Norway (Hjellbrekke and Korsnes 2009).

Representing Relationships Between Social Space and Fields

A different visual representation of social space is presented in *The Rules of Art* (Bourdieu 1996a: 124), where the oppositions between capital volume and capital configuration are presented diagrammatically, but this time, in relation to the fields of power and cultural production.

Field of Power

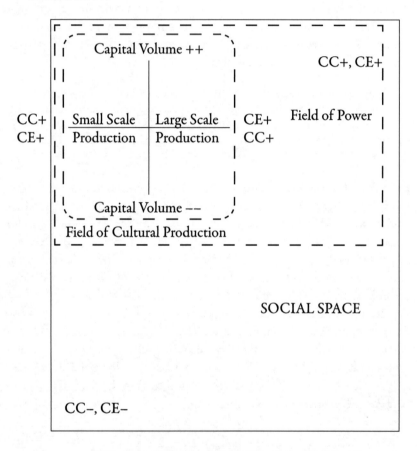

CE = Economic Capital; CC = Cultural Capital

Figure 1 Relationships between Field of Cultural Production, Field of Power
and Social Space (Based on Bourdieu 1996a: 124)

The field of power is here represented as a subset of national social space. Interestingly, Bourdieu positions all cultural producers within the field of power, but in dominated positions because they are dependent to varying degrees on those richest in capital, whatever its configuration. The field of cultural production is itself subdivided by the field strategy adopted by producers: large-scale and popular (CE+) or small-scale, restricted production (CC+). These juxtapositions between large-scale production (common for example, Vaudeville), and, small-scale production (rare for example, bohemia), generate structures within the field of cultural production.

This type of visual representation of structures within social spaces has been used in a modified form as a working tool for the Level 1 analyses described in Part I to represent the relationships between different fields of activity and the artistic field (see for example Grenfell and Hardy 2007 and Hardy 2009).

Representing Generational Change in Social Space

Individuals struggle over time for the most prestigious field positions. Consequently the internal structures of particular fields change. A visual model for these temporal changes is discussed in *The Rules of Art* (Bourdieu 1996a/92: 159), where different generations of cultural producers are represented in terms of differing dimensions of age in relation to a particular field: biological age; age of the cultural practice; age of the society, artistic age and age of the field itself. It is shown later how cultural practice, biological age and the maturity of the local and national fields, all figure strongly in the structures found in St Ives artistic field.

Bourdieu writes of this model that it 'stands out with particular clarity today because... each artistic act which leaves its mark by introducing a new position in the field "displaces" the entire series of previous artistic acts' (Bourdieu 1996a: 160).

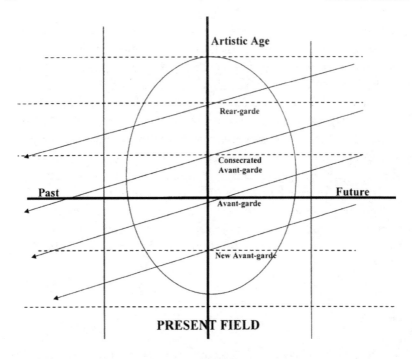

Figure 2 Generational Change in Social Space

Generation change within a field can be mapped directly through the cultural practices of its producers and the style of its cultural products because each artistic generation leaves evidence for its field position in its artefacts (the paintings) and how their ascribed values (CC and CE, auction prices, exhibitions, owners and museum displays) change over time. The value of these diagrams to show generational change in the artistic field has been explored in Hardy and Grenfell (2006).

How do you undertake a practical analysis in the light of these points? To stress, what is crucial to Bourdieu's theory of practice is that any analysis be *relational*; this is why his relational thinking tools, field, habitus and capital, must be used together to be valid. In Bourdieusian field analyses, the object of research is examined in relation to its national or international contexts; then, in relation to the links which exist with and between institutions and organizations; and lastly, in relation to particular individuals who

are active at that time. In practice, the relative emphasis given to each of the three levels of the analysis depends on the definition of the research object, whilst the order in which the three levels are undertaken can vary from field to field. Nonetheless, the research process itself is essentially the same as for any other rigorous, empirical research. It includes: (1) Constructing the Research Object; (2) Data Collection; (3) Field Analysis – Presentation of results; (4) Discussion of Outcomes; (5) Participant Objectivation.

I now want to explore these aspects of field analysis, here artistic fields, by offering an empirical example from the British art field.

The Art Field – St Ives, a Case Study

Firstly, the five generic ideas mentioned above have to be focused on the detailed relationships of the particular field, here St Ives in 1940s; a time and place chosen because artistic and social change were distinct and noticeable during this wartime period.

Construction of the Research Object

It is at the beginning of any research project that the scale, nature and focus of the investigation must be established. But, as noted in Part I, a research object for Bourdieu is never analysed of and for itself. Instead, an objective representation of it is constructed by identifying a systematic set of relationships associated with its participants, institutions and the broader social space which is its context. Thus, the construction of a research object remains open to revision throughout the investigation. As Bourdieu writes: 'Thus, there is a sort of hermeneutic circle: in order to construct a field, one must identify the forms of specific capitals that operate in it, and to construct the forms of specific capital one must know the specific logic of the field. There is an endless to and from movement in the research process that is lengthy and arduous' (Bourdieu and Wacquant 1992a: 108).

So, it is essential that the researcher constructs as good a representa-
tion of the field relationships as is possible by ensuring that the research
process is iterative and cyclic because it is never possible to analyse com-
pletely the ever-changing relationships between capital, habitus and field.
Since theory is always constructed from a particular position within the
field – the researcher's point of view – it reflects the researcher's habitus
and the field position they occupy. The resulting theorization is therefore
contingent, not a personal account, but a partial view of the social phe-
nomenon shaped by the researcher's point of view. This is why it is neces-
sary to objectify the objectifying subject – participant objectivation – as
part of the research process.

It is at the initial stages of a research project that the approach to data
is first considered. When a large-scale, quantitative approach is chosen,
then the data collected should be a representative sample of all agents and
organizations active within the field. The quality of the resulting represen-
tation of the research object is then a function of how well the sampling
process reflects the whole population.

Where a smaller scale project is envisaged, then data about the most
significant individuals and institutions in the social space are the most
useful, because these field participants occupy the most dominant field
positions, and therefore also occupy positions within the field of power,
where they are able to determine the value of field-specific capitals. Here,
the data collected is not a statistical sample, but should be a particular subset
of individuals selected because of their powerful influence on the field. This
is true even where the methods of analysis are systematic and numerical!

As noted, the following example here draws on a study of the art field in
St Ives, UK. This research project was an art historic exploration of the prac-
tices and characteristics of artists working there just before 1950 when they
were at their height. Initial research questions were: What were the struc-
tures of the artistic field in St Ives in the first part of the twentieth century?
And why was there such a marked shift in artistic practice in St Ives, from
traditional representative and figurative painting to abstract expressionism?

The approach adopted was small-scale and used only about fifty field
participants. The data was documentary, and largely biographical. Data col-
lection and analysis was intended to be qualitative. EXCEL software was

used to record data consistently across artists. This process was cyclical with the database revisited and refined at several stages in my search for invariant features and correspondences. *My* method here began with agents' habitus (Level 3) rather than the broader social space (Level 1) – see Part I and below.

Data Collection

In a Bourdieusian approach, data serves two distinct functions. Firstly, as information about individuals' practices and attitudes – often collected by interview or questionnaire. These together are the constituents of habitus and allow the identification of what acts as symbolic or field specific capital in a social space. Secondly, information about field participants' character-istics are used as a means of evaluating the cultural capital and economic capital they have each accrued so as to position them in terms of the key oppositions – capital configuration and volume.

In his empirical studies (for example, Bourdieu 1988a, Bourdieu et al. 1990c, Bourdieu 1984a/79), Bourdieu explicitly sets out the range of data which he collected and used to indicate the possession of economic, cultural and symbolic capitals. For example, in *The Love of Art*, he used analytical categories which included gender, age, occupation, place of resi-dence and level of highest qualification. These were studied in relationship to data about attitudes, and visits, to museums and art galleries to investi-gate possible regularities with capital volume and configuration (habitus). For instance, most regular visitors (55 per cent) had at least a baccalaure-ate qualification (p. 15). Similar data collection processes are described in *Distinction* and *Homo Academicus*. The range of data collected varies in relation to the research object, because significant indicators of symbolic capital vary from field to field and are defined by the particular field studied.

In the St Ives field of artistic production, artists' published biogra-phies were used as sources of information about individual characteristics, whilst the artworks themselves were examined to represent practices and dispositions. The use of published material like this is modelled on work by Bourdieu in *The State Nobility* (1996b/89:98) where he analysed obituar-ies; on later work undertaken by Fowler who used obituaries as indicators

of habitus (Fowler 2004: 145); and on work presented in *The Rules of Art* where Bourdieu makes use of personal biographies (p. 125).

Artists' published biographies are often a highly stylized and conventional form: one where similar data are offered about each artist, with the advantage of providing consistent information. Since these biographies are written (often by the artists themselves) to show the artists in a good light, they only offer achievements, including training, exhibitions, honours and prizes, date of birth and often family background, the sort of information needed to consider *habitus* in a relatively systematic way. This enabled me to construct a profile of each artist which, when examined in relation to the artist's works, indicated the *volume and configuration* of *capital* which each individual had accumulated.

Practically speaking, I began by collecting historical documentary data about the artistic field and the individuals in it, be it discursive text, biographical detail, or examples of artworks. I simply assembled as much data as I could about who lived and practised in St Ives from 1930–50 to give a broad picture of what was at stake within this field. At this stage, choices were made about what to include and exclude to bring the research object more clearly into focus. Evaluative judgements about the relative legitimacy of different types of capital were also made. These choices and judgements begin to develop the theoretical model of habitus to underpin the research. These choices were revisited several times as the structures and values of field specific capitals are clarified.

Field Analysis

As noted, many of Bourdieu's own *field* analyses were based on Geometric Data Analyses of large sample populations, for example, *Distinction* involved 1,217 respondents. Several statistical packages which identify correspondences are now in existence to support large scale studies like these (see Le Roux and Rouanet 2004; Le Roux and Rouanet 2010; Greenacre and Blasius 2006). However, adopting a Bourdieusian approach does not necessitate the use of statistical analysis and, indeed, such an approach would have been inappropriate in the St Ives study. Nevertheless, using all three levels of analysis is still essential. Below, I revisit the three levels set out in

Part I of this book in the order in which they are undertaken in the case example (Level 3 to Level 1). Here, detail and commentary are given to describe what is necessary at each level of a *small-scale* field analysis:

LEVEL 3: Compare the habitus of a range of individuals.
Rigorously examine the characteristics of individual *field* participants, including the most dominant, to identify which forms of capital are most valuable in the field. Search for common characteristics and close correspondences between field participants. Remember that the analysis is about relationships. This stage of analysis is focused on developing categories that differentiate between individuals. Good working tools for this are patience, systematic attention, correspondence tables, and, if you wish, statistical software, EXCEL, SPSS or SPAD.

LEVEL 2: Examine the interconnections between agents and *field* institutions.
Link individuals engaged in the field to organizations, institutions and other groupings or communities. Identify which institutions are most closely connected to which agents, and the nature of the interconnections. This will help to identify which other fields are active in this social space. The emerging structures can be clarified by sketching linkages diagrammatically. As the analyses progress, these are refined to represent social capital from associations with individuals, or cultural capital from differentially legitimated organizations. There are two-way relationships between organizations and agents. An individual gains valuable capital by association with prestigious institutions, whilst associations with dominant individuals enhance an institution's prestige. Look for these sorts of relationships.

LEVEL 1: Examine the *field* in relation to other *fields*, in particular, to the *field* of power. Identify and scrutinize the large-scale economic, cultural and political contexts of the research object (the broader social space) to see how this shapes the functioning of the social activity in question. Having already identified individuals and institutions active within the social space, it will be clear which fields of activity are necessary for a particular analysis. Diagrams like Figure 2 are useful working tools to consider and reconsider the inter-relationships of fields, the field of power.

These three levels of analysis each provide a different perspective on social space and together produce a picture of the social phenomenon as a dynamic complex of inter-relations between people and organizations: relations which are constructed by the value placed by the most dominant field participants on different dispositions and attributes. The result is the construction of an objective space of occupied positions together with a picture of the agents who occupy them.

A first run through the three levels show patterns in the data that point to regions within the field where dominant individuals and institutions are located. A second is then needed to investigate other individuals and institutions who 'emerge' during the first cycle because they played noticeable parts in the functioning of the field; for example, Borlase Smart or Julius Olson, both older teachers in St Ives. These individuals are not always active participants in the field itself but are often influential individuals from the field of power for example, Herbert Read – an influential art critic. With each subsequent cycle of analysis, the number of additional individuals should diminish so that the analysis stabilizes. In other words, as the analyses proceeds the research object is increasingly clearly represented. It may take several revisions to stabilize an analysis.

Information was assembled for about fifty artists, born between 1890 and 1920, and who were prominent in the field – all were exhibiting and selling their artworks during the 1940s. I tabulated this data and worked iteratively between the data itself and the groupings I had initially chosen until a stable categorization emerges (or system of coding if working quantitatively). Figure 3 shows an extract of this database.

The categories used provided the maximum number of differences between individuals (Level 3) and exposed to view artist's relationships to institutions and organizations in the field (Level 2). With only fifty participants to consider it was possible, if laborious, to identify both qualitative and quantitative connections. Early in the analysis I drafted a series of working diagrams to show links between individuals (for example, Ben Nicholson, Borlase Smart, Patrick Heron, Barbara Hepworth), local societies (for example, St Ives Society of Art), and national institutions such as the Royal Academy. These diagrams showed emerging structures – in particular, a marked split in the field between older, figurative artists who exhibited largely at Royal Academy, and younger artists and 'incomers' who favoured abstraction, exhibited at commercial galleries in London, and who knew European artists such Picasso, Mondrian and Gabo (Level 2). The two groups showed very different configurations of capital. There were very clear oppositions arising from age difference, artistic practice and from place of origin. The older group of artists possesses capital derived largely from the local artistic field, whilst the younger artistic group has cultural capital derived from the national artistic field.

Artist's Habitus	Barbara Hepworth	Naum Gabo	Wilhemina Barns-Graham	Peter Lanyon	Bernard Ninnes
Age	Born 1903	Born 1915	Born 1912	Born 1918	Born 1899
Origin	Wakefield, UK	Briansk, Russia	Fife, Scotland	St Ives	Reigate, Surrey
Cornish Connections	Invited by the Stokes to Carbis Bay, St Ives in 1938	Moved to Cornwall in 1939 to join Nicholsons and Stokes	St Ives in 1940 after visit to Mellis/Stokes	Cornish	Lived in St Ives after he married in 1930
Family	Comfortable, but not artistic	Russian Émigré Family – Pevsner	Family against artistic career	Father a musician/artist, Mother from wealthy tin mining family	Father an ironmonger from St Ives
Education	Leeds Art School	Studied medicine in Munich	Edinburgh Art School	Private education at Clifton College, Bristol, Penzance and Euston Road Art Schools	West of England School of Art, Slade School of Art
Art Schools/ Groups	'Seven and Fives' Group St Ives Arts Society, Crypt Group, Penwith Society	Invited to lead Ceramics department at new Moscow Academy, instead chose to edit weekly paper on functions of art	Taught at Leeds Art School 1956/7 St Ives Arts Society, Crypt Group, Penwith Society	St Ives Arts Society like his father. Crypt group. Taught at Falmouth and West of England Academy	St Ives Society of Art, Royal Institute of Oil Painters
Public Honours	CBE 1958 DBE 1965 Trustee of Tate Gallery 1965–72	None	CBE 2001 Honorary doctorates – St Andrews, Plymouth, Exeter, Herriot Watt Universities		Committee member and Vice president of St Ives Society of Arts
Artistic Practice	Abstract Sculptor	Abstract 3D constructions	Abstract painter Often representational	Abstraction Landscape Painting	Figurative Landscape

Figure 3 Extract from Database of Habitus of St Ives Artists (Level 3)

But why? The third perspective (Level 1 analysis) on the St Ives artistic field comes from its social and political context and the relationships within the broader social space. The relative degrees of consecration of different artistic institutions were evaluated at this stage to provide a picture of how close the field in question is to the field of power. So, for instance, an artist exhibiting with the then avant-garde Penwith Society in St Ives belonged to the restricted part of the local field of production but, since Herbert Read was the first President, this local society was one with both local and national legitimation.

However, this was the time of World War II. The functioning of many fields was disrupted. It was a time when people were on the move: soldiers were conscripted, families fled out of London for safety and many international artists left Europe for England or America. The field of power expanded as State regulation proliferated, whilst those within the field of power were largely focused on the war effort, national survival and victory. A Level 2 analysis shows that the St Ives artistic field was also divided geographically into the local artistic field of St Ives, the national field and an international artistic field.

A Bourdieusian approach always seeks to capture the objective structures of the social space and the subjective experiences of individual agents and relationships between these. Statistical analyses are supplemented by exemplification of particular individuals' positions, attitudes, and quite literally, their points of view. Visual representations, as discussed earlier, provide ways of mapping the objective, systematic relationships of the field and broader social space. However, diagrams are not sufficient without examples and case studies of the lived experience of individual agents. The discursive montage of *Distinction* demonstrates one way of doing this by juxtaposing generalized statements with illustrative examples. The descriptions of individuals' experiences in *The Weight of the World* (Bourdieu 1999a) show another.

Presentation of Results

The socio-cultural elements considered which acted as cultural capital in the St Ives field of art are embedded in Figure 4. The development of such classifying categories constitutes a major part of a theoretical model of habitus as it functioned in St Ives at that time. Artists were chosen because they were noticeable: that is, they had accrued sufficient volumes of capital to occupy dominant positions. However, the configurations of capital, which they each possessed – social, cultural and economic – varied greatly between older figurative artists and the younger artists who practiced abstraction. To present these configurations fully would require discussion of artworks. For the interested reader, the Tate gallery website, <http://www.tate.org.uk>, offers many examples of these artists' work. Examples of how these images can be discussed in relationship to artists' habitus and patterns of practice are presented visually in an extended study of this field (see Hardy 2009). Outcomes of this field analysis are also published in 'When Two Fields Collide' (Hardy and Grenfell 2006).

Discussion of Outcomes

So what are the strengths of adopting this methodology?

The benefits of any three level analysis are that it leads to an articulated picture of how a social space is structured, what is considered most valuable at any one time and place, and who occupies sufficiently dominant positions to be able to influence the exchange rates of different types of capital in the field. The costs of adopting such an approach are the large amounts of data that must be used in order to identify the most significant correspondences between people, organizations and the broader socio-cultural context. The research findings are shaped by availability, or, more frequently the inaccessibility, of particular sorts of data – often economic – and, of course, are only as valid as the data collected and the analytical

categories established. For these reasons, discussion of outcomes should not only be relational but must return to the choices and decisions made about the range and nature of data collected to reflect on the consequences of this theoretical construction of habitus.

For the St Ives field, shared configurations of capital were discernible across the artists. In the main, these capital configurations proved to be strongly associated with artistic practice – representational or abstraction, and more generally with artistic and biological age. One of the strongest features was the split between older St Ives-based artists whose artistic practice was representational, and who exhibited at the Royal Academy, and, the younger London based artists who were committed to abstraction, had strong links to recognized European avant-gardes and to London's commercial galleries. There were also clearly discernible, if complex patterns in the forms of artists' educational capital which varied by age, gender and nature of artistic practice. In other words, although only a limited time period and a restricted number of artists were included in the database, a picture emerges of how the field was structured and how those structures changed over time, moving from representation to abstraction, from St Ives Society of Art to the Penwith Society and from the local field to the national one.

On reflection, my decision to collect data about the artists most dominant in the field has had an effect on the view of field structures produced. Numerically, there were fewer women artists in the database than men, but there was a distinct female subgroup who all trained at the *Academie Colarossi* in Paris. I also found that there were large numbers of women who were members of the St Ives Society of Art but who rarely exhibited. These findings have lead to more recent field analyses of women artists at different times (Hardy 2007, Hardy 2010) and showed that women's artistic practices demonstrate different structures from those of male artists, differentiated in part by women's roles in the broader social space, but also by what was considered appropriate art education for women. In other words, while Bourdieusian analyses do provide relational descriptions of the functioning of particular spaces, they also lead to further research questions and iterative extensions of the field analysed.

Participant Objectivation

I want to say a few words about how participant objectivation may have formed part of my analyses. This aspect of Bourdieu's methodology is often overlooked, and I do no more than make some preliminary remarks here. However, I hope they open a space where my analysis of St Ives is at least framed by issues of reflexivity.

What were my interests and experience in relation to this research object? I am an academic, a mathematician, a teacher educator and a practising textile designer. At the time of the study of St Ives artists, I was living in Cornwall, loved visiting art galleries and was studying for a Masters in Modern Art History at Falmouth School of Art. My interest in education influenced the questions asked and the data collected (see Hardy 2009 for further discussion). Let us consider how this position might affect my perspective by approaching this area by drawing on another way that Bourdieu represents fields and social space – through photographs. Bourdieu often used photographs as visual representations of a social space. The best examples are perhaps in his photographs of Algerian people – workers, rural peasants and town dwellers (Bourdieu 2003a). These photographs show the apparently paradoxical relationships to be seen in every day Algeria in the 1950s: a travelling peddler uses a modern bicycle to transport and display his traditional wares; or the Algerian women hidden inside their traditional robes discuss a shop window full of high heeled shoes. It is these very specific contrasts and unexpected juxtapositions of cultural practices that illustrate how social space is structured in that time and place.

Analysing photographs *with Bourdieu*, so to speak, again demands a relational analysis. We might take both an *external* and *internal* reading of the visual images as a necessary: an external reading shows how the subject of the photograph relates to the environment (the *field* context) and to the photographer's position in it; an internal reading considers the people photographed, their relations to each other and to the spaces they occupy. The photograph reproduced below (Figure 4) is one where following in Bourdieu's footsteps, I am both the photographer and analyst. The image,

therefore, has an inherent bias – my point of view – which must be made explicit by positioning myself as both a field participant and an observer: *'participant objectivation'*. The photograph was only possible because habitus places me as 'a fish in water' in a museum space – middle-class, middle-aged and middle-income – whilst my university position provided sufficient *symbolic capital* for me to be granted permission by a museum to photograph in its galleries. Whilst the image records objectively 'what is there', it is my interest in what learning looks like in museums that conditions my choice of subject and the resulting photograph.

Figure 4 Learning in a Museum Setting

An Internal Reading

A man is taking a photograph of a painting in an art museum. He is holding a museum plan. Just in front of him stands a young girl turning to look at what he is doing. The painting, by Roy Lichtenstein, is 'Drowning Girl

1963'. The key relationships are then between the man, the girl and the picture. The huge picture has a comic book quality, but its isolated position in the gallery demonstrates highly consecrated objectified cultural capital. The man recognizes the status of the picture – it merits a photograph, all whilst showing that he is probably 'consuming' the picture as a tourist rather than as an art connoisseur. The girl, possibly his daughter, is caught between the painting and the adult. Her stance suggests a question. One might not be surprised at her puzzlement that this cartoon image, a genre probably familiar to her from comic books, is worthy of a photograph.

An External Reading

The photograph presents the painting in relationship to its physical context – a museum (CC+, CE+) and its geographical position in central New York (CC, CE++). The painting was gifted to the museum by collectors, probably a gift in lieu of tax. The relationship between the artist, the painting and its art historic context should also be considered. The role of legitimated institutions in relation to the subject matter of the photograph and the photograph as object are identified. My practice as photographer, my cultural, academic contexts, and why learning in a museum is significant for me, are all part of an external reading. In other words, a photograph provides a visual representation of a social space and what is valued within it, and may itself be subject to a three level analysis set out. In this way, photographic images can be both sources of visual data within a Bourdieusian field analysis and used as a basis for participant objectivation, as a way of positioning the researcher with respect to the object of research.

Such visual representations of social space and positions associated with it need to be understood as an attempt to offer a graphic illustration of relations; either as the structures of a field itself, or the relationship between the researcher and their research. There is a crucial distinction to be made here between the mental or visual image of a social space which is, in effect, a way of theorizing and presenting hypotheses about field structures, and, the evidence, statistical, personal, or otherwise, for that structuring.

Concluding Remarks

Ways of analysing fields are central to much of Bourdieu's empirical analyses. Different examples have been offered in this chapter as graphic forms to depict perspectives of the complex inter-relations of the social space; a space which Bourdieu argues is generated by the key oppositions between capital configurations and capital volume, and by the transformations of these over time.

For Bourdieusian analyses, several principles should be noted:

- The need to distinguish between the structures of a theoretical social space and the evidence provided for those structures through empirical analysis.
- The effect of decisions about choice of field participants, about analytical categories and about time scales on the underpinning theoretical model of habitus.
- The need to remember that legitimated institutions hold the doxa of the field and, as such, are a crucial element in every three-stage process.
- The imperative to use all three analytical levels, and all three thinking tools – capital, field and habitus in each study.
- The need to 'objectify the objectifying subject'; in other words, the necessity of turning the tools of objective analysis back on the researcher themselves as a form of *participant objectivation*.

Finally, in choosing to adopt a Bourdieusian methodology, researchers commit themselves to a process which is relational, cyclic and complex, but one which is capable of providing a dynamic representation of human activity and one which deepens one's understanding of the inter-relationships between objective structures and personal lived experiences.

JO WATSON

Widening Participation in Higher Education: Capital that Counts

Introduction

Even before the release of the Browne Report in 2010, the UK field of higher education (HE) had experienced significant changes. Already expanding admissions figures (Maringe and Fuller 2006) were given new impetus by the 1997 Dearing Report and the renewed emphasis on widening participation which was underpinned by a social justice and economic rationale (DfES 2003a, 2003b). The expectation was that HE would contribute to enhancing national competitiveness in the global economy while simultaneously supporting social cohesion and equality (Naidoo 2000; Osborne 2003).

Despite a significant increase in the proportion of students securing the qualifications required to enter, and the number actually participating in HE, under-representation of those from less privileged social backgrounds is a persistent problem (Reay et al. 2005). Participation has increased to a much greater extent than it has widened (Gilchrist et al. 2003) and it is noteworthy that 'the most disadvantaged young people are seven times less likely than the most advantaged to attend the most selective institutions' (BIS 2011: 6).

For many, getting to university is itself an achievement (Clegg et al. 2006), and while doing so might there afford opportunities, the literature suggests that students from non-traditional backgrounds encounter a range of challenges that can impact significantly on their performance, retention and experiences (see, for example, Ozga and Sukhnandan 1998; Yorke 2001a; Thomas 2002; Leathwood and O'Connell 2003; May and Bousted 2004; Sambell and Hubbard 2004). With growing appreciation

of the depth and complexity of the issues involved, there is movement away from assumptions of deficits linked to individuals or groups, towards greater recognition of the role played by institutions themselves (Thomas 2002; Leathwood and O'Connell 2003; Sambell and Hubbard 2004; Greenbank 2006).

Naturally, there are examples of individuals from non-traditional backgrounds who succeed in HE, but the pattern of collective trajectories of less privileged social groups differs sharply from that of traditional entrants (Reay 2006), and the onus falls to students to adapt to and fit in with established practices (Layer 2002; Burke 2005). Regardless of changing student demographics, significant challenges to the dominant culture of HE have been slow to emerge and its long-established traditions and practices remain oriented towards its traditional white middle-class student population (Read et al. 2003) and effectively resist inclusivity (Burke 2005). While the literature offers insight into the constrained choices, the challenges encountered and even the successes achieved by students from non-traditional backgrounds (see, for example: Ball et al. 2002; Archer et al. 2003; Forsyth and Furlong 2003; Crozier et al. 2008; Reay et al. 2009; David et al. 2010), there is less consideration given to exploring how the practices and culture of particular learning environments influence the demands that are made of students and their experiences of studying in HE.

Methodology

Providing a framework considering the interrelationship between the structuring forces of the social world and individual dispositions, actions and experiences (Grenfell 2004), Bourdieu's theory of practice offered considerable potential to illuminate students' learning experiences within the culture, practices and nuances of the HE environment they entered. This research centred on a three-year longitudinal case study in which an undergraduate health-related programme in one of the UK's research intensive universities became a vehicle for exploring the educational experiences

of students with non-traditional academic backgrounds (i.e. non-school leavers and/or those with non-A-Level qualifications).

Thirteen volunteer participants were drawn from a single cohort as they prepared to commence their studies. Data were collected via initial focus groups exploring pre-entry educational experiences and expectations of studying in HE, reflective diaries recording educational experiences that individual participants considered significant or meaningful, and one-to-one semi-structured interviews conducted towards the end of participants' first and third years of study which focused on exploring their learning experiences. Additional background data were collected via participant-completed biographical information forms and family education and employment maps. Analysis of policy and other documentation produced by government, professional and regulatory bodies, together with those produced by the dominant voices within the institution, school and department (for example, mission statements, strategies, policies, regulations, validation documents, programme specifications, timetables, module profiles and assessment criteria) provided representations and images (Mason 2002) of the field and offered insight into its pervading culture, values and assumptions (Bogdan and Biklen 2007).

Analysis of the Field

Bourdieu and Wacquant (1992a: 104–5) clarified the three levels of analysis required to effectively utilize Bourdieu's theoretical framework, and this became the guiding principle in the analysis undertaken in this research. Summarized in this section are key aspects of the initial documentary analysis which marked the level one analysis in which the relationship between the HE field and the field of political power was examined, which progressed into early level two analysis considering the structure and organization of the particular sub-field or microcosm that was the specific focus of the research.

The UK Field of Higher Education

Comprised of semi-autonomous institutions largely defining their own purposes (Select Committee 2006: 1), the UK field of HE is nonetheless influenced by the field of political power which imposes policies and directives through key government departments and their associated agents (Layer 2002). For example, with emphasis shifting from raising aspirations and achievements as a means of encouraging participation, to retention of enrolled students and graduate employability (HEFCE 2001; Greenbank 2006), links to some funding streams moved from institutional widening participation strategies and action plans to recruitment benchmarks and performance indicators associated with proportions of students from low-participation neighbourhoods, state-education and less privileged socio-economic backgrounds (Greenbank 2006).

The relationship between the two fields is not, however, straightforward and the vigorous contemporary debates shaping the future of HE in the UK illustrate that the field is not only answerable to, but able to exert influence over, the political field. The new model of substantially increased repayable tuition loans (BIS 2010) stands in some contradiction to an espoused on-going commitment to supporting social mobility through widening participation, and will witness the shifting of the financial burden to students. It is premised on an increasingly marketized field in which greater competition between increasingly diverse institutions and, ostensibly, more student choice is envisaged. With the 2012/13 transfer of public funding from institutional teaching grants to student loans for fees, institutional incomes will be linked to their ability to attract students willing to pay the fees. Even the nature of the 'market' is complex with the government seeking to manage expenditure from the public purse funding student loans by retaining some control over student numbers.

Illustrating Bourdieu's observation that not all players hold equal positions within any given field, the UK field of HE has long been differentiated. The 1992 dissolution of the divide between universities and the polytechnics offering vocational and technical alternatives (Osborne 2003) created a single, stratified field characterized by 'old' and 'new' universities with divergent reputations and functions. Various mission groups came to

represent distinct sub-fields within the sector and include, for example, the prestigious 'Russell Group' which is seen and identifies itself as representing 'elite' UK universities (The Russell Group no date), the '1994 Group' which describes itself as comprising 'internationally renowned, (smaller) research intensive universities' (1994 Group no date) and the Million+ Group representing many of the 'new' universities who 'meet the challenges of our changing society, offering the flexibility and support that are necessary to broaden participation and add value to the economy' (Million+ 2008).

These self-formed groups operate to distinguish and advance their positions within the field by defining their functions differently and arguing the significance of that function. The dominant field positions of members of the Russell Group are sustained by high levels of economic capital and their ability to attract and retain high-quality researchers, which in turn supports their ability to attract research funding and so maintains or extends their portfolios of valued capital. Older universities are also noted to draw a greater proportion of their students from traditional school-leavers with high A-Level point scores, while new universities recruit a larger proportion of mature students and those from the less privileged social backgrounds (Yorke 2001b; BIS 2011). The status of and incentives for research over teaching activity, and the additional costs, including time, associated with supporting non-traditional entrants to university, serve to reinforce the established patterns of power, prestige and status within the stratified field.

MACKELLAR UNIVERSITY:
A PLAYER AND A SUB-FIELD IN UK HIGHER EDUCATION

Mackellar University (pseudonym) is an older, well-established research-intensive university that typically demands high academic entry qualifications. Although recognized as an institution of good-standing, Mackellar is ambitious and keen to improve its national and international reputation to further enhance its position in the field. Strategy documents have acknowledged the policy tensions within the sector and the need to make decisions about where and how the institution positions itself. An explicitly identified culture of internationally recognized research and enterprise reflects the high value status of these forms of capital within the field and

foregrounds the institution's stocks of them. Responding to the political emphasis on the quality of student experience in relation to the new fees regime, Mackeller identifies a commitment to offering talented students, regardless of their backgrounds, a personalized educational experience incorporating opportunities to learn alongside world-leading academics and researchers and to engage in enterprise activity at an appropriate level.

The student participants in this research were drawn from a sub-group of the allied health professions. Entry into the profession requires a BSc (Hons) qualification, institutionalized cultural capital only accessible through engagement with and legitimation by the HE field. Professional practice is strongly influenced by health and social care agendas emanating from the political field, the standards set by independent regulatory and professional bodies, and by struggles for professional recognition and status within the healthcare field. Building on the notion of fields within fields (Grenfell and James 1998), the case study site can be understood as a microcosm of the sub-field of discipline-specific education within the broader field of HE, and the educational practices of the school concerned are strongly influenced by the policies, standards and directives of the fields within which it is embedded (Mackellar University as a sub-field of the broader HE field), and the fields by which it is surrounded (the political and professional fields). The school demanded some of the highest entry requirements within the discipline-specific field at the time. Although a small entity within Mackellar, the school's programme documentation highlighted its position in the discipline-specific field by describing its strong reputation amongst its competitors and local employers, and its strong performance for a school of its type in terms of research output.

The Research Site as Micro-Field

Comprehensive revalidation documentation associated with the school's portfolio of full-time undergraduate programmes was produced in the years immediately preceding this research. Reflecting the most dominant voices within that social space, it provides a clear indication of the pervading culture and educational approach. A range of methods were employed

to support learning and teaching, including more traditional large-group lectures, expert-led experiential and practical sessions, small group work, peer presentations, case studies and guided and self-directed learning activities. In fulfilment of the requirements of the regulatory and professional bodies, one third of the programme comprised learning under the supervision of qualified clinicians in professional practice environments and was highlighted as reflecting endeavours to facilitate the integration of theory with practice and the cross-fertilization of learning undertaken in both contexts.

Aligned with the policies and field positioning of Mackellar University, strategy documents produced by the school espoused a philosophy of research-led learning and teaching, which incorporated research-informed educational approaches, research-informed educational content, and exposure to and engagement with research processes. Assessment guidelines and academic regulations described the manner in which students' knowledge, understanding and performance in the academic and practice contexts were assessed, or in Bourdieusian terms legitimated, by staff as dominant representatives of the field. Assessment of academic performance was undertaken in a variety of ways (including unseen written examinations, oral and poster presentations, practical skills assessments, and written case studies, essays and research projects) and was said to reinforce the integration and transference of knowledge and skills and the contextualizing of their relevance to professional practice. In the absence of mitigating circumstances, students were entitled to one opportunity to redeem any failed assessment; where that attempt was unsuccessful, the student's programme of study was normally terminated.

Revalidation and programme documents alluded to some of the academic and professionally-oriented capital valued by the field. For example, it described a commitment to educational processes that develop students as 'independent, intrinsically motivated thinkers' and a curriculum that focused on developing competent clinical and professional skills, those skills required to underpin autonomous practice and team-working, and the critical and analytical skills required by users and/or creators of research evidence within the professional field. The aims, objectives and learning outcomes of individual modules of study and assessment making criteria

similarly offered glimpses of some of the forms of capital that students were expected to possess or develop to succeed, or sustain a legitimate position within the field.

Empirical Data Analysis

Following this documentary analysis, Bourdieu's theory of practice continued to underpin theoretically informed thematic analysis (Braun and Clarke 2006) of transcribed interview and reflective diary data which was contextualized with individual background information. This afforded the opportunity to more closely address Bourdieu's second and third levels of analysis by examining the experiences of individual participants within the field, identifying more specifically the forms of capital profitable within that field, and considering how habitus and portfolios of capital influenced individual positions and trajectories.

Capital That Counts

The majority of the study's participants successfully secured their professional/academic qualification and therefore accrued the sought-after cultural capital entitling them to enter the field of professional practice. While the routes to achieving this end varied widely, it was evident that even where participants' established habitus was largely incongruent with the social conditions of the field they had entered, most were able to adapt (to a greater or lesser extent) to its logic of practice and take advantage of the opportunities presented. Common to participants' experiences were the concepts of academic, linguistic, social and professionally oriented capital, portfolios of which were held in variable configurations and volumes by each participant. Figure 1 provides a model or conceptual framework illustrating these key forms of capital, which were highlighted by

the data as underpinning a 'feel for the game' (Bourdieu 1990a/80: 66), or the successful engagement with the logic of practice of the field under consideration. Each will be explained before illustrating their influence on the experiences, positioning and trajectories of individual participants within the field.

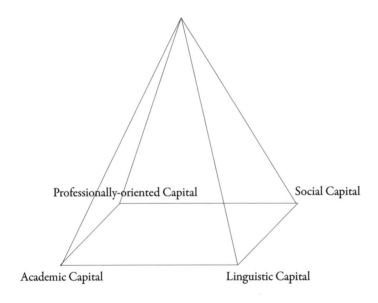

Figure 1 Capitals Identified as Profitable within the Field

Academic Capital

In *Homo Academicus*, Bourdieu used the term academic capital in relation to academic staff and to reflect graduation from the École Normale Supérieure (which summits the hierarchy in French HE (Grenfell 2007), the age at which an individual passed the aggregation, a highly selective national examination leading to prestigious teaching positions (Grenfell 2007), and the development of intellectual products such as 'lectures,

textbooks, dictionaries, encyclopaedias, etc' (Bourdieu 1988a/84: 98). He used educational capital to refer to the options studied or grade awarded in the baccalauréat (Bourdieu 1988a/84: 168). As might be expected, cultural capital of this type held particular relevance and value in the context of this research. Reflecting the spectrum of capital expected of students and academics operating within the field, my use of the term 'academic capital' might be seen as a bridge between Bourdieu's educational and academic capitals.

In this research, academic capital reflected the legitimated forms of academic skills and knowledge profitable to students within the field, which ultimately translated into academic attainment and award and therefore a higher value cultural capital. It was expected to develop over the period of students' engagement with the field and included, for example, legitimated disciplinary and related knowledge, including adherence to referencing and citation conventions; orthodox approaches to searching for, accessing and critically appraising knowledge sources and to justifying and substantiating ideas and arguments; and the legitimated style and delivery of oral presentations and written work, including the structure and tone of academic writing. Marking criteria provided some insight into the characteristics of academic capital but, holding true to the largely symbolic nature of cultural capital, much remained implicit.

Linguistic Capital

Bourdieu highlighted that language represents much more than an unproblematic instrument of communication; he said 'it provides, together with a richer or poorer vocabulary, a more or less complex system of categories, so that the capacity to decipher and manipulate complex structures, whether logical or aesthetic, depends partly on the complexity of the language transmitted by the family' (Bourdieu and Passeron; 1977a: 73). Alongside habitus, individuals develop a repertoire of language that reflects the logic of practice of the social field in which they are immersed, with the initial familial social field exerting a strong primary influence. As a medium of cultural transmission (Grenfell 2007: 89), the use and understanding of

language is variable across society and is recognisable as a specific form of cultural capital, referred to as linguistic capital (Bourdieu 1991a/82), the style of which potentially differs greatly between social fields (Grenfell and James 1998).

Linguistic capital encompasses aspects of the form and content of language valued within a field, including for example grammar, linguistic repertoire, forms of phraseology, and tone and mode of written and verbal expression or expressive style (Bourdieu and Passeron 1977; Bourdieu 1991a/82). The data emerging from this research highlighted the key role of linguistic capital in participant's experiences within the HE field they had entered and an important relationship, and the potential for conversion, between it and academic capital. Linguistic capital influenced the accessibility of various learning activities, particularly when that deployed by staff (representing more dominant voices within the field) was markedly different from that held by individual participants. It was central to the interpretation of learning outcomes, marking criteria and feedback, was critical to the capacity to present knowledge and understanding in a form legitimated by the field, and to the ability to think using language and therefore to manipulate, interrogate and develop concepts and ideas.

Social Capital

Bourdieu described social capital as 'the sum of the resources, actual or virtual, that accrue to an individual or group by virtue of possessing a durable network of more or less institutionalized relationships of mutual acquaintance and recognition' (Bourdieu and Wacquant 1992a: 119). In the context of this research, social capital was drawn primarily from social networks developed within the field and had the potential to confer benefits in the guise of, for example, access to collaborative study groups, peer-review of draft submissions, the sharing of resources and skills, and practical and emotional support. Reflecting what Bourdieu (2006: 110) called its 'multiplier effect', the data illustrated that social capital had the potential to serve as a powerful mechanism to aid the development of a 'feel for the game' and to facilitate the acquisition of linguistic and academic capital.

An important point to note is that the nature of social networks varies, and the social capital derived from them does not hold equal value. The data clearly illustrated that networks developed amongst marginalized students did not afford the same capital value as networks including students who fitted more comfortably within the field. As Bourdieu (2006: 110) explained, social capital depends not only on the size of the network of connections that an individual can mobilize, but also upon the portfolio of capital possessed by each of those with whom the individual is connected.

Professionally-oriented Capital

Cultural capital reflects the logic of practice of a field translated into 'physical and cognitive propensities expressed in dispositions to act in particular kinds of ways' (Moore 2008: 111). Amongst other things, it incorporates knowledge and skills (Bourdieu 1991a/82) and in the context of this research, professionally-oriented capital emerged as a valued form of cultural capital encompassing those aspects of students' knowledge and skills related to the practical, enacted aspects of professional disciplinary practice. It was clear from the data that professionally-oriented and academic capital were related. While each had the potential to enhance the other, they were independently identifiable so are best understood as overlapping to some extent.

Professionally-oriented capital reflected, for example, depth and breadth of knowledge appropriate to and legitimated by the practice context, a suitably professional disposition and appearance, enactment of collaborative client-centred practice, proficient execution of the professional role and associated personal management including approaches to communication and team-working, and active engagement with critical evidence-based practice, reflective practice and continuing professional development. Mirroring the development of academic capital, professionally-oriented capital was expected to develop throughout participants' engagement with the field and its most profitable form was partially characterized within marking criteria. A noteworthy feature of professionally-oriented capital is that in the vocationally-oriented programme under consideration, it

also translated into attainment, this time in relation to practice placement results, and some participants were able to deploy it to off-set limited stocks of academic capital.

Capital in Action: Positioning and Trajectories in the Field

Following thematic analysis of the corpus of data, individual summaries (averaging 2,000–3,500 words) were written to bring all data pertaining to a participant together with the emergent findings, focusing specifically on illuminating the background and habitus of the participant and the role that the identified capitals had in their experiences and trajectory within the field. With further examples of participant experiences offered elsewhere (Watson et al. 2009; Watson 2012), two contrasting examples are drawn upon here to illustrate the approach taken and the role of the valued capitals in action within the field.

George: A 'Fish in Water'

George's father was an engineer and her mother a teacher. Although she 'wasn't expected to go to [university] at all. It wasn't really mentioned' [focus group], she described a wall of graduation photos in her grandmother's house that she, her cousins and her brother 'aspired to' [family education/employment map], and upon which all were eventually represented. Having left school with a single A-Level, George became dissatisfied with her career in human resources. After starting a family and holding a series of part-time jobs that she described as 'just crap really' [first interview], and with the financial and practical support of her husband, she elected to pursue a career as a health professional. After completing an additional A-Level through correspondence while caring for a toddler and a new baby, George's ambitions required that the family relocate to allow her to

enter university aged thirty three. There, she found that her established habitus was more closely aligned with the new field than the one she had left, and she described the experience as 'like meeting a load of like-minded people' [first interview].

George had to work extremely hard to juggle the competing demands of home and studying, but unlike some other participants, there was never a sense that these two social spaces were incompatible and George moved freely between them. The congruence between George's established habitus and the logic of practice of the new field she had entered was evident in her early 'feel for the game'. Discussing what for her was the absolute clarity of assessment requirements, and illustrating the value of her established portfolio of academic and linguistic capital, she said: 'these people who say it wasn't laid out correctly for them, and people who failed saying "oh, we weren't told what to do"... and I'm going, well, we were. It's right there, you know!' [first interview].

A striking feature of George's data was that she seemed to be very capital conscious (described in her terms as being strategic) and took active steps to accrue and deploy to her advantage various forms of capital. Frequently alluded to, social capital played a particularly important role in George's engagement with the field. She was discriminating about who she worked with saying: 'I think I need to be a little "cold" and strategic and find people with good understanding of subjects and people on similar wavelengths' [reflective diary], and her approach ensured she developed high-value social capital that afforded the greatest benefit. She said: 'we would get together quite often and just debate ideas and definitely bounce ideas off each other a lot' [second interview], but also highlighted the value of social capital during challenging times, such as the failing health of her father and a further house-move in her second year: 'I couldn't have done it without their help [...] last year when I was moving and I had [two assessments] to hand in and it was just hellish, they really helped me. They were like sending me journal [articles] and things like that, proof reading...' [second interview].

Language was scarcely mentioned in George's data, suggesting that she naturally held a repertoire of linguistic capital appropriate to the field and therefore encountered few issues. While she was excited by extending and developing her academic skills and achieving academically (accruing

academic capital), her efforts were focused on the development of pro-fessionally-oriented capital as the form that was newest to her. Again, it was clear that George was strategic and proactive in this regard, as she explained: 'Whenever I've been on placement, if I've wanted to do some-thing, I've said, "Can I do this?" or "Can I try this?" And they've always said, "Yeah! Do it!" And a lot of people [peers] have said, "Oh, you got to do so much!" and I was like, "Yeah, well it's because I asked if I could do it."' [second interview].

George's willingness to challenge the professional practice and HE fields suggested confidence in her position within both. The overwhelming themes emerging from her data were of fitting in and of gathering capital – most often very strategically. A 'fish in water' (Bourdieu and Wacquant 1992: 127) from the outset and throughout her engagement with the field, George was awarded a first class honours degree and was contemplating Masters level study even before graduating.

Tracey: Excluded by the Field

Standing in stark contrast were the experiences of Tracey, whose habitus amongst the participants was one of those least congruent with the demands and expectations of the *field*. As she described: 'If I go back [home], there is no university there... you don't normally speak to anyone like that. You're a chamber maid or a shop assistant and there's a lot of, well, "Why? Why would you wanna go to uni?"' [interview]. Tracey explained that her mother was 'interest[ed] in politics and history, but unable to go to university or get a better education due to raising six children alone and having to work' [family education/ employment map]. She listed her father, a long-distance lorry driver, separately from the rest of the family on this map. Tracey's employment history included work as a beautician and a part-time veterinary assistant. She had never been expected to attend university, although an older sister had done so as a mature student and held a degree in sociology and politics.

Tracey was the single parent of two 'quite needy' sons, who remained living several hours away in their home town when she commenced

university aged forty four and with a recent Access qualification [focus group]. She had a volatile relationship with an ex-partner, but was often forced to rely on him for financial support. Describing an experience during her first year, she said: 'my ex come [sic] down, he did help me out financially, but of course he blew a storm! Oh, it was just horrendous, because, you know, being one of those people who was screaming his head off in Halls. It was... it was horrible' [interview]. Comparing her personal circumstances with those of fellow students, she described feeling embarrassed and like 'a bit of an outsider' [interview].

Tracey encountered challenges almost immediately she entered the field. Early in her first year she moved between three different halls of residence until she was allocated one that was affordable. She explained that 'for the first three months I only had this little blanket, this little fleece. I couldn't afford to buy sheets or anything [laughs] until Christmas', and she described at one point living in 'a flat alone in this block of post-grad students, but it was mostly male and they were quite wealthy and I remember feeling quite out of that, you know. I had this piddly blanket on the bed, [laughs] no pillows... I felt ever-so different from them...' [interview]. A lack of harmony between her perspectives and dispositions, ultimately her habitus, and those of fellow healthcare students contributed to social exclusion and at times to what she described as 'bullying' [interview]. Tracey did eventually establish some friendships, but it was with students who were themselves marginalized by the broader cohort, and as they also held limited stocks of capital relevant to the field, these networks conferred little benefit in advancing Tracey's position within it.

Tracey observed more than once that she had always enjoyed studying, treating it 'as a hobby' [focus group and interview]. Despite her enthusiasm, forming a study group with her social network and working hard to identify and produce what was required of her, Tracey struggled; she lacked relevant linguistic and academic *capital*, and the 'rules of the game' or logic of practice of the field were very much obscured and remained so. Tracey recognized that the demands of the new educational field differed from those she had previously encountered, saying: 'I did Psychology [on my Access course] and I got a good mark for it so I'm just wondering *why* is it not working now? That's what I don't really know. It must be really

different...' [interview]. Referring to her attempts to identify the academic level required she said: 'I'm still trying to work out what it is I think, to be perfectly honest. I mean, I don't feel it's beyond me, comprehension-wise. I understand it all. I really *like* it [...] I'm not quite sure what they want. You know, what I *think* they want isn't what they want' [interview].

Tracey said she was thrilled to be at university. She felt 'very proud' and 'really *important*' [interview], but her data was littered with examples of the incongruence between her established *habitus* and the practices and expectations of the HE *field*. Like Archer's (2003) participants, she recognized the opportunities afforded her and her children as a result of successful engagement with the field. In her interview, she observed: 'Everything that I wanted [coming to university] to achieve, it has achieved. The type of people, the type of friends, the conversations I'm having now, do you know what I mean? I'm absolutely loving it! It's what was missing in my life before... I'm not giving it up!' Ultimately, however, Tracey struggled to achieve a tolerable degree of fit or sufficient leverage to secure a legitimate place within the field. If George was 'a fish in water', Tracey was very much 'a fish out of water', and the overwhelming theme emerging from her data was of incompatibility with the field. Despite her genuine attempts to do and be what was required, there was little evidence of her gathering relevant capital. With re-sits yet to be successfully negotiated, unresolved debts owed to the university precluded her continuation and Tracey was formally denied a position in the field.

Conclusion

This research provides insight into how students experience and negotiate the demands of studying in HE and the influences brought to bear by the practices and culture of the particular sub-field they enter. Those whose habitus was most closely aligned with the dominant culture of the field held the strongest opening portfolios of relevant capital and therefore

held the stronger field positions (Watson et al. 2009). While adequate economic capital afforded a number of advantages (for example, freedom to purchase childcare and learning materials, travel between home and university and prioritize study over earning), participants' subsequent trajectories and the 'affinities, convergences and divergences' (Grenfell 2007:138) they experienced reflected their ability to develop a feel for the game and where necessary adapt their habitus, and their ability to accrue or extend portfolios of relevant capital. The conceptual framework identifying the capitals valued in and underpinning the logic of practice in this specific sub-field of healthcare education highlights the interplay between academic, linguistic, social and professionally-oriented capitals and the capacity for capital to beget capital. Demonstrating the profitability of capital in terms of practical consequences (Grenfell and James 1998), participants who secured legitimate (even if marginal) positions within the field were able to convert their portfolios into higher-value cultural capital in the form of the academic/professional qualification granting them entry to the professional field.

The methodological approach taken in this research made a genuine attempt to enact Bourdieu's three-level analysis, but there were clearly limitations. The broad field analysis was undertaken largely on the basis of documentary analysis and consultation with the literature and does not consider the status of the discipline involved in relation to others within the HE field. It could have been a much more significant and far-reaching undertaking as illustrated by the work of Bourdieu himself in *Homo Academicus*. While it offers valuable perspectives on how the practices and culture of a particular learning environment influence the demands made of students and their experiences of studying in HE, the scope of the research was narrow, the number of participants small and limited to the student voice, descriptions of their field positioning and trajectories were notional and, despite my efforts to elucidate them, the nature of the identified forms of capital remains largely implicit.

It is in relation to some of these limitations that the potential for multiple correspondence analysis to add depth and clarity to this research becomes most apparent. As a relational analytic approach, it would add to rather than replace the work to-date, facilitating a more robust construction

of the field (from macro to micro) as a multidimensional social space, and substantiate (or not) the nature and role of the identified capitals by differentiating individual positions and trajectories within the field. It is in this area that current work is focused.

In the post-Brown era of an increasingly marketized HE sector in the UK and despite apparently contradictory policies, the coalition government continues to espouse a commitment to social inclusion and widening participation. Simply inviting diverse student groups into the field will not itself change the fundamental logic of the field which will continue to privilege the most dominant factions. Neither is it possible to render the 'game' completely transparent, although Bourdieu (1994a/87:116) highlighted the possibility of reducing its opacity. The capitals model and any work that can be done to elucidate it further provide an opportunity to begin this process.

MICHAEL GRENFELL

Conclusion to Part II

The four chapters in Part II are examples of researchers adapting and apply-
ing Bourdieu's research perspective in their own fields. None of them con-
nect directly with his own empirical research, but all of them draw heavily
on concepts derived from it. Bourdieu was, of course, the most empirical
amongst the celebrated French sociologists and philosophers of the later
twentieth century. Even so, many of the analyses of his middle period were
based on observation and the descriptive statistical analyses of questionnaire
data, and it is only in his earliest work – in Algeria, the Bearn and Education
– and later work in *Weight of the World* that extensive interviews were
undertaken of the type around which the work in Part II was carried out.

'Naturalistic' or qualitative approaches to data collection and analysis
offer the opportunity for forms of study and representation that go deeper
than simple statistical depictions. Case studies, ethnography and symbolic
interactionalism, for example, are all capable of demonstrating processes
and the nature of relations underlying social phenomena. However, what is
seen in qualitative data is determined much earlier than at the stage of data
collection and analysis. As discussed in Part I, the very way we conceptual-
ize something shapes not only what we see but what we *can* see. There is a
social convention at stake – especially on the part of social scientists – in
representing social contexts in a certain way. Any Bourdieusian approach
must break with that convention in the first instance in 'constructing the
research object', and it is clear that each of the Part II chapters seeks to
do this as a way of looking afresh at their respective topics. However, it
is not enough simply to describe data in terms of Bourdieusian concepts;
a kind of metaphorization of data – for example, in the way that social
agents are discussed in terms of habitus and all site contexts as fields. It is
the interaction – in terms of structural relations – that is all-important in

such analyses, expressed in terms of the logic of practice of the context, the dominant forms of capital and their means of reproduction. In other words, description is not the same as analysis; the reconceptualization of a social phenomenon in Bourdieusian terms needs to extend to actual identification of relations and their consequences. So, in the chapters illustrated we have seen how the processes of Higher Education can be other than utilitarian, or how students' background can be decisive in terms of academic outcome; similarly, how artistic avant-gardes define themselves in terms of field relations, and how the practice of inclusion schools can be exclusive.

In these chapters, the relationship between the researcher and their research is very evident; and Bourdieu, perhaps more than most social scientists, insists that their own 'feel' or 'eye' is a critical source of knowledge that should not be overlooked in accepting the seductive sense of the neutral, objective scientist (REF). A more natural approach, he argues, is to highlight the empathy that might well exist between the researcher and the object of their research in collecting data. Indeed, anything other could amount to a form of intrusion, or symbolic violence, in the whole research process. This approach is exemplified in *Weight of the World* (pp. 607–26) where Bourdieu writes of a 'non-violent form of communication' between the two through matched pairs in interviewing. Such, he argues, allows the interviewer to put themselves in the place of the interviewee – to 'take their part'. This way, there is a kind of empathetic resonance set up in the interview, a 'genetic and generic comprehension' so that through 'subjective reasoning', 'objective causes' are uncovered. 'Objective' because it is possible to discover conditions which are common to an entire category.

The same might be said for the way we record and transcribe interviews and observations. The dangers of translation and interpretation are everywhere; for example, in the place chosen for a comma or full stop. Clearly, it is difficult to capture a social discourse in its multidimensionality – not everything can be recorded on tape. Bourdieu argues again for the intervention of the researcher as an act of 'democratization of the hermeneutic', the cultivation of a style of writing that allows the reader to situate themselves in social space at the same point as the respondent, a place from which all views emanate. What he is attempting to avoid is the kind of objective distancing that reifies the researched as an object to be

gazed upon from a particular ('scientific') point of view, which is no more than a cultural imposition. Vigilance and rigour are required in this case to escape the trap of a certain perspectivism.

These are the issues that lie, somewhat silently, behind the accounts offered in Part II. We have not been able to give all methodological procedure, nor very much actual data exemplification. However, these examples of Bourdieusian qualitative research highlight these issues for others in pursuing their own ends. Understanding in this way is synonymous with explaining, as the researcher stands in the shoes of the other and sees the world from their point of view. Such a stance is not simply a sympathetic disposition because it is held up next to a Bourdieusian epistemology and methodology, which can articulate that point of view in a structural constructivist manner. It is, therefore, necessary to insist that both identification and imposition in the collection and analysis of data need to be avoided. The type of new world view that Bourdieu encourages us to adopt is possible only by cultivating a kind of common stance with the object and source of research, which itself is only achievable if the researcher is able to objectify themselves and thus hold at one and the same time their own empirical subject, their scientific habitus, and that of who they are researching:

> ... it is solely to the extent that (researchers) can objectify themselves that they are able, even as they remain in the place inexorably assigned to each of us in the social world, to imagine themselves in the place occupied by their objects (who are, at least to a certain degree, an alter ego) and thus to take their point of view, that is, to understand that if they were in their shoes they would doubtless be and think just like them. (Bourdieu 1999a/1993: 626)

This world view is precisely the metanoia – that new gaze – that Bourdieu claims for his brand of social research. Such a domain of understanding is both epistemological and ontological for the researcher, and is the space that qualitative research from this perspective opens up.

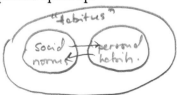

PART III

Quantitative

FRÉDÉRIC LEBARON AND PHILIPPE BONNET

Introduction to Part III

Geometric Data Analysis techniques are in direct and strong affinity with Pierre Bourdieu's sociological theory.

First, they provide a 'relational' view of social reality and help to overcome any form of 'substantialism' in the description of groups, practices or attitudes. They are consistent with Bourdieu's 'cassirerian' conception of science.

Secondly, they develop a 'spatial' representation of reality, which suits particularly well the project of operationalizing the notions of field and social space, notions which become central in Bourdieu's theoretical construction after 1971. They allow the construction of fields and social spaces as research objects which are defined as reference-spaces for the sociologist.

Thirdly, GDA techniques allow a multidimensional display of variables. They are both synthetic in the sense they permit us to summarize the links between various variables and analytical in the sense that they provide a vision of a set of independent variables (the principal dimensions) which need to be taken into account from the data.

Finally, they put a stress on the visualization of individuals seen as holders of social properties (and the two clouds resulting from MCA directly relate both spaces).

In Part III, the authors all use GDA techniques and, for most of them, relate this use to a theoretical construction which is directly inspired by or connected with Bourdieu's sociological conception. This conception is illustrated in three domains: cultural practices; education; politics.

One of the first topics is the sociology of cultural practices in line with *Distinction*; that is, with the idea that cultural practices are multidimensional and socially structured.

Based on official survey data about cultural practices in France, the chapter by Lebaron and Bonnet develops an actualization of some of Bourdieu's results and typologies as they are proposed in *Distinction*, on the basis of a combination of specific MCA and cluster analysis.

Using a Web-survey seizing a specific sub-population of amateurs, Berry, Boutet and Coavoux break with the usual 'techno-centred' analyses of the practice of video games and study this practice as a social field, defined by specific oppositions. They mobilize MCA for this purpose and show the particular dimensions organizing this practice.

A second topic is the sociology of education, which is still considered a central domain in Bourdieu's theory and empirical work.

The chapter by Fredriksen presents, on the basis of an original survey, an analysis of the competition between educational institutions in the space of 'social educator' training in Denmark, showing a complex set of differentiation principles among the students and the way they relate to different institutions, showing how institutions are 'adjusted' to particular social characteristics. MCA is here again systematically used to assess the main results.

The chapter by Tribess is centred on the issue of the success of students from the working classes. Using register data about the French region of Picardie, she shows that in certain disciplines, a more 'socially friendly' environment can help to improve the results of these students. She uses MCA as a synthesis tool which helps to understand the overall space in which this particular group evaluates.

The final three chapters of Part III are devoted to another social field: politics, an area which was illuminated by Bourdieu's conception of multidimensionality and the hypothesis of a homology between political and social properties.

The chapter by Bergström and Dalberg is based on a survey of third grade students in upper secondary schools in Uppsala (Sweden) in 2008 and their political attitudes. It reveals, through the use of a CA on doubled variables, the multidimensionality of their political space, with classical redistribution issues strongly intertwined with environmental and multicultural topics.

The chapter by Laurison, based on a 1999 survey conducted on political consultants in the United States, uses MCA and the classical 'aids to interpretation' (supplementary elements) to assess the strong relationship between the space of positions and trajectories on one side and the space of political opinion on the other, and to understand the limits or complexities of this homology.

Finally, the chapter by Álvarez-Esteban, Bécue-Bertaut, Kostov and Morin is devoted to the analysis of the inaugural speeches of the Spanish Prime Ministers (1979–2011). It shows the high potential of CA and clustering analysis to study in-depth a chronological corpus of textual data selected here from official political discourses. This chapter allows us to understand GDA methods as very powerful tools to grasp textual structures, taking into account the social dynamics of argumentation.

FRÉDÉRIC LEBARON AND PHILIPPE BONNET

Classification, Social Classes and Cultural Practices: A GDA Approach Through Bourdieu's Sociology of Culture

Introduction

Recent breakthroughs in the methodology of Geometric Data Analysis (GDA) (especially by Le Roux and Rouanet 2004, Le Roux and Rouanet 2010) allow for the development of the analysis of social space structures as started by Bourdieu during the 1970s. In particular, this work was highlighted in an article published with Monique de Saint-Martin, entitled in French 'L'anatomie du gout' ('an anatomy of taste') (Bourdieu and de Saint-Martin 1976c), which was afterwards included and expanded in the book *La distinction* in 1979 (Bourdieu 1984a/79). These breakthroughs are not just methodological refinements which 'modernize' an 'old' instrument (multiple correspondence analysis) already much used by Bourdieu himself and by numerous members of his 'team' (Rouanet et al. 2000, Lebaron 2009). They help to us examine various sociological issues which are at the centre of what can be called, thirty years after the *'Distinction* model', the issue of the existence of a 'cultural hierarchy' and its social determinants. Included here are the relative weight of various types of capital (cultural and economic) as factors of cultural inter-individual variations in lifestyles or, more specifically, the question of the structural homology which characterizes different sub-spaces constituting the global social space.

In this chapter, we focus on the issue of the determination of 'classes' of individuals on the basis of cultural practices and their sociological interpretation, especially as regards their (sociological) constituency. It is a form of analysis which has been largely used by Bourdieu since the beginning of

the 1960s (Lebaron 2009) and probably under the influence of Thorstein
Veblen, Maurice Halbwachs, Edmond Goblot and a set of other classical
and contemporary sociologists, but with an additional particular efficiency,
numerous analytical insights, and a high degree of synthesis. For example
Bourdieu describes 'distinction' as a largely unconscious attitude intended at
maintaining one's position in the social space, seen as a place of permanent
symbolic evaluation struggles. This general feature of social behaviour is
not reducible to a purely rational quest for the maximal amount of sym-
bolic capital, but it can certainly be (theoretically) 'approached' as such.
It can be argued that people try to maintain their relative position in a
general social market, where the relative value of people and practices is of
a symbolic nature and is collectively produced. As the laws of this market
are unknown by agents and permanently changing, it creates a perpetual
move of diffusion and distinction of some aspects of lifestyles, especially
cultural practices as symbolic dimensions of the 'conditions of existence'.

Bourdieu analyses types of cultural attitudes in the bourgeoisie; in
particular the adhesion to legitimate culture (recognized in the form of
'classical music' for example) is made 'natural' as a part of a general domi-
nant ethos. Attitudes are more ascetic, as they are less natural and have to be
acquired in the petty bourgeoisie. This corresponds to what he calls 'cultural
goodwill', a systematic set of behaviour, especially aiming at conquering the
more legitimate signs of integration inside the bourgeoisie. In the popular
classes, the absence of competence in highbrow cultural domains is not
seen as a lack of, but an opposition to real and realistic popular tastes. In
this chapter we base this kind of typology on a systematic GDA method-
ology, using first MCA, then a Euclidean classification.

Bourdieu's Conception of Social Classes and the 'Class-Culture' Debates

A large sociological literature has recently discussed the importance of
'cultural factors' in relation to the issue of the existence of social classes,
especially in comparison with more socio-economic definitions like the

ones which prevail in British sociology (see Bennett, Savage, Silva, Warde, Gayo-Cal and Wright 2009). The existence of a relation between social groups and cultural practices, has been largely discussed in connection with the growing importance of consumer attitudes, changes in cultural production, and the rise of 'omnivorousness' for cultural goods (Peterson and Kern 1996) as observed in various empirical studies, and especially in the Anglo-Saxon world. The idea that 'cultural hierarchies' have become more fluid and less strict has been developed since the 1990s. In parallel, another set of authors have brought into question the relevance of 'social class' as a central factor of social behaviour. Some have specifically, stressed the high level of dispersion between individuals in cultural matters around the important 'dissonances' between their tastes and practices (Lahire 2004). Recently, authors have tried to articulate Bourdieu's theory of legitimate culture and this set of new observations and ideas with the aim of making the sociological account of the class-culture relationship more 'flexible' (Coulangeon 2011).

In our view, Bourdieu's theory of 'social class' and habitus has often been misinterpreted, because it has been disconnected from the set of empirical observations, which has given it all its explanatory and interpretative strength. In particular, the use of Geometric Data Analysis methods since the 1970s has been a constant practice of Bourdieu and his main theoretical inventions (like the notion of 'social space', central in *Distinction*) have often been related to issues raised by his data material and methodological operations. Bourdieu's conception of social classes has undergone a degree of evolution since his first analyses of 'class ethos' and inequalities in the 1960s and especially so in Algeria. In *Distinction*, he proposes a complex analysis of the relationship between 'social class' and 'cultural practices' as part of a 'lifestyle' and expression of a *habitus* (Bourdieu 1984a/79). Social classes are symbolically and in particular, politically constructed on the basis of agents' positions in the social space. This construction is also bound up on the basis of their similar types of lifestyles, founded in habitus, which create 'elective affinities' between them. Cultural practices are central components of the lifestyle and participate in the symbolic construction of classes (Bourdieu 1984b).

GDA enables us to display all the observed inter-individual variability in a first step. The subsequent social space is based on the differences

between individual's characteristics. Through this process social variations can be observed in the space and their intensity can be 'shown' geometrically. This for Bourdieu was a way to concretely 'prove' the close connection between symbolic structures and the space of social conditions.

The Data

We have used the data from the 'enquête permanente sur les conditions de vie des ménages' (EPCV survey, today called 'SILC' survey at the EU level) which was carried out in 2003 with a supplement entitled 'participation culturelle et sportive' ('cultural and sport participation'). This survey is composed of 5,625 individuals aged fifteen and over and further restricted by us to the 5,497 individuals who are aged over eighteen to allow for international comparisons to be made. The survey includes a number of questions related to cultural and sport practices, which allows for the measurement of the differences in the intensity and exactly the frequency of these practices and it adds to them detailed information about individuals and households. The questionnaire has not been conceived for GDA, and especially for MCA therefore, questions with multiple choices had to be recoded in the perspective of MCA. The survey is not very rich on the economic characteristics of the respondents, such as outside household income in large classes, and some aspects of household's equipment. Their wealth, either financial or in terms of real estate is not estimated, nor the most strictly economic elements of lifestyle, such as the main budgetary headings ('budgetary coefficients'), sparing behaviour, time used for consumption and the management of money, etc.

Our first goal was to use a dataset sufficiently close to Bourdieu's data in *Distinction*, an analysis directly inspired by Bourdieu and the recent breakthroughs in GDA. The fact that data were neither collected for MCA purposes nor from Bourdieu's perspective is of course a limitation to this analysis.

The Construction of the Space

The most important step in analysis, in line with Bourdieu, is the construction of the space by the choice of active questions and in specific MCA passive modalities. This step can be described as the geometric modelling phase of the analysis. It is the heart of what Bourdieu calls the 'construction of the research object' with Passeron and Chamboredon in 'Le métier de sociologue' (Bourdieu, Chamboredon and Passeron 1968b), and a concrete operationalization of this epistemological concept. One can regret that, in numerous works which discuss 'Bourdieu's theory', either in a historical, comparative or more theoretical perspective, the issue of the way the social space is concretely constructed has been either totally left aside or under-argued. They condition the sociological relevance of the results obtained by Bourdieu and the interest of a discussion of its empirical conclusions. We have in our analysis constructed a space of cultural practices, including legitimate cultural practices (like different types of reading books or magazines), listening to classical music, etc., as well as practices more related to youth lifestyle in its multiple meanings (listening to music genres, specific radio channels, watching particular sitcoms, etc.), and more popular practices (related to popular TV programmes, listening to the radio, etc.). If the questionnaire is not centred on taste properly speaking, we kept the questions revealing preferences such as the TV channel the most watched, the genre of music most often listened to, etc. We nevertheless have to insist on the fact that this kind of survey is much more precise and rich on the amount of time spent in practices than on the expression of tastes or attitudes. It led us to leave aside in the construction of the space (but of course not as supplementary elements), dimensions which may appear as fundamental part of the lifestyle, and leisure practice in particular: concrete practices (gardening, 'bricolage', etc.), economic practices like consumption and sparing, social capital practices, sport practices. However, it is a restriction if one compares this analysis to the perspective adopted by Pierre Bourdieu and Monique de Saint-Martin in 'L'anatomie du gout', which analyses the space of lifestyles. We have therefore limited ourselves

to a 'representative sample' of cultural practices and have coded active
questions after a careful examination of elementary statistics, which has
led us in many cases to retain binary codings.

Table 1 Elementary Statistics for Active Questions (shaded categories have been put as
'passive' in the specific MCA)

TV_channel

Label of categories	Count	Percentage
Fr3_reg	525	9.55
La5/Arte	495	9.00
Cable	460	8.37
No One in Particular	1053	19.16
France2	705	12.83
TF1	1377	25.05
M6	507	9.22
Irrelevant	133	2.42
Canal+	228	4.15
Don't_Know	14	0.25

5497

TV_news

Label of categories	Count	Percentage
Rarely	687	12.50
Often	4681	85.16
Irrelevant	129	2.35

5497

TV_sitcoms

Label of categories	Count	Percentage
Never	2906	52.87
Often	2462	44.79
Irrelevant	129	2.35

5497

TV_film

Label of categories	Count	Percentage
Rarely	1978	35.98
Often	3384	61.56
Irrelevant	135	2.46

5497

TV_games

Label of categories	Count	Percentage
Never	1986	36.13
Often	3380	61.49
Irrelevant	131	2.38

5497

TV_sport

Label of categories	Count	Percentage
Never	2993	54.45
Often	2368	43.08
Irrelevant	136	2.47

5497

TV_clip

Label of categories	Count	Percentage
Never	4463	81.19
Often	902	16.41
Irrelevant	132	2.40

5497

TV_art

Label of categories	Count	Percentage
Never	3263	59.36
Often	2101	38.22
Irrelevant	133	2.42

5497

TV_docu

Label of categories	Count	Percentage
Never	1487	27.05
Often	3875	70.49
Irrelevant	135	2.46

5497

TV_theatre

Label of categories	Count	Percentage
No	4424	80.48
Yes	938	17.06
Irrelevant	135	2.46

5497

SP_movies

Label of categories	Count	Percentage
Never	2843	51.72
<1/term	928	16.88
<1/month	833	15.15
>=1/month	893	16.25

5497

SP_Theater

Label of categories	Count	Percentage
No	4634	84.30
Yes	863	15.70

5497

SP_history

Label of categories	Count	Percentage
No	5001	90.98
Yes	496	9.02

5497

SP_dance

Label of categories	Count	Percentage
No	4808	87.47
Yes	689	12.53

<div align="center">5497</div>

SP_circus

Label of categories	Count	Percentage
No	4979	90.58
Yes	518	9.42

<div align="center">5497</div>

SP_comedy

Label of categories	Count	Percentage
No	4773	86.83
Yes	724	13.17

<div align="center">5497</div>

SP_opera

Label of categories	Count	Percentage
No	5262	95.72
Yes	235	4.28

<div align="center">5497</div>

SP_concert

Label of categories	Count	Percentage
Never	4133	75.19
<1/term	1003	18.25
>=1/term	361	6.57

<div align="center">5497</div>

Regional NewsPaper

Label of categories	Count	Percentage
Never	2023	36.80
Sometimes	1563	28.43
Regularly	1911	34.76

5497

National Newspaper

Label of categories	Count	Percentage
Never	4063	73.91
Sometimes	993	18.06
Regularly	441	8.02

5497

TV Magazine

Label of categories	Count	Percentage
Never	1281	23.30
Sometimes	829	15.08
Regularly	3387	61.62

5497

Cult Mag

Label of categories	Count	Percentage
Never	4239	77.11
Sometimes	869	15.81
Regularly	389	7.08

5497

Science Mag

Label of categories	Count	Percentage
Never	4301	78.24
Sometimes	842	15.32
Regularly	354	6.44

5497

Comic Strips

Label of categories	Count	Percentage
Never	4205	76.50
<1/term	438	7.97
<1/month	364	6.62
>=1/month	478	8.70
?	12	0.22

5497

Bk_Police

Label of categories	Count	Percentage
Yes	1321	24.03
No	4176	75.97

5497

Bk_Romance

Label of categories	Count	Percentage
Yes	986	17.94
No	4511	82.06

5497

Bk_Classical

Label of categories	Count	Percentage
Yes	1195	21.74
No	4302	78.26

5497

Bk_SciFi

Label of categories	Count	Percentage
Yes	1887	34.33
No	3610	65.67

5497

Bk_History

Label of categories	Count	Percentage
Yes	1424	25.91
No	4073	74.09

5497

Bk_Politics

Label of categories	Count	Percentage
Yes	1171	21.30
No	4326	78.70

5497

Bk_Art

Label of categories	Count	Percentage
Yes	973	17.70
No	4524	82.30

5497

Music

Label of categories	Count	Percentage
French songs	1349	24.54
International pop	680	12.37
Techno/world/rap	416	7.57
Rock	232	4.22
Jazz	146	2.66
Classical	456	8.30
Other music	512	9.31
No	1706	31.04

5497

Radio

Label of categories	Count	Percentage
Anything Else	62	1.13
News	598	10.88
Mus & Conc	1212	22.05
News & Mus\|Conc	2246	40.86
Everything	435	7.91
No Radio	944	17.17

5497

Table 2 Contributions of Questions and Headings to the Overall Variance

Heading	ctr	Heading	ctr
TV	*28.5*	*SP*	*19.6*
TV_channel	12.3	SP_movies	5.3
TV_news	1.8	SP_Theatre	1.8
TV_sitcoms	1.8	SP_history	1.8
TV_film	1.8	SP_dance	1.8
TV_games	1.8	SP_circus	1.8
TV_sport	1.8	SP_comedy	1.8
TV_clip	1.8	SP_opera	1.8
TV_art	1.8	SP_concert	3.5
TV_docu	1.8		
TV_theatre	1.8		

Heading	ctr	Heading	ctr	Heading	ctr
Press	*17.5*	*Books*	*17.9*	*Mus.Radio*	*19.3*
RegNewsP	3.5	Comics	5.3	Music	10.5
NatNewsP	3.5	Bk_Police	1.8	Radio	8.8
TV_mag.	3.5	Bk_Romance	1.8		

Culture_mag	3.5	Bk_Classical	1.8		
Science_mag	3.5	Bk_SciFi	1.8		
		Bk_History	1.8		
		Bk_Scient	1.8		
		Bk_Art	1.8		

The contributions of headings are the following: 28 per cent (TV), 19 per cent (SP) and 17.5 per cent for the three others (Press, Books and Music-Radio). Headings are more or less balanced, with a slight predominance of TV.

Results of Specific MCA

We present here the results of our geometric modelling of the data.

a) Number of Axes to Interpret

We have thirty three questions with ninety active categories, and thirteen questions have passive categories. The dimension of the space is at most equal to $90 - (33-13) = 70$ (cf. Le Roux and Rouanet, 2010: 63). The five first eigenvalues are the following: $\lambda_1 = 0.1666, \lambda_2 = 0.0717, \lambda_3 = 0.0607, \lambda_4 = 0.0481$ et $\lambda_5 = 0.0468$.

The first eigenvalue is by far the most important and corresponds to modified rate of 77 per cent; the fourth is well separated from the third, so we will interpret three axes corresponding to a cumulated modified rate of 90.45 per cent.

Diagram of eigenvalues

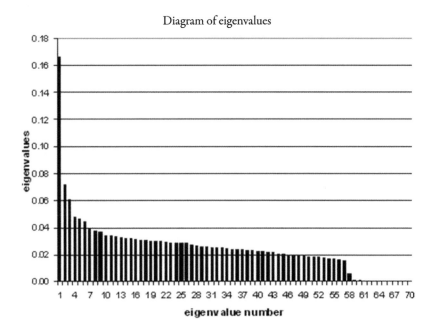

Table 3 Contributions of Themes to the First Three Axes

	Axis 1	Axis 2	Axis 3
TV	12.3	38.9	48.8
SP	24.2	12.9	5.2
Press	18.1	10.7	19.6
Books	37.9	8.8	13.9
Mus.Radio	7.4	28.6	9.6

We notice that the first three axes include all the themes with a predominance of Books and Spectacles on Axis 1, TV and Radio-Music on Axis 2, TV and Books on Axis 3.

b) Interpretation of Axes

As statistical criteria to interpret a category, we take a contribution higher than 100/90=1.; that is, the average contribution.

Table 4 Questions and Their Categories Most Contributing to the Variance of Axis 1

Axis 1 (λ1 = 0.1666)

	Axis 1		
Questions	*Categories*	−	+
TV_channel	La5/Arte		1.74
TV_art	Never	1.81	
	often		2.60
TV_theatre	yes		1.61
SP_cinema	Never	2.45	
	>=1/month		2.59
SP_theatre	yes		3.52
SP_history	yes		1.15
SP_dance	yes		1.97
SP_comedy	yes		1.71
SP_opera	yes		2.46
SP_concert	Never	1.24	
	<1/term		1.71
	>=1/term		2.53
Nat.Newspaper	Never	1.62	
	sometimes		2.33
	regularly		2.47
Cultural Mag.	Never	1.53	
	sometimes		2.70
	regularly		2.66
Scientif. Mag.	sometimes		2.40

Comic Strips		>= 1/month		1.03
Bk_Police		yes		2.22
Bk_Classical		yes		4.45
	No		1.24	
Bk_SciFi		yes		4.12
	No		2.15	
Bk_History		yes		4.31
	No		1.51	
Bk_Politics		yes		5.09
	No		1.38	
Bk_Art		yes		5.77
	No		1.24	
Music		classical		1.99
	No		2.05	
Radio		everything		1.88

<div align="right">18.21　　　65.27</div>

Thirty six categories have a contribution higher than the mean contribution. Together, they account for 83.5 per cent of the variance of Axis 1.

On this first axis, one finds on the left-hand column (negative side) categories of no practice such as no art films on TV, does not go to the cinema, never goes to a concert, no reading of national newspaper, of a cultural magazine, no reading of classical, sci-fi, politics, history or art books, no listening to music. On the right-hand column (positive side) one finds categories of rather intense cultural practices, such as TV, watching Arte, going out to places of historical interest, to dance spectacles, to comedies, to the opera, to the concert, reading a national newspaper, a cultural magazine, comics, reading classical literature, crime, politics or art books, listening to classical music, listening to the radio.

It is an axis of cultural practice or, more precisely, of 'legitimate' cultural practices.

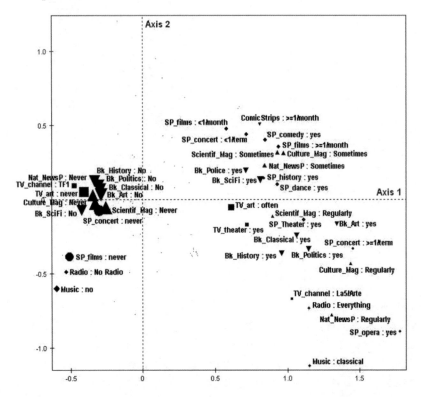

Axis 1 can be analysed as an indicator of intensity of cultural practices, especially the most 'legitimate' ones, that is the ones which characterize the 'culture lettrée' ('literary culture'); 'reading art, politics, classical and history books, reading cultural magazines, going to the theatre'. It is closely connected to cultural capital in its more legitimate classical literary form.

Table 5　Questions and Their Categories Most Contributing to the Variance of Axis 2
Axis 2 ($λ_2 = 0.0717$)

	Axis 2		
Questions	*Categories*	–	+
TV_channel	Fr3_reg	1.90	
	La5/Arte	1.71	
	M6		5.65
	Canal+		1.18
TV_sitcoms	Never	2.88	
	often		3.71
TV_film	Rarely	3.61	
	often		2.31
TV_clip	Never	1.86	
	often		10.09
SP_cinema	Never	3.31	
	<1/term		1.31
	<1/month		1.44
SP_circus	yes		1.11
SP_opera	Yes	1.44	
SP_concert	<1/term		1.47
Regional_Newspaper	sometimes		2.08
National_Newspaper	Regularly	2.05	
TV_magazine	Never	2.38	
Comic Strips	<1/term		1.31
Bk_History	Yes	1.44	
Music	International pop		4.74
	Techno/world/rap		1.50
	Classical	4.42	
	No	4.75	

Radio	News	2.76	
	Mus.&Conc.		4.57
	Everything	1.79	
	No Radio	1.72	

<div align="right">38.01 42.48</div>

Twenty nine categories have a contribution higher than the average and taken together, they contribute to 80.5 per cent of the variance of second axis.

On this second axis, one finds (on the negative side), categories of cultural practice such as: for TV, watching France 3, Arte, no sitcoms, no clips, sometimes a movie; for spectacles, opera but not cinema; for reading a national newspaper, regularly, also history books, no TV magazines; for music, either no music or classical music, and news on the radio.

On the positive side, one finds categories of cultural practices such as Canal+ and M6 for TV; sitcoms, clips and films often watched; for spectacles, cinema, the circus and concerts attended rather often; for reading, sometimes a regional newspaper and also comics; for music, international pop, techno/world/rap; and on the radio, music concerts.

This is an axis which opposes 'traditional' versus 'modern' cultural practices.

Axis 2 opposes practices related to youth culture, such as preferring the M6 channel, music clips, international pop, listening to music and to concerts on the radio, to opposite practices such as classical music, an absence of music listening or going out. It is an indicator of proximity to modern or youth culture in its broadest sense, very much devoted to music and cultural activities related to international mass cultural production. Plane 1–2 therefore already allows a distinction between three forms or types of cultural capital: classical cultural capital, 'youth' or modern cultural capital and a low form of cultural activity related to TV and local insertion.

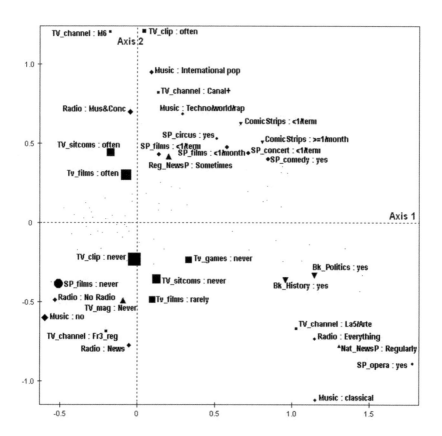

Table 6 Questions and Their Categories Most Contributing to Axis 3
Axis 3 ($\lambda_3 = 0.0607$)

		Axis 3	
Questions	*Categories*	–	+
TV_channel	France2		1.19
	M6	1.30	
TV_news	Rarely	11.31	
	often		1.91
TV_sitcoms	often		1.30
TV_film	Rarely	2.60	
	often		1.9
TV_games	Never	7.05	
	often		4.62
TV_art	often		1.86
TV_documentary	Never	6.25	
	often		2.73
TV_theatre	yes		2.16
SP_cinema	>=1/month	2.24	
SP_concert	>=1/term	1.50	
Regional_Newspaper	Never	3.16	
	regularly		3.04
TV_magazine	Never	6.55	
	Sometimes	1.65	
	regularly		4.89
Comic Strips	>=1/month	1.17	
Bk_Police	yes		1.23
Bk_Romance	yes		5.25
	No	1.15	
Bk_History	yes		1.71
Music	French songs		1.86
	Techno/world/rap	2.48	
	Rock	2.38	
		50.79	35.54

Twenty eight categories have a contribution higher than the average and together, they contribute to 86.3 per cent of the variance of the third axis. On the negative side of the axis one finds watching M6, rarely watching news or movies, never watching games or documentaries; often going to the cinema and concerts; never reading newspapers or TV magazines; reading comics; no romance books; and for music, listening to techno, rap, world music and rock.

On the positive side, one finds practices such as watching France 2, often watching the news, sitcoms, movies, games, art, documentaries and theatre; not attending outside spectacles; regular reading of a regional newspaper and a TV magazine; reading crime, romance and history books; listening to French and international pop music.

This axis opposes 'outdoor' practices related to the body and 'home' to softer practices. It is related to the corporal and environmental inscription of cultural activities.

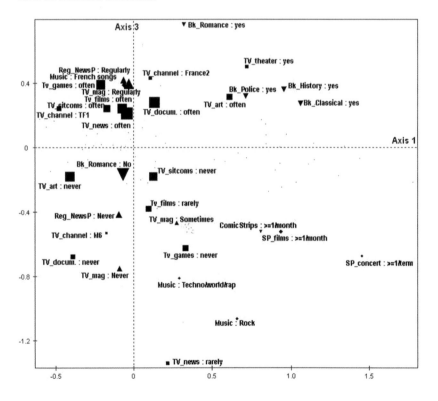

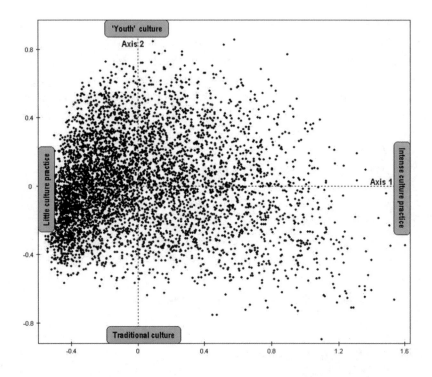

One can see the great concentration of points on the left side of the cloud (few cultural practice) contrasting with the right side of the cloud (intense cultural practice) where points are more dispersed.

The constructed space is easily interpretable in terms of cultural oppositions. On this basis, can we construct a typology of cultural groups and test its consistence with Bourdieu's analyses in *Distinction*?

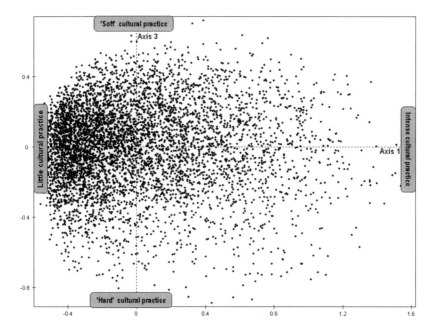

Euclidean Clustering

Are the classes resulting from a Euclidean clustering (here a hierarchical ascending clustering) similar to the families of cultural practices and habitus identified by Pierre Bourdieu in *Distinction*? Do we observe a relationship between these classes and the social characteristics of the respondents? We first have to recall here the main cultural categories stressed by Bourdieu. In the dominant groups, 'legitimate culture' is made natural through a process of socialization to classical music, literature, etc., reinforced by the school – that is a kind of 'official legitimate cultural'. Inside the dominant classes, an opposition distinguishes the groups according to their relative amount of cultural capital, between more avant-gardist practices and more 'classical' ones.

We also find this polarization between 'fractions' inside the 'petty bourgeoisie', but a common point of the members of the middle classes is to their orientation towards legitimate culture without mastering all the codes, which define it; this is what Bourdieu calls the 'cultural goodwill'. In the popular classes, the relation of domination is related to an opposition to legitimate culture seen as a culture of the dominant groups and a more realistic and real-world orientation. This is the 'taste of necessity'.

To answer our questions, we ran a HAC using Ward's method; that is minimizing the variance constituted at each step of the aggregation process. For this we have kept four classes.

To interpret the classes one proceeds as follows:

For each class c, compare the relative frequency of the category k (f_k^c) for individuals belonging to class c to the one (f_k) for all individuals. Then descriptively, the deviation between category k in class c and category k in the overall set of individuals is said to be large if $f_k^c - f_k > 0.05$ or if $f_k^c / f_k > 2$.

For the categories with large deviations, we perform the typicality test (the combinatorial test of comparison of a frequency to a reference frequency), hence a combinatorial p-value (one-sided). If $p \leq 0.025$, the frequency is statistically greater than the reference frequency with (S*) if $0.005 < p \leq 0.025$ and (S**) if $p \leq 0.005$.

The categories for which the deviation is *descriptively large and statistically significant* are said to be 'over-represented'. In the same way, they are said to be 'under-represented' if $f_k^c - f_k < -0.05$ or if $f_k^c / f_k < 0.5$, and if the result of the test is significant. The interpretation of classes is based on the sectors that are over-represented.

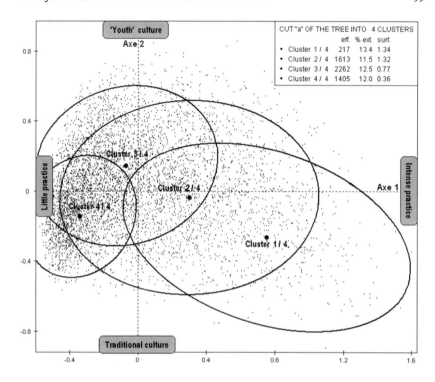

Table 7 Active and Supplementary Categories Over-Represented in Cluster 1

Cluster 1/ 4 (Count: 217 – Percentage: 3.95)					
Variables labels	*Characterizing categories*	*% of the category in the cluster*	*% of the category in the sample*	*p – value*	*Weight*
SP_Opera	yes	95.85	4.28	0.0000	235
SP_Theatre	yes	67.74	15.70	0.0000	863
Bk_History	yes	65.44	25.91	0.0000	1424
Bk_Art	yes	57.14	17.70	0.0000	973
Bk_Politics	yes	59.45	21.30	0.0000	1171
Bk_Classical	yes	56.22	21.74	0.0000	1195
Bk_SciFi	yes	60.83	34.33	0.0000	1887
Music	classical	44.70	8.30	0.0000	456

Nat_Newspaper	regularly	37.33	8.02	0.0000	441
SP_Dance	yes	41.47	12.53	0.0000	689
SP_Concert	>=1/term	35.48	6.57	0.0000	361
SP_Films	>=1/month	45.16	16.25	0.0000	893
TV_Theatre	yes	43.32	17.06	0.0000	938
TV_Art	often	62.67	38.22	0.0000	2101
Culture_Mag.	regularly	30.88	7.08	0.0000	389
SP_Comedy	yes	34.56	13.17	0.0000	724
Radio	everything	29.03	7.91	0.0000	435
TV_Channel	La5/Arte	27.19	9.00	0.0000	495
TV_Games	never	53.00	36.13	0.0000	1986
Bk_Police	yes	39.17	24.03	0.0000	1321
SP_Concert	<1/term	33.18	18.25	0.0000	1003
SP_History	yes	22.58	9.02	0.0000	496
TV_Sitcoms	never	65.90	52.87	0.0000	2906
Nat_Newspaper	sometimes	29.95	18.06	0.0000	993
Scientif_Mag.	sometimes	26.27	15.32	0.0000	842
SP_Films	<1/month	24.88	15.15	0.0001	833
Culture_Mag.	sometimes	25.35	15.81	0.0001	869
Scientif_Mag.	regularly	14.29	6.44	0.0000	354
TV_Films	rarely	43.78	35.98	0.0095	1978
SP_Circus	yes	15.67	9.42	0.0019	518
Bk_Romance	yes	23.96	17.94	0.0136	986
TV_News	rarely	18.43	12.50	0.0066	687
TV_Clip	never	86.64	81.19	0.0194	4463
TV_Mag.	sometimes	20.28	15.08	0.0214	829
Dividends	yes	48.39	29.22	0.000	1606
Laptop	yes	14.75	6.08	0.000	334
Housing	owner	53.46	42.42	0.001	2332
Health	good	79.26	66.67	0.000	3665
Education	GdeEcole	9.22	2.67	0.0000	147
Education	Master/DEA	35.02	10.06	0.0000	553
PCS42	Teachers	9.68	2.00	0.000	110
PCS42	Middle managers	11.98	3.11	0.000	171

PCS42	Retired managers and retired intellectual occupations	10.14	3.09	0.000	170
PCS42	Engineers and managers	4.61	2.15	0.018	118
Age	[56;66[25.35	14.34	0.0000	788
Age	[46;56[22.12	16.74	0.0216	920
Income	>68K€	11.06	3.15	0.0000	173
Income	46–68K€	17.05	6.64	0.0000	365

In Cluster 1, one finds thirty four categories which are over-represented. These categories concern intense cultural practices (participation and diversity): theatre on TV, art programmes, Arte channel, never watching games, sitcoms or clips; going to opera, theatre, concert, dance performance, cinema; preferring classical music; reading history, art or politics books, classical literature and a daily national newspaper. The categories 'high education', 'above forty six years' and 'high income' are over-represented.

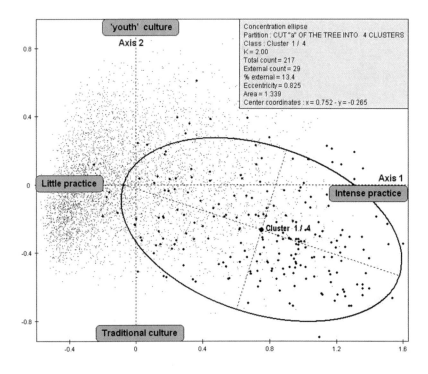

We have here a small set of individuals defined by their high level of legitimate cultural practices close to what Bourdieu calls the 'dominant taste'. In this class, high level of education (the 'grandes écoles') and dominant social groups, including in terms of income and living conditions (e.g. good reported health), especially intellectual and intermediary fractions of the dominant class, are over-represented.

Table 8 Active and Supplementary Categories Over-Represented in Cluster 2

Cluster 2/4 (Count: 1613 – Percentage: 29.34)					
Variables labels	Characterizing categories	% of the category in the cluster	% of the category in the sample	p – value	Weight
TV_Art	often	58.03	38.22	0.000	2101
Bk_Politics	yes	40.55	21.30	0.000	1171
Bk_SciFi	yes	51.89	34.33	0.000	1887
Bk_History	yes	43.09	25.91	0.000	1424
Bk_Art	yes	33.79	17.70	0.000	973
TV_Channel	La5/Arte	23.56	9.00	0.000	495
Bk_Classical	yes	36.14	21.74	0.000	1195
TV_Games	never	48.92	36.13	0.000	1986
Culture_Mag.	sometimes	27.22	15.81	0.000	869
Nat_Newspaper	sometimes	29.39	18.06	0.000	993
Comic Strips	<1/month	17.73	6.62	0.000	364
Radio	everything	18.97	7.91	0.000	435
Music	classical	19.16	8.30	0.000	456
Bk_Police	yes	34.41	24.03	0.000	1321
Nat_Newspaper	regularly	18.29	8.02	0.000	441
Scientif_Mag.	regularly	16.62	6.44	0.000	354
SP_Films	>=1/month	26.41	16.25	0.000	893

Music	rock	13.89	4.22	0.000	232
TV_Theatre	yes	26.66	17.06	0.000	938
SP_Theatre	yes	25.17	15.70	0.000	863
Culture_Mag.	regularly	16.49	7.08	0.000	389
Scientif_Mag.	sometimes	24.30	15.32	0.000	842
TV_Sitcoms	never	61.75	52.87	0.000	2906
SP_Concert	>=1/term	14.88	6.57	0.000	361
TV_Documentary	often	78.43	70.49	0.000	3875
TV_Films	rarely	43.15	35.98	0.000	1978
SP_Concert	<1/term	25.17	18.25	0.000	1003
SP_Films	<1/month	21.88	15.15	0.000	833
SP_Dance	yes	18.72	12.53	0.000	689
Comic Strips	<1/term	13.08	7.97	0.000	438
Class	upper class	18.10	9.48	0.000	521
Class	middle class	32.92	27.27	0.000	1499
Education	Bac.	15.07	10.22	0.000	562
Education	master/DEA	19.03	10.06	0.000	553
Laptop	yes	10.79	6.08	0.000	334
Health	good	73.28	66.67	0.000	3665

In cluster 2, there are thirty categories which are over represented. The categories concern the reading of various sorts of books, an active use of cultural programmes on TV channels, the rejection of popular TV programmes like TV games, a moderate reading of cultural magazines and national newspapers, cinema attendance, a taste for rock music and comic strips. The upper and middle classes are over-represented, as well as high and middle levels of education. We also see an over-representation of owners of laptops and people in 'good' health.

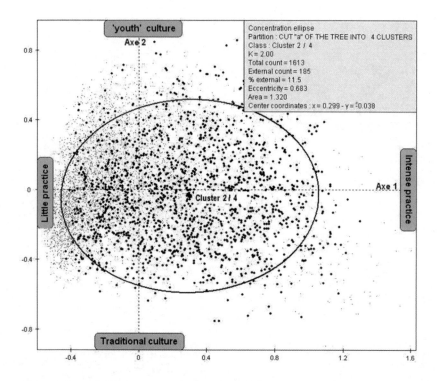

This is relatively close to Bourdieu's notion of 'cultural goodwill'. Compared to the practices of the dominant cultural group, practices here are less 'legitimate' and more 'indirect' (Arte TV channel). This attitude consists of a close relation to educational efforts and an abstract 'respect' for the dominant cultural norm.

Table 9 Active and Supplementary Categories Over-Represented in Cluster 3

Cluster 3/4 (Count: 2262 – Percentage: 41.15)					
Variables labels	Characterizing categories	% of the category in the cluster	% of the category in the sample	p – value	Weight
TV_Films	often	72.33	61.56	0.000	3384
TV_Channel	M6	17.90	9.22	0.000	507

TV_Clip	often	24.54	16.41	0.000	902
Nat_Newspaper	never	81.43	73.91	0.000	4063
TV_Sitcoms	often	52.17	44.79	0.000	2462
Radio	mus.&conc.	29.31	22.05	0.000	1212
Culture_Mag.	never	83.78	77.11	0.000	4239
Bk_Politics	no	85.28	78.70	0.000	4326
Music	international pop	18.83	12.37	0.000	680
Bk_Art	no	88.73	82.30	0.000	4524
SP_Films	<1/term	22.94	16.88	0.000	928
Music	other music	15.34	9.31	0.000	512
TV_Art	never	65.25	59.36	0.000	3263
Bk_History	No	79.93	74.10	0.000	4073
Music	techno/world/rap	13.13	7.57	0.000	416
SP_Theatre	no	89.35	84.30	0.000	4634
TV_Theatre	no	85.46	80.48	0.000	4424
Bk_Romance	yes	22.90	17.94	0.000	986
Music	French songs	29.40	24.54	0.000	1349
TV_Mag.	regularly	66.40	61.62	0.000	3387
TV_Games	often	66.05	61.49	0.000	3380
Age	[26;36[24.58	17.85	0.000	981
Education	CAP/BEP	36.38	28.22	0.000	1551
Dividends	no	75.55	70.73	0.000	3888
Housing	Tenant (without furniture)	39.61	34.80	0.000	1913
Housing	tenant	41.73	36.87	0.000	2027

In cluster 3, one finds twenty one categories that are over-represented. These categories concern cultural practices associated with youth culture: the TV channel M6, watching films, clips, sitcoms and games; listening to the radio for music; liking international pop music or techno, world or rap music.

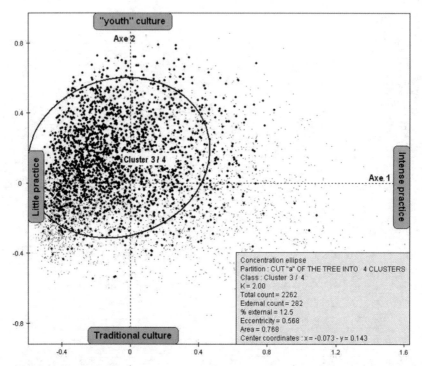

Younger age groups (twenty six to thirty six years) and those who have received vocational education are over-represented. Tenants are over-represented, as well as people without any dividend-type income. They have less economic wealth, which does not necessarily mean a low income, since they are often very young.

We have a class defined by the practice of 'modern' youth culture.

Table 10 Active and Supplementary Categories Over-Represented in Cluster 4

Cluster 4/4 (Count: 1405 – Percentage: 25.56)					
Variables labels	Characterizing categories	% of the category in the cluster	% of the category in the sample	p – value	Weight
Music	no	67.83	31.04	0.000	1706
SP_Films	never	85.91	51.72	0.000	2843

Bk_SciFi	no	90.39	65.67	0.000	3610
Comic Strips	never	97.86	76.50	0.000	4205
SP_Concert	never	94.59	75.19	0.000	4133
Nat_Newspaper	never	92.95	73.91	0.000	4063
Scientif_Mag.	never	96.58	78.24	0.000	4301
Culture_Mag.	never	95.44	77.11	0.000	4239
TV_Art	never	77.15	59.36	0.000	3263
Bk_Politics	no	96.09	78.70	0.000	4326
Bk_History	no	90.53	74.10	0.000	4073
Bk_Classical	no	93.81	78.26	0.000	4302
Bk_Police	no	90.96	75.97	0.000	4176
TV_Channel	Fr3_reg	24.13	9.55	0.000	525
Bk_Art	no	96.51	82.30	0.000	4524
TV_Channel	TF1	38.36	25.05	0.000	1377
SP_Theatre	no	95.09	84.30	0.000	4634
TV_Games	often	72.24	61.49	0.000	3380
Radio	no radio	27.90	17.17	0.000	944
TV_Clip	never	90.75	81.19	0.000	4463
SP_Dance	no	96.94	87.47	0.000	4808
TV_Documentary	never	36.01	27.05	0.000	1487
SP_Comedy	no	95.52	86.83	0.000	4773
Reg_Newspaper	regularly	43.35	34.76	0.000	1911
Bk_Romance	no	90.53	82.06	0.000	4511
SP_Circus	no	98.58	90.58	0.000	4979
TV_Theatre	no	88.47	80.48	0.000	4424
SP_History	no	98.65	90.98	0.000	5001
TV_Films	rarely	42.70	35.98	0.000	1978

Radio	news	17.30	10.88	0.000	598
TV_Mag.	never	29.61	23.30	0.000	1281
TV_Channel	France2	17.86	12.83	0.000	705
Education	primary	40.00	22.96	0.000	1262
Education	no diploma	31.81	17.85	0.000	981
Age	>= 76	25.55	10.62	0.000	584
Age	[66;76[22.92	13.21	0.000	726
Health	medium	34.45	23.78	0.000	1307
Health	not so bad	10.53	5.51	0.000	303
Health	bad	6.33	3.00	0.000	165
Car	no	27.47	17.97	0.000	988
PCS42	Retired blue-collar workers	15.66	6.80	0.000	374
PCS42	Retired farmers	8.33	2.75	0.000	151
PCS42	Retired white-collar workers	14.95	7.91	0.000	435

Categories of weak cultural practice are over-represented: not listening to music; not going to the cinema; not reading; watching TV channels FR3 (regional) or TF1 (popular); reading a regional newspaper; not listening to the radio except the news. The categories of low educational level (primary or no diploma) and the age group sixty six to seventy six and over seventy six are over-represented. 36 per cent of individuals of the working class are in this cluster. We also see an over-representation of people without a car, in relatively bad or medium health, and of retired members of the popular classes.

Class 4 is characterized by a low level of legitimate cultural practices and some specific popular practices like watching certain TV-channels.

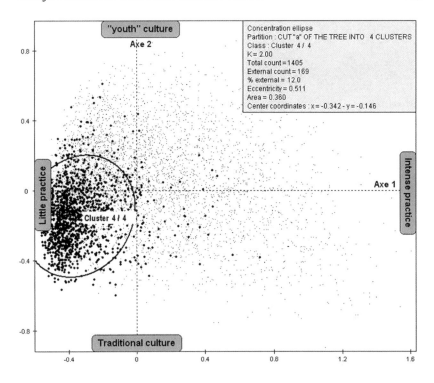

Speaking of 'necessity taste' on only the basis of their distance to legitimate culture does not totally account for the specificity of these popular practices: localized, they are also defined by a reference to traditional values, as opposed to more 'modern' youth practices. But we see that the absence of mobility and relatively bad health is consistent with the idea of practices strongly constrained by material factors, which is totally coherent with Bourdieu's hypothesis of 'taste of necessity'.

Conclusion

The four identified classes correspond to different specific cultural styles, for which the *conscious* research of distinction is not a necessary feature, but who distinguish themselves objectively from one another. We have in particular noticed a clear separation between two forms of 'popular culture', one related to the Anglo-Saxon cultural industry and the youth, and another, more traditional and localized, constrained by physical factors. These results are totally consistent with Bourdieu's analysis, provided that we contextualize it in a totally different period and in another context: France has of course changed culturally between the 1960s and the 2000s.

This approach has allowed us to examine from a new point of view the issue of the determinants of cultural practices and the social space, in a Bourdieusian perspective. The construction of a typology of cultural practices corroborates Bourdieu's analyses in *Distinction*, on the basis of recent data, and leads us to a general characterization of habitus in today's French society.

VINCENT BERRY, MANUEL BOUTET AND SAMUEL COAVOUX

Playing Styles: The Differentiation of Practices in Online Video Games

Introduction

Our collaborative work started as a reaction to some of the core assumptions of the newly developed discipline of 'Game Studies'. That body of literature, akin to cultural studies, is taking root in academia. It makes the assumption that video games are a new medium that needs to be studied using new ways of investigation. This difference is believed to be best studied by analysing the rules of the games. Most of the time, the study of games as mere formal systems of rules does not document what players actually do while playing. The studies which do so, in precise, thorough ethnographies (Taylor 2006; Pearce 2009), depict a particular way of playing, but rarely the diversity of play styles.

Video games ask for a form of cultural consumption distinct from that of television, books or music. Since they are intrinsically interactive, what matters is *what people do* with games rather than what they think about them. We thus use the expression *play styles* to designate ways players interact with video games. The purpose of our research is to describe those styles (Boutet 2012a), trace them back to their origins (Coavoux 2010b; Berry 2009), and study their relations, i.e. how each takes place in a social space (Bourdieu 1991d), where they are linked by ties of power and conflict (Coavoux 2010a). The intention of this chapter is to demonstrate that no one style can by itself characterize what it is 'to play the game'. On the contrary, playing should be viewed as choices in the making, hence understood in relation to all the other play styles surrounding it. An inquiry into practices is thus required, since the possibilities are partly created by

players – and not inscribed solely in the rules. After establishing a classification of practices, we discuss where those variations come from: to trace them back to indicators of social characteristics, like gender, generation or class, as well as gaming experience. Finally, what we demonstrate is that video game practices are modelled like a social field; as such, they are partially determined by a field of social position, and partially moved by their own field-specific dynamic.

We base this article on our various studies of online video games, and more specifically of *World of Warcraft* (*WoW*). *WoW* is a game where players control a character in a vast fantasy world (similar to J. R. R. Tolkien's *Lord of the Rings* universe). The character is partly customizable, and the choice of one of the various possible characters might lead to very different game experiences. A monthly subscription (around twelve USD) is required of the player. The main goal proposed by the game is to improve that character by training it, and acquiring virtual equipment that will increase its power. Players can also fight creatures managed by the programme (Artificial Intelligence or AI), confront other players connected at the same time, or even sell virtual goods acquired during the game. A social world is therefore simulated. We used both qualitative and quantitative methods, but the empirical aspect of the current chapter is composed of a self-administered online survey of the game players conducted in early 2009.

This chapter will first establish the need for such a study by reviewing current Game Studies literature, and showing that it does not account for the diversity of ways of playing. We will then map a social space of the online game, and show that this space is strongly structured by players' preferences and power relations. Finally, we will trace the players' positions in that social space back to their social characteristics, to find that traditional variables are not enough for such a project, and that we must take into account the specific dynamics of playing activities.

Where Are the Players?

Although a prominent artifact of contemporary mass culture, video games have not yet attracted much attention from sociologists, and the largest part of the academic literature devoted to this cultural product has arisen in the 'Game Studies' discipline. The term refers to a wide variety of works, in fields ranging from cultural studies to psychology, which attempts to make sense of video games as a single new medium. However, a striking feature of this body of literature is that the players are often absent in the analysis, as if video games were a text with no readers; when they do appear, it is as an archetypal figure of *the* player, and almost never as players. In this landscape, there is little room for a thorough analysis of the diversity of players, not only as a demographically diverse population, but also as a body of cultural consumers with very different relations to the games they play.

'Game Studies' was born, like cultural studies, in Humanities departments. However, though the Birmingham department started from a will to shift the attention from texts to readers (Hoggart 1957), the first ambition of Game Studies was to have games considered as legitimate texts, hence focusing on their formal features. Reflections on game design – i.e. the craft of making games, and the study of what constitutes a game – are dominant in the field (Bogost 2006), and other formal approaches, such as ideological criticism, also flourish (Kline, Dyer-Witheford and de Peuter 2003). In this literature, there are no such things as social actors, because the player is reduced to a trigger: there might be someone on the other side of the electronic device to activate the games' feature, eventually endowed with psychological properties, possibly influenced by the militaristic ideology of the games, but nonetheless without past, socialization or individuality. A common point to all these approaches is that the game is like a stage, set in advance, a text, already written. The player walks in after the play has been set up, in order to enact this script: there is no place for individuation or creativity, or for the play as an activity in the making.

Some authors follow the path set up by cultural studies more closely and draw attention to the various receptions of games. Adapting Stuart Hall's model of communication (1980) to video games (Raessens 2005), Anne Everett studied the different levels of reading of 'races' in video games (2005), and Richard and Zaremba (2003) the ambiguous reception of the feminine yet masculine character Lara Croft. Yet, such analyses seldom push further than the level of representations. A diversity of players is acknowledged, but they are defined as cultural *receptors*, the variation in their practices stays in the shadow. Ultimately, the game is reduced to a text, a device containing representations, and its existence as an interactive medium is negated.

Social Science's perspectives on players and playing are few, but of great value. A string of rich ethnographic studies have shed light on some of the most 'exotic' practices of online gaming, such as 'power-gamers' (Taylor 2006; Nardi 2010; Pearce 2009). They show gaming as a situated action, focus on the identity of players and the relationships between them, and tackle issues of power and conflict between the players and the editors. However, to the best of our knowledge, no comparative work has yet been undertaken. Those ethnographies focus on local, well-defined groups of players, who most of the time have a special interest in the game. However, they do not situate those groups among the larger mass of users. Mathieu Triclot's (2011) study of the successive 'regimes of experience' in video game history does provide a valuable theoretical framework, but mainly accounts for diachronic diversity in play styles.

Finally, there have been a few attempts at classifying players among the Game Studies literature (Tuuanen and Hamari 2012 lists the most prominent). They are, however, unsatisfactory from the perspective of sociology of culture and cultural consumption. The many psychological studies of video games classify players based on their 'motivations' which can be oriented towards achievement, socialization, or exploration (Yee 2006). However, such studies pay little attention to the fact that games are *played*, and that playing is a process. Instead, they tend to reify activities and players. The activities allowed by the gameplay are taken as the range of possible goals. Similarly, players are reduced to a set of distinct psychological traits traced to the way they engage in games. Therefore, the historical genesis of taste (Bourdieu 1984a) as well as the dynamics of

situated action are ignored and replaced by a vision of a value-shaped action that has long been convincingly criticized (Swidler 1986). The surveys do not ask *what* people do inside the game, but *why* they do it, whatever *it* is. Unfortunately, this underlying theory of action seems to be dominant even on the 'ludologist' side of Game Studies, investigating 'mentalities' rather than practices (Kallio, Mäyra and Kaipainen 2011).

Behavioural typologies mainly use in-game metrics analysis, using the data the games themselves produce (Williams, Yee and Caplan 2008; Drachen, Canossa and Yannakakis 2009). While fruitful, this method can only measure what the software itself measures, and ignores important dimensions of practices. Most notably, not all playing happens inside the game universe: it is a shared object that stimulates social interactions among players, in front of the screen as well as via Internet (for example, Zabban 2009). Moreover, these analyses often rely on relatively few demographic and cultural variables, with no means to reach players outside of the game, and thus assume that games can be isolated, and studied in and of themselves. In the end, they classify game design features rather than players themselves.

The Social Space of Play Styles

The study of play styles was conducted through an online survey aimed at French- and English-speaking *World of Warcraft* players. The survey, conducted in February and March 2009 by one of the co-authors, was self-administered. The respondents were recruited on game-related forums, whether specific to this game, or aimed at all MMORPG players, as well as on several prominent social network services. The questions focused on the way people played: what they value in the game, what they do in the virtual world, how and with whom they do it. Given the state of Game Studies at the time, where dozens of mostly psychological surveys were carried out on the same game, our survey was carefully designed not to appear as centred on 'addictive' behaviours.

A Multiple Correspondence Analysis (MCA) was then carried out on fifteen variables describing game practices. We made sure to include the widest range of survey questions possible in the analysis (cf. description below). However, since some questions were redundant, their presence in the algorithm could have artificially emphasized some dimensions, and we thus removed some variables from the analysis; for example, in the survey there were eight questions on raids (game trials for large player gatherings), but only one that greatly contributed to the first axis was kept. The first versions of the MCA included other active variables that have since been dropped for lack of contribution to the first axis. The active variables can be found in Table 1.

Table 1 Active Variables in the MCA

Variable name	Variable description	Modalities	Modalities description
PrefClus	What players prefer in the game (synthetic variable computed from a seven-item ordered question: In the following list, what are the elements of *World of Warcraft* do you prefer? [Please number each box in order of preference from 1 to 7]).[1] Note that some of those items were merged during the construction of the variable, so that only five modalities remain.	PvE	Cooperative play
		Hist	History of the game universe
		HL	High-level play
		PvP	Oppositional play
		Prog	Character's progression
EquPve	Best piece of PvE equipment owned before *Wrath of the Lich King* (WotLK), *World of Warcraft*'s second extension set (ranked lowest to highest).	NE	Poor, uncommon, or rare equipment – non epic
		HS	Epic equipment outside of a set
		T3–T4	T3.5 or T4 set
		T5	T5 set
		T6	T6 set
		T6+	'Sunwell T6' set

RaWoNa	Ever been to the WotLK Naxxramas raid	never	Never
		part	Have tried it
		normal	Have completed it
		hero	Have completed it on the hardest difficulty setting
ReCo	Ever read comics set in the game world	never	Never
ReFF	Ever read fan-fiction set in the game world	rare	Rarely
		often	Often or very often
PrdFF	Ever written fan-fiction set in the game world	no	Never
		private	Yes, but never published it
		public	Yes, and published it
ReHist	Ever read a history of the game world	yes	At least rarely
ReFic	Ever seen a movie set in the game world (machinima)	no	No
PrdVif	Ever produced a movie set in the game world		
AcSolo	How often does respondent (R) play on their own	yes	Often or very often
AcExpl	How often does R explore the game world	no	Never or rarely
AcBG	How often does R participate in battlegrounds		
AcAr	How often does R participate in arena fights		
AcPvP	How often does R engage in fights against other characters		
AcFreqCl	How long does R play a week (computed from three questions about the amount of time played the week before the survey, the day before the survey, and the average amount of time played a week for players who had quit the game)	1–10h	1 to 10 hours /w
		11–16h	10 to 16 hours /w
		17–25h	17 to 25 hours /w
		26–40h	26 to 40 hours /w
		41h+	41 hours /w or more

We point out that the population of *WoW* players and, more importantly, that of our sample deviates strongly from the general population.[2] Female players account for only 13.2 per cent of the sample, and students (middle-school to post-secondary education) for at least 51.4 per cent. Accordingly, the mean age is 23.6 years (standard deviation 7.1). Among those who are not students, only 15.7 per cent earned less than a high school diploma, and 24.2 per cent only that degree: the large majority is thus composed of at least university, college or vocational school graduates. Finally, excluding students, most respondents belong to the upper-middle or middle-class (28.3 per cent and 32.6 per cent respectively).[3] Respondents were recruited worldwide, since the survey was available in both French and English, but the majority live in France (46.8 per cent) and the USA (11.8 per cent). The UK, Canada and Belgium each accounted for around 4 per cent of the sample, and other nationalities featured at more than 1 per cent are: Norway, Sweden, Australia, Germany, Denmark and Switzerland, all of which are western countries with similar economies.

Given this wide diversity of demographic background, one could have expected great variations in the results of statistical analysis, should it be applied to various sub-samples (i.e. by country). This is far from being the case: the MCA, and subsequent analyses, that are presented in this chapter were also performed on various sub-samples: only male players; only French players; only students; only non-students; and every combination of the three categories (gender, nationality, student vs. non-student). In all cases, the overall structure remained the same (axis, discriminating variables and modalities), while only the proportion of players adopting a particular practice varied from one subpopulation to another. We thus only present the statistical work conducted on the sample as a whole, which allows a more in-depth analysis due to its larger sample size. Because missing data to at least one of the active variables were frequent (due to the fact that the survey was self-administered, online, and rather long), we imputed missing values using the regularized iterative MCA algorithm described in Josse et al. (2012) and implemented in the R package missMDA.

Only the first three axes of the MCA results will be discussed further. They account for 8.4, 7.6 and 6.7 per cent of the total inertia respectively,

and there is a clear step downward starting from the fourth axis, at 4.4 per cent, followed by a slow decline (the tenth axis still carries 3.3 per cent of the overall variance).

The first axis was mostly determined by participation in raids (collective trials) and by equipment (character's belongings) variables. It opposes, on the plus side, the highest level of equipment obtained (T6, T6+), completion of the most difficult raid (Naxx-hero), a preference for high-level and oppositional play, as well as time-consuming play (forty one hours a week or more); and on the minus side, the absence of equipment and raid success, a preference for in-game characters, and solitary play.

The second axis was mostly structured by cultural variables, whether they measure the production or reception of game-specific cultural goods. On the plus side feature the reading and writing of fan fiction (short stories and novellas produced by the players where the action is set up in the game world), the consumption of comics, machinima (movies generated inside the game-world), and texts of virtual world history, as well as a preference for the game's story.[4] On the minus side is the absence of reception and production practices, as well as a preference for high-level play.

Finally, the third axis shows the confrontation of oppositional and cooperative modes of play. On the plus side are the preference for PvP (fighting other players), the participation in battlegrounds and arenas (both typical of oppositional play), and the absence of PvE (fighting the game world) equipment. On the minus side are a preference for high-level (usually synonymous, in the players' dialect, with cooperative high-level play), success in raids, and the absence of arena and battleground fights.

The overall structure measured by the three first axes thus seems clear. Practices are polarized by competition. But this does not mean that all practices are competitive. Some players are engaged in competitive play, while others are exploring the game and its stories – which they share and create. Beyond 'competition', the analysis reveals two different philosophies of confrontation: some prefer to fight other players, while others would rather cooperate to vanquish digital creatures – the monstrous simulated bodies controlled by artificial intelligences.

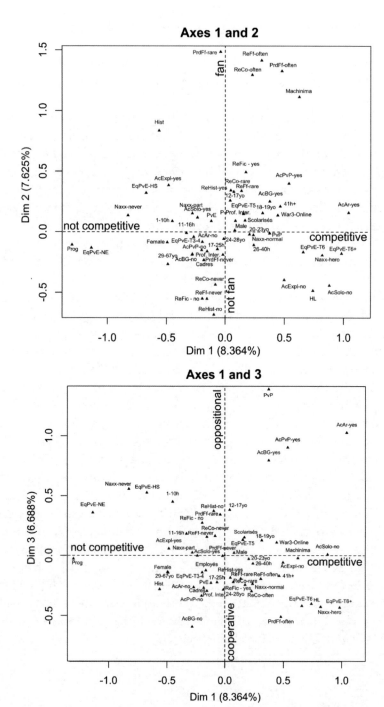

Axes 1 and 2

fan

not competitive

competitive

not fan

PrdFf-rare ReFf-often PrdFf-often
ReCo-often
Machinima
Hist
ReFic - yes AcPvP-yes
AcExpl-yes ReCo-rare ReFf-rare AcBG-yes
EqPvE-HS ReHist-yes 12-17yo
Naxx-never Naxx-part EqPvE-T5 18-19yo 41h+ AcAr-yes
AcSolo-yes Prof. Inter. War3-Online
1-10h 11-16h PvE Scolarisés
Male
AcAr-no 20-23yo PvP
Female EqPvE-T3-4 24-28yo Naxx-normal
AcPvP-no 17-25h 26-40h EqPvE-T6 EqPvE-T6+
Prog EqPvE-NE 29-67yo AcBG-no Prof. Inter. Naxx-hero
Cadres PrdFf-never
ReCo-never AcExpl-no
ReFf-never AcSolo-no
ReFic - no HL
ReHist-no

Dim 2 (7.625%)
Dim 1 (8.364%)

Axes 1 and 3

oppositional

not competitive

competitive

cooperative

PvP
AcAr-yes
AcPvP-yes
AcBG-yes
Naxx-never EqPvE-HS
EqPvE-NE 1-10h
ReHist-no 12-17yo
PrdFf-rare
ReFic - no
ReCo-never Scolarisés 18-19yo
11-16h ReFf-never EqPvE-T5 War3-Online AcSolo-no
AcExpl-yes Naxx-part PrdFf-never Machinima
AcSolo-yes Male
Prog 20-23yo AcExpl-no
Employés 26-40h
Female ReHist-yes
29-67yo EqPvE-T3-4 ReFf-rare ReFf-often 41h+
Hist PvE 17-25h ReCo-rare
AcAr-no Cadres ReFic - yes Naxx-normal
Prof. Inter. 24-28yo ReCo-often EqPvE-T6 HL EqPvE-T6+
AcPvP-no Naxx-hero
AcBG-no PrdFf-often

Dim 3 (6.688%)
Dim 1 (8.364%)

The first axis can be interpreted as that of involvement in competition vs. disinterest for competition. On the right are the players with the highest in-game economic capital, i.e. the best available equipment, who spend a significant amount of time playing, and have achieved the most difficult tasks. They are deeply involved in the gameplay. They try to achieve the topmost goals and collective trials offered by the online game. On the left, in-game economic capital is rare, the players have few achievements, and they prefer solo and exploration play. This second orientation towards the game is less structured than the competitive one, nonetheless a word exists, indicating it's a stable inclination: these players are said to be – and often call themselves: 'casual gamers'.

The second axis is that of fandom. We follow the rich literature on fan culture (Fiske 1992) to describe this inclination as a culturally active, productive engagement with cultural goods. The axis opposes fans to non-fans. Fans are deeply engaged in game-specific culture, and many among them actually participate in its production, which occurs mostly outside the game space, on other websites. Non-fans are removed from this aspect of the game, whether less implicated or engaged elsewhere – in the rationalizations, calculations and optimizations of competitive play.

The third axis draws a line between two styles of competitive play: one where players directly oppose other players (PvP), and the other where they cooperate against the artificial intelligence (PvE). In the latter, competition between players still exists, but only indirectly: the guilds (institutionalized groups of players) compete for who will be first to earn the highest achievements.

It should be noted that the results of this analysis are of interest not only because of what they show, but also because of what does not appear. Competition, fandom, and confrontation are not the only dimensions of play that ethnographic research reveals. For instance, some players value activities such as crafting and trading virtual items or playing the game in order to keep in touch with far away friends and relatives. However, multiple iterations of MCA have never put forward those dimensions of the game, and in the end, the variables describing them have been dropped from the analysis. Those activities were not differentiating enough to appear in the results – which means they are either too common or too rare, at least in the surveyed population.

On the other hand, the MCA clearly shows the multidimensionality of the actual practices in the game studied. Indeed, by its openness, the game space offers a wide range of choices, rather than a closed formal system of strict rules. Nonetheless, given players don't play at everything and tend to orient themselves towards the activities that are the most meaningful to them – which vary among players – the most discriminating choices are represented by the three axes: competitive or casual, fandom or not fandom, duelling (PvP) or coping with adversity (PvE). The cross-tabulation of these choices allows us to identify play styles, and to position them in the social space of the game.

This result is corroborated by other methods. We studied several such online-games over the past ten years, adding ethnographical observations and in-depth interviews of players to quantitative analysis. In each case, surprisingly, a given game was played in different ways by different players. However, ethnography also reveals that players do not always notice how different their choices and practices are from that of their neighbours. Part of the explanation is that each kind of practice is partially invisible to outsiders. Players share the same game space, but it's only part of their activities. In fact, an extensive part of play activity is situated outside of the interface –guild forums, performance measurement websites and software, films on YouTube, etc. In that context, different orientations towards the game lead to different sets of tools, some being shared by different play styles. The more a particular practice is developed, the more it requires additional tools, the more practitioners of other styles ignore these extensions and subtleties. The game editor gives room to those different styles: he or she encourages certain forms of players' appropriation, allows the use of 'logs' (game session data) by competitive players, as well as some forms of copyright infringements from the fans, and occasionally communicates about major fan creations.

However, since the game universe allows a variety of styles, and since the editor supports them, the system of rules favours certain styles over others by setting up systems of rewards only for some actions. Particularly, players can measure their in-game economic capital (equipment, money, character strength...) or show off their symbolic capital (prestigious guild membership, rare outfits...), but similar rankings do not exist on such a scale

for alternative dimensions of play. The competitive orientation towards the game is thus the most favoured: it relies on tools explicitly built into the game. This is not very surprising given the affinity between game and competition – noted much earlier in the work of Huizinga (Huizinga 1944). Fans act on a less institutionalized market. They have informal criteria they can use to determine what fan fiction is of high quality, what machinima is best, but due to a lack of organized recognition inside of the game world, their style seems to lag behind the competitive style. Casual players, whose practice of the game does not take into account its specificities, play by no recognized standards and are mostly ignored or frowned upon by fans and competitive players.

The result here designates a social space structured by the prominent position of a particular orientation towards the game. That position is guaranteed by the rules. The editor and the system of rules play an institutional role here, very similar to that of school and educational textbooks in social reproduction (Bourdieu and Passeron 1977a). In summary, play styles have very different (institutionally regulated) access to public existence, hence different legitimacies.

How does a player end up at one or the other pole of this social space? The addition of supplementary variables might shed light on this process. The supplementary variables considered here are mostly demographical: gender, highest educational degree obtained (excluding players still in education), occupation (coded with the INSEE PCS system), age, highest educational degree and occupation of the player's father. We also added, however, a couple of variables more specific to game culture: previous familiarity with a Real Time Strategy game (here, *Warcraft 3*, a game created by *WoW*'s editor and set up in the same imaginary world) and time when respondent first played *WoW* (the game being, at the time, about three years old).

Since the coordinates of modalities are dependent on the size of the category, and since, except for gender, the categories for supplementary variables are quite equally distributed, the graphical projection of these variables did not, at first glance, show much correlation. However, a closer look at their correlation with the first three axes does shed some light on the association between socio-demographic and game culture variables on the one hand, and play styles on the other hand.[5]

Not surprisingly, age and gender both play a significant role. Female players are more likely to play casually, and whenever they are competitive players, to favour cooperation rather than opposition. The youngest players are more likely to be fans (especially the youngest teenagers, aged twelve to seventeen) and more likely to favour PvP over PvE, which denotes a very specific engagement with culture (cultural goods being central to the life of teenagers, as has been repeatedly demonstrated), and the weight of life constraints, since PvE play imposes a lot on players (availability in the evening for guild raiding, capacity to socialize inside the guild, etc.). On the other hand, the oldest players play more casually and are less likely to be fans (a time-consuming style). Between those two categories, young adults, aged eighteen to nineteen, and less markedly, twenty to twenty three, usually hold the most powerful positions in the game. They are more likely to be competitive players, and cooperative at that.

Previous game experiences as well as the length of *WoW* experience both correlate with the three axes. Previous online experience on *Warcraft 3* (a game that could be played online or offline) is more likely to be found among the competitive, fan, and oppositional players. It is also correlated with the date of first play: *Warcraft 3* players adopted *WoW* earlier than others – in fact, the first game was a major gateway into the second. This result suggests there is such a thing as a ludic career: in-game socialization produces lasting effects on the way one plays the given game and other games (Coavoux 2010b).

Finally, occupation and level of education mainly oppose players who are still studying and all others. Students are significantly more represented on the plus side of all three axes: they are more competitive, more likely to be fans, and more oppositional than the others. Lifestyle seems to be the explanation here. Students have more available time, and fewer constraints other than familial ones, especially for those living with their parents. We can also observe slight variations along class lines. The 'cadres' (upper-middle class) are less likely to be fans and, along with the 'professions intermédiaires' (middle-class), less likely to favour cooperation rather than opposition.

Studying the Diversity of Play Styles

The social study of video game play has not yet attracted many scholars, as we have argued in the first section. Moreover, academics most often focus on the games rather than the players. It is our opinion that such a player-centred perspective is necessary to make sense of games as cultural artefacts. Such a perspective should focus on the diversity of play styles. Geometric data analysis is helpful in describing and making sense of this diversity. It points to the various play styles, and gives indications as to their relationships. A relational approach is necessary, since no style can be understood without a reference to the competing styles.

To study players rather than games, a shift of focus from motivations to practices is also necessary. Games are things people do, and a theory of action that relies on intentions and motivations fails to account for it. The value of games is constructed through the activities of players. This means that the sociologist should follow the players wherever they go. Games do not stop when the device is turned off (Zabban 2009): they go on in everyday conversations (Boullier 2004), on the Internet or in other cultural practices.

Indeed, video games belong to a larger culture in which they should be positioned (Bourdieu 1984a). They are closely associated with other cultural practices, from non-digital games to movies and music (Berry 2009). The theory of practice, and its central concept of habitus, can help us understand how this association is formed (Berry 2011).

Finally, this perspective cannot be achieved without a combination of quantitative and qualitative analysis (Coavoux 2010c). Although not emphasized in this chapter, the interpretations we were able to make of the MCA results would not have been possible without the ethnographical work the three of us conducted and described elsewhere (Berry 2009; Boutet 2008, 2012b).

Endnotes

1 Respondents were assigned a value on the basis of a hierarchical clustering conducted
 on a distance matrix computed through an optimal matching analysis of the ordered
 preference sequences. On sequence analysis, see, for one, Abbot and Tsay (2000).
2 Based on the French classification of occupations by INSEE.
3 The Game's Editor invests in the story-telling of the world – often referred to as
 'the background' of the game – on the website, but also with other products such as
 novels and comic books, parallel to the game itself.
4 Only the supplementary modalities that are correlated with one of the first three
 axes ($p < 0.05$) are hereafter mentioned.

JAN THORHAUGE FREDERIKSEN

Trawling For Students: How Do Educational Institutions Compete for Students?

Background

Competition Between Educational Institutions

Educational institutions, in Denmark as elsewhere, are increasingly economically dependent upon sustaining certain levels of recruitment for their survival. As sustaining recruitment relates to the perceived status of the specific education, the occupations to which it leads, and the institution providing the education, educational institutions struggle for dominant positions within the field of education, as well as competing for student recruitment. For a number of reasons, educational policies being the most obvious one, a dominant position within the field of education does not in itself translate to a secure position in terms of recruitment. The relative positions of educational institutions within the field of education are thus competitively related to the structure of said field. Such relations are both competitive – which is to say, the institutions are attempting to recruit somewhat similar students – but also alliances, whereby the institutions tacitly agree to pursue different groups of students, in order not to escalate their competitive struggles. This article examines a case of such competition, in order to determine how such struggles reveal and affect both the overall structure of the field of education, and the hierarchies between particular agents within that field. In order to examine such struggle, I investigate the educational institutions in question, as properties of the students they succeed in recruiting; in other words the relations between the educational institutions are here understood to be homologous to the relations between the groups of students inhabiting them.

Competition and the Field of Education

Very little research has been conducted on the profiles of recruitment within educational institutions in Denmark. While some research indicates differences between the NISE as pedagogical institutions (Hjort 1999, Gytz-Olesen 2005), no studies have attempted to examine the relations and hierarchies between Danish educational institutions. Such studies have been conducted in other Nordic countries (Börjesson et al. 2003, Broady 2002, Lidegran 2009) and their findings are to a great extent applicable in a Danish context, as are the general analyses of educational and academic institutions conducted by Bourdieu himself in (Bourdieu and Passeron 1979b/64), *The State Nobility* (Bourdieu 1996b) and *Homo Academicus* (Bourdieu 1988a), respectively. These studies generally characterize the field of education as structured by a polarity of disciplines, wherein humanities (and thus social education) is to a great extent associated with cultural capital, and with the left hand of the state (Bourdieu 1996b). Training for welfare professions must contain a relation to both the field of education, and the field of welfare work, which results in a doubly dominated position, first in relation to universities, etc. in the field of education, and secondly to bureaucratic instances of control in the field of welfare work (Brodersen 2009).

In Sweden, such studies stress the relatively dominated position of institutions catering to welfare professions, situated between academia and practical application. This position (Gytz Olesen 2005) attracts students with several particular sets of dispositions – specifically a large group of students with little or no educational capital. Such students – unlike the hitherto stable feedstock of social educator training – are disposed to navigate within the training in different, less self-reliant ways (Hultqvist and Palme 2006), thus presenting the institutions with a very heterogeneous mass of students. Such changes in student population might precipitate changing relations between institutions, and in turn affect the structure of the field of education itself.

Social Educator Training

As diverse areas of professional workers as preschool-teachers, social care-workers and care assistants for the disabled are in Denmark all united under one professional body and are collectively referred to as Social Educators, all of whom are trained in one institution: The National Institute of Social Education (NISE). Social educators form part of what Brante has termed welfare professions (Brante 2005), being a profession established, maintained and legitimized by the welfare state in order to provide specific professional rights to citizens. Such professions have had difficulties in both obtaining a monopoly in the workplace, and obtaining status comparable to the classical professions; difficulties which both relate to the care-related nature of their work, and the challenges of expertise and democratization faced by the field of welfare work (Brodersen 2009), and the entire public sector (Dahl 2005; Gytz Olesen 2005; Hjort 2008). In recent years, such difficulties have also meant a decline in applicants for social educator training, and a decrease in the level of education possessed by applicants – which in turn has meant that the relations of competition between NISE are increasingly important.

The Current Study[1]

The present article examines the relations between the Danish NISE and how they compete for recruitment. The research questions of this article follow from the above theoretical construction of the field of education and it agents and institutions. That is, to what extent do the student populations differ between institutions, and to what extent do differentiated recruitment and institutional positions relate to the field of education?

The article proceeds to show how the student population in total, and at each institution, is structured by different forms of capital, related to two fields: the field of education and the field of welfare work (wherein the social educator profession resides). The relations between institutions

are shown to be structured by these two forms of capital, but distinct, separate subsets of competitive relations relate to each of the two fields. In the first plane geography and the nomos of the field of education structure the competition, yet the second plane is structured by tacit alliances on differentiated strategies for attracting students.

Data and Methodology

The study employs two connected sets of data: a set of data retrieved from the NISE on all students enrolled at a particular subprogramme[2] of social educator training in 2003–4 (Svejgaard 2006). These data are restricted to the admission-related aspects of the student biographies (demographical data, educational history, work history), but still allow for construction of the Space of SSPSE student trajectories.[3] In addition to the original data, thirty seven individuals are added to the 796 individuals making up the original data. These additional individuals make up two entire classes of SSPSE students, which I followed for about a year, conducting interviews, and observing classroom activities for a total of forty seven hours.

Field and Capital

This study makes extensive use of the theory and concepts of Bourdieu, in describing how the NISE encompass logics stemming from two different fields. While the main concepts are explained elsewhere in this volume a few aspects of this usage warrant further explanation here. This study objectifies the position of institutions, as agents within any field, by looking at the positions of the agents associated with that institution. Thus, the position of any one educational institution in the field of education is the

geometrical centre of the positions of the students associated with that institution, within the entire population of similar students. I would argue that such positions objectively describe the relations of dominance between institutional agents in the field of education, since the students' categories of perception and recognition – habitus, as it were – both structures and is structured by the field of education, and thus the student's choice of place of enrollment is a precise indication of these structures. The metaphor of a fishing trawl proves useful here: the institutions are objectified by examining the students populating them – the 'fish' successfully caught in the trawl of each institution. By looking at the differences of the 'catch' of each institution in terms of capital possession, the relations of dominance between educational institutions are objectified as well.

Geometric Data Analysis of the Social Educator Student Population

Geometric Data Analysis[4] is a statistical technique, which allows for visual inspection and examination of multivariate relationships. While strictly speaking a descriptive technique that does not entail quantitative measures of the strength of correlations and so on, the technique allows the researcher to retain the individuals as the central unit of analysis, and provides numerous tools for examining relations between individuals.

Operationalization

The available data somewhat limits the possibilities for examining the capital volume of the social educator student. The unit of analysis chosen is the social educator students' trajectories: What social educational work

experience, education and other components allowed each student to
qualify for admission? A set of active questions was selected in order to con-
struct a space of trajectories by specific multiple correspondence analysis.
The trajectory of the students consists of nine questions, and the twenty
nine modalities which these questions contain. The questions encom-
pass the educational background[5] of the students, their social educational
work experience, their previous working careers, and two items – Social
Educational courses, and voluntary work of various kinds – which serve
as reasons for the NISE granting exemptions to educational requirements.

A complete list of the questions, the modalities belonging to each
question and the number of individuals having selected each modality is
provided in Table 1.

Table 1 Active Questions and Modalities

Question	Modality[6]	Count
Previous career	No prev. career	343
	Shop/Office	171
	Craftsman/Arts	118
	Health/Care	131
	Teacher/Youth Club	70
SocEduc courses before SSPSE	SocEduc courses	109
	No courses	724
Sports coach/Scout/Voluntary	Voluntary work etc	76
	No voluntary	757
Nursery/Nursery school	No nursery	365
	< 5 nursery	191
	5+ nursery	277
Afterschool/SFO	Afterschool+	119
	No afterschool	714

	No special care	606
Special care	Special care +	227
Other experience	No other exp	699
	Other exp +	134
Daycare	No daycare	673
	Daycare+	160
	Vocational	214
	HTX/HHX	26*
	Public school/Other	141
	GIF/Foreign	18*
Education	Social/Health	44
	Care Assist	66
	Upper 2nd (STX)	107
	Exempt educ	106
	Higher prep (HF)	111

The complete analysis of the space constructed by these questions retains three axes, in all accounting for 83.5 per cent of the modified rate of variance.[7] The eigenvalues and modified rates of variance (Le Roux and Rouanet 2004) for the first three axes are detailed in Table 2.

Table 2 Axes, Eigenvalues and Rates of Variance

Axis	Eigenvalue	Rate of Variance	Cumulated Rate of Variance	Modified Eigenvalues	Modified Rates of Variance	Cumulated Modified Rate of Variance
1	0.2051	10.23	10.23%	0.0099144	0.365322833	36.5%
2	0.1989	9.91	20.14%	0.0087026	0.320673139	68.6%
3	0.1691	8.43	28.57%	0.0040405	0.148883532	83.5%

Axis One – Indirect Trajectory Types

In Table 3 the modalities contributing above average to the construction of the first axis have been listed ascending by coordinate on the first axis.

Table 3 Contributing Modalities of Axis 1

Question	Modality	CTR	Coordinate	Indirect trajectory types
Previous career	Teacher/Youth club	10	1,5	
Other experience	Other exp +	12	1,2	*Insider* careers in trajectory
Previous career	Health/care	10	-1,12	
Social educational courses	SocEduc courses+	6	0,99	
Daycare experience	Daycare+	4	0,63	
Previous career	Craftsman/Arts	3	0,72	*Outsider* careers in trajectory
Education	Vocational	20	1,20	
Previous career	Shop/Office	16	1,23	

What I have here termed the outsider-aspect of the axis attracts modalities which are not related to welfare work, and this sums up the interpretation of the first axis: it describes *types of indirect trajectories*. While the axis describes *insiders* and *outsiders* of the field of welfare work, both sets of opposed modalities describe trajectories originating outside of social educational work. However, all the contributing modalities on the *first* axis are positioned in the negative half of axis two. Thus, important aspects of the space will elude the analysis, if the two axes are not considered together.

Axis 2: Direct/Indirect Trajectories

As axis one yielded an opposition between forms of indirect trajectories towards social education, while at the same time being in its totality in opposition to parts of the second axis, it is no surprise that the second axis is characterized by an opposition between *direct and indirect* trajectories. Table 4 details the modalities contributing above average on the second axis.

Table 4 Contributing Modalities of Axis 2

Question	Modality	Ctr	Coordinate	Direct/Indirect trajectories
Other experience	Other exp +	13	-1,23	Indirect trajectory
Previous career	Health/Care	9	-1,02	
Previous career	Craftsman/Arts	5	-0,86	
Education	Vocational	7	-0,74	
Nursery experience	No nursery	6	-0,52	
Special care experience	*(Special care+)*	*3,57*	*0,48*	
Education	Higher prep (HF)	4	0,74	Direct trajectory
Nursery experience	5+ nursery	14	0,88	
Previous career	No prev. career	18	0,89	
Education	Care assist	4	0,98	

The overall interpretation of this axis is that it opposes *the indirect trajectories* described by the first axis with *direct trajectories*. As noted above many modalities from axis one reoccur on the negative side of axis two. All but two modalities contributed above average to the first axis, underscoring once again the intimate relationship between these two axes, and these modalities all characterize some form of indirect trajectory. At the positive end of the second axis the most prominent modalities are *No previous career*, and *5+ years of nursery/nursery school experience*. These modalities indicate a direct trajectory towards social education – a trajectory that does

not include any other fields of employment prior to social education. The positive aspect is not educationally associated with any specific vocation, and this is how it differs from the negative aspect, and the first axis. All modalities on the first and second axes suggest a triangular shape: the two kinds of indirect trajectories found on axis one are opposed to the direct trajectories at the positive aspect of axis two. Summing up, the two first axes show an opposition between, on the first axis, insider and outsider trajectories in relation to the field of welfare work, and, on the second axis, an opposition between direct trajectories and indirect trajectories, in relation to social educational work.

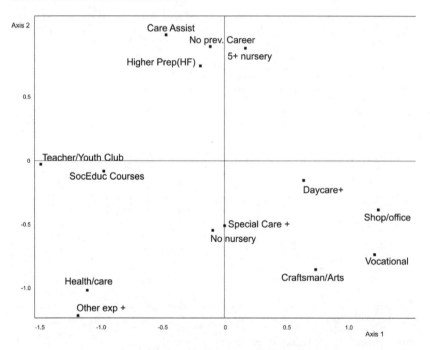

Figure 1 First and Second Axis with Contributing Modalities

Above in Figure 1 is firstly a plot of the contributing modalities on the second axis, and then a plot of the contributing modalities of both the first and second axis.

The Third Axis: Trajectory Complexity

A larger number of modalities contribute above, or just below average to the third axis of the space constructed. The third axis opposes complex trajectories, that is, trajectories composed of many components, to simpler trajectories, but as this is a complex interpretation in itself, only a few brief steps are detailed below.[8]

Table 5 lists the modalities contributing to the third axis:

Table 5 Contributing Modalities of Axis 3

Question	Modality	Ctr	Coordinate	Trajectory complexity
Previous career	Teacher/Youth club	12,92	-1,53	Complex, multiple components
SocEduc courses	SocEduc courses	19,32	-1,50	
Education	Care assist	5,54	-1,03	
Education	Exempt educ	7,37	-0,94	
After-school experience	After-school+	5,98	-0,80	
Previous career	Shop/Office	4,69	-0,59	
Special care experience	*(No special care)*	*2,29*	*-0,22*	
Nursery experience	*(< 5 nursery)*	*3,48*	*-0,48*	
SocEduc courses	*(No courses)*	*2,91*	*0,23*	Simple, few components
Nursery experience	*(No nursery)*	*2,76*	*0,31*	
Previous career	No prev. career	3,91	0,38	
Education	*(Upper 2nd (STX))*	*2,47*	*0,54*	
Previous career	*(Health/Care)*	*3,17*	*0,55*	
Special care experience	Special care +	6,12	0,58	
Education	Primary school/Other	5,38	0,70	
Education	Higher prep (HF)	4,75	0,74	

Roughly speaking, the positive aspect of axis three contains modalities which allow for direct access to social educator training: each modality satisfies one or more of the admission criteria. The negative aspect of this axis is associated with modalities that only in part allow for admission, and all of which require either further education, or other forms of social educational work experience, in order to admit the student to the NISE. In short, what this axis shows is an opposition between students whose admission qualifications are composed of multiple components – because they either have several kinds of experience, or because they have educational qualifications that do not immediately qualify the student for admission, making additional courses and/or exemptions necessary.

Trajectories in Terms of Capital

The above interpretations of the axial themes relate strictly to groups of modalities. Interpreting the axes as forms of capital entails relating the axes to specific social dominance relations coinciding with the structures of the space of student trajectories. Each of the axes refers primarily to two of the active questions – education and work experience, and this indicates that these relations of dominance stem from respectively the field of education, wherein educational capital is an important form of capital, and from the field of welfare work, wherein capital of care (Brodersen 2009, Øland 2007) is central. Upon examining the axes more closely, these forms of capital are in fact the forms of capital structuring the axes constructed in the analysis above.

The first axis, indirect trajectory types, opposed field of welfare work *insiders* and *outsiders*. The outsider aspect of the axis is associated with vocational training, and non-social educational previous careers. The cultural capital acquired in such outsider-settings differs from the cultural capital acquired in the insider-setting. These latter students are to a higher degree culturally familiar with welfare work and institutions, and have not

made a transition from a commercial work-setting into the field of welfare work. I propose that the first axis is associated with the ethos of the welfare professions within the field of welfare work, and describes possession of capital of care.

The second axis opposed direct trajectories with indirect. The immediately apparent interpretation of how this axis might be expressed as differences in capital possession is the opposition between *vocational* educational capital (that is, educational capital either vocational or directly associated with a specific profession) and *generalized* educational capital – in particular the preparatory secondary education, which is precisely not associated with any specific vocation, but rather prepares for tertiary education. This is a dominant form of capital, being harder to obtain, and providing a wider range of educational opportunities.

The third axis opposed complex and simple trajectories. It is associated with the opposition between educational capital, and a form of capital obtained from *working* within social education, but which has no value outside of the domain of social educator training. I will term this social educator capital. The social educator capital is the cultural capital obtainable through bodily practice in social educational settings, and it thus differs from the cultural capital of care which encompasses the ethos of the field of welfare work.

NISE in the Space of Trajectories

Having now constructed the space of student trajectories, it is possible to compare the student recruitment profiles of different NISE, by examining the set of NISE as a structuring factor in the space of trajectories. Figure 2 has the NISE in the vicinity of the Danish capital, Copenhagen, in bold letters; the large city NISE in italics[9] and the province NISE in plain letters. Plotted like this, the Copenhagen NISE are somewhat dispersed, although all but one are above the origin on axis two. In the same way all

Province NISE are below the origin on axis two, and so are most of the
large city NISE. Put in terms of capital: generalized educational capital
is less distinctive in the large cities than in Copenhagen, and even less so
in the province. The relations between the NISE in this plane are thus
structured by the relative value of the educational capital possessed by
the recruits. Educational capital being relatively sparse in the provinces,
alternative forms of education becomes exchangeable here, whereas in the
capital, a higher level of educational capital is necessary for admission to
the NISE. In short, the relative value and exchangeability of educational
capital diminishes with the availability of educational capital in the geo-
graphical region.

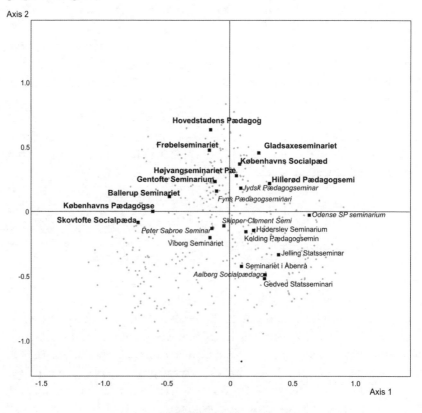

Figure 2 NISE in the Plane of Axis 1 and 2

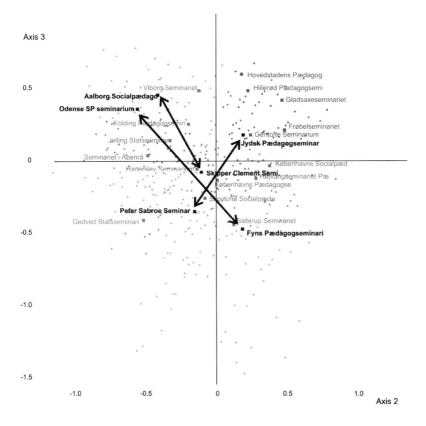

Figure 3 NISE in the Plane of Axis 2 and 3

Plotting the second and third axis (Figure 3) – and thus the direct-indirect by simple/complex axes – the separation between capital and province becomes even more remarkable. But even more telling are the relative positions of the six large city NISE. These have been emphasized, and the ones located in the same city are connected by arrows. As is apparent, NISE in close proximity have very different recruitment profiles. This is a matter of strategic positioning by the NISE, or more simply put, an illustration of tacit alliances necessitated by the arbitrary economic structures relating NISE economies with the available local student population.

The NISE are positioned here relative to the two fields to which their students relate: the field of education and the field of welfare work. The relationship between the NISE is being structured by two forms of capital: educational capital and social educator capital. This is visible as two distinct subsets of competitive relations between the institutions – each being a subset of competitive relations homologous to each of the two fields. The first set of competitive relations reveals how the field of education reproduces structures of hierarchy and dominance through the relative value of educational capital, and the geographically differentiated availability of such capital. The second set of competitive relations reveals how local competition requires the institutions to profile themselves differently, and try to ensnare discrete subsets of the student population, and does so by ascribing local, relative value to social educator capital. This form of capital is only available within the field of welfare work, and it is not likely that such capital will be exchangeable to other forms of capital outside of the field of welfare work.

Classifying the Social Educator Students

In the following analysis the relations between NISE are examined through a classification of the social educator students. The purpose of such a classification is to enable an inspection of the individuals' relationships to each other, by delineating classes: groups of similar individuals. This provides an interpretative precision, since it is no longer necessary to interpret the individuals' positions by using the sociological abstraction of the axes. It also enables me to compare subsets of the population – in this case, the population of each institution. Most importantly, *the actual relational differences of the data-set* are reconstructed in the classification – rather than classifying by a set of attributes found in the field (for instance grade point averages). A number of the aspects, which will be shown to be separating the classes, are in fact reoccurrences of the oppositions found in the axes above. Since the classification and the multiple correspondence

analysis, are different ways of extracting relations of opposition and distinction from the data, this is to be expected. However, where the axes above mostly express oppositions, the classification allows us to describe groups of individuals by their common features. In the present study, the aim is to precisely describe the differences between institutions, by way of examining the students inhabiting them. The classification allows for a very detailed inspection of, to return to the trawling metaphor, the various species of students caught by the trawls of each institution.

In the present study, I have classified the individuals according to their position on all twenty seven axes created in the multiple correspondence analysis above. The classification used separates the individuals into five classes, numbered C 1/5 through C 5/5. I shall briefly explore the classification first by providing a brief summary of the five classes created.

Five Classes of Social Educator Students

The classification chosen for this population is described below:

1. *C1/5 The Straight Ones* (n=333): This class contains all trajectories that are direct (87 per cent have no previous career, 2 per cent have Health/Care-careers, *no* members have Teacher/Club-careers and *no* members have vocational training or social/health training). This class is closely related to Nursery experience, and almost *no* other forms of experience are present.
2. *C 2/5: The Outsiders* (n=281): This class contains all trajectories that involve a background of vocational training (70 per cent of the members of this class), and a previous career in Shop/Office or Craftsman/Arts (90 per cent of the members of this class).
3. *C 3/5: Nurses etc.* (n=106): This class contains all students who partially completed training as a nurse, and worked in hospitals or similar social/health careers.

4. *C 4/5: Social/Health Assistants* (n=44): This class contains all students who were admitted to social educator training by way of training as a social/health assistant.

5. *C 5/5: Complex Insiders* (n=69): This class contains *all* students but one with a previous career in Teacher/Club, and *none* of the members have either no previous career, Craftsman/Arts, Shop/Office or Health/Care. 25 per cent of the members are trained as Care Assistants, and *none* are trained as Social/Health Assistants.

This set of classes describes most of the distinctions found in the multiple correspondence analysis above, and the aggregation indexes of these classes accounts for 6.01 per cent of the variance contributed to the space, which is quite an adequate level of description.[10]

In Table 6, the classes are described by what capital they possess, in each of the three axial dimensions of the space constructed.

Table 6 Classes by Capital Composition

Classes by capital composition	Indirect trajectory type (Axis 1)	Trajectory directness (Axis 2)	Trajectory complexity (Axis 3)
C 1/5: Straight Ones	None	Generalized educational capital	None
C 2/5: Outsiders	None	None	Social Educator capital
C 3/5: Nurses etc	Capital of Care	None	None
C 4/5: Social/ Health Assistants	None	None	None
C 5/5: Complex Insiders	Capital of Care	None	Social Educator capital

The above comparison shows that in terms of capital composition, the five classes are quite different. As the only class possessing a notable amount of generalized educational capital, this possession translates to a dominant position for the Straight Ones-class, in relation to the field of education, and the relations of competition related to that field. The relative absence of all three forms of capital puts the Social/Health Assistants-class in a dominated position along all three axes.

The two remaining forms of capital: Care and Social educator capital places the last three classes in a complicated struggle being both dominant and dominated. In relation to the field of education, both of these forms of capital are dominant, but in relation to the field of welfare work, these forms of capital are to some extent also dominant; with the capital of care to a higher degree than social educator capital. The relations of competition related to the field of welfare work are, however, secondary to the competitive structures stemming from the field of education. This means that in relation to the NISE, the Complex Insiders-class, and the Nurses both dominate the Outsiders-class.

Classifying the NISE Population

Using the classification it is now possible to describe the different recruitment profiles of the NISE in both more detail, and in a directly comparable way. In the four circle diagrams below the classwise distribution of the students at different NISE has been depicted. The four diagrams depict respectively the student population at all the Copenhagen/Capital NISE combined, at all the Province NISE combined, and finally at two NISE located in the same, large City. These four circle diagrams allow us to compare the similarities, differences and distinctiveness of the student population of these four NISE.

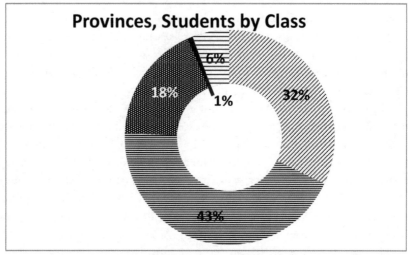

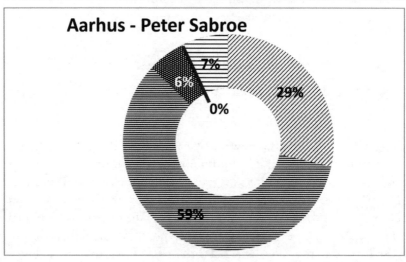

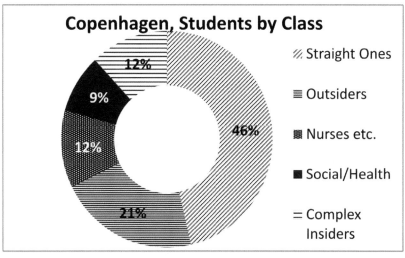

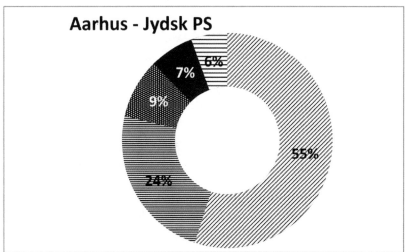

Figure 4 NISE Populations by Classes

The four diagrams can be compared in three different ways: comparing Provinces and Copenhagen; comparing the two Aarhus NISE; and comparing the Aarhus NISE as a set, with the Copenhagen/Provinces-set. Each comparison reveals particular aspects of the structure of competition between the NISE, but as it turns out, the fundamental relations are very similar.

Each diagram shows the class composition of the population, and by extension the relative capital composition within the NISE. Comparing the Copenhagen NISE and the Provinces NISE reveal a large difference in the number of Straight Ones members and the number of Outsiders, and a less obvious, but still important difference in the number of Social/Health Assistants. The Copenhagen NISE appear to succeed in recruiting students with generalized educational capital, at the cost of not recruiting students from the Outsiders-class. Conversely, the NISE in the provinces appear to recruit a large number of outsiders, and a smaller number of Straight Ones.

The same profile of differences appear between the two NISE located in the large city Aarhus, even more skewed, with more than 35 per cent difference in the distribution of students between the two classes Straight Ones and Outsiders.

The three levels of comparison can thus be summed up as follows: The capital composition of the student populations at respectively the Copenhagen and Provinces NISE reproduce the overall structure of dominance within the field of education. This structure of dominance is homologous to the structure of dominance between two closely sited NISE. The relative value of different forms of capital thus seems to be constant throughout the space of student trajectories, and the different forms of domination within the relations between the NISE, appear recursively at all levels of interaction between agents of this field.

Conclusion

This article has demonstrated three points: that the structures of competition between similar educational institutions are multilayered relations; that these different relations stem from both the field of education, and other fields the educational institutions cater for; and that the structures of competition are reproduced at both large and small scale within the field, reiterating the relations of symbolic dominance within the field at all levels of the field. The study is quite small scale, but it indicates that examining the role of institutions as agents in their own right, within the field of education allows the researcher to transcend simple ideas of educational institutions as hierarchically related, and instead examine the relations of such institutions within a wider social context. Geography, and the local availability of capital, proves highly relevant for the above analyses. The findings indicate that competition between institutions is much more related to the current state of the Danish field of education, than to the more easily perceived differences between institutions, such as didactical profiles, emphasis on particular subareas of social education, advanced e-learning set-ups etc. Such attempts at making the training appear attractive, or perhaps less daunting, must be understood in relation to the more general structures of capital value and dominance within the field of education. The chances of increased recruitment for any one specific form of training depends upon the extent to which such training attempts to recruit those students already structurally disposed to seek out that particular educational institution.

Methodological Perspectives

This article's use of institutions as subsets of agents is hardly the most innovative use, of geometric data analysis, and similar points may be found in several of the student studies Bourdieu made of the French educational

system. The usage of hierarchical class analysis, however, brings the individuals in the analysis to the fore, and allows for any number of combinations with qualitative data. While the present study reveals competition to be structured by features of the field of education, a qualitative examination of the agents' dispositions, and their relation to the field of education would provide opportunities to both examine the social efficacy of the institutional and individual strategies employed by agents in the field, and the educational outcome of these structural differences. If the entire group of NISE systematically recruits a different subset of the population of social educator students, then the student population may in turn mean differences in what professional habitus the students possess in the end. This raises the question of whether such structures of competition reduce professional cohesion, introducing educational distinctions into the profession, by way of institutional hierarchies. Such studies would allow us to consider and assess the social effects of the marketization of the educational system in detail.

Endnotes

1 This paper is a spin-off from the study making up the PhD research project *Between Practice and Profession* (Frederiksen 2010), which explores social educator professional training in numerous different ways.

2 The study is restricted to a special subprogramme of social educator training: the Specially Structured Programme for Social Educator training (SSPSE). This programme caters to unskilled workers already working within the field of social education, and allows such workers to complete social educator training faster (one year full time and two years part time compared to three and a half years full time), with a smaller amount of work practice (three months compared to fifteen) and a higher study grant (half to full unemployment benefits compared to regular study grant). This programme is one of several ways in which NISE may widen the range of recruitment, because this programme allows certain groups of students to enroll and follow social educator training – groups who would otherwise be precluded from doing so due to economic and employment issues. As such, the SSPSE is considered

to embody radical recruitment expansion strategies that may indicate the nature of the future of all social educator training.

3 I use the term *social biography* as an analytical term, whereas *trajectory* refers to the empirical constructs. The social biography refers to the succession of socially pertinent events making up the students' life histories until the point of admission at the SSPSE, whereas the trajectory is the specific empirical objectivation of each individual.

4 A full introduction is beyond the realms of possibility here, and readers are instead referred to introductions such as Le Roux and Rouanet (2010) – or, for a completely thorough reference, Le Roux and Rouanet (2004). For the purposes at hand, the GDA consist in a specific multiple correspondence analysis of the SSPSE student trajectories. Such an analysis constructs a mapping of both the modalities used for describing the individuals as well as the individuals themselves. By treating each individual's response profile as a point, the position in space of which is equal to the profile of modalities selected by the individual, a space of very high dimensionality is constructed. This position of individuals and modalities within that space is projected into one or several planes, allowing visual inspections of the relative positions. This plane is then examined by way of exploring which modalities contribute the most to constructing the axes spanning the plane. This is of course an unacceptably short presentation of several highly complex procedures, entailing numerous analytical choices and strategies. Much more thorough descriptions are available in the references given in the text, and in particular in Le Roux and Rouanet (1998).

5 The educational modalities may deserve some further explanation for readers unfamiliar with the Danish educational system. Exempt Educ – the student does not directly qualify for admission, but has been exempted from this requirement. Public school/Other – the student has only mandatory primary school. Vocational – the student's secondary school is some form of vocational training. Social/Health, Care Assist – two forms of vocational training aimed at various forms of welfare work. *GIF/Foreign*, *HTX/HHX*, Higher Prep (HF), Upper 2nd (STX) – all general preparatory secondary school exams. They are here ordered in an approximate order of academic value.

6 * and italicization identify modalities that are put as passive in the analysis – that is, modalities which are of insufficient frequency to be analysable, and thus prevented from contributing themselves to the analysis, cf. Le Roux and Rouanet (2004).

7 It should be noted at this point that the description of how the specific multiple correspondence analysis was conducted, and how the data were recoded in order to perform the analysis, the interpretative decisions and numerous other aspects of the craft of geometric data analysis, have been omitted in the present account, for reasons of legibility and due to space-constraints.

8 The reader is referred to Frederiksen (2010) for an extended discussion of this axis and its interpretation.

9 A large city is understood here as a city containing more than one NISE.
10 The aggregation indexes – that is to say, the contribution of the dipole of the two
 classes combined at each of the final five levels of the classification – are given in the
 table below:

Table 7 Class Aggregation Indexes

5 (C3/5 joined with C4/5)	6.33%
4 (above joined with C5/5	7.17%
3(C1/5 joined with C2/5)	8.20%
2 (3 and 4 above joined)	8.79%
1 (all joined)	9.20%
Total	39.69%

ANDREA TRIBESS

In Which Social Context Will Working-Class Students Obtain an Academic Qualification?

Introduction

In France, as in other countries, there are basically two view points about how to democratize higher education. The first suggests that more working-class children would be successful in their university studies if they were encouraged to aim for the highest standards – that is, to leave home; to integrate in student life and to learn how to be a student; to 'leave' their *primary habitus*, in this context, if it is considered as a 'handicap' (Bourdieu and Passeron 1970; Coulon 1997). The second view suggests adapting higher education to fit the working-class primary *habitus* through proposing short technical courses, small classes, proximity sites, interactive teaching methods. In short, creating an organization that allows the working-class children to engage in higher education studies without leaving their primary class *habitus*, so considered as a possible resource (Retière 2003; Renahy 2010; Poullaouec 2010).

However, there are different ways of considering success in higher education. Tristan Poullaouec (Poullaouec 2010) points out that working-class children who obtain any qualification belong to a sort of elite relative to their social environment. Following this point of view, we will consider that working-class children who obtain any qualification, even if it is the lowest one, have already succeeded in their studies. In contrast, those who stay at university for one or more years without obtaining any diploma will be considered as having failed their university studies. So in our analyses the main distinction is between those students who do not obtain a university qualification and those who do obtain a qualification. Here we make

no distinction if it is a technical diploma (*DUT*), or a Bachelor's degree (*licence*), a Master's degree (*master*) or other higher qualification. As Cédric Hugrée argues, those students have achieved a 'respectable course'; 'ascensions sociales honorables' (Hugrée 2009) At the same time, the qualifications and consequently the jobs they will take up after study, remain less prestigious and less well paid than those of their peers with the same grades from higher social classes (Hugrée 2009).

In this chapter, we will study the social space of the University of Picardie (located in the north of France) and briefly illustrate its current hierarchies. We will then see whether, within this space, there are any possibilities for working-class children to succeed on the 'respectable courses' mentioned above. That is, notably, in the adapted university courses which have emerged in the French University system since the democratization of secondary graduation and consequently of higher education in the late 1980s.

To assess the existence of these possibilities, we will focus on a peripheral university site which has been created specifically to widen the access for lower class rural children to the university, namely the 'antenne' (secondary campus site) of Beauvais, situated in the south of Picardie. In this small university campus, students generally seem to maintain the lifestyle adopted during their secondary education. That is they continue to live with their parents, travel daily to their place of study, learn in small classes with possibly interactive methods, and follow no magisterial course (amphitheatre) thanks to the low number of students. Our question here is does this university campus really widen access to Higher Education and increase the chances for working-class children to obtain a higher education qualification?

To answer this question, similar Higher Education fields offered on the main campus of Amiens, as well as in the peripheral campus of Beauvais, will be compared across the Sciences, Arts and Technical disciplines. We examine the success rates in each education field for each campus and the social origins of the students. In an attempt to explain the differences between Amiens and Beauvais, we use interviews of students and professors on both sites. Also, in order to situate the particularities revealed in the preceding analyses into the social space of UPJV, we use Geometric Data Analysis, in this instance specifically Multiple Correspondence Analysis (MCA).

Data and Methods

This research is based on statistical and qualitative data collected at the University of Picardie, located in the North of France. The database (*ApoPic*) is composed of the entire set of university enrolments at the University of Picardie-Jules Verne (UPJV), from 1998 to 2008. It comprises about 100,000 students over ten years. The quantitative data has been complemented by a range of about forty interviews with students and professors on the main campus of Amiens and on the peripheral campus of Beauvais.

Our research has concentrated on two cohorts of secondary graduates enrolling in UPJV: the cohorts of 1999 and 2004. We then reduced the number of observations, creating two populations of about 5,000 students. The 2004 cohort is the most recent which we can observe in an interval of five years and it is also the first which enrolled within the new LMD-system (*Licence, Master, Doctorat* – Bachelor, Master, Doctorate). The 1999 cohort enrolled five years earlier and, at this time, there still existed a specific French university diploma obtainable in two years, the *DEUG* (*Diplôme d'Etudes, Universitaires Générales*), as well as a diploma obtainable in four years known as the Maîtrise.

In the first part of this chapter, we do not take into account the level of qualification (technical diploma (*DUT*), general university diploma (*DEUG*), Bachelor's degree (*licence*), Master's degree (*master*) or higher diploma), neither the time needed to obtain it, nor the discipline in which the diploma has finally been obtained. Rather, our interest is in the students who obtain *at least one UPJV diploma in five years*. In the second part, the diploma obtained will be more detailed, though not the time needed to obtain it, nor any change to another UPJV education field, to another university or another higher education institution.

We use the expression 'working-class children' to indicate students whose parents, generally the father, occupies a low qualified or a worker job. For practical reasons, we will not distinguish between blue-collar workers ('ouvriers') and white-collar workers ('employés'), or between qualified and unqualified workers, office or commerce wage-employees, for example, even if these positions constitute different social situations. The group of upper-class children is composed of students whose parents are declared to

be heads of firms with more than ten employees, professors, engineers and so called '*cadres*' (executives). Primary school teachers are classified with all the other occupations as belonging to the 'middle-classes'.

From the Predictions of Social Reproduction to a Specific Hypothesis about Working-Class Students

Bourdieu and Passeron (1970) suggested that working-class children would have more success in higher education if they had already been selected in secondary-school. So it was in the 1970s, when only a minority of working-class children attained higher education. But Bourdieu and Passeron predicted that wider access of working-class children to secondary-school graduation (the '*baccalauréat*' or 'bac') and afterwards to university would change this fact. As they argued in their book *Social Reproduction*:

> It also follows from these analyses that if the proportion of working-class students entering university was significantly increased, those students' degree of relative selection would, as it declined, less and less offset the educational handicaps related to the unequal social-class distribution of linguistic and cultural capital. (...) So we would see the reappearance of the direct correlation between academic performance and social-class background (...). (Bourdieu and Passeron 1977a: 76)

In other words, since secondary education would be less selective among working-class children, university selection should increase. The 'second university explosion' from 1985 to 1995 has increased the proportion of working-class students in universities. Sociologists discuss this in terms of whether it means 'qualitative democratization' or only 'numerical democratization' of higher education. At the same time, some university courses have increased the selection at enrolment or in the first study years; for example, enrolment in the Technical University (IUT) is subject to a selection process.

This selection is also perceived by the new students and their parents, who may consider that only selective courses are worthy of undertaking: 'I would have preferred', said the mother of a young student on the day of his first enrolment at the university in 2010, 'that my son was accepted in a higher school or in a Technical University Institute (IUT)'. As he had

not been accepted in these institutions, his mother finally accepted her son's decision to enroll in a university course without selection at entry. In the same way young students in a Technical University Institute (*IUT*) announce proudly during the interview: 'We've been selected to study here!'

In accordance with Bourdieu and Passeron's analysis, the access of working-class children to non-selective university courses, and particularly to the peripheral university campus of Beauvais, should increase across time.

While Bourdieu and Passeron's analysis underlines social inequality in regard to access to Higher Education, we pay more attention to the question of which context is more likely to lead working-class children to get university diplomas? Asking this question, the researcher clearly adopts the point of view of working-class children wondering where they have the highest chances of obtaining a Higher Education diploma. In this theory, working-class children are supposed to not enter into competition with upper-class children, but to look for an honourable issue for their often difficult educational path.

Our hypothesis is that with the exception of the few working-class children with an excellent educational capital and a particular autonomy relative to their peers (Reay, Crozier and Clayton 2009), working-class children who have graduated from secondary-school will have better chances of obtaining a diploma if studying in a less competitive and more familiar university environment, which allows them to maintain their class *habitus*, as is the case in the campus site of Beauvais.

A Comparison Between Two Sites of the UPJV: Amiens and Beauvais

To test this hypothesis, we will concentrate on the peripheral university site of Beauvais. It was created in the late 1990s, and successively changed its educational offerings. Currently, there are three main fields of study: the Technical University Institute (IUT), which offers different commercial and management courses; the scientific disciplines, with biology and chemistry courses; and the arts disciplines, offering applied foreign languages and a more general historic-geographic-literary course leading essentially to the primary school teaching professions. Except for the last course, equivalent courses also exist on the main site in Amiens.

In this site, students coming mostly from nearby cities and villages continue generally to live with their parents throughout their studies, do not take student jobs, and usually continue to have the same kind of life-style they had in their secondary-school. In some courses, like Techniques of Commercialization in the IUT or Applied Foreign Languages (*Langues étrangères appliquées*) in university, groups of secondary-school classmates come altogether in the first year.

These students seem to seldom meet up after the university day in their respective homes, a continuation of their secondary-school practice. They carry on their lifestyle from school until the end of their university studies in Beauvais. A student at Beauvais described her relationships at secondary-school as follows: 'My current friends are all from the same secondary-school. We met in the "foyer" or in the courtyard of our institution. Outside, in Beauvais, there was nothing to do! Generally we remained at school'. As another first year student at Beauvais explains: 'I've been here six months. But already we have good friendships. (...) We only meet during the week – given that I live far away from here. But otherwise, we often eat together on the campus'.

This situation is slightly different on the main site in Amiens, where students quickly become more independent from their parents' residence and can also have some urban sociability after classes. 'I have made some new friends in my year, in my group, at the university. In this way, I knew the friend with whom I am currently sharing a flat' (student in the first year of social sciences in Amiens). 'I find that there are a lot of things to do in Amiens. Every day there is something that happens. At the moment, there is a festival with a lot of artists coming from far away' (student in biology in the third year in Amiens).

By maintaining certain aspects of their primary *working-class habitus* the Beauvaisian students are less likely to obtain higher university quali-fications. As we will see below, our data confirms this relationship. These students as a group are less likely to obtain Master's degrees or higher qualifications than others. But even though the Beauvaisian students won't reach higher levels of diploma, perhaps they are more likely than those of the main site to take any diploma? To verify the impact of the local study context, we will compare similar courses proposed in two different sites of the University of Picardie.

Table 1 Rate of Students Obtaining At Least One UPJV-Diploma in Five Years
According to Social Origin, Education Field and University Campus at the First Year at
UPJV, Cohorts 1999 and 2004

	Cohort 1999					
	Amiens		Beauvais		%Beauvais – % Amiens	
	%	N	%	N	B-A	N
Sciences	41%*	568	46%	83	+4.8**	651
working-class	39%	165	46%	35	+6.3	
middle-class	47%	214	55%	33	+7.8	
upper-class	36%	152	25%	12	-11.2	
unknown	35%	37	33%	3	-1.8	
Literary	50%	311	37%	113	-12.3	424
working-class	50%	107	26%	50	-24.5	
middle-class	51%	108	51%	35	+0.5	
upper-class	51%	67	50%	14	-0.7	
unknown	38%	29	29%	14	-9.4	
IUT	88%	207	79%	281	-9.3	488
working-class	91%	69	77%	122	-14.3	
middle-class	88%	84	76%	86	-12.5	
upper-class	83%	48	90%	41	+6.9	
unknown	83%	6	78%	32	-5.2	
	Cohort 2004					
	Amiens		Beauvais		%Beauvais – % Amiens	
	%	N	%	N	B-A	N
Sciences	35%	524	56%	32	+20.8	556
working-class	44%	122	67%	15	+22.4	
middle-class	40%	167	60%	10	+19.9	
upper-class	25%	195	40%	5	+14.9	
unknown	40%	40		2	Ns	

Literary	57%	221	32%	78	-24,5	299
working-class	59%	85	32%	41	-27.1	
middle-class	62%	63	48%	21	-14.3	
upper-class	45%	55	11%	9	-34.3	
unknown	61%	18	14%	7	-46.8	
IUT	81%	225	69%	217	-12.2	442
working-class	83%	65	64%	97	-19.2	
middle-class	83%	84	78%	58	-5.7	
upper-class	74%	62	70%	27	-3.8	
unknown	93%	14	69%	35	-24.3	

Source: Apopic, UPJV, 1998–2008

* Example: 41 per cent of the 568 secondary-school graduates enrolling in sciences at the UPJV in 1999 have obtained at least one UPJV-diploma in five years.

** Example: The success rate of working-class students from cohort 1999 enrolled in Sciences is 4.8 points higher in Beauvais than in Amiens; this advantage of Beauvais increases in cohort 2004, with a difference of 20.8 points.[1]

Table 2 Social Composition and Scholastic Capital in the Education Fields Present at Amiens and Beauvais, Cohorts 1999 and 2004

	Cohort 1999			Cohort 2004		
	Amiens	Beauvais	B-A	Amiens	Beauvais	B-A
Sciences						
% working-class students	29%	42%	+13	23%	47%	+24
heterogeneity ratio*	9.2	3.4	-5.8	16.0	3.3	-12.7
% baccalauréat without honours	62%	83%	+21	56%	84%	+28
Literary						
% working-class	34%	44%	+10	38%	53%	+14
heterogeneity ratio	6.3	2.8	-3.5	6.5	2.2	-4.3
% baccalauréat without honours	74%	81%	+8	70%	79%	+10

IUT						
% working-class	33%	43%	+10	29%	45%	+16
heterogeneity ratio	7.0	3.4	-3.6	9.5	2.8	+6.8
% baccalauréat without honours	74%	71%	-3	70%	81%	+10

* (Upper-class/working-class) * 10. Here: in the 1999 cohort enrolling in Sciences at Amiens, there are 9.2 upper-class students for ten working-class students in the first study year; meanwhile, the same heterogeneity ratio is 3.4 at Beauvais.

These tables show that our hypothesis seems to be verified within the scientific disciplines. Here the ratio of upper-class students to working-class students is higher on the main campus in Amiens than in the peripheral campus of Beauvais. However, the success rate is higher in Beauvais; in sciences, the local organization in small working groups and less competition seems to increase the chances for working-class students to obtain at least one university diploma in Amiens after five years. This difference cannot be explained by a smaller initial educational capital in Amiens: the rate of secondary graduates without honours is always higher at Beauvais than at Amiens, and this segregation even increases from 1999 to 2004.

This difference is also perceived by the young students, as witnessed by this first year at Beauvais: 'Some school friends told me that in sciences at Amiens, there are professors who discourage and things like that. They didn't have enough places and I didn't like that idea. (...) From the four school friends who began their scientific course at Amiens, only one has continued!' There also seems to be more competition in Amiens, as a Science student in the third year at Amiens mentions: 'Last semester, there was a girl who was absent the whole time, and she asked me for my notes, she asked all of us, and she passed her examinations whereas other students didn't! It's not fair; I don't like that... So, this semester I won't make the same mistake!' All in all, the study environment in sciences at Beauvais appears better adapted to working-class students.

However, in the Arts courses at Beauvais, the greater proportion of working-class students, in contrast, obtain a lower success rate. This result contradicts our hypothesis in regard to the supposed systematically positive effect of social homogeneity (even if, as seen above, in the literary

disciplines, the heterogeneity ratio is lower than in sciences and the difference between Beauvais and Amiens is less important). Possibly the study context and quality is not the same on both campuses. As already expressed by Bourdieu and Passeron (1970: 144), literary skills are more dependent on family background than the technical and scientific ones.

We have observed that the pedagogical organization is quite different in the three education fields present at Beauvais. While the Technical Institute and the Arts disciplines of Beauvais work independently from the main site in Amiens (and even in competition concerning the History and Geography professors, who may consider teaching at Beauvais as a form of relegation), the Scientific disciplines are strongly related to the main site in so far as programmes and examinations are organized and taught by the same professorial team, as explained by a science professor met at Beauvais: 'In sciences, the students are well integrated. They know that they are a part of the UPJV because the professors travel from one campus to the other. The professors at Amiens come here to Beauvais and generally teach the same lessons. (...)'.

The Social Space of the UPJV Cohort of 2004

However, as written by Bourdieu and Passeron (1970: 222):

> Vigilance against the temptation of treating the elements independently of the relations which constitute them into a system is particularly necessary when comparing different periods. Thus, to grasp the social significance of the different social categories' share in the different faculties or disciplines, one has to take into account the position this or that faculty or discipline occupies at a given time within the system of faculties or disciplines.

To see the place of the campus of Beauvais in the social space defined by the whole Picardian University, our data will now be submitted to a specific MCA (Le Roux and Rouanet 2010). Our interest is in the cohort of 2004 enrolled at university immediately after secondary graduation. We have taken five questions as active in the MCA: the education field, secondary section ('filière du bac'), secondary graduate distinction ('mention au bac'), professional categories of the parents ('PCS parents') and residence.

1. Education field: SCIENCES (sciences-mathematics – computer sciences), LAW/ECONOMICS (law, political and economic sciences), LITERARY[2] (literature, languages, history, geography), SOCIAL SCIENCES (sociology, psychology, arts, 'Staps' (sport), philosophy, etc) and IUT (Technical University Institute).
2. Secondary discipline: Bac S (sciences), L (literary or arts subjects), ES (economics), pro (vocational/technical).
3. Secondary graduation honours:[3] B/TB ('Bien' or 'Très Bien'; with high/highest honours), AB ('Assez Bien'; with honours) or Passable (without honours).
4. Professional categories of the parents: PCS pop (working-class), PCS inter (middle-class), PCS sup (upper-class), PCS unknown (without profession or not known).
5. Residence: with parents, collective residence (University residences), private residence (own flat, private student room or other residence).

We consider that these questions structure the social space of the university.[4] To know where within this space the working-class students have more chances to obtain qualifications, we are taking the following supplementary categories.

1. The attainment of a *diploma* of the Picardian University over five years (without distinction of the time needed to obtain it, neither the discipline in which it has been obtained – students can change courses inside the university): no diploma, bac+2 ('DUT', technical diploma, prepared in two years), bac+3 (Bachelor's degree, prepared in three years), bac+4 or more (Master's degree prepared in four years or higher degree).
2. The *university campus*: Amiens (main campus), Beauvais (peripheral campus), other peripheral campus.
3. The *employment* status: 'employed', 'not employed'.
4. *Gender*: Male, female.
5. *Age at secondary graduation*: eighteen years or less (on time/advance), nineteen years or more (late).

We analyse the first principal plane, constituted by axes 1 and 2, which represents around 23 per cent of the variance (see Figure 1). It clearly shows the common social reproduction pattern and we will analyse the locations of different categories in this space.

A first pole of the plane 1–2 corresponds to upper-class contexts (PCS sup), more likely to take a scientific *baccalauréat* (Bac S) in time (eighteen years or less), with high or highest honours ('B/TB'), to study medicine or sciences, not at a peripheral campus ('Beauvais' or 'other site') but at the main campus. Not far from this is the category 'private residence', which indicates resources and/or acceptance of migration in the studying context, both attributes of the upper-class *habitus*.[5]

Also related to scientific, as well as technical, specializations, one finds another set of categories grouped on the bottom right part of the plane. One finds here mostly the category 'male', more likely to have a foreign secondary-school diploma, to live in private or university collective residences.[6]

The categories referring to properties of working-class students of peripheral campuses are situated in the left bottom part of that plane and reflect well the particularities of Beauvais: less educational capital (nineteen years or more, vocational or economic baccalauréat, 'Bac pro', 'Bac ES', without distinction, 'passable'), employed at the first year.

On the upper left side, one finds the following categories: females who have a literary or arts secondary graduation without honours, Arts and Literature courses at the campus of Amiens, live with their parents.

The projection of success rates as a supplementary variable largely reflects the differential success rates in relation to the education field. The education field with the highest rates of graduation inside the 2004 cohort is composed by the Technical University Institutes where 77 per cent of the 2004 cohort obtain at least one UPJV diploma in five years, followed by Literary, Social Sciences, Arts, Law and Economics courses (around 51 per cent), Sciences (38 per cent) and, last of all, Medicine/Pharmacy (15 per cent). There are some variations across time, notably in the Sciences, where the success rates have risen notably in the 2004 cohort and in Medicine and Pharmacy where, on the contrary, it has diminished, but the general order remains the same in all the cohorts from 1998 to 2008.

We see here the socially differentiated choices of the education fields: upper-class children who enroll at the UPJV choose above all Sciences

and Medicine/Pharmacy, while at the secondary-school they already prepared the most prestigious scientific baccalauréat; 'bac S' (Sautory 2007). Upper-class children with an Arts or Economic 'baccalauréat' generally do not go to universities, and even less to peripheral (in France) universities as represented by Amiens, but to highly selective, often also private, higher education courses. So there are very few of this type of student at the IUT, Arts and economics courses. While upper-class children prefer scientific and medical studies at the main campus in Amiens, the latter are the least graduating of all the education fields at the UPJV in an interval of five years. These students are likely to obtain a Medicine or Pharmacy qualification after five years, but also to leave the UPJV to go elsewhere, in order to find a particular specialization in another university or to go to another selective higher education course, and so leave our sample.

This first analysis summarizes the social inequalities of access to different university studies. Nevertheless, since at the *Beauvaisian* campus the number of students enrolling in the IUT is much higher than those enrolling in Sciences or Literary courses, yet it does not help to understand the role of the peripheral campus which is supposed to adapt its pedagogic approach to the working-class *habitus*.

An analysis of the whole field of the UPJV contains very different and contradictory sub-fields, which need to be studied separately. Therefore we will conduct a second MCA in the restricted field of sciences (Figure 2). Here again we will keep two axes for our analysis, and interpret categories in plane 1–2.

As expected, the first principal plane of this MCA shows that the scientific subfield is more homogeneous than that of the whole UPJV (the overall variance is 1.8 in the scientific field, against 2.8 in the whole UPJV field (see Annex 2)). As we can see from Figure 2, in the bottom right part of the plane of axes 1 and 2, being a student at Beauvais is close to the category low cultural capital and coming from working-class families (PCS pop) and having less educational capital (nineteen years+, 'Bac ES', 'passable'). Nevertheless, enrolled in chemistry at Beauvais, the supplementary variable 'obtain two and three year diplomas' ('Bac+2, Bac+3)' is situated in this part of the space. Students enrolled in Amiens are more likely not to obtain any diploma in five years, or, for some of them, a Master's degree.[7] This MCA summarizes the particularities observed above in the subfield of Sciences at the UPJV.

The comparison between the whole UPJV-field and the sub-field of sciences, underlines that the global statistical analyses do not reveal some particularities. It was only after our meeting with *Beauvaisian* students which revealed the possible advantages for working-class students to choose proximity campus courses, which enabled them to obtain university diplomas without having to leave their habitual social environment.

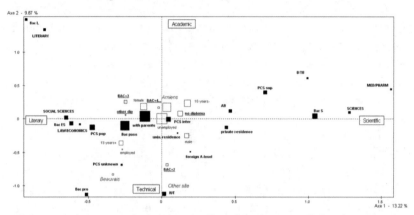

Figure 1 Cohort 2004 of Secondary Graduated Students Enrolled in the UPJV in 2004, Specific MCA with Choice of Active Categories
Source: Apo-Pic, UPJV, 1998–2008. For details, see Annex 1.

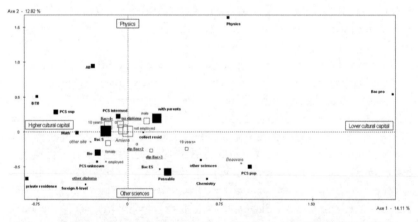

Figure 2 Cohort 2004 of Secondary Graduated Students Enrolled in SCIENCES at the UPJV in 2004, Specific MCA with Choice of Active Categories
Source: Apo-Pic, UPJV, 1998–2008. For details, see Annex 2.

Conclusions

As predicted by Bourdieu and Passeron's analysis, social selection in the first years of study increases as the percentage of working-class children and particularly of those with less educational capital increases in the less selective education fields of the UPJV: Literary disciplines, Social Sciences, Law-Economics, and especially the peripheral campus of Beauvais. But nevertheless, by choosing the less privileged peripheral campus in certain education fields (such as Sciences), the same disadvantaged students may obtain their diplomas more easily than their peers enrolled at the main campus at Amiens. The reason for this higher success rate probably lies in the organization of the teaching which is more adapted to the popular *habitus*: students can stay at home, so they are less pressurized into taking a job, they continue their secondary socialization patterns in the sense of meeting mainly on the campus without being excluded from university sociability – since all students do so –, the professors pay more attention to each student because the class sizes are usually similar to those in the secondary-school, students participate in the lessons because upper-class students are less present at Beauvais, and so on.

But the higher success rate at Beauvais concerns only Sciences, where the professorial team makes a particular effort to maintain the same scientific levels at both campuses, with the same teaching team, content and examinations, whilst this is not quite the case in the other disciplines. At the same time, competencies in the Arts are perhaps more dependent than technical and scientific ones on family background, as expressed by Bourdieu and Passeron (1970: 144). In other words, the influence of higher education should in any case be greater in Sciences and Technical courses than in Arts courses. It is also possible that the Science Faculties needed to retain their students earlier on in their courses more than the other education fields of the UPJV. In turn this brought about improvements in pedagogical practices, which had particular benefits for the working-class students at Beauvais. Nevertheless, in any case it demonstrates that such pedagogic efforts can be successful.

The results of our MCA remind us that the higher success rate in Sciences at the peripheral campus of Beauvais represents a marginal sub-field in the UPJV, and also that *Beauvaisian* Science students will generally obtain less important diplomas than those of Amiens. However, in regard to the high rate of drop-out without any diploma, we can say that the peripheral campus of *Beauvais* contributes to the democratization of university diplomas in the scientific subfield. For working-class children, and particularly for those with low educational capital, remaining in their usual social environment can be an advantage. In other words, if the professorial team and the university are enabled to do their jobs correctly at peripheral campuses, access to Higher Education diplomas can be widened to include not only the technical university courses – as shown by the systematically high success rates in the IUT – but also by adapted academic courses.

In conclusion, we can affirm that the peripheral Beauvais campus represents an establishment of relegation, since upper-class students increasingly avoid it and the diplomas obtained by its students are the lowest ones, but at the same time, if the peripheral campus is not considered as such by the professorial team, it offers a supplementary chance for less qualified working-class students to obtain a university diploma.

Annex 1: Specific MCA, Cohort 2004, UPJV

Table 3 Variances of Axes (Eigenvalues λ), MCA Cohort 2004, UPJV

Axis	Eigenvalue λ	Variance rate (% of overall variance)	% cumul
1	0.3713	13.22	13.22
2	0.2773	9.87	23.09
3	0.2412	8.59	31.68
4	0.2162	7.70	39.38
5	0.2112	7.52	46.90

6	0.2054	7.31	54.21
7	0.2035	7.25	61.45
8	0.1963	6.99	68.44
9	0.1832	6.52	74.96
10	0.1762	6.27	81.24
11	0.1699	6.05	87.28
12	0.1547	5.51	92.79
13	0.1273	4.53	97.32
14	0.0668	2.38	99.70
15	0.0047	0.17	99.87
16	0.0036	0.13	99.99
17	0.0001	0.00	100.00
18	0.0001	0.00	100.00
19	0.0000	0.00	100.00
Overall variance	2.80907		

Annex 2: Specific MCA, Sciences, Cohort 2004

Table 4 Variances of Axes (Eigenvalues λ), MCA Cohort 2004, Sciences

Axis	Eigenvalue λ	Variance rate (% of overall variance)	% cumul
1	0.2613	14.11	14.11
2	0.2375	12.82	26.93
3	0.2230	12.04	38.97
4	0.2130	11.50	50.47
5	0.2012	10.86	61.34
6	0.1917	10.35	71.69

7	0.1662	8.97	80.66
8	0.1596	8.62	89.28
9	0.1520	8.21	97.49
10	0.0190	1.02	98.51
11	0.0141	0.76	99.27
12	0.0084	0.45	99.72
13	0.0052	0.28	100.00
14	0.0000	0.00	100.00
Overall variance	1.85192		

Endnotes

1 A part of this significant difference in the success rate in the Sciences in the 2004 cohort at Beauvais and Amiens is due to the fact that a part of the higher class students (middle-class and upper-class) who were enrolled in these subjects at Amiens in their first university year will subsequently move to Medicine or Pharmacy and, by doing so, will not obtain a diploma within five years. If we exclude those students from our sample, the difference between Beauvais-Amiens will decrease to eighteen points for the working-class students and to thirteen points for the higher class students; if one considers that all of those students enrolling in Medicine/Pharmacy are likely to obtain a diploma after five years, the advantage of Beauvais will decrease to thirteen points for working-class students and to only one point for higher class students (Source: 'Apo-Pic', UPJV).

2 While Literary and Social Science courses usually come under the category of 'Arts Faculties', here I have divided them into two parts because the literary courses are the only ones which are taught on both the main and the peripheral campus.

3 Here we use American High School graduation distinctions because they are divided into four categories and so are more similar to the French ones than the English ones.

4 The scholarship has already been integrated into the socio-professional categories whose frontiers have been redressed according to the scholarship-rate.

5 Not so far from this pole, close to the origin, is the supplementary category 'no success' in obtaining qualification.

6 Since the information is collected at enrolment, at the beginning of studies, the number of students who have already left their parents is very limited in the entire sample. Generally it concerns atypical geographic trajectories.

7 At Beauvais chemistry and biology courses are combined but our data result more at chemistry. The diploma 'Bac+2' is a technical diploma and indicates that some of the science students at Beauvais have changed to an IUT inside the UPJV, where they then obtained a DUT. Generally, there are fewer graduates from physics and mathematics than from biology and chemistry. The aforementioned *Beauvaisian* advantage over Amiens regarding success rates in the sciences is also true in each scientific discipline analysed separately.

YLVA BERGSTRÖM AND TOBIAS DALBERG

Education, Social Class and Politics: The Political Space of Swedish Youth in Uppsala

Introduction

The decline in citizens' political participation in Western societies has been of growing interest for academics over the past few decades. It can of course be identified as a potential risk to the political systems in terms of losing their legitimacy and undermining key relationships between citizens and the state, many of which are sustained by political parties (Putman 2000). Of much concern is young citizens' absence from political parties and their disengagement in local political communities (Michelletti 2003). However, going hand in hand with the trend of decline in political party membership and party activism, contemporary research recognizes the rise of relatively new forms of political participation, having their origins in wider social and technological changes (Inglehart 1971). This mode of political activism includes consumer politics, demonstrations, public protests and 'sit-ins' and canvassing. Along with social forums like global justice campaigns, this has changed the landscape of possible action and offers new arenas and alternatives to traditional forms of political activities such as joining a political party. It is also recognized that these political movements are far from homogenous. They consist of diverse interests ranging from social justice, environmental protection and human rights issues to formerly more traditional issues of economic redistribution and labour politics and seem to resemble a diverse group of activists with a heterogeneous social background (Pakulski 1995).

Of central concern is how it is possible to grasp the complexity of contemporary political agendas and a changing social structure? The aim of this chapter is twofold: (1) to understand the relationship between political interests, opinions and attitudes and (2) to examine the correspondence between the space of political position-takings and educational position and social origin.

Over the past few decades it has been commonly accepted among some scholars of political science and sociology, that social and cultural change has led to an upheaval in traditional political value orientations and systems, as if there existed a new *and* an old political agenda dividing generations in their political orientation and engagement (Inglehart 1990). The kernel of Ronald Inglehart's argument (whose work has been the most empirically wide-ranging in exploring cultural transformations), is that important groups in western societies are acting in pursuit of goals which no longer have a substantial relationship towards the imperatives of economic security. He argues that 'for the younger cohort, a set of "post-bourgeois" values, relating to the need for belonging and to aesthetic and intellectual needs would be more likely to take top priorities' (Inglehart 1971). Whereas previous generations were more likely to orient their political opinions and voting behaviour out of material interests in wealth and security, the new and younger generations are more likely to orient their political convictions out of post-materialist interests in the form of individual freedom and self-expression (Inglehart 1997). The shift towards post-materialist values has brought about a shift in the political agenda in advanced industrial societies; a rising concern for environmental protection, human rights, LGBT and equality issues and generally moving away from emphasis on economic growth. As such it has, in turn, brought a shift from politics divided by class conflict towards clashes based on issues concerning cultural differences and values around the quality of life. Over time, and due to the growing complexity of the political agenda and a trend where traditional hierarchies are replaced by new criteria of social hierarchies, social class is claimed to lose its analytic strength in explaining changes in political attitude, voting behaviour and party loyalties (Lipset et al. 1993).

Our point of departure, inspired by Pierre Bourdieu's classical sociology, is however to examine the underpinning of a multidimensional political

space (Bourdieu 1984). The question is how different political opinions, attitudes and values are related to one another as distinct and coexisting positions? How close or distant are so called old traditional political issues on redistribution related to environmental issues and questions concerning international relations? Is it possible to discern proximity between LGBT, human rights issues and what other political issues are they possibly juxtaposed to? How are issues on income taxes related to privatization of welfare institutions? Rather than seeing attitudes as the private view of respondents, with a set of given social attributes, the point is to assess how far attitudes are opposed to and adhere to others through being located in different places in a political space.

Contrary to the argument that social class has vanished as a structuring factor of political opinions, we are concerned about the relationship between social position and political position-takings. In this context class is conceptualized as a multidimensional phenomenon in order to unravel a correspondence between social position and political position-takings (for example opinions, attitudes and interests). In Bourdieu's classical work *Distinction*, the probability of leaning towards the political left or the right depended at least as much on the relative weight of cultural and economic capital, as on the relative weight of the volume of capital possessed itself (Bourdieu 1984). The opposition between intellectuals and industrial employers, or on a lower level of overall capital and social hierarchy, between primary teachers and small merchants, illustrates the source of differences in disposition, which is, in position-takings. In a recent application of Bourdieu's analytical approach to Danish survey data, Sommer Harrits et al. demonstrate a homology between the social space and space of political attitudes. The economic fraction is distinguished from the cultural fraction through oppositions between right-wing old politics (economic fraction) and left-wing new politics (cultural fraction). Further, they unveil how capital composition divide the traditional left-right politics in Denmark, whilst capital volume appears to influence voting behaviour in matters of choosing between particular parties within the respective left and right blocks (Sommer Harrits et al. 2009).

Methodology

The data stems from a survey conducted among third grade students in upper secondary schools in Uppsala in 2008. Being a town with academic traditions, the population of Uppsala is characterized by high levels of educational attainment. From the initial number of 1,097[1] individuals in the survey we have selected 538 for the construction of the political space. This selection was been done in order to keep those individuals with the least number of non-responses.[2]

Out of a total of ninety three questions measuring political attitudes opinions and interests, twenty four questions were selected based on their content and contribution to the constructed political space. These twenty four questions may be divided into five thematically different subgroups covering the main topics of the contemporary political debate in Sweden (see Table 1 below).

Table 1 Questions Used as Active Variables

Topic	*What is your opinion on...?*	*How interested are you in...?*
Liberal economy	Lowering the taxes on high incomes	National economy
	Avoid privatizing hospitals	Domestic economy
	Decrease income inequality	
Cultural pluralism/ ethnocentrism	Allow fewer refugees	Foreign labour rights
	Increase economic support for immigrants' cultural practices	
	Increase support for immigrants' development of native language	
Environmental issues	Increase the gas taxes for the sake of environmental improvement	Environmental issues
	Stop private motoring in the cities	Animal rights
	Preserve nuclear power after 2010	

	Sweden should become member of EMU	Questions related to the EU
Supra-nationality	Sweden should terminate EU-membership	
	Develop EU into European United States	
	Sweden should apply for NATO membership	
	How much trust do you put in the work of the following...? institutions?	
	Government	
Trust/confidence in established society and its authorities	Parliament	
	City council	
	EU-parliament	
	Political parties	

As for the variables used to analyse the significance of social origin and educational position for political position-taking, we have employed rather broad classifications on both social origin and educational position each of which has seven categories (cf. Table 6, Appendix). Social origin ranges from 'working class' to the 'professions' and the 'upper middle classes'. The middle classes are separated into cultural and economic fractions.[3] The seven categories of educational position are mainly based on differences in curricular content.[4] In addition to these variables, gender will also be taken into account.

Correspondence Analysis

The family of data analysis techniques known as Geometric Data Analysis (GDA) offers a couple of well suited methods for the purpose of identifying different dimensions in a multivariate data set. A common approach to

the kind of data under scrutiny in this chapter is Multiple Correspondence Analysis (MCA) in which data is represented as clouds of points. However, employing MCA to a Likert scale response set tends to generate a so-called Guttman effect (Le Roux and Rouanet 2004) where the MCA reveals an underlying one-dimensional structure, which takes a parabolic shape in the principal plane. This is certainly true for our data set, which is why we have opted for Correspondence Analysis (CA). In order to employ CA, the active variables have been recoded according to a doubling technique, which in this case is a dichotomization of the variables (Le Roux and Rouanet 2004); see Table 2 below. Hence CA will be applied to a table of Individuals × Variables with a doubling of variables.[5]

Table 2 Recoding of Variables Using Doubling Technique: An Example

Raw responses	Doubled (recoded) variables	
How interested are you in environmental issues?	InterestedInEnvironmentalIssues_–	InterestedInEnvironmentalIssues_+
Very interested	0	4
Interested	1	3
Moderately interested	2	2
Not that interested	3	1
Not interested at all	4	0

The first axis is the most important and it contributes to 22 per cent of the total variance. The second axis contributes to 13 per cent, and the third to 9 per cent. Together these three axes contribute to 43 per cent of the total variance.

Table 3 Variances of Axes

	Axis 1	Axis 2	Axis 3
Eigenvalues	0.0895	0.0542	0.0351
Percentage of total inertia	21.75	13.17	8.52
Cumulated percentage	21.75	34.91	43.43

An initial analysis of the contribution by points to each of the first three axes shows that the first axis is mainly concerned with economic, ethnocentric, and environmental issues (see Table 4 below). Environmental issues contribute the most, 32 per cent, followed by ethnocentrism and liberal economy, 28 and 25 per cent respectively. Issues of trust in established institutions, 43 per cent, and supra-nationality, 29 per cent, contribute the most to the second axis. On the third axis, issues of liberal economy contribute the most, 45 per cent, followed by supra-nationality, 21 per cent. One can also notice that the axes relate to different kinds of questions and their format. On the first axis, questions where the respondent is asked to give his or her opinion (agree/disagree) on different issues have the largest contribution, 87 per cent. Questions where respondents were asked to take a position on political issues were also the most common among the questions in the present analysis. On the second axis, questions on the degree of trust the respondents put into different established institutions, contributes the most, 43 per cent, followed by questions of the opinion format, 38 per cent. Questions concerning the degree of interest the respondents have in different issues have the largest contribution to the third axis, 72 per cent.

Table 4 Contributions to the First Three Axes by Theme and by Type of Question

Theme	Axis 1	Axis 2	Axis 3
Liberal economy	24.90	7.20	44.75
Cultural pluralism-ethnocentrism	27.80	10.83	11.53
Environmental issues	31.93	10.53	12.78
Supra-nationality	14.14	28.74	21.11
Trust in established institutions	1.23	42.71	9.83
Total	100.00	100.00	100.00

Type of question			
Interests	11.27	19.37	71.52
Opinions	87.49	37.92	18.65
Trust	1.23	42.71	9.83
Total	100.00	100.00	100.00

The Political Space of Upper Secondary Students in Uppsala

The political space among upper secondary students in Uppsala is mainly structured in three dimensions of which the first two will be studied in detail below. The first dimension is constituted by differing opinions on different issues, the second by 'Trust versus Distrust' in established political institutions and attitudes towards Swedish EU-membership and EU-policy, and the third dimension is one of interest vs. disinterest in different political issues.

Figure 1 presents the plane of axis 1 and 2 and the variables that have contributed above average to the establishment of these two axes. The first, horizontal axis is characterized by different opinions on redistribution issues, as well as issues dealing with environmental protection and cultural pluralism; these can be related to so called 'post-materialistic' values. On the right hand side we find attitudes that are positive towards lower taxes on high income and private hospital profits, as well as a more positive attitude towards NATO membership and nuclear power. Together with these we also find attitudes that are more negative towards income equality, cultural support to immigrants and attitudes in favour of a restrained refugee policy. On the opposite, left hand side, attitudes in favour of redistribution and a more egalitarian approach to welfare issues are found, i.e. position-takings that are more positive towards income equality and a more negative attitude towards a lowering of high income taxes and private hospital profits. On the left hand side of the figure we also find attitudes that are more positive towards cultural support to immigrants and negative towards a restrained refugee policy, as well as a more positive approach towards increased taxes on gasoline and more negative towards nuclear power.

Issues of trust versus distrust establish the opposition on the second vertical, axis. In the upper part of Figure 1 there is a stronger trust in established institutions – the government, the national and European parliament, the communal council and in political parties – and also an attitude that may be characterized as more open to participation in the European community, here measured by attitudes towards Swedish membership in EU and EMU as well as general interest in questions regarding the EU. In the lower part of Figure 1 we have the opposite attitudes i.e. distrust towards established institutions and resistance towards Swedish participation in the European community.

The third dimension, as mentioned above, is characterized by oppositions between interest and disinterest in issues such as national and domestic economics, issues regarding the EU, and foreign labour rights (see Table 5, Appendix).

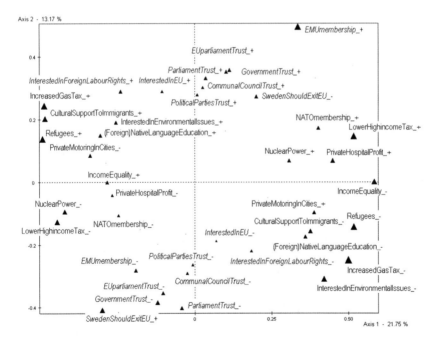

Figure 1 Space of Political Opinions and Attitudes Plane of Axis 1 and 2

Given the character of the oppositions on the first axis our analysis lays bare that the suggested shift from old politics, where the conflict is drawn along materialist interests in wealth and security, to new politics oriented towards post-materialist interests in qualities in life, is exaggerated. Old and new political conflict lines seem to be intertwined rather than kept apart. Issues of redistribution, i.e. old politics, appears juxtaposed to environmental and ethnic/cultural issues, i.e. new politics.

So far we have dealt with the cloud of modalities in the principal plane of axis 1 and 2. However, one must not forget that the relations established between modalities i.e. proximity and distances reflect different attitudes or, if you will, political position-taking among individuals. This does raise the question as to what extent are there juxtaposed political position-takings that could actually be interpreted as coherent discrete political orientations that resemble similar political position-takings and are distanced to opposed opinions?

In order to interpret the distinct and coexisting political position-takings and their correspondence to social and educational assets, an Ascending Hierarchical Clustering (AHC) was performed on the first three axes. We have chosen to interpret a partition into four clusters, for which our sociological interpretation has the greatest viability.[6] These four different clusters of political orientations among individuals are presented in Figure 2, where the cloud of individuals in the principal plane of axis 1 and 2 is displayed. They are characterized by orientations in the political space and of social origin and educational position.

The first, a 'Left-wing', cluster is characterized by position-takings for environmental protection by grouping those who advocate economic redistribution, and hold positive attitudes towards refugees and cultural pluralism as well as those who advocate withdrawal of Swedish membership in EU. The willingness to exit the EU does not prevent individuals in this cluster from a considerable interest in issues relating to the EU. Students from social science programmes with a language or culture orientation and students from aesthetic, media and commerce programmes are overrepresented in this cluster. Daughters of a cultural upper middle class and a cultural middle class origin are overrepresented in this cluster.

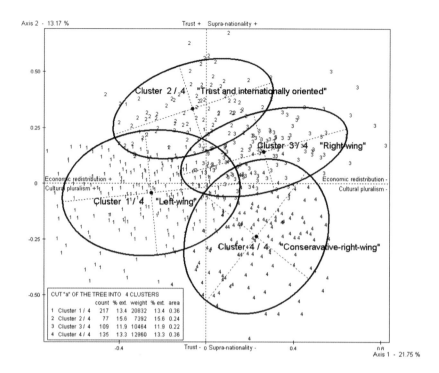

Figure 2 Cloud of Individuals and Partition 3 into 4 Clusters

The second, a 'Trust and internationally oriented', cluster mainly gathers those who avoid strong positions for either a left-wing or right-wing orientation. Holders of this position are trustful in the Swedish parliament and the political parties, as well as in the EU parliament. Here we find an interest in domestic economy, in foreign labour rights and EU-policy, and those who are reluctant to exit the EU. Students from natural science programmes are overrepresented in this cluster. Daughters with a professional (for example, physicians) upper class origin are overrepresented.

The third, 'Right-wing', cluster is characterized by political liberalism, attitudes approving of private hospital profit making and advocating wage dispersion, coupled with a substantial interest in economic issues. There is also a high level of trust in established institutions; both on a national

and supra-national level, among those whose political position-takings are gathered in this third cluster. Students from technology programmes, social science programmes with an economic orientation and international baccalaureate are overrepresented in this cluster. So too are the sons with a professional and cultural middle class origin, as well as the sons and daughters of economic middle class origin.

The fourth, 'Conservative-right-wing', cluster is characterized by low trust and a tendency to not agree with most of the statements, except when it comes to Swedish refugee policy. Here we find those who strongly agree that Sweden should allow fewer refugees, and also hold a non-egalitarian attitude towards immigrants. Notably there is a marked overrepresentation of position-takings against increased gas taxes. Students from vocational programmes, especially vehicle and electricity, are overrepresented in this cluster as are daughters and above all sons of the working class (and unemployed).

Discussion

These four clusters have unveiled the relationship between distance and proximity in opinions on the one hand, and how coherent and discrete political orientations correspond with educational position and social origin on the other hand. Students on the natural science programmes are overrepresented in cluster 2. This means that these students harbour a high degree of trust in the political system and are oriented towards international issues of labour rights. They also exhibit an egalitarian attitude towards immigrants and interest in national economy. An equally clear resemblance in political *position-takings*, as the re-distribution issues that divide the left-wing and right-wing positions in the first and third cluster, is not noted here. The natural science programme is an exclusive educational position marked by a high social recruitment and gender balance, as well as a relatively even spread between economic and cultural class fractions. Here we find holders of a great overall volume of capital, for example, the

sons and daughters of employers, CEOs, and university professors. As visualized in Figure 2, from the point of view of the relative weight of overall volume, the second cluster is thus undoubtedly opposed to those who are most deprived, that is sons and daughters of unskilled workers that are overrepresented in cluster 4 in the lower level of Figure 2, and gathered around a conservative-right political position-taking.

From the point of view of the relative weight of inherited cultural and economic assets, sons and daughters of university professors tend to be opposed to sons and daughters of employers and CEOs. On a lower level in the social hierarchy, sons and daughters of compulsory school-teachers are opposed to sons and daughters of small businessmen and merchants. The marked distance between the left-wing cluster and the right-wing cluster, corresponds with economic and cultural class fractions respectively and a horizontal gender differentiation. Also we found an overrepresentation of especially the daughters of the cultural middle class and upper middle class in the left-wing cluster (1). In contrast, the sons and to some extent daughters of economic middle class and upper middle class are positioned on the opposite side in the right-wing cluster. This distance in position-taking not only corresponds with distances between economic and cultural class fractions, it also corresponds with educational position as well. The female dominated social science programmes (with language and cultural orientations), overshadowing the first cluster are distanced from the male dominated technical programmes overrepresented in the third cluster. The farthest vertical distance between the internationally oriented cluster and the conservative right-wing cluster correspond with a large gap between educational positions on natural science programmes and the educational position on vocational programs 'vehicle' and 'electricity'. We find the strongest confidence in the political system among girls and boys in natural science programmes and the least among boys in the 'vehicle' and 'electricity' programmes. Likewise, we find the strongest support for an egalitarian approach towards immigrants among girls with a cultural middle and upper middle class, and the weakest protection for so called cultural pluralism is among boys from working class. Thus we can conclude that the cluster analysis unveils a vertical hierarchic distinction, which is structured by class and a horizontal distinction structured by class fraction and gender.

From a sociological point of view there is an interesting difference between the international orientation in cluster 2 and the conservative right-wing orientation in cluster 4 which can be traced back to the character of issues at hand. EU-policy, EMU-membership, foreign labour rights are more abstract in language as well as in subject, without direct reference to the experience of everyday life, than issues such as gas taxes. The more specifically political or politically scientific the question, the larger the difference in propensity to answer them can be seen between those with least and most inherited educational assets, as well as between students on vocational programmes and preparatory programmes. It is among individuals with high grades and whose parents invested a considerable amount of time in higher education that we find those who actually produce an opinion on the more abstract issues. Conversely, individuals with fewer educational assets, those from families with less or no academic experience, attending vocational programmes, produce fewer opinions the more abstract the issue becomes. However, these differences disappear the more concrete and everyday the issue is, such as gas taxes, the right to free abortion. The probability to respond and produce an opinion relates to what can be called a theoretical point of view. In Bourdieu's terminology a 'vision scolastique'; scholastic view (Bourdieu 1998b), which are qualities that those programmes that prepare for higher education also prepare for – in other words, both to the qualities of the question and of the individual. Bourdieu unravelled the correspondence between social and cultural position and the preparedness to produce a political opinion, and how scholastic point of view is the very condition of that which we usually call the political (Bourdieu 1984a).

Political skills – that is the ability and willingness to take a stand – are intimately associated with qualities that academic programmes prepare for. This is especially so for the students at the prestigious science programme who seem to value what we, with reference to Bourdieu, call a scholastic view. It also corresponds, however, with a kind of class ethos or a class habitus. We witness here a *readiness* to provide an answer to political questions (as much as anything).

The large distance between the international orientation and the conservative right-wing orientation ultimately relates to social class and then not only in the sense of a class ethos, but more as a feeling of a class' social conditions. The egalitarian attitude towards immigrants, and an interest in international issues, is shared by those whose existential security in the knowledge society is secured in an educational position, thus keeping the doors for future educational investments open. The distance between those who trust the political system and those who do not, follows the large gap between those who are in position with a high volume of overall capital and those deprived of it. In a similar vein it is mainly the students on natural science programmes and students on the language and cultural oriented social science programmes that have adopted the novel post-material political values. Thus, we can conclude that these findings detect a homology between social structures, the field of education and political space.

Finally, we conclude that by employing a theoretical framework inspired by the works of Bourdieu, and methodologically constructing a political space using techniques in line with the theoretical point of departure, we argue that the political space of Swedish youth in Uppsala is structured by social and educational conditions. The method of correspondence analysis reveals the relations between different political orientations and unveils the way the political cleavage between old traditional political redistribution issues are intertwined with a clash on multicultural issues and environmental protection. Considered all together the analysis illustrates an almost hierarchical order of political socialization where not only different opinions, but rather the interaction of interest, trust in political institutions and opinion – or political position-takings – outline what tend to be a homology between social structures and political orientations.

Appendix

Table 5 Variables with Contributions Above Average, Axis 13.

Axis 1	Ctr	Positive side	Ctr	Negative side	Ctr
Refugee policy	12.0	refugees_-	6.1	refugees_+	5.9
Increase taxes on gasoline	11.4	gas_tax_-	5.8	gas_tax_+	5.7
Lower high income tax	10.8	lower_highinc_tax_+	5.8	lower_highinc_tax_-	5.0
Cultural support to immigrants	8.6	cult_support_immigr_-	3.7	cult_support_immigr_+	4.8
Income equality	7.8	inc_equality_-	5.2	inc_equality_+	2.6
Private motoring in cities	6.2	priv_motoring_cities_+	3.3	priv_motoring_cities_-	2.9
Preserve nuclear power	6.1	nuclear_power_+	2.6	nuclear_power_-	3.5
Private hospital profit	5.7	priv_hosp_profit_+	3.5	priv_hosp_profit_-	2.1
Support to immigrants' native language education	5.2	native_lang_edu_-	2.8	native_lang_edu_+	2.4
Interest in environmental issues	5.0	intrst_environ_iss_-	3.1	intrst_environ_iss_+	1.9
NATO membership	4.7	NATO_memb_+	2.9	NATO_memb_-	1.8
Total	83.4		44.8		38.6
Axis 2	Ctr	Positive side	Ctr	Negative side	Ctr
EMU membership	10.7	EMU_memb_+	6.8	EMU_memb_-	3.9
Trust in Swedish government	10.6	government_tr_+	5.1	government_tr_-	5.5

	Ctr	Positive side	Ctr	Negative side	Ctr
Trust in Swedish parliament	10.2	parliment_tr_+	4.6	parliment_tr_-	5.6
Trust in EU parliament	9.6	EU_parliament_tr_+	4.8	EU_parliament_tr_-	4.8
Sweden should exit EU	8.6	Exit_EU_-	3.4	Exit_EU_+	5.2
Trust in communal council	6.7	communal_council_tr_+	3.4	communal_council_tr_-	3.3
Trust in political parties	5.6	political_parties_tr_+	2.9	political_parties_tr_-	2.7
Interest in foreign labour rights	4.9	intrst_foreign_lab_rights_+	2.8	intrst_foreign_lab_rights_-	2.1
Increase taxes on gasoline	4.7	gas_tax_+	2.3	gas_tax_-	2.4
Interest in environmental issues	4.5	intrst_environ_iss_+	1.7	intrst_environ_iss_-	2.8
Interest in EU issues	4.2	intrst_EU_+	2.5	intrst_EU_-	1.6
Total	80.2		40.3		39.9
Axis 3	Ctr	Positive side	Ctr	Negative side	Ctr
Interest in national economics	24.8	intrst_nat_economics_+	14.6	intrst_nat_economics_-	10.1
Interest in domestic economics	17.6	intrst_domes_economics_+	7.9	intrst_domes_economics_-	9.7
Interest in EU issues	10.4	intrst_EU_+	6.3	intrst_EU_-	4.1
Sweden should exit EU	9.3	Exit_EU_-	3.7	Exit_EU_+	5.6
Interest in foreign labour rights	8.0	intrst_foreign_lab_rights_+	4.5	intrst_foreign_lab_rights_-	3.5
Interest in animal rights	5.9	intrst_anim_rights_+	3.2	intrst_anim_rights_-	2.7
Interest in environmental issues	4.9	intrst_environ_iss_+	1.8	intrst_environ_iss_-	3.0
Total	80.8		42.2		38.6

Table 6 Educational Programme, Social Origin and Gender – Representation in Four Clusters

Characteristic categories	Subpopulation selected for CA						Total population	
	N	% of category in set	c1	c2	c3	c4	N	%
Gender								
Women	279	51.9	65.9	54.5	36.7	40.0	583	53.1
Men	251	46.7	31.8	45.5	61.5	59.3	490	44.7
Gender-n/a	8	1.5	2.3	0.0	1.8	0.7	24	2.2
Total	538	100.0	100.0	100.0	100.0	100.0	1097	100.0
Educational programme								
Natural science	111	20.6	22.1	32.5	23.9	8.9	172	15.7
Technology programme	42	7.8	3.7	9.1	11.0	11.1	68	6.2
Social science – languages and culture	76	14.1	25.3	19.5	2.8	2.2	129	11.8
Social science – economic; International Baccalaureate	116	21.6	14.3	22.1	36.7	20.7	210	19.1
Aesthetics; Media; Commerce	89	16.5	24.9	9.1	8.3	14.1	210	19.1

Health Care; Handicraft; Food; Hotel and restaurant programmes	44	8.2	6.0	3.9	7.3	14.8	134	12.2
Construction programme; Vehicle programme; Electricity programme	60	11.2	3.7	3.9	10.1	28.1	174	15.9
Total	538	100.0	100.0	100.0	100.0	100.0	1097	100.0
Social origin (Class+fraction)								
Professions	58	10.8	11.5	18.2	10.1	5.9	92	8.4
Economic upper middle class	35	6.5	6.5	7.8	9.2	3.7	55	5.0
Cultural upper middle class	31	5.8	7.8	9.1	2.8	3.0	47	4.3
Economic middle class	96	17.8	13.8	19.5	27.5	15.6	203	18.5
Cultural middle class	115	21.4	26.3	16.9	22.9	14.8	203	18.5
Working class	157	29.2	27.2	19.5	22.0	43.7	355	32.4
Unemployed, no answer	46	8.6	6.9	9.1	5.5	13.3	142	12.9
Total	538	100.0	100.0	100.0	100.0	100.0	1097	100.0

Table 7 Overrepresented Modalities in Clusters 1 and 2

Variables	C1			C2		
	Modality	% of category in group	% of category % in set	Modality	% of category in group	% of category % in set
Income equality	++	52.5	31.6	+	35.1	28.4
Interest in domestic economics	-	24.0	16.5	+	49.4	27.0
Interest in national economics	-	30.4	25.7	+	32.5	16.4
Lower high income tax	-	57.6	36.1	+	24.7	19.2
Ban private hospital profit	++	50.2	29.0	+	29.9	21.4
Cultural support to immigrants	+	36.4	21.4	+-	46.8	30.5
Interest in foreign labour rights	+-	35.9	30.1	+	39.0	16.0
Allow less refugees	-	55.3	32.3	-	44.2	32.3
Support to immigrants' native language education	++	22.1	13.4	+	41.6	27.5
Increase taxes on gasoline	++	32.3	19.3	+	48.1	24.5
Interest in animal rights	++	17.1	10.6	+-	44.2	29.2

Interest in environmental issues	++	35.5	24.2	++	40.3	24.2
Preserve nuclear power	-	38.7	20.8	+	26.0	16.5
Stop private motoring in cities	++	24.4	14.3	+	39.0	26.2
EMU membership	-	61.8	42.2	++	27.3	10.2
Interest in EU issues	+	17.5	15.8	+	32.5	15.8
Make EU into a United States	-	64.5	48.1	+-	24.7	17.1
NATO membership	-	56.2	35.1	+	16.9	9.1
Sweden should exit EU	+	19.8	13.0	-	71.4	41.5
Trust in communal council	+-	56.7	48.9	+	61.0	21.9
Trust in EU parliament	-	28.6	16.5	+	53.3	21.6
Trust in political parties	-	24.4	18.6	+	50.7	21.6
Trust in Swedish government	+-	49.3	37.7	+	62.3	27.7
Trust in Swedish parliament	+-	52.1	38.5	+	62.3	32.0

Table 8 Overrepresented Modalities in Clusters 3 and 4

Variables	c3			c4		
	Modality	% of category in group	% of category % in set	Modality	% of category in group	% of category % in set
Income equality	+-	37.6	21.8	-	20.0	11.5
Interest in domestic economics	++	27.5	16.2	-	21.5	11.5
Interest in national economics	+-	40.4	28.1	-	41.5	21.8
Lower high income tax	++	41.3	19.3	++	27.4	19.3
Ban private hospital profit	-	30.3	14.7	+-	27.4	18.6
Cultural support to immigrants	-	50.5	31.6	-	63.0	31.6
Interest in foreign labour rights	+-	41.3	30.1	-	48.9	19.7
Allow less refugees	+	32.1	21.8	++	43.0	19.5
Support to immigrants' native language education	-	29.4	19.3	-	42.2	19.3
Increase taxes on gasoline	-	44.0	30.7	-	68.2	30.7
Interest in animal rights	+-	38.5	29.2	-	37.0	17.5

Interest in environmental issues	+-	39.5	25.7	–	27.4	7.6
Preserve nuclear power	++	43.1	28.3	–	28.9	20.5
Stop private motoring in cities	+-	35.8	26.6	-	39.3	20.8
EMU membership	+	24.8	9.3	-	52.6	42.2
Interest in EU issues	+-	47.7	32.5	–	45.2	18.6
Make EU into a United States	++	16.5	6.3	–	27.4	19.7
NATO membership	++	16.5	7.1	–	34.1	30.1
Sweden should exit EU	-	64.2	41.5	++	19.3	14.9
Trust in communal council	+-	60.6	48.9	–	20.0	8.0
Trust in EU parliament	+	34.0	21.6	–	22.2	9.7
Trust in political parties	+-	60.6	47.8	–	23.7	8.0
Trust in Swedish government	+	39.5	27.7	–	21.5	8.7
Trust in Swedish parliament	+	50.5	32.0	–	22.2	8.2

Endnotes

1 In total there were 2,507 individuals enrolled in the third year of upper secondary school in Uppsala in the school year of 2008/09, not counting the schools with a private principal organizer to whom we were not allowed access (544 individuals). Our survey therefore covers two fifths of the third year student population in schools with a municipal principal organizer.

2 Keeping all 1,097 individuals produces a strong first axis representing the degree to which the individuals have or have not responded to the questions that are active in the correspondence analysis. As can be seen in Table 6 in the appendix this results in a slight overrepresentation of students from natural social science programmes as well as students with a social origin in professions and cultural middle classes. Students from vocational programs and students with unemployed or working class parents are slightly underrepresented.

3 The classification of social class is based on an analysis of thirty two occupational categories, open-ended comments and reported occupation within the public or private sector. As such, it is not based on an analysis of volume and composition of cultural and economic capital. Social class is here considered as an indicator of cultural and economic capital, for example, the category 'university professor' indicates high volume of both cultural and economic capital with the former being the dominant form, whereas the category 'business manager' indicates that economic capital is predominant. Hence the resulting variable for social class is a combinatorial variable.

4 The Swedish secondary school is roughly divided into programmes preparing for further studies and vocationally-oriented programmes. The former consists of natural and social science programmes and technology programmes while the latter consists of all other programmes such as construction, health care, business and administration. These programmes have been grouped together in a combinatorial variable in order to have sufficient frequencies in each group. Natural science consists of all natural science branches, and the same goes for technology programmes. The different branches of social science programmes have been divided into two categories, language and culture on one hand and economic on the other hand, based on radically different orientations both curricular-wise and political position-takings. We have also placed the International Baccalaureate in the economic social science category. The categories for the vocationally-oriented programmes consist of, in terms of curriculum, more diverse programmes which tend to be closely related in the political space in our analysis.

5 For similar uses of CA and doubling technique, see Le Roux and Perrineau (2011: 5–29).

6 The partition into four clusters accounts for 54.1 per cent of the variance of the cloud, which is just above the rule of thumb which states that 'the between-variance should be greater than the within-variance' (Le Roux and Rouanet 2004: 114).

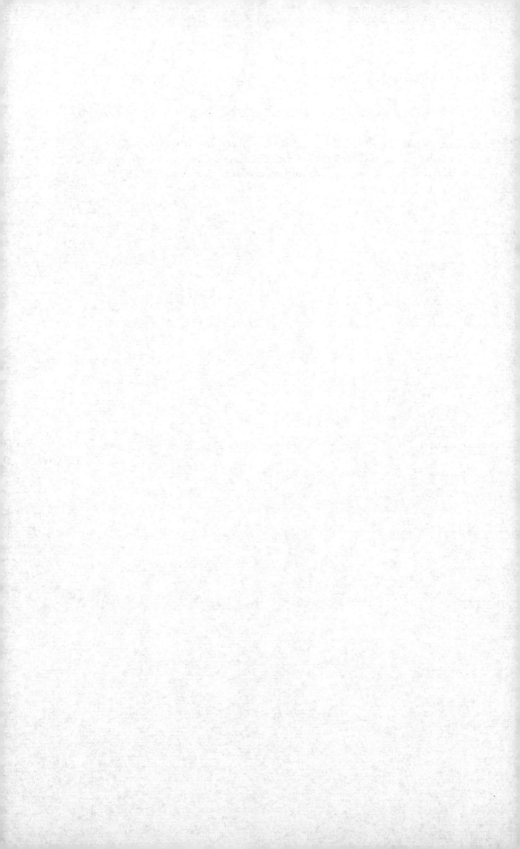

DANIEL LAURISON

Positions and Position-Takings Among Political Producers: The Field of Political Consultants

Introduction

Political consultants are an essential part of the American electoral process. Consultants shape every political message Americans hear in major elections, decide whether and how individuals will be contacted by campaigns, and create the ads flooding television and the internet as elections near. They also advise politicians once they attain elected offices, devise public relations and lobbying strategies for corporate clients, move in and out of the political party organizations, and serve as pundits and in other roles in the media. In other words, political consultants play key roles in the American field of power, producing much of the political culture experienced by ordinary Americans. This work takes its inspiration from Bourdieu's descriptions of the political field and other fields of cultural production (Bourdieu 1991a, 1993b) as well as from other work on the properties of fields and their relevance for what is produced within them (Fligstein and McAdam 2011; Armstrong and Bernstein 2008).

In this chapter, I ask: is this indeed a field with structures that map onto those found in other fields? And do consultants' opinions correspond to their positions in the field? I use a specific Multiple Correspondence Analysis (MCA) and find the answer to be 'yes' to both questions.

Context

Campaigns are usually studied in terms of their direct outcomes – winning or losing an election – but they are also producers and distributors of cultural objects. Presidential campaigns create hundreds of hours of video and audio output in speeches, commercials, conventions; they also distribute countless pages of text and images in websites, print ads, mailers, and other media. Almost all of this creative output is designed and produced by political consultants (Dulio 2004).

 Political consultants clearly exert tremendous influence over campaigns in the United States; however, their influence is relatively new historically, following a shift in the role of the political parties in American elections. Through the first half of the twentieth century, political parties were the primary mobilizing force during campaigns, coordinating the selection of candidates, the hiring of staff, the crafting of political messages, and the formulation of campaign strategy (Crotty and Jacobson 1980; Dalton and Wattenberg 2000; Wattenberg 1998). A variety of changes in electoral laws and party organizations resulted in the current system, in which candidates assemble their own campaign teams of staff and consultants (see for example, Sabato 1988; Katz and Mair 1995; Farrell and Webb 2000). This, in turn, facilitated the rise of a new type of political actor – the professional political consultant.

 'Political consultant' generally refers to someone who is paid to work on multiple races in a single election cycle (Medvic 2003). Political consulting is a relatively small, but growing, occupation. While Rosenbloom estimated that in 1972 there were 300 firms providing any services to campaigns, and about 100 that 'regularly manage[d] political campaigns' (1973:4), by 1999 James Thurber and his co-investigators (Thurber, Nelson, and Dulio n.d.) identified 2,587 individuals who were principals or senior partners in political consulting firms. A few years later, Johnson (2001) estimated that there were between 3,000 and 7,000 full-time political consultants in the United States.

When political consulting first emerged as an important and likely permanent part of the campaign landscape, scholars were primarily concerned with consultants' impact on the democratic process. Many worried that the involvement of outsiders in political campaigns meant the intrusion of market principles into politics and the likely rise of their attendant ills: increases in unethical practices, campaigns focused on image rather than substance, and decreasing accountability of elected officials. Some scholars blamed consultants for the downfall of parties (Rosenbloom 1973), while others simply accused them of taking advantage of parties' decline to their own benefit (Blumenthal 1980; Sabato 1981). These accounts and some later ones (Petracca 1989; Mancini 1999) depicted consultants as interlopers and mercenaries: public relations and advertising experts who introduced a new and mostly unwelcome style of campaigning into American politics. While it is difficult to know what motivated early entrants to the consulting field, contemporary consultants are not that different from party operatives in their reports of their motivations (Dulio 2004) or trust in citizens to make good decisions in the voting booth (Dulio and Nelson 2005). Rather than being adversaries of parties, consultants work in tandem with them, providing services parties no longer offer and collaborating to win elections (Dulio and Nelson 2005; Dulio 2004; Kolodny and Dulio 2003; Thurber and Nelson 2000, 2004; Thurber 2001; Kolodny and Logan 1998). Many scholars now think of parties as strong networks of actors which include consultants, rather than as unified entities with consultants on the outside (Skinner, Masket, and Dulio 2012; Montgomery and Nyhan 2010; J. Bernstein and Dominguez 2003; J. Bernstein 1999; Herrnson 2009).

Scholars now know a good deal about the professed motivations of political consultants, their relationships with each other, with parties, and with candidates, and their views of the electorate; and there has been some work on predictors of success among consultants (Grossmann 2009a; Montgomery and Nyhan 2010). However, there has been no analysis of the structure of the field of political consultants, nor of differences among consultants' views on campaigning and the electorate.

There have been studies of other fields of symbolic production (Bourdieu 1993b; Neff, Wissinger, and Zukin 2005; Peterson and Anand 2004), of the political field in other countries (Bourdieu 1991a; Denord et

al. 2011; Hjellbrekke et al. 2007), and of other parts of the United States political field (Medvetz 2008, 2012), but none of these have looked at political consultants particularly. These works tend to show that the structure of the field influences the approach individuals and organizations take to creating cultural objects, as well as (what is essentially the same thing) their strategies for advancing within their field. Identifying the positions and position-takings of the consultants behind the production of electoral politics in the United States is thus an important task.

Multiple Correspondence Analysis can describe the key oppositions in the field; and then show whether and how these oppositions structure consultants' opinions about voters, politics, and campaigns. This, in turn, can shed light on the kinds of cultural objects being produced by political consultants and campaigns.

Data and Descriptive Statistics

In this work, I use data from a 1999 survey of senior-level political consultants designed by Dulio, Thurber, and Nelson, conducted at the 'Center for Congressional and Presidential Studies' at American University and funded by the Pew Charitable trusts, as part of the 'Improving Campaign Conduct' grant (Thurber et al. n.d.). The research team first identified 2,587 principals and senior associates in consulting firms, then randomly selected respondents to interview; those selected for calls were only interviewed if they were active in campaigns *and* if their firm specialized in general consulting (which ranges from offering comprehensive strategic and messaging advice to essentially managing campaigns), polling, media (creating and placing TV and radio ads), fundraising, direct mail (creating and sending printed pieces), research (either data management or research on the opposing candidate), or field operations (managing face-to-face contact with constituents). The sample thus should be representative of principal and senior associate political consultants overall, except that people who

only provided services such as phoning or web design were excluded. I focus my analysis on the 402 consultants in the study who reported working on at least one Presidential, Senate, Gubernatorial, or Congressional race in the past three years, excluding the 103 who had only worked on races at lower levels of government.

Before turning to the MCA, it is worth examining the demographic composition of this field when the survey was taken. The median age was forty five; the average career at that point had been eighteen years long, and over 90 per cent of consultants had been in politics at least seven years. As noted by other studies (Dulio 2005, Dulio and Nelson 2004), the field is overwhelmingly white (95.5 per cent), college-educated (90 per cent), and male (82 per cent). Political consultants are remarkably well-educated: 98 per cent have at least some college, as compared with only 46 per cent of the over-twenty five population;[1] 39.5 per cent have a graduate degree and an additional 10.3 per cent have attended graduate school but not earned a degree. As there are no formal certification procedures or educational requirements for political consulting, thus the high education level is not simply an artefact of the structure of the field.

Analysis: Constructing a Representation of the Field of Political Consultants

In order to generate a comprehensive depiction of the field of political consultants in the United States, this article uses Multiple Correspondence Analysis (see Le Roux and Rouanet 2009). MCA is well-suited to field studies because it allows for, as Wacquant put it, 'applying the relational mode of thinking encapsulated by the notion of field, [in order to] set out in each particular case to uncover empirically the specific configurations assumed by the complexus of oppositions that structure the field of interest' (Bourdieu 1996b: 10). MCA has thus been used by scholars since Bourdieu to study a number of other fields, including central bankers (Lebaron 2008),

and the Norwegian field of power (Denord et al. 2011; Hjellbrekke et al. 2007). MCA can reveal how a field is structured as well as the location of individuals in that field. Instead of analysing how variables each matter with 'all else held constant' as in regression analyses, the approach makes it possible to see how the salient modalities operate together, and then examine the distributions of opinions across the constructed representation of a field or social space.

A cloud of individuals is constructed such that the distance between any two individual points in the space (which can have very high dimensionality) indicates the dissimilarity of those individuals' responses to the response categories used in constructing the space. Individuals with identical answers to all questions would be located at the same point; individuals with no overlap whatsoever will be quite distant from one another, and more distant the less their responses are shared by others.

Another feature of MCA is that it does not rely on (or even take into account) any ordering of the categories within a given question. After the clouds of individuals and categories are constructed, they are then projected onto the principal axes in such a way as to maximize the variance expressed by each axis (see Le Roux 2010: 24–8). These axes are interpreted by examining both the 'contributions' of different modalities to these axes as well as the coordinates of the categories in planes created by the principal axes. In order to decide how many axes to retain for interpretation, one must look at three factors: the pattern of decreasing eigenvalues of the axes, the 'cumulated modified rates' of variance (shown below in Table 1), and equally as important, the interpretability of the axes (Le Roux and Rouanet 2010: 51). Axes are interpreted by examining the contributions of the various categories to each axis; categories which contribute a greater percentage of the variance than the 'average' category are included in the analysis, with those categories with the largest contributions dominating the interpretation.[2]

The principal axes determine how the clouds are projected into two-dimensional 'maps' and distances on these maps indicate which categories have the most and least in common with other categories. Categories near

the middle of a space are more common and/or more heterogeneous in terms of the other categories; those near the edges are less common and/or have less in common with other categories. Categories distant from one another in the space have few if any members in common; categories close to one another have many members in common. Once the representation of the field of consultants (in this case) has been carried out, it will be possible to see the distribution of their origins, and of their opinions about politics (as well as any other characteristics of interest) within this space. These 'supplemental' categories – questions and answer choices not used to construct the space – are 'projected' into the cloud of categories; each category's coordinates are determined by, essentially, averaging the coordinates of all respondents who chose that category (plus a translation factor related to the eigenvalue of the axis).

The present analysis seeks to answer three questions: what are the key oppositions in the field of political consultants? What attributes or origins structure those oppositions? And how do oppositions in the field shape consultants' views of the political process?

In order to represent field of political consultants, I used variables which describe major aspects of consultants' positions in their fields: their types of work, career histories, and current positions. As is customary in MCA, I tried a number of combinations of active questions and recodings of the categories in order to achieve a stable representation of the data (one not overly affected by small changes in recodings), a well-balanced one (such that very small categories are not exerting undue influence on the principal axes), and one with a relatively high level of total variance captured by the first few axes. I settled on thirteen questions with thirty seven active categories. Table 1 includes the frequencies and percentages for each modality, as well as its contributions to Axes 1 and 2 and coordinates on those axes.

Table 1 Questions, Categories, Contributions and Coordinates

Topic				AXIS 1		AXIS 2	
Variable	Modality	N	%	Ctr.	y1	Ctr.	y2
Type Of Work							
Speciality							
	direct mail	29	7.3	0.5	0.38	2.8	-0.82
	fundraiser	26	6.5	0	0.11	5.1	1.18
	general	187	46.8	0	-0.01	5	0.43
	media	72	18.0	0.1	0.1	2.1	-0.46
	pollster	63	15.8	0.6	-0.28	7.3	-0.91
	research (passive)	10	2.5				
	phones (passive)	2	0.5				
	other (passive)	4	1.0				
	field (passive)	7	1.8				
	total contribution of the question			1.2		22.4	
Clients							
	commercial and political	318	79.1	0	-0.02	2.3	-0.23
	only political	82	20.4	0	0.07	9.7	0.92
	missing data (passive)	2	0.5				
	total contribution of the question			0.1		12.1	
Career History							
Worked for Elected Official							
	no	180	44.78	6	-0.53	3.4	-0.37
	yes	222	55.22	4.8	0.43	2.8	0.3
	total contribution of the question			10.8		6.2	

Worked for Party							
	no	217	53.98	0.7	-0.16	7.1	-0.48
	yes	184	45.77	0.8	0.19	8.5	0.57
	missing data (passive)	1	0.25				
	total contribution of the question			1.5		15.6	
Worked for Print News							
	no	305	75.87	0	0.03	0	0.01
	yes	97	24.13	0.1	-0.11	0	-0.04
	total contribution of the question			0.2		0	
Worked for Broadcast News							
	no	310	77.11	0.2	0.07	0.7	0.13
	yes	92	22.89	0.6	-0.24	2.3	-0.42
	total contribution of the question			0.8		3	
First Role in Politics							
	campaign staff	223	55.47	4	0.39	5.3	0.41
	consultant	170	42.29	5.4	-0.52	6.9	-0.54
	missing data (passive)	9	2.24				
	total contribution of the question			9.5		12.3	
Current Position							
Level in Firm							
	principal	376	93.5	0.4	0.1	0	0.03
	sr. associate	23	5.7	5.4	-1.39	0.5	-0.4
	jr. associate (passive)	3	0.8				
	total contribution of the question			5.8		0.6	

Assist from Party							
	no	53	13.2	10.1	-1.26	0.9	-0.34
	yes	349	86.8	1.5	0.19	0.1	0.05
	total contribution of the question		11.6			1	
AAPC Member							
	no	216	53.7	4.1	-0.4	1.7	0.24
	yes	179	44.5	4.9	0.48	2	-0.28
	missing data (passive)	7	1.7				
	total contribution of the question		8.9			3.8	
Income from Consulting							
	under $50	87	21.64	8.5	-0.9	4.9	0.63
	$50-$100k	86	21.39	2.7	-0.52	0.3	-0.16
	$100-$150k	78	19.4	1.5	0.41	0.4	-0.2
	$150-$200k	41	10.2	3.6	0.85	0	0.07
	$200k+	73	18.16	7.6	0.93	0.6	-0.24
	missing data (passive)	37	9.2				
	total contribution of the question		24			6.3	
Number of National Races							
	1 to 3 races	83	20.65	5.4	-0.73	1.7	0.38
	4 to 8 races	106	26.37	3.3	-0.51	0.2	0.12
	9 to 15 races	98	24.38	0.7	0.24	0.1	0.06
	>16	115	28.61	8.7	0.79	3.2	-0.44
	total contribution of the question		18			5.2	

Number of Lower-Level Races							
	0 local races	22	5.47	0.1	-0.18	1	0.56
	1 to 6 races	71	17.66	2	-0.48	2.8	0.53
	7 to 15 races	98	24.38	0.9	-0.27	0.6	0.2
	16–35	105	26.12	0	-0.01	0	0.04
	>36	99	24.63	4.8	0.63	7.3	-0.72
	missing data (passive)	7	1.74				
	total contribution of the question			*7.7*		*11.7*	

Note: Contributions for those modalities maintained for interpretation of each axis are in bold; total question-contributions maintained for interpretation are in bold italics. Modalities not used in the analysis are noted with (passive).

Type of work includes: Speciality (Direct Mail, Fundraiser, General Consultant, Media Consultant, Pollster; other, less frequent, specialities were made passive), Type of Clients (Commercial & Political or Only Political). *Career History* includes: First Campaign Role (Campaign Staff or Consultant; other less frequent categories were made passive), and a series of binary yes/no variables indicating whether the consultant ever worked for an elected official, a political party, or print or broadcast news organizations. Finally, *Current Position* includes: income from consulting (five categories in $50,000 increments), number of national races worked on in the last three cycles (including presidential, senate, governor's and house races, divided four roughly even groups among those with at least one race), number of lower-level state and local races worked on in last three cycles (divided into those who did no lower-level races, and then into four roughly even groups for the rest), and whether they had ever received assistance from a Party committee (as an indicator of the quality of the races the consultant has worked on, because parties generally only offer assistance to races they believe are competitive and important).

Findings 1: Key Oppositions Among Political Consultants

I retain only the first two axes for interpretation; together, they describe over 74 per cent of the variance of the clouds; the third axis meets some criteria for interpretation, but primarily opposes those with media experience to those without, and is therefore substantively less interesting.

Table 2 Variances of Axes, Modified Rates and Cumulated Modified Rates

	Axis 1	Axis 2
Variance of Axes (eigenvalue)	0.159	0.135
Modified Rates	49.5%	24.7%
Cumulated Modified Rate	49.5%	74.2%

The categories with contributions to each axis above the threshold for interpretation have their contributions indicated in italics in Table 1. The first axis describes an opposition between the dominant and the dominated or aspiring political consultants. Generally, those at the top (of the field as well as in Figure 1), earn the most money, work on the most races, and possess key field-specific capitals in the form of experience working for elected officials, having started out working on campaigns, and membership in the American Association of Political Consultants (AAPC). The bottom of the figure (and the field) is defined by lacking each of those attributes, as well as never having received assistance on a race from a party organization, and being only a senior associate, rather than a principal, in a consulting firm.

The second axis describes an opposition between the more politically-oriented consultants, on the right, and more commercially-oriented ones on the left. The political pole includes consultants who started out on campaigns, have worked for party organizations, who only work with political clients, who work on relatively few races, and whose specialities are fundraising or general consulting (both skills not readily transferable to commercial organizations). The commercial pole is those who started as consultants, have never worked for a party or an elected official, work

on large numbers of races each cycle, and specialize in either polling or direct mail. This opposition has some affinity with what Bourdieu called the *autonomous* and *heteronomous* poles of many fields of cultural production, respectively; however it would not be fully accurate to describe any part of the consulting field as *autonomous*: the more political side of the field overlaps other parts of the political field (parties and elected officials). Still, it appears from some of the results discussed below that more commercial principles indeed motivate those on the left side of the figure, and more purely political principles operate on the right.

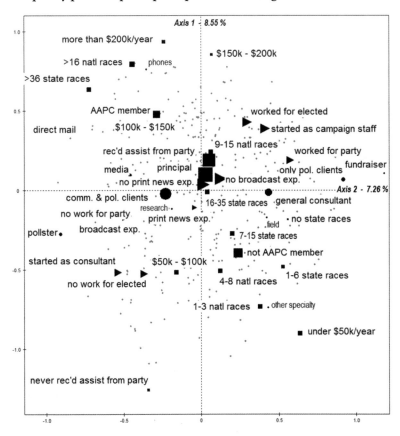

Figure 1 Active Categories and Active Individuals

Findings 2: Structuring Factors

Now that we have a reasonable construction of the field of political con-
sultants, and a depiction of the key oppositions (dominant/dominated
or successful/striving on the first, vertical axis and political/commercial
on the second), we can ask what differences among consultants structure
positions in this field. Figure 2 shows a number of attributes of consultants
and their career trajectories projected as supplemental categories into the
same plane depicted in Figure 1.

The most striking result in Figure 2 is the strong, monotonic relation-
ship between consultants' age when they began work in politics and their
current position in the field; this is neither simply the necessary precursor to
longer experience in politics (as can be seen by the less consistent pattern for
years in politics) nor an effect of age (which is not shown in this figure, but
which follows no clear pattern in the space). People of colour and women
are located in the dominated portion of the space, along with those who
have spent less than ten years in politics. These findings, combined with
the position of starting out in politics as campaign staff (rather than as a
consultant) in Figure 1, point to the probability that dominant positions
accrue to those from relatively privileged backgrounds. Because working
on a campaign is intrinsically a high-risk career move, the characteristics
of entry-level political work make it an unlikely choice for someone with-
out both a deep passion for politics and some pre-existing connections to
political actors. Campaigns are necessarily time-limited, and while a win-
ning campaign may lead to jobs with the newly-elected official or in further
campaigns, working on a losing campaign has fewer potential rewards.
Furthermore, working as an entry-level staffer on a political campaign
normally pays only subsistence wages for round-the-clock work (Watson
and Campbell 2003). We know from multiple studies of political interest
that young people who are deeply interested in electoral politics are also
disproportionately male, white, and from well-off, well-educated families
(Leighley and Vedlitz 1999; Verba, Schlozman, and Brady 1995; Verba,
Burns, and Schlozman 1997; Wolfinger and Rosenstone 1980). It is thus
quite likely that starting early and starting out working on campaigns are

greatly facilitated by coming from a better-off family, although this question requires further empirical validation.

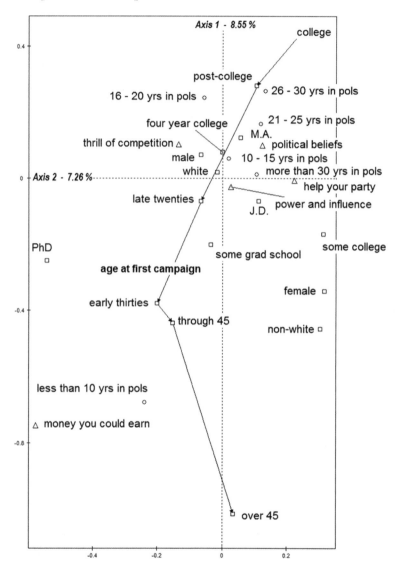

Figure 2　Structuring Factors

On the other hand, Figure 2 shows that there is little relationship between education and position in the field; this is surprising, as education and other types of cultural capital are strongly associated with success in most fields. It appears instead that this is a field that rewards internally-generated capitals, social capital and dispositions acquired through years of direct experience in campaigns. Further, Figure 2 indicates that those who enter political consulting without a passion for politicking – who recall their initial motivation as being monetary – are far less successful than those who report becoming consultants for the thrill of competition, to help their party or further their political beliefs, or even to gain power and influence. Finally, Axis 2 separates those who entered consulting for either money or thrills from those who did it to help their party, lending support to the interpretation of this as a commercial-political axis; women and people of colour are also centred on the pure-politics side of Axis 2.

Findings 3: Opinions About Politics

Finally, we turn to the third question for this chapter: how consultants' views on campaign strategies and voters are structured by their position in the field.

Opinions on four sets of questions are represented in Figure 3. Answers to the question 'How much trust and confidence do you have in the wisdom of the American people when it comes to making a choice on election day?' are indicated with 'trust electorate' and up-pointed triangles. The two questions about what causes voter cynicism, money in campaigns and negative campaigning (with its trajectory traced), are indicated with circles. There are four questions about the acceptability of various campaign practices, all indicated with down-pointed triangles: using truthful information misleadingly out-of-context, using push polls – persuasion-oriented phone calls disguised as polls – with its trajectory traced, using negative ads focused on an opponent's personal characteristics, and using negative ads deliberately to decrease turnout. Finally, there is a question

about the quality of the party organizations (with its trajectory traced), and one about candidate quality, both indicated by plus signs.

Figure 3 How Consultants' Views on Campaign Strategies and Voters Are Structured By Their Position in the Field

Some clear patterns emerge: in general, it can be seen that those in the dominant part of the field generally are the most comfortable with the status quo of campaigns. They are the most likely to find acceptable three of the four types of campaign tactics considered ethically problematic by political scientists: both kinds of negative ads and the use of out-of-context 'facts'. The pattern is reversed, however, for push polls, where the main difference lies along Axis 2: those on the commercial side of the field, including importantly pollsters, are the most opposed to the practice, most likely because it damages their reputation. Not only do the most successful

consultants find most debatable campaign tactics acceptable, they also do not think these tactics are responsible for voters' cynicism: the degree of blame accorded to both negative campaigning and the role of money in politics increases monotonically with lower positions in the field (this pattern holds for other potential causes of voter cynicism asked about in the survey as well, though they are not shown here).

Those in the dominant part of the field also have the highest level of trust in the electorate, but the lowest opinions of both party organizations and candidates for House and Senate seats. Those at the 'top' clearly have the least critical approach to their work, but are most critical of other political actors.

The new entrants and dominated members (challengers) of the profession, those with the least income, and the smallest number of candidates, on the other hand, express the most criticism of the status quo of campaigning, the least faith in the electorate, but the least concern also about the quality of candidates or parties.

Discussion and Conclusion

This analysis reveals a clear correspondence between consultants' positions in their field and their views on politics and campaigns. It does, however, have some limitations. The data used are somewhat dated; more recent studies of consultants indicate the basic features of the field (for example, Grossmann 2009b) probably have not changed much, but some things might have. A more complete analysis of the field would make use of more detailed information on consultants' career trajectories and backgrounds than was available in this survey. Finally, although political consultants are often the most powerful actors within campaigns and certainly the most highly remunerated, a complete study of the field of campaigning would have to include party and campaign staff. Nonetheless, this study reveals the utility of multiple correspondence analysis for understanding a field.

This is the first analysis of the structure of a key part of the field of power in the United States. I have shown that there are clear oppositions structuring the field of political consultants: between the dominant and the dominated or aspiring consultants and between the pure-politics and commercially-oriented politics poles. Supplemental variables projected into the space constructed by the MCA reveal that dominant political consultants tend to have started in politics very young, and that internal capitals probably matter the most for advancement. There are most likely disadvantages in this field, then, for those from less well-off backgrounds, who are less likely to be able to take the risks involved with entry-level campaign work, especially when they are young.

Finally, this analysis reveals a clear opposition between those at the top of the field and those at the bottom in their views about politics: the most established are the most positive about a variety of practices regularly deployed in campaigns, while the dominated/new entrants are much more critical. This means that established political consultants are generally comfortable with a number of tactics political scientists and the general public consider problematic; while previous studies have been relatively sanguine about consultants' views on campaigning (for example, Dulio and Nelson 2005) as they are on average not that different from other political actors, these findings imply that the dominated consultants, many of whom are challengers who will be moving into the dominant parts of the field as their careers advance, may also change their views on the ethics of campaigning as they become more established in the field.

Endnotes

1 Author's calculation from 2000 General Social Survey.
2 More formally, there are four mathematical steps:

 Step 1: Given two individuals i and i' and a question q, if both individuals choose the same response category, the part of distance [between their points in the space] due to question q is zero; if individual i chooses category j and

individual i' chooses category $j' \neq j$, the part of (squared) distance due to question q is $d2q\,(i\,,i') = 1/fj + 1/fj'$, where fj and fj', are the proportions of individuals choosing j and j', respectively. The overall distance $d(i,i')$ is then defined by $d2\,(i,i') = 1/Q\,\Sigma q\,d2q\,(i\,,i')$ (see Le Roux and Rouanet 2004a). Once the distance between individuals is determined, the cloud of individuals is determined.

Step 2: The principal axes of the cloud are determined (by orthogonal least squares), and a principal subspace is retained.

Step 3: The principal cloud of individuals is studied geometrically, exhibiting approximate distances between individuals.

Step 4: The *cloud of categories* consists of J category points [J is the number of active modalities or response categories]. (Greenacre 2006)

RAMÓN ÁLVAREZ ESTEBAN, MÓNICA BÉCUE-BERTAUT,
BELCHIN KOSTOV AND ANNIE MORIN

Structure and Vocabulary Flow in Chronological Corpora: Contributions of Correspondence Analysis and Labelled Hierarchy

Introduction

The technique of chronological corpora constitutes a specific genre for textual analysis (Benzécri 1981; Lebart et al. 1998, chapter 7; Murtagh 2005). Through this technique we find the corpora formed by a series of texts coming from a unique source. Although their authors can differ, such as leading articles of the same newspaper over a long period of time, inaugural speeches by the successive Prime Ministers of one country or, more generally, texts produced by the same institution can be ordered chronologically.

When studying this kind of corpus, the main objectives are to uncover which time-related changes appear, but also capture the overall organization of the texts (Bourdieu 1996a: 258–60). In this chapter we want to show how combining correspondence analysis (CA) with labelled time-constrained hierarchy, offers a very rich tool. CA allows for visualizing the orientation of a narrative (Benzécri 1973; Lebart et al. 1998; Murtagh et al. 2005, 2011; Bourdieu, 1996a), that is, the shape of the changes through taking into account all the interdistances. The labelled chronological hierarchy can provide an account of the vocabulary flow along the dimension of time, through taking advantage of the local distances. We advocate that the results of both methods complement one another but have to be jointly read. In this chapter we have applied this methodology to the chronological corpus composed of the inaugural speeches delivered by successive Prime

Ministers of Spain from 1979 to the present day. However, our main aim is to highlight the type of results that are generated and show how they enrich one another without delving into their interpretation from a political perspective. In Section 2, we present the data to be used and in Section 3, we discuss the methodology applied and in Section 4 we will consider the main results obtained. We close with some conclusions about the methodology.

The Inaugural Speeches of the Spanish Prime Ministers (1979–2011)

Democracy returned to Spain after Franco's long dictatorship from the Civil War (1936–9) until his death (20 November 1975), when a Constitution was voted on 6 December 1978. This Constitution stipulates that the candidate to be Prime Minister, proposed by the King of Spain, has to be elected by the parliament (with absolute majority in the first ballot, but only simple majority in the second). Before the vote, the candidate delivers a speech where he/she details his/her government programme.

Since 1978, eleven speeches have been delivered, at dates indicated in Table 1, by six different politicians: Adolfo Suárez and Leopoldo Calvo-Sotelo, both of *Unión del Centro Democrático* (UCD, centre right), Felipe González from *Partido Socialista Obrero Español* (PSOE, left), José-María Aznar from *Partido Popular* (PP, right), José-Luis Rodríguez Zapatero (PSOE) and Mariano Rajoy (PP). Spanish governments are highly stable with only two speeches corresponding to the same legislature, because of Adolfo Suárez's resignation at the beginning of 1981. We recall that the second ballot for electing Leopoldo Calvo-Sotelo (23 February 1981) – who did not have absolute majority in the first on 19 February – was brutally interrupted by the military putsch. Finally, after the failure of the putsch, Leopoldo Calvo-Sotelo was elected on 25 February, with absolute majority. The eleven inaugural speeches have been taken from the version published into the *Diario de Sesiones del Congreso de los Diputados*.

Main Characteristics of the Speeches

Altogether, the speeches are 10,191 occurrences long (with an average length of 9,265 occurrences) and are formed from 9,453 different words. The first speech, by Adolfo Suárez in March 1979, is the longest while the shortest was delivered by Felipe González in December 1989.

Table 1 Lexicometrical Characteristics of the Speeches

Date	Speech	Length	Length index base 100	Hapax	Original words	Length composed from original words	Originality index	Figures and dates
30 March 1979	Suárez	12145	131,09	639	706	796	1,19	108
19 February 1981	Calvo-Sotelo	8266	89,22	417	447	480	1,05	33
30 November 1982	González-1	9423	101,71	560	600	642	1,24	41
23 July 1986	González-2	11335	122,34	319	379	461	0,74	45
5 December 1989	González-3	7592	81,94	251	280	316	0,76	37
8 July 1993	González-4	8138	87,84	323	348	377	0,84	42
3 May 1996	Aznar-1	10243	110,56	371	397	430	0,76	42
25 April 2000	Aznar-2	8283	89,40	279	305	357	0,78	55
15 April 2004	Zapatero-1	7881	85,06	390	430	478	1,10	28
8 April 2008	Zapatero-2	8829	95,30	473	511	570	1,17	82
19 December 2011	Rajoy	9779	105,55	553	617	700	1,30	91
	Total	101914	100	4575	5022	5607	1	604

For this study, neither lemmatization nor stemmatization are performed, also no stop-list is used.

Table 1 provides a summary of the lexical characteristics of the eleven speeches. Hapax are words used only one time in the whole corpus. The original words are those which are only used in the corresponding speech. The originality index is computed by including the count of the original words and also the length of the speech (Labbé and Hubert 1993).

Frequent Vocabulary

Among the words repeated at least 100 times, we find the following substantives *politics* (411), *government* (403), *Spain* (320), *State* (235), *society* (218), *Your Honours* (189), *years* (183), *employment* (162), *citizen* (158), *system* (158), *country/ies* (155; 120), *Parliament* (154), *development* (143), *reform* (133), *Communities* (128), *economy* (128), *process* (124), *problems* (123), *Constitution* (120), *effort* (120), *policies* (116), *legislature* (113), *action* (110), *growth* (105), *objective* (102), *security* (102), *Administration* (101), *law* (101). Concerning the verbs, different flexions of *to be, to have, must, to do* and *to want* are very used such as: *he/she/it must* (137), *we have* (132), *there is/are* (127), *to do* (125), *he/she/it has* (102), *I want* (101). Only a few adjectives are found among the most frequent words: *social* (185), *Spanish* (feminine and masculine flexions: 128; 102), *economic* (143) and *foreign* (108).

We can note that, altogether, the hundred most frequent words cover 53.9 per cent of the whole corpus.

Methodology

Our main objective is to uncover the shape of the corpus and to show how this is informative. CA is a suitable method for that purpose, although its results have to be read under the light of chronological clustering. The starting point is counting the frequencies of the word occurrences in the texts and computing distances between texts from theses frequencies. In accordance with correspondence analysis, chi-square distance between lexical profiles is used. Hereafter, we recall the principles of correspondence analysis and time constrained clustering, as well as its variant called chronological clustering. Next, we propose to label the obtained hierarchy by computing the lexical specificities of the nodes.

Correspondence Analysis and Pattern of Vocabulary Changes

Correspondence analysis (CA) was developed by Benzécri (1973, 1981) as a powerful method to tackle a large range of issues related to texts. To begin with, the texts are considered as sequences of occurrences (token) of words. Then the corpus is encoded into a frequency table, whose rows are the texts and columns are the words. The frequencies are converted into proportions and the profiles of both sets of rows and columns are computed. The distributional equivalence principle and the requirement for a quadratic formula led to choose the chi-square distance between rows and between columns (Benzécri 1973). Rows and columns are endowed by weights issued from the margins of the proportion table, proportional to their length, in the case of the row-texts, and to their frequency, in the case of the column-words. Thus, CA builds a space of words and a space of texts such that:

- the words are all the closer as they more often co-occur;
- the texts are all the closer as they contain the same word co-occurrences.

By looking for the main dispersions axes, CA visualizes the similarities between row profiles and column profiles as well as their mutual associations.

In the case of a chronological corpus, the vocabularies of time adjacent texts are expected to be more similar to one another, than those of long-interval separated texts. Over time, new words appear that can replace others, which become rarer. This vocabulary renewal pattern frequently leads to a temporal trajectory of the texts along a *horseshoe pattern* on the first principal plane issued from CA and, possibly, to specific trajectories, detailed in Benzécri (1973: 483) on the following axes. However, departures from this basic pattern are possibly observed; these departures are meaningful and constitute relevant information. Thus, CA is able to visualize the pattern or shape of a given corpus track of the vocabulary, whose part related to time can be identified on a low-dimension space (Lebart et al. 1998; Lebart et al. 2000; Murtagh 2005). In order to take into account a higher dimensionality and thus put to the fore the peculiarities of the different sub-periods of the corpus, chronological clustering emerges as a necessary and complementary tool.

Chronological Clustering

Constrained clustering (Legendre and Legendre 1998: 756–9) takes into account contiguities among the objects and only allows the union of adjacent objects or groups of objects. Here, a temporal contiguity is imposed and only time-adjacent speeches or groups of speeches can be united into a node. In accordance with CA, the distance between speeches, is measured by the chi-square distance between their profiles. Complete linkage is selected to measure the distances between two nodes of texts in order to avoid inversions when building the hierarchy.

Chronological clustering (CC; Legendre and Legendre 1998: 696–9) is a variant that imposes temporal contiguity to the clustering activity, but adds a statistical test before authorizing the fusion of two terminal or intermediate nodes. This test determines whether the units belonging to both nodes are significantly different from each other; if this is the case, the fusion is not allowed. A probability p is computed and compared with a pre-established significance level α. If $p <= \alpha$, the null hypothesis is rejected and the fusion of the nodes is prevented. Changing the value of α actually changes the resolution of the clustering results: when α is small, only the sharpest discontinuities in the chronological corpus are identified while increasing its value leads to form more and smaller groups to bring out more discontinuities in the data series. In our case, we are interested in locating the possible significant changes in the vocabulary used in the speeches, to the extent that they are fundamental to guide the interpretation.

Labelled Hierarchy

Characteristic Words

The frequency of any word in any text is compared to its frequency in the whole corpus but taking into account the lengths of both the corpus and the text. A p-value is associated to the comparison allowing for determining if the word under consideration is significantly either over or underused. This test is performed for every couple (word, text) leading to listing the words characterizing every text (Lebart et al. 1998, chapter 6).

Chronological Elements

In the case of chronological corpora, Lebart et al. (1998, chapter 7) propose to identify the words and segments associated with the temporal evolution. The starting point is similar to this of the extraction of the characteristic

words. First, the words that characterize the texts for example, $T_1, T_2, T_3,...,$ Tn,; the sub-index refers to the chronology are identified. After this the process is repeated on the texts grouped in larger sequences, two by two - $[T_1, T_2], [T_2, T_3], [T_{(n-1)}, Tn]$ - then on the texts grouped three by three $[T_1, T_2, T_3], [T_2, T_3; T_4], [T_{(n-2)}, T_{(n-1)}, Tn]$ and so on. At the end of the process, every word is associated to the text or group of texts, for which it presents the smaller p-value, that is, to the sequence which it better characterizes.

Labelling the Nodes

We adapt the selection of the chronological elements to characterize every node of the hierarchy, including the terminal ones that correspond to the texts. The nodes built from chronological clustering are sequences of time adjacent texts. Thus, it makes sense to compute a p-value for every couple (word, node) by following the rationale laid out in the previous sections. Thus, a word labels the node that it better characterizes. This process, apart from easing the capture of the hierarchical vocabulary flow, allows for identifying both the specialized (local) words and those characterizing longer periods.

Application to the Inaugural Speeches of the Spanish Parliament

The methodology presented in the preceding section is applied to the corpus consisting in the eleven inaugural speeches by Spanish Heads of Government presented in Section 2. The results provided by the different steps have to be jointly read.

Correspondence Analysis

For correspondence analysis, a frequency threshold equal to twenty five was chosen and thus 500 different words were kept. This medium threshold corresponds to our interest in obtaining a good image of the whole of the eleven speeches, that is, a global vision of Spanish politics from this point of view. Chronology, whose values are the dates of the speeches, is used as a supplementary variable.

The speech by Felipe González in 1986 (Gz-1986) is considered as supplementary in order to avoid its considerable influence on the first axis (its contribution to the inertia would be over 50 per cent if kept active). This leads to a first axis to which a majority of the speeches contribute, allowing us to identify the main trends.

Correspondence analysis performed on the lexical table, that is, the speeches×words table (eleven speeches, 500 words), but considering the fourth speech as supplementary as mentioned above, leads to a first principal plane keeping 33.4 per cent of the total inertia (Figure 1, p. 282). First, it is advisable to read this plane without reference to the vocabulary as it is better at capturing the shape of the corpus. It should be noted that much of the vocabulary depends on local events, while we are mainly interested in extracting general rules, reflected through the trajectory of the speeches on this plane.

All the speeches and an excerpt of the words are visualized. Chronology is represented apart, as a supplementary variable.

The trajectory of the speeches is drawn. A bootstrap on the occurrences is performed to validate the trajectory (Valencia and Alvarez-Esteban 2012). The bootstrap trajectories are represented on the map leading to conclude to a high stability of the positions of every speech and of the trajectory itself. We find that we do not obtain the usual horseshoe pattern (Lebart et al. 1998). However, we can state that the principal plane conveys most of the temporal evolution of the vocabulary as far as it is reflected in the evolution of the vocabulary, as assessed by:

- The fact that only these two axes have a high or medium correlation with the time variable (corr(axis_1, chronology)=-0.85; corr(axis_2, chronology)=-0.48). These values show that chronology would be quite perfectly reconstructed from the first two axes,
- The very high value of RV coefficient (=.71). This coefficient (Robert and Escouffier, 1976) measures the similarity between the configurations of speeches as issued from the first CA principal subspace and chronology. A RV coefficient equal to one would mean that both configurations are homothetic. We can add that RV coefficient is the highest when the configuration of the speeches on the first two axes is considered, as compared to the values obtained when higher dimensions CA subspaces are taken into account.

At this stage, we can assess that chronology is dominating, as it determines the first plane, although other factors play a role, as indicated by the fact that this plane only accounts for 33.4 per cent of the inertia.

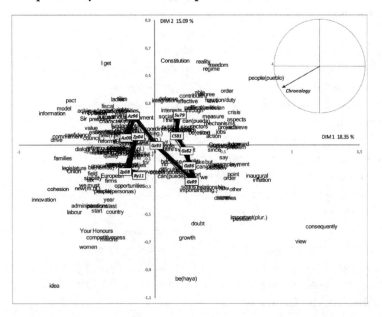

Figure 1 First Principal Plane Issued from CA Applied to the Speeches×Words Table

Shape of the Corpus on the First Plane

The pattern that is observed (Figure 1) is very stable relative to small changes in the frequency threshold. The shape of the corpus can be seen either as the succession of two parabolas or as a trajectory [1979–89] and almost parallel to the second axis, followed by a parabola [1993–2011]. We favour the second version in accordance with the chronological clustering which precisely constitutes these two final nodes, as this algorithm does not establish their union (which would have been the latter) (Figure 2).

In any case, the first plane shows two, well differentiated, periods [Su-1979–Gz-1989] and [Gz.1993–Ry-2011] are opposed on the first axis. The significantly over-used words of both periods give good account of the opposition between them (Table 2).

Table 2 Characteristic Words of the Two Main Temporal Periods

[Su1979–Gz1989]	[Gz1993–Ry2011]
people, politics, inflation, freedom, European Community, countries, problem/s, effort, crisis, integration, time, inaugural, action, hope, unemployment, evolution, reality, relationship/s, order, effectiveness, interests, laws, projects, cooperation, mechanisms, defence, coordination, aspects, measure, doubt, struggle, growth, progress, Constitution, security	*European Union, reform(s) (tax/labour reform), commitment, confidence, Spanish, pact, legislature, model, council, state/ public administration, competitiveness, agreement/s, innovation, dialog, Spain, impulse, stability, country, Parliament, quality, families, field, employment, idea (of Spain), public policies, welfare, financing, activity, information, women, cohesion, tax, firms, spending, autonomous communities, millions, resources, government, opportunities, will, law, character, collaboration, frame, system, value, citizens, objective, difficulties, world, pensions, consensus, improvement*

Vocabulary Changes Not Included in the Temporal Trend

All the vocabulary changes do not fit into the temporal trend which are reflected on the principal plane. The other tendencies, either particular to a speech or to a group of speeches, are captured by axes 3 and above.

For every speech, we have computed its global squared distance with its predecessor (in the whole space). This is the squared distance as projected on the first principal plane as well as their ratio (the latter divided by the former). This ratio measures not only the quality of representation of the distances between successive speeches, but also the part of the vocabulary changes that fits the temporal trend (Table 3). We have to underline the very low ratio computed for (Az-2000, Zp-2004) as well as for (Zp-2008, Ry-2011) indicating that both José Luis Rodríguez Zapatero and Mariano Rajoy break with their predecessors from the point of view of their vocabularies.

Table 3 Proportion of the Trajectory Between Successive Speeches Fitted
in the Temporal Trend

Speech	Su-1979 Cs-1981	Cs-1981 Gz-1982	Gz-1982 Gz-1986	Gz-1986 Gz-1989	Gz-1989 Gz-1993	Gz-1993 Az-1996	Az-1996 Az-2000	Az-2000 Zp-2004	Zp-2004 Zp-2008	Zp-2008 Ry-2011
Ratio	0.27	0.22	0.23	0.52	0.60	0.47	0.31	0.12	0.42	0.12

Axis 3 mainly reflects the opposition between the two first speeches delivered by Felipe González (Gz-1982 and Gz-1986) and the last two (Gz-1989 and Gz-1993). This axis mainly shows that the last speeches by Felipe Gonzalez discard words such as *people*, *laws*, *unity* and *decision* to use general words such as *to support*, *functioning*, *step*, *relationship* and *position*. Axis 4 underlines the strong opposition between the two speeches by José-Luis Rodríguez Zapatero and Mariano Rajoy's. The former multiplies topics such as *terrorism*, *cohesion (social)*, *research*, *equality (of the women* and *culture)*

that are not relevant concerns in the other speeches. The latter insists on economic topics with words such as *budget, labour (labour reform), deficit, firms, competitiveness, unemployment,* almost absent before.

Organization of the Argumentation as Reflected Into the Labelled Hierarchy

For chronological clustering, a lower threshold on the words frequency equal to ten is used. This clustering is performed considering the ten dimensions of the space in which the speeches are placed, using the chi-square distance between the speeches and complete linkage to value the distance between nodes.

Figure 2 represents the hierarchy labelled by the chronological words. We are not looking for a partition, but for a global reading of the hierarchical structure of the eleven speeches.

The first important feature to note is that the corpus consists of two disjoined final nodes – [Su-1979–Gz-1989] and [Gz-1993–Ry-2011] – whose union is not authorized by the CC. Table 2 shows the characteristic words of the two main node-sequences. The flow of the arguments along the textual hierarchy, from top to bottom, is commented on in the following section.

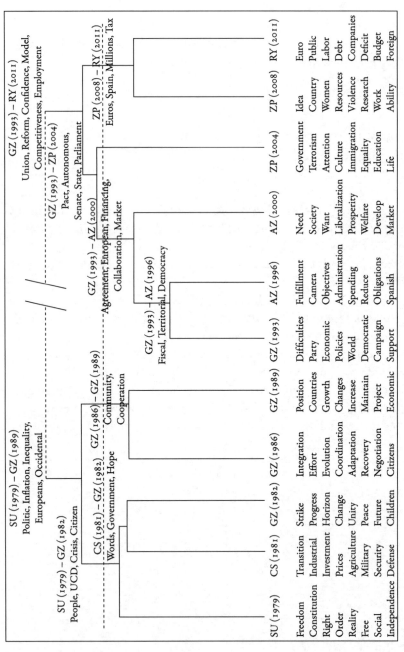

Figure 2 Labelled Hierarchy

Synthesis of the Results

In summary we favour the two nodes [Su-1979–Gz-1989] and [Gz-1993–Ry-2011] at the highest level and then five sub-periods, as suggested by the cut of the hierarchy marked on Figure 2 and finally, the terminal nodes, when they present relevant characteristics. In fact, the two branches correspond. The first to the transition's leaders, that is, to leaders who were present in the political life before Franco's death and went on until 1989 and beyond, and the second, to a new generation of leaders, among whom the oldest (José María Aznar) was only twenty two at Franco's death. The difference between the vocabulary of both sets of speeches is very evident and already mentioned above.

The Transition's Leaders [Su-1979–Gz-1989]

The speeches have a very political tone, as evidenced by the first label of this node (politics). In this period, the Prime Ministers have to face problems such as inflation (very high at that period) and inequalities (inequality) inherited from Franco's dictatorship.

This period divides into two main nodes by which we characterize the vocabulary, using their characteristic words and segments. We use more detailed information than the one reproduced in the labelled hierarchy, reduced because of the available space.

SUÁREZ 1979 – GONZÁLEZ 1982

This sub-period is known as 'the transition' in Spain. It includes Su-1979, Cs-1981 – by two politicians from UCD, a centre-right Party, created by Adolfo Suárez which quickly declined when he left the political life and Gz-1982 by Felipe González from PSOE.

Its main topics are the organization of the State and the legal reforms needed to move from a dictatorship to a democratic regime. *System of*

government, State and *State governed by the rule of law* appear in the speeches by Adolfo Suárez and Leopoldo Calvo-Sotelo where the *Constitution* is relevant. In fact, legal regulations have to be developed. *Law, legislative* and *administrative* are frequent.

At this moment, internal problems overshadowed foreign relationships which are hardly mentioned. Struggle for freedom and democracy requires effort and leads to the use words such as *freedom, free* and *peace*.

Serious *problem(s), conflict, solution* and *resolution* are the reflection of the many difficulties that Spain and its politicians have to face. In the economy field, *inflation*, although reduced from 26 per cent in 1977 to 16 per cent a year later, and a global economic crisis are important issues. *Industrial, unemployment, job* and *creation of job opportunities* are induced by the fact that during 1978–84 more than 20 per cent of industrial employment and agriculture was destroyed. The agricultural problem linked with the first actions for integrating the EEC is referred to by *agriculture, farmers, agribusiness and agricultural*.

Government action has to be based, as stated in these speeches, on *independence, rigor* and *effectiveness*. *Progress* has to be achieved, starting from a *real analysis* and a good capture of the *reality*. *Change* is one of the characteristics of this period, especially *political change* accompanied by *hope, security, expansion* or *future*, words that mainly appear in Gz-1982's speech.

GONZÁLEZ 1986 – GONZÁLEZ 1989

These two speeches by Gonzalez are supported by an absolute majority of his party in Parliament, and thus for his election as Prime Minister. On 13 June 1985 the Act of Admission of Spain into the European Communities was signed, but only came into force on 1 January 1986. This admission led Spain to open up to foreign countries after years of political and economic isolation. The process required by the integration of Spain into Europe is widely commented on, as well as the relationships between Spain and other countries, through words such as *integration, isolation, adaptation, European, community, countries*. Foreign policy is increasing, also towards

countries outside of the EEC leading to mention *Eastern countries, Latin America, America* and *Western countries.*

Internal aspects also are mentioned as *internal security, security policy, defence policy, internal conditions* and *internal. Economic* and *social problems* are not resolved as evidenced by the words *deficit, inflation rate, growth rate, commercial, consumption, infrastructure, jobs creation, inequalities, social policy* and drugs. Terrorism (from E. T. A.) remains an important issue, as reflected by *terror* and *terrorists.*

Government action is often posed in positive terms such as *effort, challenge, struggle, fighting, sanitation, growth, sustained, increase, forward, further progress.* The need for change still appears with *changes* and *development*, but not in the sense of rupture with the previous period but seeking an evolution.

Despite having a parliamentary majority, the candidate for Prime Minster offers consensus to the opposition and social forces. That leads to the use of *adaptation, cooperation, coordination, agreement, negotiation, respecting, arranged* and *general interests.*

A New Generation of Leaders [Gz-1933–Ry-2011]

Although the last speech by Felipe González is included in this period, we can say that in Spain, which is now considered as a modern and democratic state, a new generation of leaders begin to appear.

GONZÁLEZ 1993 – AZNAR 2000

The last speech by Felipe Gonzalez and the first by José María Aznar, are influenced by the fact that they have to gain the support of other parties. They offered *compromise, programme, agreement(s), conversations* and *collaboration.* The internal organization of the State is again discussed, but from the point of view of *Autonomous Communities, regional governments, regions* and *autonomy.* A new model of *regional financing, funding model, fiscal responsibility* and *general government spending* is proposed.

Concerning foreign policy, the EEC was renamed on 7 February 1992 by the Maastricht Treaty of European Union (EU) and thus modifies some words. However, its importance in the speeches decreases. *European, Europe, new world order, convergence* and the *convergence criteria* are highly mentioned.

In Gz-1993, some difficulties are pointed out such as *economic crisis, competitiveness economic recovery, fiscal, party funding, rentals, structural reforms.*

Nevertheless, these years are of *expanding economy, prosperity, stability, consolidation, benefits, opportunities* and *welfare.* New issues arise such as the *information society, telecommunications, budget balance, budget, deficit reduction, liberalization, reforms, taxes, social protection* and *competitiveness.*

RODRÍGUEZ ZAPATERO 2004 (PSOE)

José Luis Rodríguez Zapatero's first speech is a landslide after eight years of José Maria Aznar's conservative government. He declares his opposition to the way Jose Maria Aznar was governing, looking for '*another spirit*' leading to use *to retrieve, dialogue, renewal, participation, consensus* and *respect.* In 2004 José Luis Rodríguez Zapatero takes a commitment with the Spanish society in the first person. He emphasizes the words *commitment* and *wish.* He shows a personal approach to government: *government* and *my government.* He pays much attention to measures of *equality* for *wo*men. A great number of references to terrorism are included: *terrorism, terror* and *victims of terrorism,* very much influenced by the terrorist attacks on 11 March 2004 on four Madrid trains – a few days prior to the election – due to jihadist groups; 191 people died and 1,858 were injured.

Government action announces many reforms such the *Senate. Immigration culture, innovation, research* and *knowledge* are also overrepresented.

In foreign policy, José Luis Rodríguez Zapatero emphasizes the withdrawal of Spanish troops from Iraq. He insists on the principles of acting within the international laws for foreign affairs.

RODRÍGUEZ ZAPATERO 2008 – RAJOY 2011

The crisis that affects *Spain* is the common point of both speeches. *Millions* of *Euros* are needed and changes in *taxes* are considered. *Financial* and *financial systems* are commented on. However, Zp-2008 does not include most of the effects of the financial and economic crisis, although many references concern *plans, projects* and *laws* (excluding the Constitution), which was not the case in his former speech. First measures to face up to the global financial and economic crisis are announced and economic issues appear with *economy* and *growth* whose frequencies significantly increase as compared with the first José Luis Rodríguez Zapatero's speech. *Economic growth, economic activity and economic* are widely used.

References to *firms* increase, first in Zp-2008 and strongly in Ry-2011, as well as *company, business, entrepreneurs* and (activity) *sectors. Unemployment* although already huge, is not mentioned by Zp-2008 but becomes widely discussed in the speech by Mariano Rajoy who gives figures (5–4 million) having increased by more than 3.4 million in the last four years.

Finance in Zp-2008 concerns the financing of regional governments, while in the Ry-2011 is related to the economic crisis. *Finance, capital, budgetary, budget* are used in Zp-2008 and their frequencies greatly increase in Ry-2011 which refers to solutions to be included in the *Law of State Budget*. Because of the crisis, reforms are needed. Ry-2011 refers to the *reform of Public Administration*, both of the *central State* and *regions* leading to high frequencies of *public* and *public accounts*. Ry-2011 extensively mentions *control* and *spending* reduction as well as *public debt, deficit, millions, numbers*, through the prism of the *Fiscal Stability Law. Employment* and *generation of employment* again become a concern.

Conclusions

Concerning the application of the technique, we have to underline that Spanish politicians have in most cases adapted, their speech to reality. This adaptation leads to important changes between the successive speeches by the same politician that are frequently clustered in different nodes. Surprisingly, neither a *right* nor a *left* vocabulary emerges.

We have proposed a methodology, linking several data analysis methods, which provide access to the vocabulary changes as embedded into both the text progression and the selected words. This methodology visualizes the shape of a text, through correspondence analysis graphics, and uncovers its organization, both in terms of segmentation into lexically homogeneous parts than of their hierarchical structure, through clustering methods. Furthermore, the flow of arguments is tracked and placed along this hierarchical structure.

This demarche can be applied to either an oral or written text. Every speech plays a specific role in the progression of the argumentation and is mainly characterized by its differences with the others. This textual structure is easily captured and put to the fore by combining correspondence analysis and constrained clustering while its decryption through conventional reading would be very tedious and time-consuming.

Software Note

Correspondence analysis and bootstrap have been performed by using STABIDAT software. It can be freely downloaded from http:\ralve.uni-leon.es. Chronological clustering is an R function available on demand to the second or third authors.

Acknowledgement

This work has received support from the Departament d'Universitats, Recerca i Societat de la Informació de la Generalitat de Catalunya. Agència d'Ajuts Universitari i de Recerca (grant: 2009SGR688).

FRÉDÉRIC LEBARON AND PHILIPPE BONNET

Conclusion to Part III

Part III shows the fertility of the combination of a sociological theoretical programme inspired by Bourdieu, as presented in Part I, and the appropriate use of Geometric Data Analysis techniques.

GDA techniques allow us to operationalize empirically the concepts of social space and field and to substantiate statistically the relations between dispositions and practices, positions and position-takings, trajectories and lifestyles, actors and discourses.

Since the 1970s, Bourdieu and his colleagues have made a systematic and important use of these techniques, especially Multiple Correspondence Analysis (MCA): his first article referring to GDA was 'L'anatomie du gout' (1976c) with Monique de Saint-Martin, republished in *La distinction* (1979). Then came the article 'Le patronat', with Monique de Saint-Martin, in 1978. After these two major publications of empirical results which are clearly strongly based on GDA methods, Bourdieu published the results of two MCAs in *Homo academicus* (1984) in order to study the universe of academics; he completed his analysis of 'Le patronat' in *La noblesse d'Etat* (1989) with a series of CAs and MCAs. He also published the results of GDA methods in a large collective study about the field of real estate companies and public policies in France (Bourdieu et al. 1990; Bourdieu 2000). It is no surprise that Bourdieu used these techniques in: 1) an investigation about cultural practices and lifestyles; 2) a study of dominant groups (economic and intellectual elites); and 3) the (economic) sociology of a 'market' and a public policy sector.

The assessment of 'social space' and 'field' effects is a way to 'quantify' Bourdieu's theory without reducing it to oversimplified indicators, as is sometimes done in more positivist applications. These notions emerged in Bourdieu's work during the very period when he used GDA techniques as

a way to construct his research object and to investigate the main regularities inside the global society and inside its specific subspaces.

The general homological relationship between social properties and orientations has been a major aspect of this work. It is also illustrated here in various domains, from culture to education and politics, and in several different national contexts: France, the US, Sweden, Denmark and Spain.

The similar methodological apparatus provided by GDA helps to 'compare' and 'contextualize' empirical results from these various situations; it is in this sense a way to move from monographic observations to more general conclusions. The conclusions of the various chapters presented here allow us to assess more general relationships between social properties and attitudes or practices; and to describe the complexity of concrete social spaces.

Conversely, empirical results obtained thanks to this framework allow us to renew and refine our sociological theory and are an original way to consider, in line with Bourdieu's philosophy of science, that sociological concepts are mainly practical tools for research.

MICHAEL GRENFELL AND FRÉDÉRIC LEBARON

Conclusion

Reference was made at the outset of this book to the way that Bourdieu's approach to studying the social world promises to 'restore to men the meaning of their actions' and, implicitly, a collection such as the present one suggests that this way of viewing things has a premium over others. In the first part of this book, we aimed to explain the general background to Bourdieu's viewpoint: where it came from, what it gave rise to, and the principles on which it was based. Here, we saw that a Bourdieusian perspective has to be founded on two salient elements: firstly, a philosophical base with an epistemologically charged set of analytical concepts; secondly, a commitment to empirical investigation. The first of these is based around *structure* as an organizing concept to express the multilayered relations that are set up within and between individuals. The second requires an openness to intervene in site specific contexts of the social world with an open mind and to look for and see beyond the conventional ways of interpreting it. And, of course, the two are co-terminus with the theory of practice guiding both the object and the subject of research. Part II then offered a series of practical exemplifications of applications of this theory of practice based around a methodological approach, which can broadly be termed 'qualitative'. Here, such key concepts as 'field', 'habitus' and 'capital' were brought to analyses of education and art to elucidate the underlying generating structures of a series of context studies. We saw here how data collection itself was of critical importance because of the tacit relations that were set up between the researcher and the researched, and how interpretation was dependent on the preconceived constructions of the researcher. Thus, there was a need a 'rupture' from them. Part III then offered a whole series of studies taken from a geometric analytical approach to data. Evidently, GDA does provide us with a procedure that

can depict social reality spatially and display a whole set of variables in a multidimensional way. To this extent, it *is* certainly more technical and technicist. However, we should not be seduced by its (apparent) statistical rigor into believing that such quantitative techniques are necessarily 'better' that qualitative, descriptive ones. Critical to both approaches is the whole 'construction of the research object', as initiated in Bachelard's tradition: Why it is chosen? In whose interest? To what end? To emphasize a point made earlier, such a construction comes with all the weight of previous constructions behind it. The 'pre-constructed is everywhere', to paraphrase Bourdieu. This is no less true for both qualitative and quantitative techniques, and it requires extreme academic rigor to break away from conventional (consecrated) forms of thought in order to develop a new gaze of the social world. So, survey data collection from questionnaires can be just as skewed as interview questions used in ethnographic interviews. Similarly, once a certain interpretation of a social space is made, there is always the temptation to select data to support it. So, exemplary citations are inserted into analytical discussions to bolster particular narratives emerging from qualitative research. In GDA, key variables are used to demonstrate how groups of individuals act together dispositionally. But, the latter is a key notion in Bourdieu – individuals are 'disposed' to behave in a certain way in a certain time and place. It is never totally determined. Why some individuals act in some ways some of the times – or not – and others do not can only really be explained by things that are left out of the statistical analysis itself; including the individual particularities and idiosyncrasies, and the way these exert symbiotic and inhibitory effects on social events when they are caught at a certain time and place in the social horizon.

This leads us to the paradox of change and stasis in Bourdieu. We need analytical tools that allow us to stabilize the dynamic of the social world sufficiently to express something of the semi-permanency of underlying generating structures. This is particularly challenging in a so-called postmodernist world of contingency and regress, where temporality and arbitrariness are seen as the chief features of contemporary social life. However, we need concepts and a theory that cannot only account for change but indeed demonstrate it in its very analysis. Bourdieu further acknowledges that such a dynamic emerges in a world that is so multidimensional that

we cannot hope to capture it in its totality. The way towards a 'good' representation of it is, hence, not to study a representative sample but to capture something of its wholeness. Since we cannot offer a complete representation of the multiplicity of social space, we can study something of the symbolic forms, which arise from them, and which in many ways mirror the former. Paradoxically, a study of symbolic forms therefore offers us knowledge of not only ideational but also material structures – superstructure and infrastructure – in society.

The word 'Paradox' is perhaps a good place to pause at this point, since it evokes the contradictory nature at the heart of much of Bourdieu's theory of practice and consequent method. Besides stasis and change, there is the whole subjective/ objective tension, one that Bourdieu described as both ubiquitous and ruinous in the social sciences. How can we be subjectively objective and/or objectively subjective? Both are necessary if we are to achieve the social dialectical way of thinking that is critical to this way of working. In a similar vein, the principal goal of scientific endeavour is often claimed to be the pursuit of objective knowledge, commonly predicated on the neutral researcher; whilst Bourdieu's approach is to recognize, and objectify, the interests of the researcher themselves. This objectification of the 'knowing subject' gives rise to two distinct sources for scientific knowledge. Firstly, if the researcher is identified with a field context, which they often are, their knowledge of it must be seen as a source of scientific knowledge. Secondly, and at the same time, such an *objectivation* can purge such knowledge of the very interests it cites in its name. At this point, in the way that Bourdieu argues, explanation and description are synonymous with understanding since a relationship is set up between the text and the reader, the researcher and the knowledge, which is equally structured in its constructivist and relational nature as the field of study. In many ways, this begins to sound like some form of recurrent reflexivity, perhaps even narcissistic in outcome. But, this relationship between researcher, text and reader implies the formation of a 'critical community' who can verify claims by a form of collective engagement; indeed, this is the final definition of what can pass as objective, scientific knowledge. Moreover, what Bourdieu is calling for is opposed to the conventional view of the 'self-aware' researcher, which he sees as giving in to the temptation to believe that thought can

transcend thought itself. It aims to do this by the application of the conceptual tools themselves. Because they were derived from practice, from a practical, causative, empirical engagement, set within a reflexive stance, they can be deployed in a similar fashion. In other words, what is claimed is that the tools themselves have an epistemological integrity that can act as analytical matrices when brought to empirical data. It is not just a question of using these concepts as heuristic devices, useful metaphors to enhance analyses in terms of a social constructivism, but deploying them in the full knowledge of the dynamic they imply. To this extent, the concepts might even be seen as a kind of 'final vocabulary', in the way that the American philosopher Richard Rorty used the term to denote 'the best we can do' at a particular moment in time. The significance of seeing analytical language in this way is that it both escapes from post-modernist relativity all whilst recognizing that the consequent knowledge obtained from such a process is partially contingent. Bourdieu argues along similar lines when he writes of 'radical doubt' with respect to the knowledge that is the outcome of this type of research. 'Doubtful' in the sense that whatever is claimed is offered in an 'at best' way, always leaving space to return and further elucidate findings. Bourdieu himself did this in several of his works, often re-engaging with topics and data decades after they were first addressed. 'Radical' in the sense that there is nothing tentative about such an approach, because what is claimed in its name has been described by a rigorous application of epistemological principles as referred to above. Nevertheless, Bourdieu is the first to acknowledge that the resultant outcomes of his method may at first seem less than conventional approaches; implying that the latter are often mistaken in their surety.

In this way, Bourdieu's methodological approaches are attempting to avoid two common traps in the social sciences: an unwarranted form of objectivism – often employing sophisticated statistics to 'crush one's rivals; and, an accented form of relativism expressed through a weak form of constructivism.

And the results? We might well ask: What it is to 'know' in this way? How does one understand it? How experience it? How share it? Bourdieusian language, if taken to its logical limit, shapes not only the way we think, but also the way we *can* think about the social world. If we

adopt a certain language, it transforms our thought patterns and, in so doing, the way we act in the social world. Such an action in turn necessarily changes the structure of the field itself, which, of course, in its own turn continues transformation. In place of 'objective knowledge' in the form of falsifiable statements in the Popperian mode, what is gained is a kind of 'reflexive objectivity' that operates in a unique way in that it requires a different form of engagement, a certain attitude of mind. Bourdieusian key concepts can be seen as providing an associative vocabulary for all those involved in the research to share in this 'new gaze', what has been called a 'metanoia'. Such a stance is *radical* in its practice. It confronts and breaks with conventional patterns of practice and knowing. It challenges the researcher to think outside of their normal interests. It calls on the reader to adopt an epistemological approach to understanding. The studies in this book represent a community of sorts, or researchers developing this stance. It would be fair to say that we are only in the early stages of such a movement, if that is what it is. This is pioneering work and, at the moment, there is already an uneasy gap between working from qualitative and quantitative perspectives, whilst what we need is an integration of both. Bourdieu would have been the first to acknowledge that this way of working is costly on time and effort and, in many ways, challenges the common practice of scholarship line production in order to maximize academic profit: fast reading, partisan critiques, publishing league tables, etc. However, he would also remind us that the truth is that truth is at stake, and anything other than vigilance and commitment in both theory *and* practice is nothing less an act of academic *mauvaise foi*. Bourdieu talks repeatedly about the conversion and reconversions that must go on, the ruptures from the pre-constructed, and the necessity to found a genuine science of the ordinary – a *libido sciendi*. Those who share in this mission act rather like 'praxeological agents' in articulating what to do and the reasons for doing it. The authors of the chapters in this book hope that you the reader will take encouragement and possibly even inspiration from the work presented here in setting about carrying out your own.

Bibliography

Abbot, A. and Tsay, A. (2000). 'Sequence Analysis and Optimal Matching Methods in Sociology: Review and Prospect', *Sociological Methods Research*, 29 (3), 3–33.

Ahn, S. (2000). 'OP-ED: What happens to the common school in the market?' *Journal of Curriculum Studies*, 32 (4), 483–93.

Amnå, E. and Ekman, J. (2012). 'Political participation and civic engagement. Towards a new typology', *Human Affairs*, 22, 283–94.

Angelides, P. and Ainscow, M. (2000). 'Making sense of the role of culture in school improvement', *School Effectiveness and School Improvement*, 11 (2), 145–63.

Archer, L. (2003). 'The "value" of higher education'. In L. Archer, M. Hutchings and A. Ross (ed.), *Higher Education and Social Class: Issues of exclusion and inclusion*. London: RoutledgeFalmer.

Archer, L., Hutchings, M. and Ross, A. (ed.) (2003). *Higher education and social class: Issues of exclusion and inclusion*. London: RoutledgeFalmer.

Armstrong, E. A., and Bernstein, M. (2008). 'Culture, Power, and Institutions: A Multi-Institutional politics approach to social movements', *Sociological Theory* 26 (1), 74–99.

Ashbaker, B. Y. and Morgan, J. (2001). 'Growing roles for teachers' aides', *www.eddigest.com*, 66 (7), 60–4.

Australian Education International (AEI) (2010). *International Student Survey: Overview Report*. Canberra: Commonwealth of Australia.

Avramidas, E., Bayliss, P. and Burden, R. (2002). 'Inclusion in action: An in-depth case study of an effective inclusive secondary school in the South-West of England', *International Journal of Inclusive Education*, 6 (2), 143–63.

Bagley, C., Woods, P. A. and Woods, G. (2001). 'Implementation of School Choice Policy: Interpretation and response by parents of students with special educational needs', *British Educational Research Journal*, 27 (3), 287–311.

Baker, B. (2002). 'The Hunt for Disability: The new eugenics and the normalization of school children', *Teachers College Record*, 104 (4), 663–703.

Ball, S. J., Davies, J., David, M. and Reay, D. (2002). '"Classification" and "Judgement": Social class and the "cognitive structures" of choice of higher education', *British Journal of Sociology of Education*, 23 (1), 51–72.

Beaud, S. (2002). *80% au bac... et après? Les enfants de la démocratisation scolaire*, Paris: La Découverte.

Benavot, A. and Resh, N. (2003). 'Educational Governance, School Autonomy and Curriculum Implementation: A comparative study of Arab and Jewish schools in Israel', *Journal of Curriculum Studies*, 35 (2), 171–96.

Bennett, T., Savage, M., Silva, E., Warde, A., Gayo-Cal M. and Wright, D. (2009). *Culture, Class, Distinction*. London: Routledge.

Benzecri, J. P. (1973a). *L'analyse de données: Tome 1 La Taxonomie*. Paris: Dunod.

Benzecri, J. P. (1973b). *L'analyse de données: Tome 2 L' analyse de correspondances*. Paris: Dunod.

Benzecri, J. P. (1981). *Pratique de l'analyse des données: Tome 3 Linguistique & Lexicologie*. Paris: Dunod.

Benzecri, J. P. (1992). *Correspondence Analysis Handbook*. New York: Marcel Dekker Inc.

Bernstein, J. (1999). *The Expanded Party in American Politics*. University of California: Berkeley.

Bernstein, J. and Dominguez, C. B. K. (2003). 'Candidates and Candidacies in the Expanded Party', *Political Science & Politics*, 36 (2), 165–9.

Berry, V. (2009). *Les Cadres de l'Expérience Virtuelle: Jouer, Vivre, apprendre dans unmonde numérique*, Université Paris-Est. Thèse de doctorat (sous la direction de Patrice Flichy).

Berry, V. (2011). 'Sociologie des MMORPG et Profils de Joueurs: Pour une théorie sociale de l'activité (vidéo)ludique', *Revue des sciences sociales*, 45, 78–85.

Bird, M. (2008). *The St Ives Artists: A Biography of Place and Time*. Lund Humphries.

Blasius, J. and Michael, G. (ed.) (1998). *Visualization of Categorical Data*. San Diego: Academic Press.

Blasius, J. and Greenacre, M. (1994). *Correspondance Analysis in the Social Sciences*. London: Elsevier Academic Press.

Blue-Banning, M., Summers, J. A., Frankland, H. C., Nelson, L. L. and Beegle, G. (2004). 'Dimensions of Family and Professional Partnerships: Constructive guidelines for collaboration', *Exceptional Children*, 70 (2), 167–84.

Blumenthal, S. (1980). *The Permanent Campaign: Inside the World of Elite Political Operatives*. Boston: Beacon Press.

Bogdan, R. C. and Biklen, S. (2007). *Qualitative research for education: An introduction to theory and methods, 5th Edition*. Boston MA: Pearson.

Bogost, I. (2006). *Unit Operation: An Approach to Videogame Criticism*. Cambridge: MIT Press.

Bolitho, R. and Medgyes, P. (2000). 'Talking Shop: From Aid to Partnership', *ELT Journal*, 54 (4), 379–88.

Börjesson, M. (2003). 'Det Svenska högskolafältet och lärarutbildningarna', *Institutionen för lärarutbildning Uppsala*. http://www.ped.uu.se/larom/texter/pdf-filer/Detsvenska högskolefältet.pdf.

Börjesson, M. (2005) 'Transnationella Utbildningsstrategier. I–IV Pedagogiska Institutionen SEC/ILU'. *Uppsala Universitet*: Uppsala. http://www.skeptron.uu.se/broady/sec/sec-37.pdf.

Boullier, D. (2004). 'La Fabrique de l'Opinion Publique dans Les Conversations Télé', *Réseaux*, 126, 57–87.

Bourdieu, P. (1958). *Sociologie de l'Algérie*. (New Revised and Corrected Edition, 1961). Paris: Que Sais-je.

Bourdieu, P. (1961). 'Révolution dans la Révolution', *Esprit*, Jan., 27–40.

Bourdieu, P. (1962a). *The Algerians* (trans. A. C. M. Ross). Boston MA: Beacon Press.

Bourdieu, P. (1962b). 'Célibat et condition paysanne', *Etudes rurales*, 5–6, 32–136.

Bourdieu, P. (1962c). 'De la Guerre Révolutionnaire à la Révolution', in F Perroux (ed.) *L'Algérie de Demain*, Paris: PUF.

Bourdieu, P., Darbel, A. Rivet, J. P. and Seibel, C. (1963). *Travail et Travailleurs en Algérie*. Paris – The Hague: Mouton.

Bourdieu, P. and Sayad, A. (1964). *Le Déracinement, La Crise de l'Agriculture Tradionelle en Algérie*. Paris: Les Editions de Minuit.

Bourdieu, P. with Darbel, A. (1966). 'La Fin d'Un Malthusianisme?' in Darras (ed.), *Le Partage des Bénéfices, Expansion et Inégalités en France*. Paris: Minuit.

Bourdieu, P. and Passeron, J. C. (1967a). 'Sociology and Philosophy in France: Death and resurrection of a philosophy without subject', *Social Research*, 34 (1), 162–212.

Bourdieu, P. (1967b). 'Postface to Panofsky, E. T'. in *Architecture Gothique et Pensée Scolastique* (tr. Bourdieu, P). Paris: Minuit.

Bourdieu, P. (1968a). 'Structuralism and Theory of Sociological Knowledge', *Social Research*, 35 (4), 681–706.

Bourdieu, P., Chamboredon, J. C. and Passeron, J. C. (1968b). *Le Métier de Sociologue. Préalables épistémologiques*. Paris: Mouton/Bordas.

Bourdieu, P. (1971a/67). 'Systems of Education and Systems of Thought'. In M. F. D. Young (ed.), *Knowledge and Control: New directions for the sociology of education*. London: Macmillan.

Bourdieu, P. (1971). 'Systèmes d'Enseignement et Systèmes de Pensée'. *Revue Internationale des Sciences Sociales*, XIX (3), 338–88.

Bourdieu, P. (1971b). 'The Thinkable and the Unthinkable', *The Times Literary Supplement*, 15 October, pp. 1255–6.

Bourdieu, P. (1971c). 'Intellectual Field and Creative Project'. In M. F. D. Young (ed.), *Knowledge and Control: New directions for the Sociology of Education*. London: Macmillan.

Bourdieu, P. (1966). 'Champ Intellectuel et Projet Créateur', *Les Tempts Modernes*, Nov, 865–906.

Bourdieu, P. (1971d). 'L'opinion Publique n'Existe Pas', *Noroit*, 155.

Bourdieu, P. (1972a). 'Les Stratégies Matromoniales dans le Système de Reproduction', *Annales*, 4–5, 1105–27.

Bourdieu, P. (1972b). 'Les Doxosophes', *Minuit*, 1, 26–45.

Bourdieu, P. (1973). 'Cultural Reproduction and Social Reproduction'. In R. Brown (ed.), *Knowledge, Education, and Cultural Change*. London: Tavistock.

Bourdieu, P. (1975). 'L'ontologie politique de Martin Heidegger', *Actes de la Recherche en sciences sociales*, 5–6, 109–56.

Bourdieu, P. and Boltanski, L. (1976a). 'La production de l'idéologie dominante', *Actes de la recherche en sciences sociales*, 2 (2–3), 3–73.

Bourdieu, P. (1976b). 'Le Champ Scientifique', *Actes de la recherche en sciences sociales*, V, 2 (2–3), 88–104.

Bourdieu, P. and De Saint-Martin, M. (1976c). 'Anatomie du goût', *Actes de la recherche en sciences sociales*, 2 (5), 2–81.

Bourdieu, P. and Passeron, J.-C. (1977a/70). *Reproduction in Education, Society and Culture*. (trans. R. Nice). London: Sage.

Bourdieu, P. and Passeron, J.-C. (1970). *La Reproduction. Eléments pour une théorie du système d'enseignement*. Paris: Les Editions de Minuit.

Bourdieu, P. (1977b/72). *Outline of a Theory of Practice* (trans. R. Nice). Cambridge: CUP.

Bourdieu, P. (1972). *Esquisse d'une théorie de la pratique. Précédé de trois études d'ethnologie kabyle*. Geneva: Droz.

Bourdieu, P. (1979a/1977). *Algeria 1960* (trans. R. Nice). Cambridge: Cambridge University Press.

Bourdieu, P. (1977). *Algérie 60 structures économiques et structures temporelles*. Paris: Les Editions de Minuit.

Bourdieu, P. and Passeron, J.-C. (1979b/64). *The Inheritors, French Students and their Relation to Culture* (trans. R. Nice). Chicago: The University of Chicago Press.

Bourdieu, P. and Passeron, J.-C. (1964). *Les héritiers, les étudiants et la Culture*. Paris: Les Editions de Minuit.

Bourdieu, P. (1982a). *Leçon sur une leçon*. Paris: Les Editions de Minuit.

Bourdieu, P. (1982b). *Ce Que Parler Veut Dire: L'économie des échanges linguistiques*. Paris: Fayard.

Bourdieu, P. (1984a/79). *Distinction* (trans. R. Nice). Oxford: Polity.

Bourdieu, P. (1979). *La Distinction. Critique sociale du jugement*. Paris: Editions de Minuit.

Bourdieu, P. (1984b). 'Espace social et genèse des classes', *Actes de la Recherche en Sciences Sociales*, 52 (53), 3–14.

Bourdieu, P. and Salgas, J.-P. (1985a). 'Le rapport du Collège de France. Pierre Bourdieu s'explique', *La Quinzaine Littéraire*, 445, 8–10.

Bourdieu, P. (1985b). 'Les intellectuals et les pouvoirs. Retour sur notre soutien à Solidarnosc', in *Michel Foucault, une histoire de la vérité*. Paris: Syros.

Bourdieu, P. (1985c). 'The genesis of the concepts of "habitus" and "field"', *Sociocriticism*, 2 (2), 11–24.

Bourdieu, P. (1985d). 'Social Space and the Genesis of Groups', *Theory and Society*, 14 (6), 723–44.

Bourdieu, P. (1986). 'The Forms of Capital'. In J. Richardson (ed.), *Handbook of Theory and Research for the Sociology of Education*, pp. 241–58. New York: Greenwood Press.

Bourdieu, P. (1987). 'What Makes a Class?', *Berkeley Journal of Sociology*, 32, 1–18.

Bourdieu, P. (1988a/84). *Homo Academicus* (Trans. P. Collier). Oxford: Polity.

Bourdieu, P. (1984). *Homo Academicus*. Paris: Les Editions de Minuit.

Bourdieu, P. (1989a). 'Social Space and Symbolic Power', *Sociological Theory*, 7, 14–25.

Bourdieu, P. (1989b). 'Reproduction interdite: La dimension symbolique de la domination économique', *Etudes Rurales*, 113–14, 15–36.

Bourdieu, P. and Wacquant, L. (1989c). 'Towards a Reflexive Sociology: A workshop with Pierre Bourdieu', *Sociological Theory*, 7 (1), 26–63.

Bourdieu, P. (1990a/1980). *The Logic of Practice* (trans. R Nice). Oxford: Polity.

Bourdieu, P. (1980). *Le Sens Pratique*. Paris: Les Editions de Minuit.

Bourdieu, P., Boltanski, L., Castel, R. and Chamboredon, J. C. (1990b/1965). *Photography. A Middle-brow Art* (trans. S. Whiteside). Oxford: Polity.

Bourdieu, P. (1965). *Un Art moyen, essai sur les usages sociaux de la photographie*. Paris: Les Editions de Minuit.

Bourdieu, P., Darbel, A. and Schnapper, D. (1990c/1966). *The Love of Art. European Art Museums and their Public* (trans. C. Beattie and N. Merriman). Oxford: Polity Press.

—— (1966). *L'Amour de l'art, les musées d'art et leur public*. Paris: Les Editions de Minuit.

Bourdieu, P. (1991a/82). *Language and Symbolic Power* (trans. G. Raymond and M. Adamson). Oxford: Polity Press.

Bourdieu, P., Chamboredon, J.-C. and Passeron, J.-C. (1991b/1968). *The Craft of Sociology* (trans. R. Nice). New York: Walter de Gruyter.

—— (1968). *Le Métier de sociologue*. Paris: Mouton-Bordas.

Bourdieu, P. (1991c/1988). *The Political Ontology of Martin Heidegger* (trans. P. Collier). Oxford: Polity Press.

—— (1988). *L'ontologie politique de Martin Heidegger*. Paris: Les Editions de Minuit.

Bourdieu, P. (1991d). 'Social Space and the Genesis of "Classes"'. In *Language and Symbolic Power*, pp. 229–51. Cambridge, Mass: Harvard University Press.

Bourdieu, P. and Wacquant, L. (1992a). *An Invitation to Reflexive Sociology* (trans. L. Wacquant). Oxford: Polity Press.

—— (1992). *Réponses. Pour une anthropologie réflexive*. Paris: Seuil.

Bourdieu, P. (1992b/1989). 'Principles for reflecting on the curriculum', *The Curriculum Journal*, 1 (3), 307–14.

—— (1989). *Principes pour une réflexion sur les contenus d'enseignment*.

Bourdieu, P. (1992c). 'Questions de mots: une vision plus modeste du rôle des journalistes', *Les Mensonges du Golfe*, 27–32.

Bourdieu, P. (1992d). 'Pour une Internationale des intellectuels', *Politis*, 1, 9–15.

Bourdieu, P. and Eagleton, T. (1992e). 'In Conversation: Doxa and Common Life', *New Left Review*, 191, 111–22.

Bourdieu, P. (1992f). 'Social Space and Genesis of Classes', *Language and Symbolic Power*, 227–51.

Bourdieu, P. (1993a/1980). *Sociology in Question* (trans. R. Nice). London: Sage.

—— (1980). *Questions de sociologie*. Paris: Les Editions de Minuit.

Bourdieu, P. (1993b). *The Field of Cultural Production: Essays on Art and Literature*. Oxford: Polity Press.

Bourdieu, P. (1993c). 'Principles of a Sociology of Cultural Works'. In S. Kemal and I. Gaskell (ed.), *Explanation and Value in The Arts*. Cambridge: CUP.

Bourdieu, P. and Pasquier, S. (1993d). 'Notre Etat de misère', *L'Express*, 18 March, 112–15.

Bourdieu, P. (1993e). 'Responsabilités intellectualles: Les mots de la guerre en Yougoslavie', *Liber*, 14 (2).

Bourdieu, P. (1993f). 'Concluding Remarks: For a sociogenetic understanding of intellectual works'. In C. Calhoun, E. LiPuma and M. Postone (ed.) *Bourdieu: Critical Perspectives*. Oxford: Policy Press.

Bourdieu, P., Passeron, J.-C. and De Saint Martin, M. (1994a/65). *Academic Discourse*. Oxford: Polity.

—— (1965). *Rapport Pédagogique et Communication*. The Hague: Mouton.

Bourdieu, P. (1994b). 'Un parlement des écrivains pour quoi faire?', *Libération*, 3 November.

Bourdieu, P. (1994c). 'Comment sortir du cercle de la peur?', *Libération*, 17, 22–3.

Bourdieu, P. (1994d/1987). *In Other Words: Essays Towards a Reflexive Sociology* (trans. M. Adamson). Oxford: Polity.

—— (1987). *Choses dites*. Paris: Les Editions de Minuit.

Bourdieu, P. and Grenfell, M. (1995a). *Entretiens*. CLE Papers 37: University of Southampton.

Bourdieu, P. (1995b). 'Social Space and Symbolic Power'. In D. McQuarie (ed.), *Readings in Contemporary Sociological Theory: From modernity to post-modernity*, pp. 323–34. Englewood Cliffs, NJ: Prentice-Hall, Inc.

Bourdieu, P. (1996a/92). *The Rules of Art* (trans. S. Emanuel). Oxford: Polity Press.
—— (1992). *Les règles de l'art. Genèse et structure du champ littéraire*. Paris: Seuil.
Bourdieu, P. (1996b/1989). *The State Nobility. Elite Schools in the Field of Power* (trans. L. C. Clough). Oxford: Polity Press.
—— (1989). *La noblesse d'état. Grandes écoles et esprit de corps*. Paris: Les Editions de Minuit.
Bourdieu, P., Derrida, J., Eribon, D., Perrot, M., Veyne, P. and Vidal-Naquet, P. (1996c). 'Pour une reconnaissance du couple homosexuel', *Le Monde*, 1 March.
Bourdieu, P. (1998a/1994). *Practical Reason*. Oxford: Polity Press.
—— (1994). *Raisons pratiques. Sur la théorie de l'action*. Paris: Seuil.
Bourdieu, P. (1998b). *Outline of a theory of practice* (trans. R. Nice). Cambridge: Cambridge University Press.
Bourdieu, P. (1999a/1993). *The Weight of the World. Social Suffering in Contemporary Society* (trans. P. Parkhurst Ferguson, S. Emanuel, J. Johnson, S. T. Waryn). Oxford: Polity Press.
—— (1993). *La Misère du monde*. Paris: Seuil.
Bourdieu, P. (1999b). *Statistics and Sociology* (trans. D. Robbins). UEL: Social Politics Paper No. 10.
Bourdieu, P. (2000a/1997). *Pascalian Meditations* (trans. R. Nice). Oxford: Polity Press.
—— (1997). *Méditations pascaliennes*. Paris: Seuil.
Bourdieu, P. (2000b). *Propos sur le champ politique*. Lyon: Presses Universitaires de Lyon.
Bourdieu, P. (2000c). *Les Structures sociales de l'economie*. Paris: Seuil.
—— (2005). *The Social Structures of the Economy*. Cambridge: Polity Press.
Bourdieu, P. (2000d). 'Entre amis', *AWAL: Cahiers d'Etudes Berbères*, 5–10.
Bourdieu, P. (2000e). 'Making the Economic Habitus: Algerian workers revisited' (trans. R. Nice and L. Wacquant), *Ethnography*, 1 (1), 17–41.
Bourdieu, P. (2000f). 'A Scholarship With Commitment. Pour un savoir engagé', *Agone*, 23, 205–11.
Bourdieu, P. (2000g). 'Manifeste pour des états généreux du mouvement européen', *Le Monde*, 1 May, p. 7.
Bourdieu, P. and Wacquant, L. (2000h). 'La nouvelle vulgate planétaire', *Le Monde Diplomatique*, May, 6–7.
Bourdieu, P. and Swain, H. (2000i). 'Move Over, Shrinks', *Times Higher Educational Supplement*, 14 April, p. 19.
Bourdieu, P. (2000j). 'Participant Objectivation', address given in receipt of the Aldous Huxley Medal for Anthropology, University of London, 12 November, *Mimeograph*, p. 12.

Bourdieu, P. (2001a/1998). *Masculine Domination*. Oxford: Polity Press.

—— (1998) *La Domination masculine*. Paris: Seuil.

Bourdieu, P. (2001b). *Contre-feux 2. Pour un mouvement social européen*. Paris: Raisons d'Agir.

Bourdieu, P. (2001c). *Science de la science et réflexivité*. Paris: Raisons d'Agir.

—— (2004). *Science of Science and Reflexivity*. Cambridge: Polity Press.

Bourdieu, P. (2002a). 'Pierre par Bourdieu', *Le Nouvel Observateur*, 31 January 2002 Paris, 30–1.

Bourdieu, P. (2002b). *Le bal des célibataires. Cris de la société en Béarn*. Paris: Seuil.

Bourdieu, P. (ed. Discepolo and F. Poupeau) (2002c). *Interventions (1961–2001)*. Marseilles: Agone.

Bourdieu, P. (2003a). *Images d'Algérie*. Paris: Actes Sud.

Bourdieu, P. (2003b). 'Participant Objectivation', *The Journal of the Royal Anthropological Institute*, 9 (2), 281–94.

Bourdieu, P. (2004). *Esquisse pour une auto-analyse*. Paris: Raisons d'Agir.

Bourdieu, P. (2005/ 1997). 'From the King's House To The Reason of State'. In L. Wacquant (ed.), *Pierre Bourdieu and Democratic Politics*. Cambridge: Polity Press.

—— (1997). 'De la maison du roi à la raison d'état: un modèle de la genèse du champs bureaucratique' *Actes de la Recherche en Sciences Sociales*, 118, 55–68.

Bourdieu, P. (2006). 'The Forms of Capital'. In H. Lauder, P. Brown, J.-A. Dillabough and A. H. Halsey (ed.), *Education, Globalisation and Social Change*, Oxford: Oxford University Press.

Bourdieu, P. (2007). *Sketch for a Self-analysis*. Cambridge: CUP.

—— (2007). *Esquisse pour une auto-analyse*. Paris: Raisons d'Agir.

Bourdieu, P. (2008a/ 2002). *Interventions: Social Science and Political Action*. (ed.) T. Discepolo and F. Poupeau. London: Verso.

—— (2002). *Interventions (1961–2001)*. Marseilles: Agone.

Bourdieu, P. (2008b/2002). *Bachelors' Ball*. Oxford: Polity Press.

—— (2002). *Le bal des célibataires. Cris de la société en Béarn*. Paris: Seuil.

Boutet, M. (2008). 'S'orienter dans les espaces sociaux en ligne. L'exemple d'un jeu', *Sociologie du travail*, 50, 447–70.

Boutet, M. (2012a). 'Jouer aux jeux vidéo avec style', *Réseaux*, 173–4 (3), 208–34.

Boutet, M. (2012b). 'Un rendez-vous parmi d'autres. Ce que le jeu sur Internet nous apprend du travail contemporain', *Ethnographiques.org*, 23.

Bradley, D., Noonan, P., Nugent, H. and Scales, B. (2008). *Review of Australian Higher Education: Final Report*. Canberra: Department of Education, Employment and Workplace Relations.

Brain, K. and Reid, I. (2003). 'Constructing Parental Involvement In An Educational Action Zone: Whose need is it meeting?' *Educational Studies*, 29 (2–3), 291–305.

Brante, T. (2005). 'Staterne og professionerne.' In Eriksen, T. R. and Jørgensen, A. M., *Professionsidentitet i forandring*. København: Akademisk Forlag.

Braun, V. and Clarke, V. (2006). 'Using Thematic Analysis in Psychology', *Qualitative Research in Psychology*, 3, 77–101.

Broady, D., Börjesson, M. and Palme, M. (2002). 'Det svenska högskolefältet under 1990-talet. Den sociala rekryteringen och konkurrensen mellan lärosätena'. In Furusten, T. (ed.) *Perspektiv på högskolan i ett förändrat Sverige*. Stockholm: Högskoleverket. http://www.hsv.se/download/18.539a949110f3d5914ec800086798/ isbn91-88874-91-5.pdf

Brodersen, M. (2009). 'Fra "professioner" til "felt for velfærdsarbejde"'. In *Tidsskrift for Arbejdsliv* Nr. 3.

Burke, P. J. (2005). 'Access and Widening Participation'. *British Journal of Sociology of Education*, 26 (4), 555–62.

Carrington, S. (1999). 'Inclusion Needs A Different School Culture', *International Journal of Inclusive Education*, 3 (3), 257–68.

Carrington, S. and Elkins, J. (2002). 'Comparison Of A Traditional and An Inclusive Secondary School Culture', *International Journal of Inclusive Education*, 6 (1), 1–16.

Cimbricz, S. (2002). 'State-mandated Testing and Teachers' Beliefs and Practice', *Education Policy Analysis Archives*, 10 (2). Retrieved 28 November 2002 from http://epaa/v10n2.html

Clark, C., Dyson, A., Millward, A., and Robson, S. (1999). 'Theories of Inclusion, Theories of Schools: Deconstructing and Reconstructing the "Inclusive School"', *British Educational Research Journal*, 25 (2), 157–77.

Clegg, S., Bradley, S. and Smith, K. (2006). '"I've Had To Swallow My Pride": Help seeking and self-esteem', *Higher Education Research and Development*, 25 (2), 101–13.

Coavoux, S. (2010a). 'L'espace social des pratiques de World of Warcraft'. In H. Ter Minassian and S. Rufat (ed.), *Les jeux vidéo comme objet de recherche*, pp. 253–80. Paris: Questions Théoriques.

Coavoux, S. (2010b). 'La carrière des joueurs de *World of Warcraft*'. In S. Craipeau, S. Genvo and B. Simonnot (ed.), *Les jeux vidéo au croisement du social, de l'art et de la culture*, pp. 43–58. Nancy: Presses Universitaires de Nancy.

Coavoux, S. (2010c). 'The Quantitative-Qualitative Antinomy in Virtual World Studies'. In T. J. Wright, D. G. Embrick and A. Lukacs (ed.), *Utopic Dreams and Apocalyptic Fantasies. Critical Approaches to Researching Video Game Play*, pp. 223–44. Lanham, MD: Lexington Press.

Colonna, F. (1975). *Instituteurs Algériens 1883–1939*. Paris: Presses de la fondation nationale des sciences politiques.

Coulangeon, P. and Lemel, Y. (2009). 'The Homology Thesis: Distinction Revisited'. In Robson, K. and Sanders, C. (ed.), *Quantifying theory: Pierre Bourdieu*. Springer Netherlands.

Coulangeon, P. (2011). *Les métamorphoses de la distinction*. Paris: Grasset.

Coulon, A. (1997). *Le métier d'étudiant. L'entrée dans la vie universitaire*. Paris: PUF.

Council of Australian Governments (COAG) (2010). *International Students Strategy for Australia: 2010 – 2014*. Accessed 12 November 2011 at http://www.coag.gov.au

Crehan, K. and Von Oppen, A. (1988). 'Understanding of Development: an arena of struggle', *Sociologia Ruralis*, XXVIII (2–3), 113–45.

Crotty, W. J. and Jacobson, G. C. (1980). *American Parties in Decline*. Boston MA: Little Brown and Company.

Crozier, G., Reay, D., Clayton, J., Colliander, L. and Grinstead, J. (2008). 'Different Strokes For Different Folks: Diverse students in diverse institutions – experiences of higher education', *Research Papers in Education*, 23 (2), 167–77.

Cummins, J. (2000). *Language, Power and Pedagogy: Bilingual children caught in the crossfire*. Clevedon: Multilingual Matters.

Dahl, H. M. (2005). 'Fra en klassisk til en (post?)moderne opfattelse af professioner?' In Eriksen, T. R. and Jørgensen, A. M. (ed.), *Professionsidentitet i forandring*. København: Akademisk Forlag.

Dalton, R. J. and Wattenberg, M. P. (2000). *Parties Without Partisans: Political Change in Advanced Industrial Democracies*. Oxford: Oxford University Press.

David, M. with Bathmaker, A.-M., Crozier, G., Davis, P., Ertl, H., Fuller, A., Hayward, G., Heath, S., Hockings, C., Parry, G., Reay, D., Vignoles A., and Williams, J. (ed.) (2010). *Improving learning by widening participation in higher education*. Improving Learning Series. London: Routledge.

Denord, F., Hjellbrekke, J., Korsnes, O., Lebaron, F. and Le Roux, B. (2011). 'Social Capital In The Field Of Power: The case of Norway', *The Sociological Review*, 59 (1), 86–108.

Department for Business Innovation and Skills (2011). *Higher education: Students at the heart of the system*. London: Department for Business, Innovation and Skills.

Department for Education and Skills (2003a). *The Future of Higher Education*. Norwich: Department for Education and Skills.

Department for Education and Skills (2003b). *Widening Participation in Higher Education*. Norwich: Department for Education and Skills.

Department of Business Innovation and Skills (2010). *Higher Ambition: The future of universities in a knowledge economy*. Department of Business, Innovation and Skills, London.

Drachen, A., Alessandro C., and Yannakakis, G. (2009). 'Player Modeling Using Self-Organization in Tomb Raider: Underworld'. Paper presented at the *IEEE Symposium Computational Intelligence and Games*. Milano, Italy.

Duemer, L. S. and Mendez-Morse, S. (2002). 'Recovering Policy Implementation: Understanding implementation through informal communication', *Education Policy Analysis Archives*, 10 (39), 1–11.

Dulio, D. A. (2004). *For Better or Worse?: How Political Consultants Are Changing Elections in the United States*. Albany: State University of New York Press.

Dulio, D. A. and Nelson, C. J. (2005). *Vital Signs: Perspectives on the Health of American Campaigning*. Washington, D. C.: Brookings Institution Press.

Everett, A. (2005). 'Serious Play: Playing with Races in Contemporary Gaming Culture'. In J. Goldstein and J. Raessens (ed.), *Handbook of Computer Game Studies*, pp. 311–26. London: MIT Press.

Fairclough, N. (2003). 'Political Correctness': The politics of culture and language', *Discourse and Society*, 14 (1), 17–28.

Farrell, D. M. and Webb, P. (2000). 'Political Parties as Campaign Organizations'. In Dalton, R. and Wattenberg, M. (ed.) *Parties without Partisans: Political Change in Advanced Industrial Democracies*, pp. 102–28.

Fiske, J. (1992). 'The Cultural Economy of Fandom'. In Lisa Lewis (ed.) *The Adoring Audience: Fan Culture and Popular Media*, pp. 30–49. London: Routledge.

Fligstein, N. and McAdam, D. (2011). 'Toward a General Theory of Strategic Action Fields', *Sociological Theory*, 29 (1), 1–26.

Forsyth, A. and Furlong, A. (2003). *Losing Out? Socioeconomic Disadvantage and Experience in Further and Higher Education*. Bristol: The Joseph Rowntree Foundation.

Fowler, B. (ed.) (2000). *Reading Bourdieu on Society and Culture*. Oxford: Blackwell.

Fowler, B. (2004). 'Mapping the Obituary: Notes towards a Bourdieusian Interpretation'. In L. Adkins and B. Skeggs (ed.), *Feminism After Bourdieu*, Oxford: Blackwell.

Frederickson, N., Dunsmuir, S., Lang, J., and Monsen, J. J. (2004). 'Mainstream-Special School Inclusion Partnerships: Pupil, parent, and teacher perspectives', *International Journal of Inclusive Education*, 8 (1), 37–57.

Fullan, M. (2000). 'The Three Stories of Education Reform', *Phi Delta Kappan, 81*(8), 581–4.

Gay, G. (2002). 'Culturally Responsive Teaching in Special Education For Ethnically Diverse Students: Setting the stage', *Qualitative Studies in Education*, 15 (6), 613–29.

Giangreco, M. F., Edelman, S. W., Broer, S. M. and Doyle, M. B. (2001). 'Paraprofessional Support of Students with Disabilities: Literature from the past decade', *Exceptional Children*, 68 (1), 45–63.

Gilbert, A., LeTouzé, S., Thériault, J. Y. and Landry, R. (2004). *Teachers and The Challenge of Teaching in Minority Settings*. Ottawa: Canadian Teachers' Federation.

Gilchrist, R., Phillips, D. and Ross, A. (2003). 'Participation and Potential Participa-
 tion in UK Higher Education'. In L. Archer, M. Hutchings and A. Ross (ed.),
 Higher Education and Social Class: Issues of exclusion and inclusion. London:
 Routledge Falmer.
Gorsuch, G. J. (1999). 'Monbusho Approved Textbooks in Japanese High School
 EFL Classes: An Aid or a Hindrance to Educational Policy Innovations?', *The
 Language Teacher*, 23 (10), 5–15.
Greenacre, M. (2006). *Multiple Correspondence Analysis and Related Methods.* Abing-
 don: Taylor and Francis. Accessed 25 March 2011 at http://cdsweb.cern.ch/
 record/1010874
Greenacre, M. and Blasius, J. (2006). *Multiple Correspondence Analysis and Related
 Methods.* Florida: Chapman and Hall.
Greenbank, P. (2006). 'Institutional Widening Participation Policy in Higher Educa-
 tion: Dealing with the "issue of social class"', *Widening Participation and Lifelong
 Learning*, 8 (1), 27–36.
Grenfell, M. and James, D. (1998). *Bourdieu and Education: Acts of Practical Theory.*
 London: Falmer.
Grenfell, M. (1996). 'Bourdieu and The Initial Training of Modern Language Teach-
 ers', *British Educational Research Journal*, 22 (3), 287–303.
Grenfell, M. (2004). *Pierre Bourdieu: Agent Provocateur.* London: Acumen.
Grenfell, M. (2006). 'Bourdieu in the Field: From the Béarn to Algeria – a timely
 response', *French Cultural Studies*, 17 (2), 223–40.
Grenfell, M. (2007). *Bourdieu, Education and Training.* London: Continuum.
Grenfell, M. (ed.) (2012). *Pierre Bourdieu: Key Concepts.* Stocksfield: Acumen.
Grenfell, M. and Hardy, C. (2007.) *Art Rules. Pierre Bourdieu and the Visual Arts.*
 Oxford: Berg.
Grossmann, M. (2009a). 'Campaigning as an Industry: Consulting Business
 Models and Intra-Party Competition', *Business and Politics* 11 (1). Accessed
 21 March 2012 at http://econpapers.repec.org/article/bpjbuspol/v_3a11_3ay
 _3a2009_3ai_3a1_3an_3a2.htm
Grossmann, M. (2009b). 'Going Pro? Political Campaign Consulting and the Profes-
 sional Model', *Journal of Political Marketing*, 8 (2), 81–104.
Gutierrez, K. D. (2002). 'Studying Cultural Practices in Urban Learning Communi-
 ties', *Human Development*, 45, 312–21.
Gytz Olesen, S. (2005). *Rekruttering og rekonstruktion – om praktikker og italesættelser i
 pædagoguddannelsen.* Afd. for Pædagogik. København: Københavns Universitet.
Hall, S. (1980). 'Encoding/Decoding'. In S. Hall, D. Hobson, A. Lowe and P. Willis
 (ed.) *Culture, Media, Language: Working Papers in Cultural Studies*, pp. 128–38.
 London: Hutchinson.

Hardy, C. and Grenfell, M. (2007). 'When Two Fields Collide', *International Journal of Arts in Society*, Volume 1, cgpublisher.com

Hardy, C. (2007). 'Feminising the Artistic Field'. Paper presented at the European Conference for Educational Research, University of Ghent, Belgium, September.

Hardy, C. (2009). 'Bourdieu and the Art of Education: A Socio-Theoretical Investigation of Education, Change and the Arts'. Unpublished doctoral thesis, University of Southampton, Winchester, UK.

Hardy, C. (2010). 'Why are There So Few Well Known Women Artists?' Paper presented at the Annual Conference of Autobiography of British Sociological Association, December.

Harrits, G. S., Prieur, A., Rosenlund, L., Skjøtt-Larsen, J. (2010). 'Class and Politics in Denmark: are Both Old and New Politics Structured by Class?', *Scandinavian Political Studies*, 33 (1), 1–27.

Herrnson, P. S. (2009). 'The Roles of Party Organizations, Party-Connected Committees, and Party Allies in Elections', *The Journal of Politics*, 71 (4), 1207–24.

Higher Education Funding Council for England. (2001). *Strategies for widening participation in higher education: A guide to good practice*. Bristol: Higher Education Funding Council for England.

Hjellbrekke, J. (1999). *Innføring i korrespondanceanalyse*. Bergen: Fagbokforlaget Vigmostad & Bjørke AS.

Hjellbrekke, J. (2007). 'The Norwegian Field of Power Anno 2000', *European Societies*, 9 (2), 245–73.

Hjellbrekke, J. (2009). 'Quantifying the Field of Power in Norway'. In K. Robson and C. Sanders (ed.), *Quantifying Theory: Pierre Bourdieu*. New York: Springer Science and Business Media.

Hjort, K. (1999). *En helt anden virkelighed*. Roskilde: Roskilde Universitetsforlag.

Hjort, K. (2002). *Moderniseringen af den offentlige sektor*. Frederiksberg: Roskilde Universitetsforlag.

Hjort, K. (2008). *Demokratiseringen af den offentlige sektor*. Frederiksberg: Roskilde Universitetsforlag.

Hoggart, R. (1957). *The Uses of Literacy: Aspects of working-class life with special references to publications and entertainments*. London: Chatto and Windus.

Hornberger, N. H. (2004). 'The Continua of Biliteracy and the Bilingual Educator: Educational linguistics in practice', *Bilingual Education and Bilingualism*, 7 (2–3), 155–71.

Huberman, A. M. and Miles, M. B. (1998). 'Data Management and Analysis Methods'. In N. K. Denzin and Y. S. Lincoln (ed.), *Collecting and Interpreting Qualitative Materials*, pp. 179–210. Thousand Oaks: Sage Publications.

Hugrée, C. (2009). 'Les classes populaires et l'université: la licence... et après?', *Revue française de pédagogie*, 167, avril–juin.

Hugrée, C. (2010). 'Le CAPES ou rien? Parcours scolaires, aspirations sociales et insertions professionnelles du "haut" des enfants de la démocratisation scolaire', *Actes de la recherche en sciences sociales*, 183, juin.

Huizinga, J. (1944). *Homo Ludens: A study of the play element in culture*. London: Routledge and Kegan Paul.

Hultqvist, E. and Palme, M. (2006). *Om de kunde ge en mall*. Paper, Tredje nordiska konferensen om pedagogikhistorisk forskning: Stockholm.

Inglehart, Ronald (1971). 'The Silent Revolution in Europe: Intergenerational Change in Post-Industrial Societies', *American Political Review*, 65 (4), 991–1017.

Inglehart, R. and Flanagan, S. (1987). 'Value Change in Industrial Societies', *American Political Science Review*, 81 (4), 1298–319.

Inglehart, R. (1990). *Culture Shift in Advanced Industrial Society*. Princeton: Princeton University.

Inglehart, R. (1997). *Modernization and Post-modernization: Cultural, Economic and Political Change in 43 Countries*. Princeton, NJ: Princeton University Press.

Inglehart, R. and Welzel, C. (2005). *Modernization, Cultural Change and Democracy: The Human Development Sequence*. Cambridge: Cambridge University Press.

Johnson, Dennis W. (2001). *No Place for Amateurs: How Political Consultants Are Reshaping American Democracy*. New York: Routledge.

Josse, J., Chavent, M., Liquet, B. and Husson, F. (2012). 'Handling Missing Values with Regularized Iterative Multiple Correspondance Analysis', *Journal of Classification*, 29, 91–116.

Kallio, P. K., Mäyra, M. and Kaipainen, K. (2011). 'At Least Nine Ways to Play: Approaching Gamer Mentalities', *Games and Culture*, 6 (4), 27–353.

Katz, R. S. and Mair, P. (1995). 'Changing Models of Party Organization and Party Democracy: The Emergence of the Cartel Party', *Party Politics*, 1 (1), 5–28.

Kavale, K. A. and Forness, S. R. (2000). 'History, Rhetoric, and Reality: Analysis of the inclusion debate', *Remedial and Special Education*, 21(5), 279–96.

Kline, S., Dyer-Witheford, N. and de Peuter, G. (2003). *Digital Play. The Interaction of Technology, Culture, and Marketing*. Montréal: McGill-Queen's University Press.

Kolodny, R. and Dulio, D. A. (2003). 'Political Party Adaptation in US Congressional Campaigns', *Party Politics*, 9 (6), 729–46.

Kolodny, R. and Logan, A. (1998). 'Political Consultants and the Extension of Party Goals', *Political Science and Politics*, 3, 155–9.

Kugelmass, J. W. (2001). 'Collaboration and Compromise in Creating and Sustaining an Inclusive School', *International Journal of Inclusive Education*, 5 (1), 47–65.

Kumaravadivelu, B. (2006). 'Dangerous liaison: Globalisation, Empire and TESOL'. In J. Edge (ed.), *(Re) locating TESOL in the Age of Empire*, pp. 1–26. London: Palgrave Macmillan.

Labbe, D. and Hubert, P. (1993). *La richesse du vocabulaire*. Colloque de l'ALLC-ACH, Paris. http://lexicometrica.univ-paris3.fr/article/numero0/VocabRichness.pdf

Lahire, B. (2004). *La culture des individus: Dissonances culturelles et distinction de soi*. Paris: La Découverte.

Layer, G. (2002). 'Developing Inclusivity', *International Journal of Lifelong Education*, 21 (1), 3–12.

Leathwood, C. and O'Connell, P. (2003). '"It's a struggle": The construction of the "new student" in higher education', *Journal of Education Policy*, 18 (6), 597–615.

Lebaron, F. (2009). 'How Bourdieu "Quantified" Bourdieu: The geometric modeling of Data'. In K. Robson and C. Sanders (ed.), *Quantifying theory: Pierre Bourdieu*. Springer Netherlands.

Lebaron, F. (2010). 'L'analyse géometrique des données dans un programme de recherche sociologique: Le cas de la sociologie de Bourdieu' *Revue MODULAD*, 2, 103–9.

Lebaron, F. (2008). 'Central Bankers in The Contemporary Global Field of Power: A "social space" approach', *The Sociological Review*. http://www.u-picardie. fr/~LaboERSI/mardi/fichiers/m64.pdf

Lebart, L., Piron, M., and Morineau, A. (2006). *Statistique exploratoire multidimensionnelle. Visualisation et inférence en fouilles de données* (4th ed.), Paris: Dunod.

Lebart, L., Salem, A., and Berry, L. (1998). *Exploring textual data*. Dordrecht: Kluwer.

Legendre, P. and Legendre, L. (1998). *Numerical Ecology* (2nd edition). Amsterdam: Elsevier Science.

Leighley, J. E. and Vedlitz, A. (1999). 'Race, Ethnicity, and Political Participation: Competing Models and Contrasting Explanations', *The Journal of Politics*, 6 (4), 1092–114.

Le Roux, B. and Rouanet, H. (1998). *Interpreting axes in Multiple Correspondence Analysis, Visualization of Categorical Data*. San Diego: Academic Press.

Le Roux, B. and Rouanet, H. (2004). *Geometric Data Analysis: From Correspondence Analysis to Structured Data Analysis*. Dordrecht: Kluwer.

Le Roux, B. and Rouanet, H. (2009). *Multiple Correspondence Analysis*. Sage: London.

Le Roux, B. and Perrineau, P. (2011). 'Les différents types d'électeurs au regard des différents types de confiance', *Les cahiers du CEVIPOF*, 5–29.

Lidegran, I. (2009). *Utbildningskapital. Om hur det alstras, fördelas och förmedlas*. Acta Universitatis, Studier i utbildnings- och kultursociologi 3, Uppsala.

Lipset, Seymor, M., Clark, Terry, N. and Rempel, M. (1991). 'Are Classes Dying?' *International Sociology*, 6 (3), 397–410.

Lipset, Seymor, M., Clark, Terry, N. and Rempel, M. (1993). 'The Declining Political Significance of Social Class', *International Sociology*, 8 (3), 293–316.

Mamlin, N. (1999). 'Despite Best Intentions: When inclusion fails', *The Journal of Special Education*, 33 (1), 36–49.

Mancini, P. (1999). 'New Frontiers in Political Professionalism', *Political Communication*, 16 (3), 231–45.

Manyak, P. C. (2002). 'Welcome to Salon 110: The consequences of hybrid literacy practices in a primary-grade English immersion class', *Bilingual Research Journal*, 26 (2), 213–34.

Maringe, F. and Fuller, A. (2006). *Widening Participation in Higher Education: A policy overview*. School of Education: University of Southampton.

Marginson, S. (2004). 'National and Global Competition in Higher Education', *The Australian Educational Researcher*, 31 (2), 1–29.

Marginson, S. (2008). 'Global Field and Global Imagining: Bourdieu and worldwide higher education', *British Journal of Sociology of Education*, 29 (3), 303–15.

Marginson, S. (2009). 'Bradley: a short-term political patch-up', *University World News*, 58, 1.

Marginson, S. (2011). 'It's a Long Way Down', *Australian Universities Review*, 53 (2), 21–33.

Mason, J. (2002). *Qualitative Researching, 2nd Edition*. London: Sage.

May, S. and Bousted, M. (2004). 'Investigation of Student Retention Through an Analysis of the First-Year Experience of Students at Kingston University', *Widening Participation and Lifelong Learning* 6 (2), 42–8.

McCray, A. D. and Garcia, S. B. (2002). 'The Stories We Must Tell: Developing a research agenda for multicultural and bilingual special education', *Qualitative Studies in Education*, 15 (6), 599–612.

MacDonald, K. (1995). *The Sociology of the Professions*. London: Sage.

Medvetz, T. (2008). *Think Tanks as an Emergent Field*. New York: Social Science Research Council.

Medvetz, T. (2012). *Think Tanks in America*. Chicago: University of Chicago Press.

Medvic, S. K. (2003). 'Professional Political Consultants: An Operational Definition', *Politics*, 23 (2), 119–27.

Micheletti, M. (2003). *Political Virtue and Shopping. Individuals, Consumerism, and Collective Action*. New York: Palgrave.

Million+ (2008). About Million+. Retrieved 15 May 2008 from http://www.millionplus.ac.uk/aboutus.htm

Montgomery, J. and Nyhan, B. (2010). The Party Edge: Consultant-Candidate Networks in American Political Parties. Paper 8. http://opensiuc.lib.siu.edu/pnconfs_2010/8

Moore, R. (2008). 'Capital'. In M. Grenfell (ed.), *Pierre Bourdieu: Key concepts*. Stocksfield: Acumen.

Muel-Dreyfus, F. (1983). *Le métier d'éducateur*. Paris: Les Editions de minuit.

Murtagh, F. (2005). *Correspondence analysis and Data Coding with Java and R*. Boca Raton: Chapman & Hall.

Naidoo, R. (2000). 'The "Third Way" to Widening Participation and Maintaining Quality in Higher Education: Lessons from the United Kingdom', *Journal of Educational Enquiry*, 1 (2), 24–38.

Nardi, B. (2010). *My Life as a Night Elf Priest. An Anthropological Account of World of Warcraft*. Ann Arbor: Michigan University Press.

Neff, G., Wissinger, E. and Zukin, S. (2005). 'Entrepreneurial Labor among Cultural Producers: "Cool" Jobs in "Hot" Industries', *Social Semiotics*, 15 (3), 307–34.

Nova Scotia Department of Education and Culture. (1996). *Special Education Policy Manual*. Halifax: Nova Scotia Department of Education and Culture.

Okada, A. (1999). 'Secondary Education Reform and the Concept of Equality of Opportunity in Japan', *Compare*, 171–89.

Øland, T. (2011). *Progressiv pædagogik*. Dafolo: København.

Oplatka, I., Hemsley-Brown, J., and Foskett, N. H. (2002a). 'The Voice of Teachers in Marketing Their School: Personal perspectives in competitive environments', *School Leadership and Management*, 22 (2), 177–96.

Oplatka, I., Foskett, N., and Hemsley-Brown, J. (2002b). 'Educational Marketization and The Head's Psychological Well-Being: A speculative conceptualization', *British Journal of Educational Studies*, 50 (4), 419–41.

Osborne, M. (2003). 'Increasing or Widening Participation in Higher Education? A European overview', *European Journal of Education*, 38 (1), 5–24.

Ozga, J. and Sukhnandan, L. (1998). 'Undergraduate Non-Completion: Developing an explanatory model', *Higher Education Quarterly*, 52 (3), 316–33.

Pakulski, J. (1995). 'Social Movement and Class: The decline of the Marxist paradigm'. In L. Maheu (ed.), *Social Movements and Social Classes*. London: Sage.

Pearce, C. (2009). *Communities of Play. Emergent Cultures in Multiplayer Games and Virtual Worlds*. Cambridge: MIT Press.

Pearson, S. (2000). 'The Relationship Between School Culture and IEPs' *British Journal of Special Education*, 27 (3), 145–9.

Pennycook, A. (1994). *The Cultural Politics of English as an International Language*. London: Longman.

Pennycook, A. (1995). 'English in the world/The world in English'. In J. W. Tollefson (ed.), *Power and Inequality in Language Education* pp. 34–58. Cambridge: Cambridge University Press.

Pennycook, A. (1998). *English and the Discourses of Colonialism*. London: Routledge.

Peterson, R. A., and Anand, N. (2004). 'The Production of Culture Perspective', *Annual Review of Sociology*, 30, 311–34.

Peterson, R. A. and Kern, R. M. (1996). 'Changing Highbrow Taste: From Snob to Omnivore', *American Sociological Review*, 61 (5), 900–7.

Petracca, M. P. (1989). 'Political Consultants and Democratic Governance'. *PS: Political Science and Politics*, 22 (1), 11–14.

Phillion, J. (2002). 'Classroom Stories of Multicultural Teaching and Learning', *Journal of Curriculum Studies*, 34 (3), 281–300.

Phillipson, R. (1992). *Linguistic Imperialism*. Oxford: Oxford University Press.

Phillipson, R. (1994). 'English Language Spread Policy', *International Journal of the Sociology of Language*, 107, 7–24.

Phillipson, R. (1999). 'Voice in Global English: Unheard chords in crystal loud and clear', *Applied Linguistics*, 20 (2), 265–76.

Phillipson, R. (2003). *English – Only Europe? Challenging Language Policy*. London: Routledge.

Phillipson, R. (2008). 'The Linguistic Imperialism of Neoliberal Empire', *Critical Inquiry in Language Studies*, 5 (1), 1–43.

Phillipson, R. (2009). *Linguistic Imperialism Continued*. New York and London: Routledge.

Poullaouec, T. (2010). *Le diplôme, arme des faibles. Les familles ouvrières et l'école*. Paris: La Dispute.

Priestley, M. and Rabiee, P. (2002). 'Hopes and Fears: Stakeholder views on the transfer of special school resources towards inclusion', *International Journal of Inclusive Education*, 6 (4), 371–90.

Putnam, R. (2000). *Bowling Alone: The Collapse and Revival of American Community*. New York: Simon and Schuster.

Raessens, J. (2005). 'Computer Games as Participatory Media Culture'. In J. Goldstein and J. Raessens (ed.), *Handbook of Computer Game Studies*, pp. 373–88. London: MIT Press.

Read, B., Archer, L. and Leathwood, C. (2003). 'Challenging Cultures? Student Conceptions of "Belonging" and "Isolation" in a Post-1992 University', *Studies in Higher Education*, 28 (3), 261–77.

Reay, D. (2006). 'The Zombie Stalking English Schools: Social class and educational inequality', *British Journal of Educational Studies*, 54 (3), 288–397.

Reay, D., Crozier, G. and Clayton, J. (2009). '"Strangers in paradise"? Working-class students in elite universities', *Sociology*, 43 (6), 1103–21.

Reay, D., David, M. E. and Ball, S. (2005). *Degrees of Choice: Social class, race and gender in higher education*. Stoke on Trent: Trentham Books.

Renahy, N. (2010). 'Classes populaires et capital d'autochtonie. Genèse et usages d'une notion', *Regards Sociologiques*, 40, 9–26.

Retière, J-N. (2003). 'Autour de l'autochtonie. Réflexions sur la notion de capital social populaire', *Politix*, 63, 121–43.

Richard, B. and Zaremba, J. (2003). 'Gaming with Grrls: Looking for Sheroes in Computer Games'. In J. Goldstein and J. Raessens (ed.), *Handbook of Computer Game Studies*, pp. 283–300. London: MIT Press.

Robert, P. and Escouffier, Y. (1976). 'A Unifying Tool For Linear Multivariate Statistical Methods: The "RV" coefficient', *Applied Statistics*, 25, 257–65.

Rosenbloom, D. L. (1973). *The Election Men; Professional Campaign Managers and American Democracy*. New York: Quadrangle Books.

Rouanet, H., Ackermann, W. and Le Roux, B. (2000). 'The Geometric Analysis of Questionnaires: The lesson of Bourdieu's La Distinction', *Bulletin de Méthodologie Sociologique*, 65, 5–18.

Sabato, L. (1988). *The Party's Just Begun: Shaping Political Parties for America's Future*. Glenview, Ill: Scott/Foresman Little, Brown College Division.

Sabato, L. (1981). *The Rise of Political Consultants: New Ways of Winning Elections*. New York: Basic Books.

Sambell, K. and A. Hubbard (2004). 'The Role of Formative "Low-Stakes" Assessment in Supporting Non-Traditional Students' Retention and Progression in Higher Education: Student perspectives', *Widening Participation and Lifelong Learning*, 6 (2), 25–36.

Sammels, M. (2006). *Australian Aid: Promoting Growth and Stability*. A White Paper on the Australian Government's Overseas Aid Program. Submitted by the Australian Reproductive Health Alliance.

Sautory, O. (2007). 'La démocratisation de l'enseignement supérieur: évolution comparée des caractéristiques sociodémographiques des bacheliers et étudiants', *Education & formation*, 74, April.

Select Committee for Education and Skills. (2006). *New Inquiries into Higher Education*. The United Kingdom Parliament.

Skinner, R. M, Masket, S. E. and Dulio, D. A. (2012). '527 Committees and the Political Party Network', *American Politics Research*, 40 (1), 60–84.

Skutnabb-Kangas, T. (1998). 'Human Rights and Language Wrongs – A future for diversity?', *Language Sciences*, 20 (1), 5–27.

Skutnabb-Kangas, T. (2000). 'Linguistic Human Rights and Teachers of English'. In J. K. Hall and W. G. Eggington (ed.), *The Sociopolitics of English Language*, pp. 22–45. Australia: Multilingual Matters.

Stake, R. E. (1994). 'Case Studies'. In N. K. Denzin and Y. S. Lincoln (ed.), *Handbook of Qualitative Research*, pp. 236–47. Thousand Oaks: Sage.

Stirrat, R. L. (2000). 'Cultures of Consultancy', *Critique of Anthropology*, 20 (1), 31–46.

Svejgaard, K. L. (2006). *At være i uddannelse griber fat i én*. Frederiksberg: Pædagogseminariernes Rektorforsamling.

Swidler, A. (1986). 'Culture in Action: Symbols and Strategies', *American Sociological Review*, 51 (2), 273–86.

Taylor, T. L. (2006). *Play Between Worlds: Exploring Online Game Culture*. Cambridge, Mass.: MIT Press.

The Russell Group (no date). About The Russell Group. Retrieved 29 April 2008 from http://www.russellgroup.ac.uk/about.html

Thomas, L. (2002). 'Student Retention in Higher Education: The role of institutional habitus', *Journal of Educational Policy*, 17 (4), 423–42.

Thurber, J. A. (2001). *The Battle for Congress: Consultants, Candidates, and Voters*. Washington, D. C: Brookings Institution Press.

Thurber, J. A. and Nelson, C. J. (2000). *Campaign Warriors: Political Consultants in Elections*. Washington: Brookings Institution Press.

Thurber, J. A., and Nelson, C. J. (2004). *Campaigns and Elections American Style*. Westview Press.

Thurber, J. A., Nelson, C. J. and Dulio, D. A. (1999). *1999 Survey of Political Consultants as part of the Improving Campaign Conduct grant, funded by Pew Charitable trusts, Center for Congressional and Presidential Studies, American University*.

Triclot, M. (2011). *Philosophie des jeux vidéo*. Paris: Zone.

Tuuanen, J., and Hamari, J. (2012). 'Meta-synthesis of player typologies'. Paper presented at *DiGRA Nordic 2012: Local and Global – Games in Culture and Society*. Tampere, Finland.

Valencia, O. and Alvarez-Esteban, R. (2012). 'A Bootstrap Procedure in The Context of Correspondence Analysis: Numerical approach to measure the stability of axes', *Estudios de Economía Aplicada*, 30, 1–28.

Valentine, F. (2001). *Enabling citizenship: full inclusion of children with disabilities and their parents*. Ottawa: Canadian Policy Research Networks.

Vaughan, D. (1992). 'Theory elaboration: The heuristics of case analysis'. In H. Becker and C. Ragin (ed.), *What is a case?* pp. 173–202. New York: Cambridge University Press.

Veenstra, G. (2009). 'Transformations of Capital in Canada: A "social space" approach'. In K. Robson and C. Sanders (ed.), *Quantifying theory: Pierre Bourdieu*, pp. 61–7. New York: Springer Science and Business Media.

Verba, S., Burns, N. and Schlozman, K. L. (1997). 'Knowing and Caring About Politics: Gender and Political Engagement', *The Journal of Politics*, 59 (4), 1051–72.

Verba, S., Schlozman, K. L. and Brady, H. E. (1995). *Voice and Equality: Civic Voluntarism in American Politics*. Cambridge, MA: Harvard University Press.

Watson, J. (2012). 'Profitable Portfolios: Capital that counts in higher education', *British Journal of Sociology of Education*, 34 (3), 412–30.

Watson, J., Nind, M., Humphris, D. and Borthwick, A. (2009). 'Strange New World: Applying a Bourdieuian lens to understanding early student experiences in higher education', *British Journal of Sociology of Education*, 30 (6), 665–81.

Watson, R. P. and Campbell, C. C. (ed.) (2003). *Campaigns and Elections: Issues, Concepts, Cases*. Boulder, Colo: Lynne Rienner Publishers.

Wattenberg, M. P. (1998). *The Decline of American Political Parties, 1952–1996*. Cambridge, MA: Harvard University Press.

Widin, J. (2010). *Illegitimate Practices: Global English language education*. Bristol: Multilingual Matters.

Williams, D., Yee, N. and Caplan, S. (2008). 'Who Plays, How Much, and Why? Debunking the stereotypical gamer profile', *Journal of Computer-Mediated Communication*, 13 (4), 993–1018.

Wolfinger, R. E. and Rosenstone, S. J. (1980). *Who votes?* Yale NJ: Yale University Press.

Yee, N. (2006). 'Motivations for Play in Online Games', *CyberPsychology & Behavior*, 9 (6), 772–5.

Yorke, M. (2001a). 'Formative Assessment and Its Relevance to Retention', *Higher Education Research and Development*, 20 (2), 115–26.

Yorke, M. (2001b). 'Outside Benchmark Expectations? Variations in non-completion rates in English higher education', *Journal of Higher Education Policy and Management*, 23 (2), 148–58.

Zabban, V. (2009). 'Hors jeu? Itinéraires et espaces de la pratique des jeux vidéo en ligne', *Terrains & Travaux*, 15, 81–104.

1994 Group [no date]. *About us*. Retrieved 14 May 2008 from http://www.1994group. ac.uk/aboutus.php

Notes on Contributors

RAMÓN ÁLVAREZ ESTEBAN is Associate Professor at Universidad de León. His areas of specialism are textual data, statistical analysis of socioeconomic variables, multivariate data analysis in marketing research, stability and resampling methods in multivariate methods. His key publications include 'Rating of products through scores and free-text assertions: Comparing and combining both', *Food Quality and Preference*, 19, 122–34 (2008); 'Statistical Study of Judicial Practices', *Lecture Notes in Artificial Intelligence* LNCS 3369, 25–35 (2005) (with M. Ayuso and M. Bécue-Bertaut); and 'Assessing the stability of supplementary elements on principal axes maps through bootstrap resampling. Contribution to interpretation in textual analysis' (with O. Valencia and M. Bécue-Bertaut) in C. H. Skiadas (ed.), *Statistics for Industry and Technology, Advances in Data Analysis*.

MÓNICA BÉCUE-BERTAUT is Associate Professor at Universitat Politècnica de Catalunya. Her areas of specialism are multidimensional analysis and applications to survey data, analysis of mixed textual and contextual data, argumentative structure in law domain and sensometrics. Her key publications include 'Rhetorical strategy in forensic closing speeches: Multidimensional statistics-based methodology' in *Journal of Classification* (in press) (with B. Kostov, A. Morin and G. Naro); 'Multiple factor analysis and clustering of a mixture of quantitative, categorical and frequency data' in *Computational Statistics & Data Analysis*, 52, 3255–68 (with J. Pagès) (2008); and 'A principal axes method for comparing contingency tables: MFACT' in *Computational Statistics & Data Analysis*, 52, 481–503 (with J. Pagès) (2004).

YLVA BERGSTRÖM is Docent (Associate Professor) of Sociology of Education in the Department of Education at Uppsala University. She is a member of the research unit Sociology of Education and Culture (SEC) <http://www.skeptron.uu.se/pers/ylvab>.

VINCENT BERRY is Assistant Professor at the University of Paris 13 and a member of the 'Leisure, games and cultural objects of childhood' research team in the EXPERICE laboratory. His work analyses the evolution of games, players and contemporary play culture (toys, board games, video games, role playing games, etc.). He is the author of a sociological survey on the practice of MMORPG, 'The Virtual Experience: to play, live and learn in a video game' published in 2012.

PHILIPPE BONNET is a CNRS social psychologist and statistician at the Cognitive Psychology and Neuropsychology Laboratory of Paris Descartes University (LPNcog), who for many years collaborated with H. Rouanet and B. Le Roux in the Mathematics and Psychology Group. His main research interests are in geometric data analysis of quantitative, qualitative and textual data with emphasis on structured data and applications to behavioural and social sciences. His publications include 'Analyse géométrique des données: une enquête sur le racisme' in *Mathématiques, informatique et Sciences humaines*, 34, 136, 5–24 (1996) and 'On-line sentence processing in Swedish: cross linguistic developmental comparisons with French' in *Journal of Child Language*, 38, 1–33 (2011).

MANUEL BOUTET is a post-doctoral researcher at Université François Rabelais de Tours and is working on the project LUDESPACE (JCJC SHS 1 2011) funded by the Agence Nationale de la Recherche. His research focuses on the everyday uses of digital technologies, both online and offline, with an emphasis on the way the small changes introduced to our ordinary experiences have great impacts on our life- and work styles. He is also the founder of the annual meeting 'Game Studies? à la française!' of the French association OMNSH <http://www.omnsh.org>.

SAMUEL COAVOUX is a PhD candidate at the École Normale Supérieure de Lyon and teaches at the Université d'Avignon (France). His research focuses on the weak receptions of cultural objects, from classical paintings to videogames. He recently co-edited with Hovig Ter Minassian and Samuel Rufat *Espace et temps des jeux video* (2012).

TOBIAS DALBERG is a PhD candidate in Sociology of Education in the Department of Education at Uppsala University. He is a member of the research unit Sociology of Education and Culture (SEC) <http://www.skeptron.uu.se/pers/ylvab>.

CARLA DIGIORGIO specializes in inclusive education. Her PhD thesis focused on an analysis of identity, power and educational practice in a francophone school in Canada. Since then, she has written two books in the field of inclusive education and several book chapters. She uses Bourdieu's theory of social structure and change to analyse the dynamics in heterogeneous educational environments such as second language classrooms, international baccalaureate classrooms and programmes for children and adults with learning challenges. She continues to work in teacher preparation programmes, curriculum design for graduate education programmes in Canada and research and consulting on educational matters. She has been the editor of the *Canadian Journal of Education* and is on the advisory panel of the *International Journal of Inclusive Education*.

JAN THORHAUGE FREDERIKSEN is Assistant Professor in the Department of Media, Culture and Cognition at the University of Copenhagen. He specializes in Educational Sociology and in particular the field of Professional Training and Sociology of Professions. He currently heads a research project exploring the relationship between social class background, geographical location and professional training in the field of welfare work. His key publications include 'Between Practice and Profession', PhD thesis, Roskilde University (2010) and 'Quelling dissent with democracy', *European Journal of Social Education* (2013).

MICHAEL GRENFELL is Chair of Education at Trinity College, University of Dublin, Ireland. His areas of research include education, art and culture, language and Bourdieu. He had a long association with Bourdieu over a twenty-year period and has written extensively on him as well as applied his work to a range of areas: *Bourdieu, Language and Linguistics* (2011); *Art Rules: Bourdieu and the Visual Arts* (with C. Hardy) (2007);

Agent Provocateur – Pierre Bourdieu (2004); *Bourdieu, Education and Training* (2007); *Language, Ethnography and Education* (2012); and *Pierre Bourdieu – Key Concepts* (2012).

CHERYL HARDY is a Senior Lecturer and independent researcher and has worked in universities in Southampton, Winchester, Plymouth and London. She specializes in mathematics education, arts and aesthetics education, philosophy, and leadership and management. Her publications include *Language, Ethnography and Education* (2012), *Art Rules* (2007) and *Bourdieu, Language and Linguistics* (2012).

BELCHIN KOSTOV is a PhD student at Universitat Politècnica de Catalunya. He is a statistician at the Transverse Group for Research in Primary Care, IDIBAPS, Barcelona, Spain. His areas of specialism are analysis of textual data, sensometrics and biostatistics. His key publications include 'An original methodology for the analysis and interpretation of word-count based methods: multiple factor analysis for contingency tables complemented by consensual words' in *Food Quality and Preference* (in press) (with M. Bécue-Bertaut and F. Husson) and 'MFACT, a new functionality in MFA FactoMineR' in *R Journal*, 5, 29–38.

DANIEL LAURISON is a post-doctoral research fellow in the Sociology Department at the London School of Economics and Political Science. He earned his PhD in sociology from the University of California, Berkeley in 2013. His research examines the ways social position shapes both the production and perception of political content; he is also interested in classed differences in individuals' relations to and judgments of fields of cultural production and sets of cultural objects beyond politics. He has written on American professional campaign operatives as well as public opinion, and is currently collaborating on a project examining social and cultural inequalities in Britain.

FRÉDÉRIC LEBARON has been Professor of Sociology at the University of Versailles-Saint-Quentin-en-Yvelines (UMR Professions-Institutions-Temporalités) since September 2013, following sixteen years at the

university of Picardie-Jules Verne in Amiens, where he directed the Centre Universitaire de Recherches sur l'Action Publique et le Politique – épistémologie et sciences sociales (CURAPP). He specializes in social sciences methodology, economic sociology, political sociology and social inequality. He has written and edited several books, including *Lectures de Pierre Bourdieu* (with Gérard Mauger), *Les indicateurs sociaux au XXIème siècle*, *La crise de la croyance économique* and *Le savant, le politique et la mondialisation*. He has also published approximately seventy journal articles and book chapters.

ANNIE MORIN is Associate Professor at the University of Rennes. Her areas of specialism are data analysis, clustering and classification with applications to text mining and image mining. Her previous works are on speech recognition and her key publications include 'Visualization of Temporal Text Collections Based on Correspondence Analysis' in *Expert Systems with Applications*, 39(15) 12143–57 (2012); 'Textual features for corpus visualization using correspondence analysis' in *Intelligent Data Analysis*, 13:795–813 (2009); and 'Caviz: An interactive graphical tool for image mining', *Journal of Computing and Information Technology*, 16:295–302 (2008).

ANDREA TRIBESS is Associate Researcher at the CURAPP – ESS and holds a PhD in Demography and Social Sciences from the École des Hautes Études en Sciences Sociales, Paris. She is interested in popular lifestyles, inter-class relationships and empowerment processes in rural and urban areas. Her key publications include *Un village sarde contemporain: pouvoirs et contrepouvoir* (2011).

JO WATSON is Senior Lecturer and Director of Programmes for Physical and Rehabilitation Health at the University of Southampton, where she leads the pre-registration education of allied health professionals in the Faculty of Health Sciences. She is an occupational therapist by background and her research focuses on student experiences in higher education, particularly understanding and supporting the success of students entering under the widening participation agenda.

JACQUELINE WIDIN is a senior lecturer at the University of Technology, Sydney where she coordinates the TESOL and Applied Linguistics Education programmes, and she has extensive experience in the teaching and research of English as an additional/international language. She has a particular interest in the relationship between language learning, human rights and sociopolitical dynamics across the English Language Teaching field. She is the author of *Illegitimate Practices: Global English Language Education.*

Index